The Two-Headed Deer

CALIFORNIA STUDIES IN THE HISTORY OF ART

Walter Horn, Founding Editor

James Marrow, General Editor

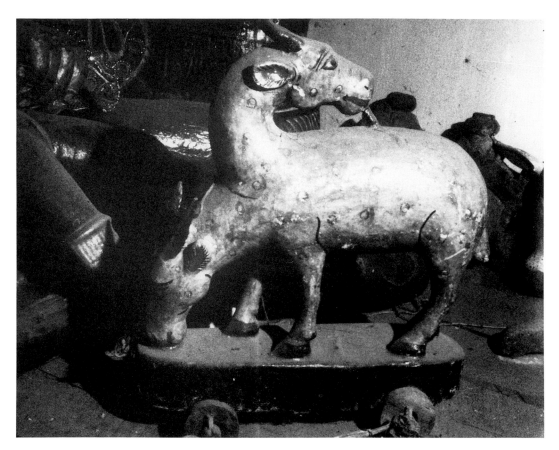

Bisipada Rāmalīḷā. Magic deer.

The Two-Headed Deer ∴

ILLUSTRATIONS OF

THE RĀMĀYAṆA IN ORISSA

Joanna Williams

University of California Press

Berkeley Los Angeles London

The publisher gratefully acknowledges the contribution provided by the Art Book Endowment of the Associates of the University of California Press, which is supported by a major gift from the Ahmanson Foundation.

Published with the assistance of the Getty Grant Program

University of California Press
Berkeley and Los Angeles, California

University of California Press, Ltd.
London, England

© 1996 by
The Regents of the University of California

Library of Congress Cataloging-in-Publication Data
Williams, Joanna Gottfried, 1939–
 The two-headed deer : illustrations of the Rāmāyaṇa in Orissa /
Joanna Williams.
 p. cm.—(California studies in the history of art ; 34)
 Includes bibliographical references and index.
 ISBN 0-520-08065-3 (alk. paper)
 1. Vālmīki. Rāmāyaṇa—Illustrations. 2. Art, Indic—India—
Orissa. 3. Narrative art—India—Orissa. I. Title. II. Series.
N7307.074W56 1996
704.9′48945922′095413—dc20 95-4978

Printed in the United States of America

CONTENTS

ILLUSTRATIONS

Maps

Plates (*following page* 88)

Figures

(Pages given for Figures 1–48, all in Chapter 1.
Other figures follow page 194)

ACKNOWLEDGMENTS

My research on Orissan palm-leaf manuscripts began in 1979 with a Guggenheim Fellowship. In 1982–83, a Senior Research Grant from the American Institute of Indian Studies enabled me to spend a year in the area of Puri, focusing on this project and participating in the life of one of the great Hindu pilgrimage centers. Subsequent shorter visits were part of my work for the Ford Foundation in Delhi from 1984 to 1986. A sabbatical from the University of California at Berkeley made it possible to see the Dasapalla Rāmalīḷā in 1990.

I am grateful to established "Orissa hands" abroad, who were supportive and gave good advice about carrying out research in this part of India: Drs. Hermann Kulke, Eberhard Fischer, Louise Cort, Thomas Donaldson, and Frederique Marglin. At home, my son, Dylan, kept me abreast of the Western artistic genre most comparable to my subject, the comic book.

The people of Orissa who helped in my work should all be thought of as my co-authors. Purna Chandra Mishra of Puri deserves the title Independent Scholar rather than Research Assistant, having been indispensable to many foreign researchers over the years. His wife, Suresvari Mishra, Reader in Sanskrit at Puri Women's College, was of immense help in deciphering manuscripts as well as making me feel at home in Puri. In Bhubaneswar I had the privilege of studying Oriya, the language of Orissa, with Tripti Mohanty, then completing her doctorate at Utkal University and trained as an instructor in the Eastern Regional Language Centre. With lucidity and infectious good nature she gave me insights into local culture that could only come from the daughter of a *daitya* (Puri temple priest) family. Professors K. S. Behera and K. C. Sahu of Utkal University, Professor P. K. Mishra of Sambalpur University, Mr. D. P. Das of the Orissa State Department of Education, and Dr. Dinanath Pathy all generously shared interesting information with me. Without the cooperation of the painters of Raghurajpur, Danda Sahi, and Puri, no serious discussion of their work would be possible. Among my many friends in that community, Jagannath Mahapatra must be singled out as master artist. The hospitality of Sonepur, Asureshvar, and Dasapalla colors my account of rural performances. Finally, I cannot begin to list all the ways I am indebted to Dr. J. P. Das of New Delhi.

In the transformation of a complex manuscript into this book, I am grateful for Stephanie Fay's careful copyediting and dogged pursuit of my idiosyncratic turns of phrase. The entire project might have foundered without the enthusiastic support of Deborah Kirshman as Fine Arts Editor of the University of California Press. And Natasha Reichle has prepared the index with care and good judgment.

Photographs not otherwise credited are my own.

A NOTE ON THE USE OF INDIAN TERMS

Because my subject is Orissa, I have used the Oriya form for names and vocabulary, which is generally, but not always, the same as Sanskrit (and often distinct from the Hindi forms used elsewhere in India). Hence Hanumāna rather than the more familiar Hanuman. In transliteration I follow the Library of Congress system, except in *ch* and *chh* (rather than *c* and *ch*), and *ṛi* (rather than *ṛ*). For ease of reading by the nonspecialist, I have omitted diacritical marks on place names and on the names of people living in the past hundred years.

INTRODUCTION

This book concerns illustrations of the Rāmāyaṇa, an epic poem with epic implications for contemporary India. I have chosen, however, to focus upon the single region of Orissa—rich rice-growing plains along the eastern coast, between Bengal and Andhra, a region relatively homogeneous, traditional, and peaceful (see maps). Orissa is known for its elegantly carved and architecturally ambitious temples, dating from A.D. 600 to 1250. The illustrations considered here, however, are less familiar sequences of pictures from the nineteenth and twentieth centuries. My reason for addressing this topic is not that of the mountaineer who climbs a peak "because it is there" (and unclimbed). Rather I should profess a tripartite personal agenda.

First, having spent most of my scholarly career studying the ancient art of South Asia, I was tantalized by questions that seemed unanswerable. For example, in the process of analyzing reliefs of the life of the Buddha from the fifth century A.D., the Gupta period, I considered earlier images and Buddhist texts as alternative sources for iconography.[1] When neither image nor text corresponded to a particular Gupta carving, it was tempting to credit the sculptor with creating a new version of the story. Yet it was also impossible to be certain what verbal guidelines were actually current in written, let alone in oral, form. Comparison required a body of art in which it was clear what written text the artist actually knew and for which oral traditions were preserved. I must admit in advance that the recent material upon which I settled is not without its own problems and includes two genres with potentially different relationships between image and word. Moreover the projection of recent patterns onto the ancient past requires caution. This book presents information essential for that analogy but does not take understanding ancient art as its goal.

Second, having chosen to work in Orissa, I reflected on why interesting and beautiful pictures here had been largely neglected in the overall framework of Indian art, whereas the images of some traditions (e.g. Gupta sculpture or Mughal painting) had been examined and reexamined. A litany of accusations about scholarly biases does not seem to me productive. Yet one of many reasons for such neglect is worth considering—the "folk art" status of the two genres considered here. As I studied both, I found a continuum between rough work, rooted in a

1

Map 1. Orissa

2. Ganjam District

village or popular context, and refined, complex images, some produced by the same artist, others within the same generic form. I became uneasy with the polarization of folk and elite art, even in its Indian formulation, *deśi* (local) and *mārgi* (mainstream). Such dichotomies have been uneasily transferred from the realm of verbal lore to that of visual, and the terms merit fuller theoretical analysis. In this book I have deliberately included some images that most art historians would classify as folk art. Part of my hidden agenda is to make both the rough, gutsy and the refined parts of the Orissan pictorial tradition interesting and accessible to a wide audience.

A third incentive to undertake this particular study came in the course of looking at a fine set of illustrations of a poetic text in a museum with a discerning American collector of Indian painting. He remarked as we considered the tenth picture: "What a waste to have these together, where they become boring; each one would be a masterpiece by itself." This reaction is symptomatic of our treating as separate pictures images designed to be seen in sequence.[2]

Formal analysis need be performed on only one member of a set whose style is consistent. Likewise the content of a single picture can be addressed in isolation. But for a series with narrative content, we must consider several images in sequence to understand how the story is told visually. Indian illustrated manuscripts have usually been analyzed on the basis of draftsmanship and design in the isolated page. Such qualities need not be neglected. Yet to restrict oneself to them is to omit dramatic qualities such as variety, surprise, and emotional development sustained over a sequence of images. The present study attempts to talk about sequential content without dismissing formal qualities in individual images. My goal is to present this material as interesting even to the collector whose reaction galled me, and at the same time to demonstrate that the pictures have another dimension, missed if one is seen in isolation. This task is not peculiar to Orissa, so I focus upon images of the epic Rāmāyaṇa, some version of which is known to virtually every Indian and which ought to have a place in the world's literary canon.

For methodological guidelines, three comparisons between pictures and other sequential art forms come to mind. The first is cinema, a medium that comprises sequential images as well as words and other sounds. However fine the photography, it would be difficult to judge a movie from isolated frames, omitting other "filmic" qualities. My own experience of Indian culture began with the films of Satyajit Ray. What captivated me most in the *Apu* trilogy was the unfamiliar mixture of emotions depicted and evoked, the sense that one could move rapidly back and forth between grief and amusement. My bafflement at so meandering a plotline perhaps reveals the limitations of a viewer raised on American cinematic aesthetics in the 1950s. When I eventually read Bibhuti Banerji's novel, on which the movies were based, I realized that Ray had tightened up the plot and reduced the number of emotional reversals. Nonetheless, I would claim that the films do reveal a structure based on the development of several complementary moods, the *rasas* that will figure in my own analysis, which contrast with an Aristotelian preoccupation with plot or structure based on a coherent sequence of action.

A powerful film concerning contemporary life in Orissa, the very region of this book, suggests an analogy with the pictures discussed here. The title of that movie, *Maya Mriga* (The Magic Deer), alludes to a theme in the Rāmāyaṇa central to this study. In the film, the deer is an emblem of the illusory nature of traditional family values, such as respect for parents and support for siblings, in an age when education (itself traditionally valued) encourages the young to put themselves first. Unfortunately that film is not easily accessible to an English-speaking audience, so I shall not pursue the comparison. The immensely popular version of the Rāmāyaṇa shown on Indian public television in 1987 and 1988 will be more familiar to many readers; thus references to the TV series occur throughout this book.

Finally, one must note that cinema and video are usually more collaborative media than the painting and book illustration considered here, even in the case of a strong director such as Satyajit Ray, who guided both photography and music with care. Hence the analogy is not inevitably useful as a means to understand the production of images. Furthermore, the existence of a film, like theater, in time that is not reversible (despite the existence of the video cassette) gives it a different status from pictures whose order the viewer participates in determining.

The comic strip forms a yet more apt comparison for the illustrated book. One might argue that today's most vital sequential graphic art form is the comic, both in India and in the West.[3] In the Orissan book, the same artist normally executes pictures and text, and the text is presumably copied from another manuscript. The comic, likewise, may be produced by one artist, although many comics result from collaboration between artist, author, and letterer. The fact that the Western comic usually presents a new story makes recognizability a major issue, whereas any images of the Rāmāyaṇa have an initial legibility. As the distinguished man of letters A. K. Ramanujan has put it, no Indian ever reads the Rāmāyaṇa for the first time.[4] Nonetheless, the interpretation of its depiction requires the reader's cooperation. Thus it seems fruitful to bear in mind several devices of the comic throughout this book: framing, the spectator's position, and variations in the number and size of panels to indicate the passage of time.

A third tradition analogous to narrative images is purely verbal narrative. This comparison is perhaps most promising as a source of theoretical models, having attracted the most attention. The burgeoning field of narratology provides frameworks rooted in literary criticism but readily applied to pictures that tell stories.[5] Some Westerners and educated Indians may feel that because older images do not tell stories clearly to us, they were not intended to tell stories at all. One could counter, however, that the stories *were* clear to the knowledgeable.[6] One could also argue, as I do, that clarity is not the only possible goal of a story. In Chapter 5 I shall attempt to construct a narratological framework suited to Indian pictorial images.

Here I shall simply sketch some elements of the theoretical models from literature that I do find useful and not specific to Western culture. In the first place, the Russian formalists have distinguished *story* (the underlying "argument" or chronological sequence of events) and *discourse* (the form in which argument and events are actually presented).[7] When we turn to images, it would be easy to reduce these concepts to a verbal story and a visual discourse, but it is worth remembering that there is also a discrepancy between the two at the verbal level and hence that the text illustrated need not constitute *the* story. The story in fact lies in the mind of the artist, and its retrieval requires looking at the pictures in addition to reading the accompanying words. In this book, pictorial discourse is the primary concern.

Roland Barthes begins his seminal essay, "The narratives of the world are numberless," and I admire his generally pluralistic vision of the subject.[8] Barthes notes the fallacy described in the scholastic formula *post hoc, ergo propter hoc*, linking consecution (order) and consequence (causation). He also remarks that elements in a story may have a phatic role, that is, communicate feelings rather than ideas. Most important for me, Barthes provides an exemplary framework in which

narrative structure functions as a code, limiting but not determining the tale that ensues.[9] In other words, he admits the freedom of the artist, which I find particularly necessary in dealing with Indian traditions too readily treated as formulaic. Thus he avoids both mechanical classification of imagery and complete randomness.

Gérard Genette, in focusing on one major novel, Proust's *À la recherche du temps perdu*, provides a large body of analytic concepts.[10] These seem most helpful in considering the temporal dimension of the story, and my discussion of matters of order is indebted to him. Hence the terms "anachrony" (departure from chronological order), "analepsis" (flashback), and "prolepsis" (flash-forward). Matters involving the narrator, which Genette classifies as mood and voice, are more problematic in the realm of pictorial narration in general. His term "focalization," roughly identified with a narrative point of view, has been questioned but not discredited, and visual equivalents have been suggested.[11] Given the broad impersonality of Sanskrit literature, I consider our stories as "nonfocalized" in general, but the concept may be helpful in several cases where an entire sequence is presented as an illusion.

In organization, the present work takes on some of the labyrinthine complexities of Indian storytelling. I have been tempted at points to separate out entirely my different concerns for various readers. But I do not want the student of art history to be able to bypass the rich Indian stories. Nor do I want the student of Indian literature or of narratology to be able to bypass the visual adventure of Orissan pictures. Chapter 1 presents a variety of verbal versions of the story of Rāma. Chapter 2 introduces Orissan painting and manuscript illustration as a whole in traditional formal, historical, and contextual terms, as they survive from the late eighteenth century on. Chapter 3 addresses earlier sculptural images of the subject of Rāma in the same region, as a visual precedent for the pictures. Chapter 4 compares systematically the diverse pictorial versions (our discourse) of ten events in the story. Chapter 5 considers each pictorial discourse in sequential terms, returning to theoretical issues. Chapter 6 attempts to draw conclusions about meaning, indeterminate as that may be, about the artists' storytelling choices, and about our judgment of the success of the pictorial narratives.

Finally, I feel compelled to underscore a philosophical point that might be lost, coming from an art historian telling a complex, pluralistic story that suggests complete relativism. The fact that we all make mistakes is trivial but true. This is comparable to pointing out that there are germs everywhere; we are not therefore justified in performing surgery in a sewer. There are mistakes as well as germs, and I would like to minimize both. But it does interest me that two or more answers to one question may be correct. This modified form of relativism underlies my argument in several ways.

The Story ∴ 1

A RÉSUMÉ

Any discussion of variant tellings and depictions of the story must presuppose some familiarity with a basic version of the plotline. Because no Indian hears the Rāmāyaṇa for the first time, Indians and adoptive Indians (South Asian specialists) will not need the following résumé. This prelude is intended for Western readers venturing into a new field. To follow theoretical issues, we cannot remain outsiders and must begin like children with a fairy tale. The following bare-bones account, devoid of interpretive comment, is limited to the gist of the Sanskrit epic that is relevant to later versions current in Orissa. Illustrations from a manuscript discussed in Chapter 2 are included here because they depict clearly and directly many parts of the plot. They are part of an Orissan précis of the tale, the literal translation of which appears in Appendix 3, and thus a few incidents in our résumé are not depicted while others are added. Traditionally the story of Rāma is divided into seven epic chapters, or *kāṇḍas*.

I. Bāla Kāṇḍa

Once upon a time, Daśaratha, King of Ayodhyā, lacked a son. The sage Riśya-śṛiṅga, induced to leave his forest retreat to bring rain to a neighboring kingdom (Figure 1), also performed a sacrifice for Daśaratha that yielded a fertility-inducing porridge (Figure 2). Daśaratha distributed this to his three wives (Figure 3): Kausalyā gave birth to Rāma, Kaikeyī to Bharata, and Sumitrā to the twins Lakṣmaṇa and Śatrughna (Figure 4). After a few years the sage Viśvāmitra came to the court to ask Daśaratha to lend him Rāma, in order to destroy demons who had been attacking the sage's sacrifices. This Rāma did, accompanied by his favorite brother, Lakṣmaṇa (Figure 5). His youthful exploits, beginning with killing the demoness Tāḍakī (Figure 6) and attacking other obstructors of the sage's sacrifice (Figure 7), demonstrated his role as an incarnation of the god Viṣṇu come to earth ultimately to destroy the chief demon, ten-headed Rāvaṇa. The youthful Rāma released Ahalyā, a beautiful woman, from a curse (Figure 8). He also stopped in the court of King Janaka, where a test was under way for the hand of princess Sītā ("Furrow," because she was born from the earth); various princes were attempting to bend

7

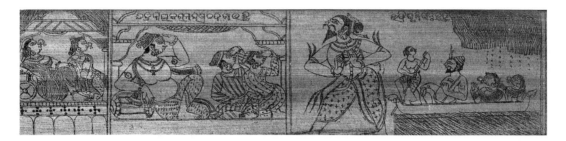

Figure 1. Round *Lāvaṇyavatī* (courtesy National Museum of Indian Art, New Delhi, no. 72-165/I). Performer begins, Riśyaśṛṅga brings rain, f. 97r.

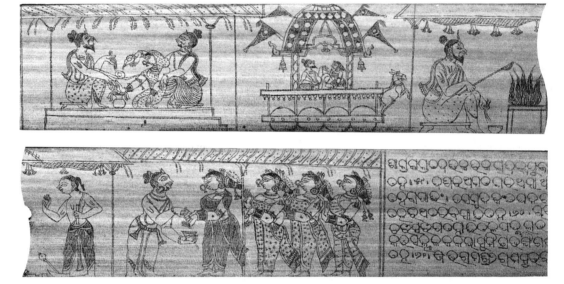

Figures 2, 3. Round *Lāvaṇyavatī* (NM 72-165/I), f. 97v: (*top*) Riśyaśṛṅga performs sacrifice for Daśaratha; (*above*) Distribution of porridge to queens.

the mighty bow of the god Śiva. Rāma alone was able to perform this feat (Figure 9) and thereby won Sītā as his wife (Figure 10). On the way home he encountered the powerful ascetic Paraśurāma and was again challenged to bend a supernatural bow. Rāma succeeded and as a warrior (kṣatriya) proved himself equal to the priestly (brahman) avatar of the same god Viṣṇu (Figure 11).

II. Ayodhyā Kāṇḍa

Back in Ayodhyā, Daśaratha prepared to crown prince Rāma as his successor. At that moment, egged on by her servant Mantharā, the second queen, Kaikeyī, chose to redeem a boon the aged king had granted her in his youth (Figure 12).

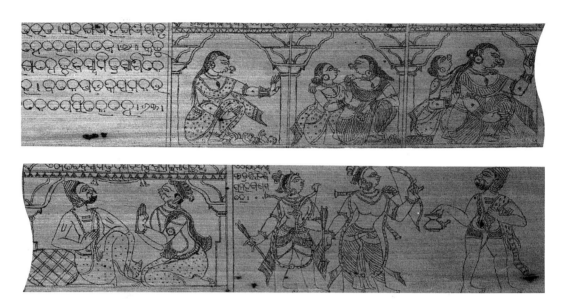

Figures 4, 5. Round *Lāvaṇyavatī* (NM 72-165/I), f. 98r: (*top*) Birth of Daśaratha's sons; (*above*) Viśvāmitra takes Rāma and Lakṣmaṇa.

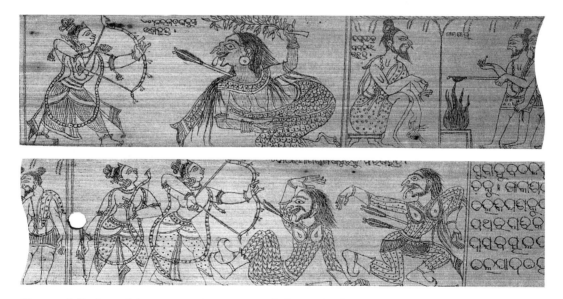

Figures 6, 7. Round *Lāvaṇyavatī* (NM 72-165/I), f. 98v: (*top*) Death of Tāḍakī, Viśvāmitra's sacrifice; (*above*) Rāma fights the demons Subāhu and Mārīcha.

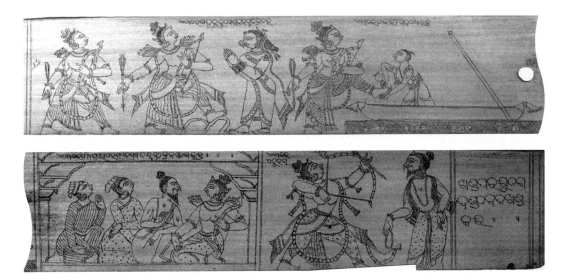

Figures 8, 9. Round *Lāvaṇyavatī* (NM 72-165/I), f. 99r: (*top*) Ahalyā released from curse, Boatman washes Rāma's feet; (*above*) Rāma, at Janaka's court, bends Śiva's bow.

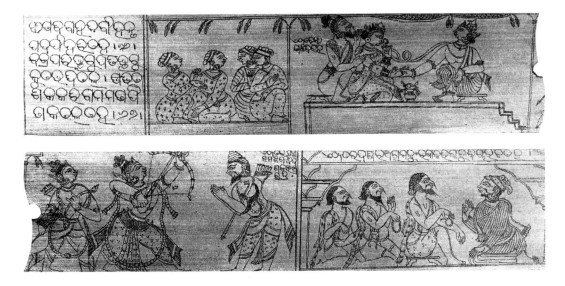

Figures 10, 11. Round *Lāvaṇyavatī* (NM 72-165/I), f. 99v: (*top*) Rāma and Sītā's marriage; (*above*) Meeting with Paraśurāma, Preparations for Rāma's coronation.

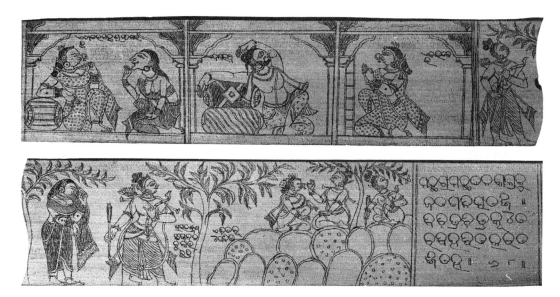

Figures 12, 13. Round *Lāvaṇyavatī* (NM 72-165/I), 100r: (*top*) Mantharā,
Daśaratha and Kaikeyī; (*above*) Rāma's exile, Chitrakūṭa Hill.

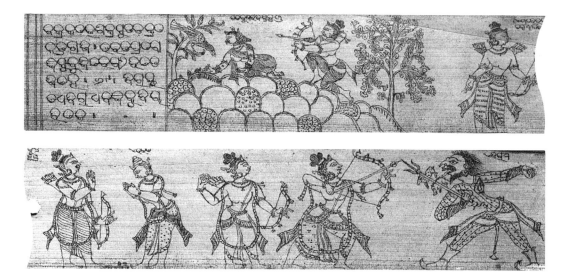

Figures 14, 15. Round *Lāvaṇyavatī* (NM 72-165/I), f. 100v: (*top*) Rāma shoots
the crow; (*above*) Bharata's visit to Rāma, The heroes confront the demon
Virādha.

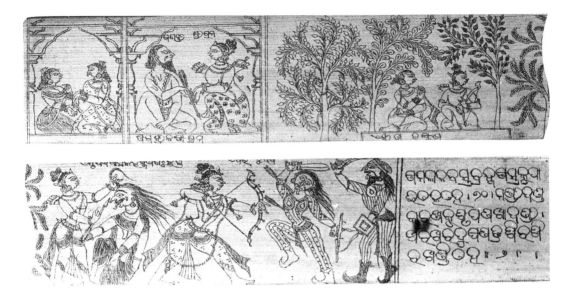

Figures 16, 17. Round *Lāvaṇyavatī* (NM 72-165/I), f. 101r: (*top*) The sage Atri and his wife, Anasūyā, welcome the exiles; (*above*) Śūrpaṇakhā denosed, Her demon brothers.

Daśaratha was thus compelled, against his will, to crown her son, Bharata (absent from court at the time), and to exile Rāma to the forest for fourteen years. Rāma acceded dutifully to this plan and departed with Lakṣmaṇa and Sītā, settling first on the charming mountain Chitrakūṭa (Figures 13, 14). Daśaratha died of grief. Bharata returned to Ayodhyā in horror at his own succession and proceeded to visit Rāma in an unsuccessful effort to bring back the rightful king (Figure 15). Bharata agreed to rule in his brother's name, setting Rāma's sandals on the throne that had been moved in mourning to a village near Ayodhyā.

III. Araṇya Kāṇḍa

Dwelling in a wilder part of the forest (Figures 15, 16), Rāma and Lakṣmaṇa encountered various demons, including Śūrpaṇakhā, the sister of Rāvaṇa, the ten-headed demon king. She assumed a beautiful form but failed to seduce the two heroes. In fact Lakṣmaṇa cut off her nose and ears in a traditional gesture of disrespect (Figure 17). Śūrpaṇakhā sought redress from her brothers, first Khara, whose forces Rāma defeated, then the elder Rāvaṇa. This ruler persuaded the demon Mārīcha to take the form of a golden deer, which enchanted Sītā (Figure 18). Rāma went off to hunt it, leaving his wife in his brother's charge in a forest hut. Shot, the deer cried "Lakṣmaṇa" in Rāma's voice, and Lakṣmaṇa was compelled to assist his brother, leaving Sītā alone. Then Rāvaṇa appeared in the form of a mendicant, lured her from the hut by appealing to her pious generosity, and carried her away in his aerial chariot, Puṣpaka, to his golden citadel, Laṅkā (Fig-

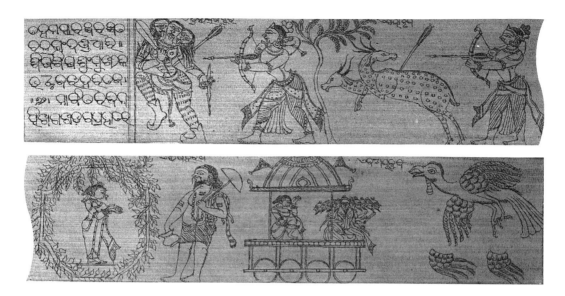

Figures 18, 19. Round *Lāvaṇyavatī* (NM 72-165/1), f. 101v: (*top*) The demon Triśiras, Magic deer; (*above*) Sītā's kidnap, Jaṭāyu's attack.

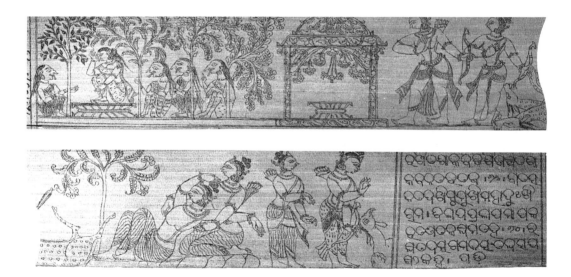

Figures 20, 21. Round *Lāvaṇyavatī* (NM 72-165/1), f. 102r: (*top*) Sītā in Laṅkā, Rāma returns to hut; (*above*) Rāma swoons, meets Jaṭāyu.

ures 19, 20). On the way, the divine vulture Jaṭāyu attempted unsuccessfully to stop the abduction and fought with Rāvaṇa. Found dying, this bird informed the brothers what had happened (Figure 21). Rāma was stricken by intense grief.

IV. Kiṣkindhā Kāṇḍa

The brothers entered Kiṣkindhā, the realm of the monkeys, a forest filled with demons such as the headless Kabandha, with tribal hunters, and with sages (Figures 22–24). They were approached by Hanumāna, general of the ruler Sugrīva, who had received Sītā's jewels as she was flying and was hence alerted to the crisis (Figure 25). Sugrīva had occupied the throne of Kiṣkindhā while his elder brother Vālin was presumed dead but was banished when the brother returned. Rāma demonstrated his power as equal to the task of helping Sugrīva by kicking the body of the giant Dundubhi, whom the mighty Vālin had killed, and by shooting through seven trees with one arrow (Figure 26). Then Sugrīva challenged Vālin to a fight, in which Rāma, hidden behind a tree, eventually shot Vālin. During the subsequent rainy season Rāma grieved on Mount Mālyavan (Figure 27), and Sugrīva celebrated his own restoration by drinking. Finally the monkeys searched in all directions and discovered that Sītā had been taken to Laṅkā.

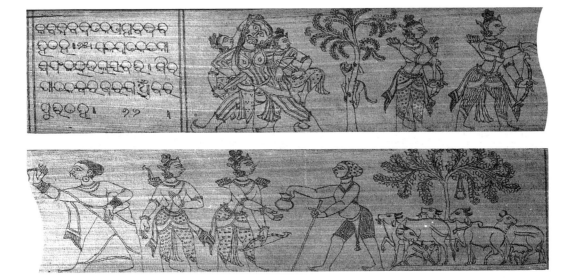

Figures 22, 23. Round *Lāvaṇyavatī* (NM 72-165/1), f. 102v: (*top*) The demon Kabandha with Rāma, Lakṣmaṇa; (*above*) Rāma and Śabarī (tribal woman), Cowherds.

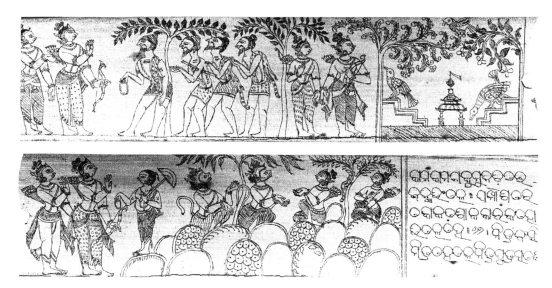

Figures 24, 25. Round *Lāvaṇyavatī* (NM 72-165/l), f. 103r: (*top*) Rāma meets ascetics; (*above*) Rāma meets Hanumāna, Sugrīva.

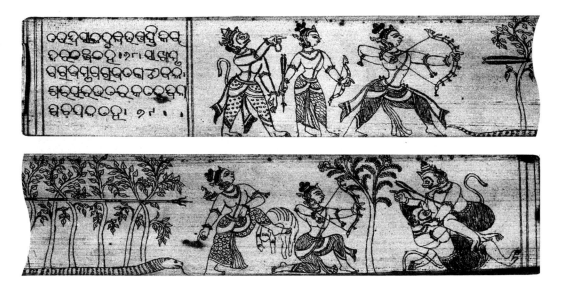

Figure 26. Round *Lāvaṇyavatī* (NM 72-165/l): (*top*) Rāma shoots through seven trees; (*above*) Rāma kicks Dundubhi's bones, Death of Vālin, f. 103v.

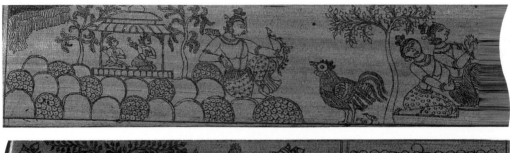

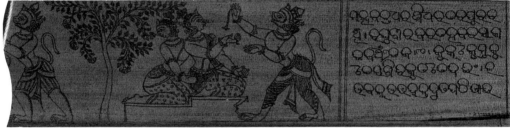

Figures 27, 28. Round *Lāvaṇyavatī* (NM 72-165/I), f. 104r: (*top*) Rāma on Mount Mālyavan; (*above*) Hanumāna goes and returns.

V. Sundara Kāṇḍa

Hanumāna leapt across the ocean, evading various demons, to reach the citadel of Laṅkā, where he assumed a tiny form to spy on the demons' life. He delivered a ring from Rāma as a token to Sītā, imprisoned by demonesses in a grove of asoka trees. She affirmed her willingness to wait for rescue by Rāma. Hanumāna in heroic form wreaked havoc on the demon citadel and was captured by Rāvaṇa's son Indrajita. The monkey's tail was bound with rags soaked in oil and set on fire, at which point he escaped and used his flaming tail as a torch to set the buildings of Laṅkā ablaze. At last he and the monkey search party returned to Rāma (Figure 28).

VI. Yuddha Kāṇḍa

Rāma and his monkey allies camped by the straits of Laṅkā, where the demon Vibhīṣaṇa, having tried to persuade his brother Rāvaṇa to return Sītā, defected from the demons' side. The monkeys constructed a causeway of boulders across the ocean and the army marched to Laṅkā (Figure 29). The battle began with personal combat between Sugrīva and Rāvaṇa, after which various diplomatic efforts and ruses ensued. The fighting warmed up, magic weapons playing a vivid role (Figure 30). Rāvaṇa's giant brother Kumbhakarṇa had to be wakened from six months' sleep, to which he was entitled each year, and he destroyed countless monkeys before he was slain by Rāma (Figure 31). Indrajita incapacitated Rāma and Lakṣmaṇa (Figure 32), who were resuscitated when Hanumāna flew to the Himalayas and brought back Mount Gandhamādana together with the medicinal

herbs that grew there (Figure 33). Indrajita was ultimately killed by Lakṣmaṇa and Rāvaṇa by Rāma (Figure 34). Sītā could not be reunited with Rāma until she performed an ordeal by immersing herself in fire. Emerging unscathed, she demonstrated that she had remained faithful while in another man's house (Figure 35). Vibhīṣaṇa was crowned in Laṅkā (Figure 36). At last Rāma and Sītā returned to Ayodhyā for his coronation (Figures 37–40).

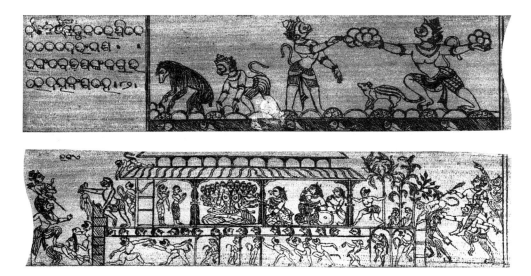

Figure 29. Round *Lāvaṇyavatī* (NM 72-165/I): (*top*). Building the bridge; (*above*) Attack on Laṅkā, f. 104v.

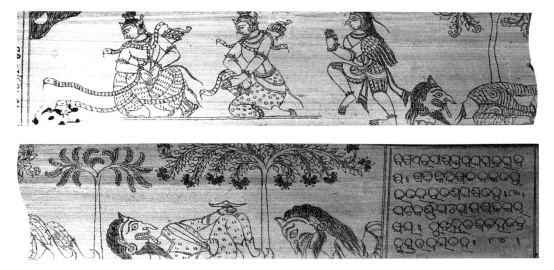

Figures 30, 31. Round *Lāvaṇyavatī* (NM 72-165/I), f. 105r: (*top*) Garuḍa rescues Rāma and Lakṣmaṇa from serpent-arrows; (*above*) Death of Kumbhakarṇa.

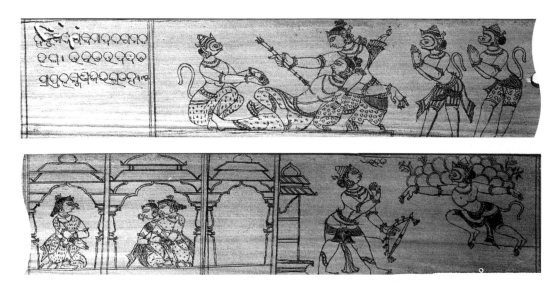

Figures 32, 33. Round *Lāvaṇyavatī* (NM 72-165/I), f. 105v: (*top*) Lakṣmaṇa wounded; (*above*) Hanumāna brings mountain, watched by Bharata.

Figure 34. Round *Lāvaṇyavatī* (NM 72-165/I). Death of Rāvaṇa, f. 106r.

Figures 35, 36. Round *Lāvaṇyavatī* (NM 72-165/I), f. 106v: (*top*) Sītā's test;
(*above*) Coronation of Vibhīṣaṇa in Laṅkā.

Figure 37. Round *Lāvaṇyavatī* (NM 72-165/I), f. 107r: (*top*) Return to Ayodhyā;
(*above*) Coronation of Rāma.

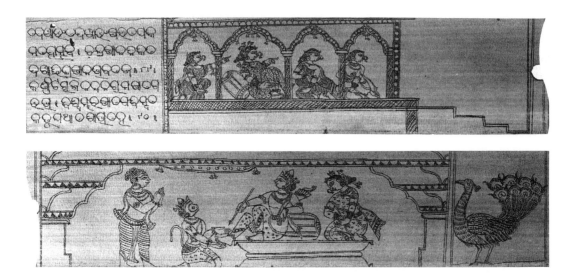

Figure 38. Round *Lāvaṇyavatī* (NM 72-165/I), f.107v: (*top*) Lāvaṇyavatī watches (*above*) coronation of Rāma.

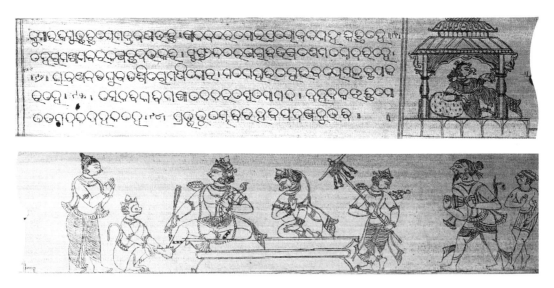

Figure 39. Round *Lāvaṇyavatī* (NM 72-165/I), f. 108r: (*top*) Lāvaṇyavatī watches (*above*) coronation of Rāma.

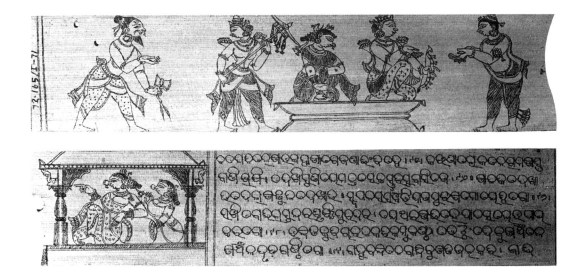

Figure 40. Round Lāvaṇyavatī (NM 72-165/1), f. 108v: Lāvaṇyavatī (*above*) watches performance (*top*).

VII. Uttara Kāṇḍa

The final book includes diverse stories about the earlier life of the principal actors, as well as seemingly unrelated episodes. It also includes a most problematic sequel to the story. Because of popular doubts about Sītā's fidelity, Rāma felt compelled to send her into exile. There she took refuge in the hermitage of the sage Vālmīki and gave birth to Rāma's twin sons, Lava and Kuśa. Rāma performed a horse ceremony, the traditional perquisite of an emperor, and was challenged by these two boys, who recited the family's story, the Rāmāyaṇa as composed by Vālmīki. Rāma recalled Sītā, but she returned to her mother, the Earth. And Rāma returned to heaven as the god Viṣṇu.

LITERARY VERSIONS OF THE RĀMĀYAṆA IN ORISSA

That there are many Rāmāyaṇas has been acknowledged in a number of recent essays.[1] The remainder of this chapter presents those verbal versions of the story that seem relevant as background to Orissan pictures, which are the main concern of my book as a whole. First the written texts. The reader is advised not to expect a complete survey of versions of the epic, even in Oriya. Such surveys have already been made, and the student of literature may consult the following works directly: K. C. Sahoo, *Oriya Rāma Literature*—an authoritative, detailed description of the full range of texts by an Oriya scholar;[2] K. Bulke, *Rāmkathā (Utpati aur Vikās)*—a magisterial Hindi survey of all kinds of Indian and Southeast Asian written texts;[3] W. L. Smith, *Rāmāyaṇa Traditions in Eastern India*—a selective and provocative treatment of Assamese, Bengali, and Oriya versions.[4]

Literature may of course play a variety of roles in relation to visual imagery. Some works might be termed "canonical," as the Bible is for Christian art; that is,

they may provide a relatively standardized framework of orthodoxy.[5] While Vālmīki's Sanskrit Rāmāyaṇa has been accorded this status, this text itself varies considerably with time and place, and it may have been too inaccessible or unfamiliar to have played a canonical role in fact, although Vālmīki's name is revered. A second role that literature plays is as a text explicitly illustrated. Here Orissan manuscripts of the *Adhyātma Rāmāyaṇa* and the *Vaidehīśa Vilāsa* that include pictures are obvious examples. Likewise for at least one set of paintings by professional painters we have a short, popular poem that the artist set out to illustrate, verse by verse. But the third role of literature is more amorphous and significant: it may provide a familiar and hence influential version of a story to which the artist has been exposed. Here the long Rāmāyaṇa of Baḷarāma Dāsa, read sequentially in temples and available in many villages in the form of unillustrated manuscripts, may have had a powerful, if not "canonical," impact. Similarly, various performed versions, departing from this as well as from Vālmīki and other texts, are a potent source of artistic imagery. Nor, finally, should the relation between texts and images be viewed as deterministic or one-way. Surely at times verbal stories reflect pictures that the teller has seen. With all these complexities in mind, it is worth situating some relevant literary traditions briefly, before turning to the images.

Vālmīki

If one asks an Oriya, or for that matter any north Indian, today, "Who wrote the Rāmāyaṇa?" the answer is almost inevitably Vālmīki. This sage's role is encoded in many versions of the story, which begin with the killing of a male *krauñcha* bird while it was making love. Vālmīki was moved by the sorrow (*śoka*) of the mate to recite a verse composed of thirty-two syllables, the meter (*śloka*) of the great epic itself. And in most versions of the last book, when Sītā is banished, it is Vālmīki's hermitage where she takes refuge and where her sons Lava and Kuśa are born and raised. Hence his place as the composer of the tale.

The modern scholar, armed with techniques of textual analysis as well as with practical skepticism, is aware that all seven volumes are hardly the work of a single author, and one may question the historicity of Vālmīki himself. It has long been felt that the core comprises books two through six, the Ayodhyā through Yuddha Kāṇḍas. These probably originated in the seventh and sixth centuries B.C., whereas books one and seven (the Bāla and Uttara Kāṇḍas) were added between the third century B.C. and the first A.D.[6] The method of transmission was exclusively oral at first, with some mnemonic devices that counteracted the inevitable process of diversification. Textual scholars recognize broadly differing northern and southern recensions, from which a critical edition has been constructed in the past thirty years.[7] Within the former, western and eastern recensions can be discerned, the second most relevant for us.[8] At the same time, we may in fact consider the seven volumes as a whole and ascribe them to Vālmīki, simply because they were not critically differentiated by the Orissan public in the eighteenth century and later.

The sequence of events recited in my résumé is that of the Vālmīki text of eastern India, found also in many later versions to be considered in more detail.

The Sanskrit, while at times self-contradictory and open to criticism, seems to present two broad concerns. One is moral—the role of the principal characters as ethical models. Thus Rāma's nature, perhaps two-dimensional to Western eyes, is built around his generally unemotional acceptance of demands made by higher authority, including the abandonment of his kingdom and, ultimately, of his wife. Occasional lapses, such as the slaying of a woman (Tāḍakī) or the use of a ruse to kill the monkey king Vālin, have been met with a rich array of Indian analyses and explanations. Likewise Sītā, Lakṣmaṇa, Hanumāna, and other actors serve as models of Indian social values, which may explain the enduring popularity of the epic as well as the urge to adapt it to modern circumstances.

A second concern is aesthetic and, paradoxically, emotional. The Rāmāyaṇa is identified as the Ādikāvya, or first example of High Poetry, a status that derives less from its technical poetics than from the broad sense of mood. While Rāma himself grieves remarkably little at his own travails, the story itself is built around the emotion of sorrow (*karuṇa rasa*), which informs major moments and hence is imparted to the audience.[9] Others among the nine standard moods—the heroic, the humorous, even the erotic—are brought in, but it is the pathetic that prevails. Thus our mythical author, or rather the text itself as it has evolved, shows a general aesthetic intent that unifies diverse stories of palace intrigue and fairy-tale exploits in the jungle.

It has been argued that this Sanskrit text provides a basic framework for the vernacular poems of eastern India, which only explain, reduplicate, resolve, apologize for, and in minor ways elaborate upon Vālmīki to reflect various later concerns.[10] Indeed there are Oriya transliterations of Vālmīki,[11] and he is invoked as the originator of the story in most Oriya versions discussed below. The great sixteenth-century Orissan poet Balarāma Dāsa refers to pandits in his day reciting Vālmīki's text.[12]

Yet granting its moral and aesthetic power, I find it difficult to accord Vālmīki's Sanskrit a consistent role in directly guiding later literary versions of the Rāmāyaṇa, let alone visual ones. This objection derives partly from my focus upon authors such as Śāralā Dāsa and Upendra Bhañja, who depart substantially from Vālmīki's framework. I am struck by the ease with which Vālmīki is invoked today by people who have in fact not read the Sanskrit or even a complete translation of it into some modern language. In short, my picture of the role of Vālmīki for Orissan artists is similar to the one attributed to him in the television version of the epic that captivated India in 1987 and survives in the form of videocassettes.[13] Each episode acknowledges the sage as the original author, and there is no suggestion of explicitly departing from his version for any reason. This acknowledgment does not indicate complete familiarity with the Sanskrit, although undoubtedly the television producer and his advisors knew some version of Vālmīki's text. But they also drew upon a variety of other traditions, including a wide range of vernacular versions explicitly invoked in the cause of national integration. Nor does respect for Vālmīki rule out innovations like those of past retellers of the story. If one is struck that more of the vernacular versions corresponds to Vālmīki than to any other ancient source (such as Jain variants that present a substantially altered structure), that may be because Vālmīki's Sanskrit preserves a consensus version of other written as well as oral Rāma stories. These must collectively be taken as

the source for later authors and indeed for most people in a society where writing did not have its present normative status. We would be deluded to search for a single model or to privilege one, whatever its classical status.

Later Sanskrit Versions

Recasting the story in Sanskrit did not stop with the epic that bears Vālmīki's name; many literary and religious versions are known. I shall focus on two that were illustrated in Orissa. The first is of pan-Indian significance—the *Adhyātma* ("Supreme Spirit") *Rāmāyaṇa,* one of a class of short Sanskrit works composed with later devotional and philosophical concerns. This has been ascribed to the fifteenth or early sixteenth century and is associated with Banaras in particular.[14] The impact of the *Adhyātma Rāmāyaṇa* on vernacular writing is widely recognized, not only on Tulsī Dās's *Rāmcharitmānas,* as one might expect from the composition of that influential Hindi poem in the same place a few decades later, but also on works in tongues as distant as Malayalam.[15] The major Bengali *Rāmāyaṇa* by Kṛttibāsa, similar in some ways, may have been composed slightly earlier; yet elements that it shares with the *Rāmcharitmānas* seem to be interpolations into the unusually elastic Bengali text. Similarly we shall hear more of the *Adhyātma Rāmāyaṇa* as a source for Oriya writers.

The *Adhyātma Rāmāyaṇa* may be understood as a condensation of Vālmīki, leaving out those matters that do not focus upon Rāma, with three broad additional concerns. First, this is a work of monistic Vedānta philosophy, for which all phenomena are dependent upon the world soul, or *brahman,* here equated with Rāma himself, who is undifferentiated, without attributes (*nirguṇa*). Thus events are preordained. For instance, Mantharā does not act from her own evil to prevent Rāma's coronation but is impelled by the goddess Sarasvatī (2.2.46). Illusion, or *māyā,* in this system characterizes everything. The epitome of this principle is the order Rāma gives Sītā, as he departs to hunt the illusionary deer (*māyā mṛiga*), that she hide her true self in the fire inside the hut and create an illusionary form (Māyā Sītā) that will be kidnapped by Rāvaṇa (3.7.3–4). Thus his own grief at her loss is feigned, even to his brother, and the story is robbed of direct tragedy. At the same time, the tale assumes a rich phenomenological irony. Māyā Sītā had previously appeared as a motif in earlier texts, such as the *Kūrma* and *Brahmavaivarta Purāṇas,* reflecting concern with Sītā's purity. But illusion plays a larger role in the *Adhyātma Rāmāyaṇa* as a consistent principle that undercuts the actual plot.

Second, this text is informed by *bhakti,* or a devotional attitude toward Rāma, who hence becomes more a god and less a mere human. This attitude is visible in a good deal of later Rāmāyaṇa literature and is comparable to the development of devotion to Kṛiṣṇa in north India, but here the devotee is seen predominantly in the stance of a servant, rather than that of a lover, unlike Kṛiṣṇa with his female followers, the *gopīs.* The *Adhyātma Rāmāyaṇa* is associated with the Rāmānandin sect of ascetics (*sadhus*), for whom the preferred name-ending Dāsa (servant) indicates the ideal of humility.[16] At the same time in the *Adhyātma,* Rāma becomes more than one of a number of avatars, is equated with Viṣṇu himself, and at times seems to transcend even Viṣṇu.[17] The result is to create a tension between the

Vedānta philosophical context, in which even the ultimate reality of Rāma as an actor in the world should logically be called into question, and the devotional urge to emphasize his exploits.

Bhakti is visible in the way in which the *Adhyātma Rāmāyaṇa* presents Rāma as delivering to salvation those whom he kills, for example the demon Mārīcha (3.7.22–25). Moreover, devotion is explicit in a number of hymns of praise inserted into the text, such as the encomium uttered by Ahalyā when she is released from the form of a stone (1.5.43–64). The best known of these passages, the sermon preached by Rāma as chapter 5 of the last book known as the *Rāmagītā* (imitating the *Bhagavadgītā*), is probably older than the text as a whole.[18]

Third, the *Adhyātma Rāmāyaṇa* incorporates Śaiva and tantric elements, again producing some contradictions with the philosophical and devotional aspects of this work. The framework, in which the story is told by Śiva in answer to Pārvatī's questions, may not in itself be of great significance, for it is part of the status of the text as a Purāṇa. Before the bridge to Laṅkā is built, Rāma installs a *liṅga* on the shore and worships Śiva, presumably a nod to the actual shrine at Rameshvaram (6.4.1–4). One is reminded that this text served the Rāmānandins, a Vaiṣṇava sect centered in Benares, the abode of Śiva. Similarly, tantric or Śakta elements have been discerned, although it may also be argued that *śakti* is fundamentally conceived here as Rāma's *māyā*, occasionally acting through Sītā but not an independent feminine force of creation.[19] The text is in general complex and reflects conflicting currents, like most documents of Indian religion.

The popularity of the *Adhyātma Rāmāyana* in Orissa is indicated by its repeated translation into Oriya between 1600 and 1900. Of the translations, the one most frequently illustrated was that of Gopala Telenga, made in the middle of the eighteenth century.[20] Gopala, a Telugu speaker as indicated by his name, was a brahman who served at the court of the ruler Ajit Sinha in Sambalpur. His is not entirely a literal translation of the standard Sanskrit text. For example, Rāvaṇa takes not only Sītā but also her entire hut to avoid touching her, a motif that appears elsewhere to minimize the possibility of her pollution. Most significant, at the beginning of each book Lord Jagannātha is invoked, and in the sixth, the Yuddha Kāṇḍa, sixty verses are added in his praise. In the same way that Śiva could be accommodated in the original text, the principal god of Orissa could be brought into this vernacular translation.

The *Brahma Rāmāyaṇa* is a second and far less widely known Sanskrit work, not composed in Orissa but extant in two copies there, one of which is illustrated.[21] Both of these manuscripts are in simple Sanskrit, not translated but in Oriya characters, like most Oriya copies of the *Gīta Govinda*, which was easily understood in the same form. Elsewhere the text exists in Devanagari script.[22] It appears to be part of a larger work called the *Bṛhatkośala Kāṇḍa* and to have fallen into three portions—Rāma's *Līlā*, the marriage of Rāma and Sītā, and then additional play or *Līlā*.[23] The Rāmāyaṇa plot is minimal, although the episodes of Ahalyā and Tāḍakī do appear in the illustrated Orissan version. The bulk of the text, however, concerns Rāma's sport with a number of women. There is strong resemblance to Kṛṣṇa's relationship to the cow-maidens (*gopīs*), in which the seemingly erotic relation to the godhead is in fact a form of ecstatic devotion appropriate to

male followers as well as female. The elaborate description of *rāsa* (rustic dance) dominates this text, as in many Kṛṣṇa-ite works.[24] Thus the Rāma-*bhakti* of the *Adhyātma Rāmāyaṇa* is taken one step further in such a work.

Early Oriya Texts

In addressing the textual sources of Orissan pictures of the Rāmāyaṇa, it would be impossible to omit two monuments of early Oriya literature, even though neither has, to my knowledge, been directly illustrated. Both Śāralā Dāsa's *Mahābharata* and Balarāma Dāsa's *Jagamohana Rāmāyaṇa* are so well known and widely revered that we may presume most artists in the region would have had some familiarity with them.

The Ādikavi, or Father of Vernacular Poetry in Orissa, Śāralā Dāsa, active probably in the third quarter of the fifteenth century, is famed for his *Mahābhārata*.[25] This work draws upon oral traditions, including elements that also crop up in different form in various Sanskrit works.[26] It was followed by three more or less literal translations of the epic, none of which equalled Śāralā's in popularity. The poet is identified as a śūdra, a peasant whose brother was a ferryman, a status that is in keeping with the rural language and earthy flavor of his work. For instance, Śiva's worship as the *liṅga* is explained with a story that he shocked his mother-in-law by addressing her naked at the time of a ceremony, so that she cursed him to be worshiped in the undignified form of a phallus.[27] Likewise local touches are only to be expected—for example the enlargement of the story of the tribal Ekalavya, who, in the guise of the Śabara Jara, kills Kṛṣṇa and follows his unburned body to Puri, where it becomes Lord Jagannātha.[28]

Like the Sanskrit *Mahābhārata,* Śāralā Dāsa's poem includes a version of the story of Rāma that is yet further removed from Vālmīki. Here again some details occur in other versions, such as the explanation of Śūrpaṇakhā's anger with Lakṣmaṇa for having decapitated her son Japa while he was meditating in an anthill.[29] Rāma is said to be reborn as Kṛṣṇa, and Lakṣmaṇa (who is also an avatar of Śiva) as Balarāma, linking various strands of plot and religion. Some elements are shared with the Bengali tradition, such as the inclusion of multiple forms of Rāvaṇa killed in different ages.[30] Śāralā Dāsa's expanded accounts of the ascetic Riśyaśṛiṅga, of the magic deer, and of the incident of a milkman who feeds the heroes in the forest are discussed below in connection with their illustrations.

Balarāma Dāsa worked some forty years after Śāralā and is usually viewed as part of the Oriya entourage of the great Bengali Vaiṣṇava reformer Chaitanya, who visited Puri in 1510. In fact his lengthy version of the Rāmāyaṇa seems to have been completed in 1504 and is not directly influenced by Chaitanya.[31] His supposedly frenzied religious devotion, along with tales of the entire group of Oriya saints known as *pañcha sakhās* (five companions of Chaitanya), may be a later fabrication. In a colophon he is identified as the son of the minister of a ruler and as a karaṇa (scribe).[32] Thus he belonged to what was in fact quite a high-placed subcaste in Orissa, although technically he was a śūdra, part of the lowest of the four major ranks of Hindu society, a position emphasized by followers of Chaitanya in view of the ideal of humble servitude. In general his brand of Vaiṣṇavism, centered on Jagannātha, is rooted in Orissa in the late fifteenth century.

Baḷarāma Dāsa puts his story in the mouth of four different narrators, framing the epic in a complex way like the *Rāmcharitmānas.*[33] Indeed he honors Vālmīki as the first narrator on earth, and his *Jagamohana Rāmāyaṇa* (also known as *Dāṇḍi Rāmāyaṇa,* from the meter) includes most of the variants of the eastern recension of Vālmīki, such as the story of how the demon Kālanemi attempted to deter Hanumāna from visiting Mount Gandhamādana, detailed below in Chapter 4. He also introduces elements found in the *Adhyātma Rāmāyaṇa,* although not peculiar to it: the framing dialogue between Śiva and Pārvatī and the creation of a Māyā Sītā before the kidnap. Indeed, illusion appears often as a matrix for phenomena, as in the *Adhyātma Rāmāyaṇa.*[34] There are again affinities with Bengali Rāma stories, as well as with south Indian vernacular versions.[35] At the same time, events are consistently localized in Orissa; thus Rāma's return to Ayodhyā becomes the Bāhuḍā Jātrā, or return of Lord Jagannātha's cart procession in Puri. Some events are given amusing human twists: on Mount Mālyavan Rāma gets a crane to supply him with food cooked by Sītā, overcoming the bird's reluctance to accept food from a mere woman by assuring it that wife and husband are one.[36] At the same time, Baḷarāma Dāsa must be credited with some originality. For example, the distinctively Oriya story of the origin of mushrooms in the umbrellas severed from Rāvaṇa's chariot appears for the first time in writing in the *Jagamohana Rāmāyaṇa.*[37] On the whole this text weaves a wealth of novel detail around the framework of Vālmīki. Its central place in the Orissan religious tradition is shown by its being read orally in toto, as Tulsī Dās is used elsewhere in north India during the festival Dashahra.

Baḷarāma Dāsa dealt with the story of Rāma in a number of other, shorter poems of the forms known as *chautiśā* (thirty-four couplets beginning with each letter of the alphabet in sequence) and *bārahmāsā* (with twelve verses for the months). These seem particularly to draw upon the Sundara Kāṇḍa and the grief of the separated couple.[38] No illustrated copies of those works are known.

Two unpublished minor works are worth mentioning here because they have been illustrated at least once. These are a *Durgā Stuti* and a *Hanumāna Stuti* ascribed to Baḷarāma Dāsa, known from an illustrated manuscript now in Ahmedabad.[39] Such *stutis* form a large class of popular verses in praise of various gods and goddesses. Several addressed to Durgā are attributed to Hīna (inferior) Baḷarāma; although they follow the same meter as the *Jagamohana Rāmāyaṇa,* they are probably not the work of the sixteenth-century poet. The Ahmedabad illustrated text describes the occasion when Rāma and Lakṣmaṇa were bound by Indrajita's snakearrow. The hero recites his previous story to Durgā, who advises him to pray to Garuḍa, who in turn comes and disperses the snakes. The following part of the same work is devoted to Hanumāna.

Later Oriya Texts

Oriya literature since 1550 includes many versions of the Rāmāyaṇa. There are, for example, several short works called *Ṭīkā Rāmāyaṇa,* each purporting to be a précis of Baḷarāma Dāsa, in fact also adding new stories.[40] The *Vilaṅkā Rāmāyaṇa* of Siddheśvara Dāsa is probably a work of the seventeenth century, concerning an interlude between the Yuddha and Uttara Kāṇḍas, in which a thousand-headed

Rāvaṇa was killed with the intervention of Sītā in the battle.[41] The eighteenth-century *Angada Paḍi* of Vipra Lakṣmīdhar Dāsa focuses on Angada's embassy to Rāvaṇa.[42] Such short versions, like the ephemeral pamphlets summarizing the epic that are sold today, must have been widely known.

Yet it was the complex writing of Orissa's great poet, Upendra Bhañja, that was more frequently illustrated. Upendra was a member of the royal family of Ghumsar in central Orissa, today on the western edge of Ganjam District.[43] His grandfather, the Rājā Dhanañjaya, had in the seventeenth century written a euphuistic poem called *Raghunātha Vilāsa*, in which Rāma is identified with Jagannātha.[44] Upendra may have been born around 1670 and presumably lived in the world of the court, although his father ruled only briefly.[45] He himself mentions his initiation into the Rāma Tāraka Mantra, a spell invoking the protection of Rāma, which accords with his frequent use of the Rāma story in his poetry. His seventy poetic works, many of them long, belong mainly to the early eighteenth century.

Upendra Bhañja's writing in general can hardly be described with neutrality. One touchy issue is his frequent use of erotic subject matter, which must have been widely acceptable in Orissan society at some points, although it has at times been condemned as obscene. A second sticking point is his elaborate style, which carries that of his grandfather many stages further. His word choice is arcane and Sanskritic, although the proximity of Oriya to Sanskrit makes his diction less artificial than it might seem. He employs the gamut of literary devices known to courtly poetry, or *kāvya: śleṣa* (punning), *yamaka* (alliteration), *gomūtra* (zigzag reading), and many more. Such devices would seem to make for such obscurity that one might expect his work to have been known only in very limited circles. Yet his verses have long been used in the storytelling tradition called *pāla*, where the verbal ingenuity, romance, and music of his lines still captivate rural audiences. As the great Oriya freedom fighter Gopabandhu wrote in this century,

> Oh Upendra, the Pandits recite your lines at courts,
> Gay travellers on the road,
> The peasants in the fields and ladies in the harems,
> And the courtesans too, while they dance.[46]

The *Vaidehīśa Vilāsa*, or "Sport of the Husband of Sītā," is a prime example of Upendra's poetic dexterity. Each line in the work begins with the letter *Va*. Each canto differs from the next in the poetic device it employs, so that the effect is varied in sound as well as in substance. One canto may consist of relatively straightforward descriptive couplets, while the next is long complexly rhymed verses based on double entendres. Nor does the selection of subjects inevitably emphasize the erotic, or *śṛngāra*, mood. Vālmīki's first six books (the Uttara Kāṇḍa is omitted altogether by Upendra) correspond to the following cantos of the *Vaidehīśa Vilāsa*:

Bāla Kāṇḍa: Chhāndas 1–16

Ayodhyā Kāṇḍa: Chhānda 17

Araṇya Kāṇḍa: Chhāndas 18–26

Kiṣkindhā Kāṇḍa: Chhāndas 27–33

Sundara Kāṇḍa: Chhāndas 34–39

Yuddha Kāṇḍa: Chhāndas 40–52

The brief treatment of the critical events of the Ayodhyā Kāṇḍa shows a distinct preference for the lyrical over the dramatic.

The *Vaidehīśa Vilāsa* refers respectfully to its own predecessors:

> Vālmīki and Vyāsa each wrote Rāma's epic.
>> Hanumāna, the wind's son, wrote the play *Mahānāṭak*.
> Bhoja wrote *Champu*: Kalidāsa's was perfected.
>> Baḷarāma Dāsa wrote Oriya. On all I've reflected,
> Bemused by these masterworks, with great trepidation.
>> There are stars in the sky for illumination,
> Yet in the dark, fireflies also glow.
>> Please therefore accept my humble verses below.
>
>> (1.4)

In fact Upendra departs from Vālmīki, following Baḷarāma Dāsa in matters such as the creation of Māyā Sītā and going further than his Oriya predecessors in the inclusion of folk elements. He even alters the familiar structure by presenting Sītā's birth before Rāma's.

A second work by the same poet will enter into our study, although its main plot does not concern Rāma at all. This is the *Lāvaṇyavatī,* a romantic tale concerning the heroine for whom it is named and the hero Chandrabhānu.[47] Originally a heavenly couple, they are reborn as a princess of Simhala and a prince of Karnataka, who falls in love with her portrait. They meet in a dream, exchange love letters, meet secretly at the temple of Rameshvaram, and are married with their parents' consent. When Chandrabhānu departs to quell a rebellion, the couple live in romantic separation, but they are eventually reunited and ascend to the throne of Karnataka.

During preparations for the wedding, Lāvaṇyavatī's father commissions a traveling entertainer to perform the Rāmāyana in order to arouse her desire for Chandrabhānu.[48] As the translation of this portion in my Appendix 3 shows, the events of the epic are summarized succinctly in the text, generally following Upendra Bhañja's own *Vaidehīśa Vilāsa.* At the conclusion, however, we realize that Lāvaṇyavatī has identified Rāma with her own beloved, and hence she presumably thinks of herself as Sītā, the kidnap prefiguring her separation from Chandrabhānu. The adaptation of the Rāmāyana in particular to the needs of romance may have to do with Upendra's own predilection for this divinity, apparent elsewhere in his work. In the *Lāvaṇyavatī* itself, Rāma is invoked at the very beginning. It is also appropriate, in view of the role of *māyā* in versions of the Rāmāyana popular in Orissa, that the whole tale should be presented as an illusion within a plot where dream and magic play a recurrent role.

Among other recent authors, Viśvanātha Khuṇṭiā is worth mentioning, not because he was directly illustrated but because his version of the Rāma story was second only to Baḷarāma Dāsa's in popularity. His name indicates that he belonged to a brahman family of temple servants in Puri. Khuṇṭiā probably wrote early in the eighteenth century, and he was aware of Upendra Bhañja's works but primarily followed Vālmīki.[49]

Viśvanātha Khuṇṭiā's work is titled *Vichitra Rāmāyaṇa, vichitra* meaning "varied in melody," for the work is broken into sections to be sung to different *rāgas.* It is also called a Rāmalīlā, suggesting its use as a dance-drama, and indeed it is not only read as a text but also used by boy dancers (Goṭipuas) and is beloved for its simple lyrical poetry. This version of the story follows the southern recension of Vālmīki, rather than the eastern (as did Baḷarāma Dāsa's) and is on the whole closer to the Sanskrit plot than to Śāraḷā Dāsa's *Mahābhārata* or even Upendra Bhañja's *Vaidehīśa Viḷāsa.*

Viśvanātha Khuṇṭiā's *Vichitra Rāmāyaṇa,* perhaps because of its popularity, has played host to interpolations, which do not appear in older manuscripts of this text.[50] The episode of Mahīrāvaṇa is an interesting one, actually attributed in the printed text to Vikrama Narendra, a nineteenth-century author of his own, separate, *Rāmalīlā.* This story, widespread in Sanskrit and in Indian vernaculars although not in most Oriya texts, involves an additional demon invoked by Rāvaṇa after the death of his son Indrajita. Hanumāna forms a fortress of his extended tail to protect the heroes but is tricked into letting Mahīrāvaṇa enter and abduct them. Mahīrāvaṇa prepares to sacrifice them to a form of the Goddess, but Rāma asks the demon to demonstrate how to bow before her, at which point the Goddess decapitates him. The Śakta twist to the story, which is to be expected in Bengal, must also have appealed to elements in the populace of Orissa.

PERFORMANCES

The value of the fact that various oral traditions remain alive in Orissa is inestimable for the art historian usually forced to work from written texts alone. But I am also acutely aware of the difficulty of conveying ephemeral, constantly varying, and multidimensional versions of stories. Hence the impassioned but unsystematic nature of my account. I shall not pretend to do justice to the rich performing arts of Orissa per se.

Popular Enactments: Rāmalīlā, Danda Jātrā, Sahi Jātrā

Rāmalīlā ("Geste of Rāma"[51]) is a widespread type of popular performance. The genre encompasses various dramatic enactments of the story of Rāma by nonprofessional actors, men playing women's roles, common throughout north India, ranging in duration from ten to thirty-one nights, concluding on the autumn holiday Dashahra. In eastern India, however, Dashahra is fundamentally associated with some form of the Goddess. In Orissa in particular, Rāmalīlā is performed during the two weeks following Rāma's birthday, Rāmanavamī, in March or April,[52] a time that makes sense for an enactment that begins with Rāma's birthday, on Rāmanavamī. This timing within the agricultural cycle makes the performance a celebration of the spring harvest. And it is pleasant at the beginning of intense summer heat for villagers to enjoy the cool night hours with performances, generally from midnight till dawn, while actors and audience are free to sleep in the daytime.

Another difference between these Rāmalīlās and those of north India, which are generally based upon the *Rāmcharitmānas* of Tulsī Dās, is the use of many

different versions of the story in Orissa. I contend that the experience of viewing village performances of Rāmalīlā, vivid from childhood memory and from annual repetition, at times had more impact upon artists than did normative written texts. Yet the very diversity of Oriya Rāmalīlās urges one to be cautious in drawing a connection with particular modern survivals. At least we can be sure that there were some performances in the areas and at the times in which most of the illustrated Orissa Rāmāyaṇas were made. My observations are weighted in favor of those places where I actually watched Rāmalīlās in 1983 and 1990.

In both years, I spent much of the fortnight following Rāmanavamī in Dasapalla, a small town (c. 10,000 inhabitants) in the forested interior of Puri District, whose Rāmalīlā is locally considered the best dramatic spectacle. The text recited here and commonly referred to as "the Purāṇa" is a copy of the *Rāmalīlā* of Vikrama Narendra, a little-known early nineteenth-century author.[53] Local tradition traces the performances back to the reign of the ruler of Dasapalla state, Krishna Chandra Deo Bhanj (1805–45), who was also known for his pacification of the Khonds and other tribes in his kingdom. Narayana Deo Bhanj (1896–1913) sponsored particularly splendid performances and built (300 meters from his palace) the Mahāvīr Temple, where today most of the drama takes place.[54] Old people remember with nostalgia the days of royal support, when the queen loaned her own gold jewelry to the actors. After Indian independence the Temple Endowment Board took over supervision with remarkable effectiveness. There is widespread enthusiasm, both among local administrators and elders (such as the school teacher Brindaban Mohanty, who selflessly directs performances these days) and among the actors. People tell of a former actor, who as an old man lost his voice but who insisted on playing his role while others spoke the lines. A similar spirit is still alive among many local youths today. The reputation of Dasapalla is also due to its spectacular props, a 25-foot crane that serves as Puṣpaka Vimāna and a 30-foot image of Rāvaṇa, burned on the final night (Figure 41). Each year old wooden masks of cunning design are vividly repainted—Śūrpaṇakhā's with a removable nose. Most have slits beneath the painted eyes, enabling the actor to see, while the eyes of the mask itself are more emphatic than they would be if cut out. Electric lights are used lavishly today, both to decorate the town for the festival and, ingeniously, as part of the performance. For example the three lines drawn by Lakṣmaṇa on the ground in front of Sītā's hut consist of strings of tiny bulbs that suddenly glow, highlighting the protective boundary.[55]

Among other Rāmalīlās, Bisipada, a smaller town (c. 3,000 inhabitants) 10 kilometers southeast of Phulbani, struck me as most traditional in 1983, although in 1990 it had lost some of its vitality. Here a palm-leaf text is in use, composed by Janārdana Dāsa at least a century and a half ago.[56] Bisipada was never a royal center, and the performance there was in the past, as it is today, organized by the village elders, largely Bisois (soldiers, of the khandayat caste), who gave their name to the town. Props survive in older form than those of Dasapalla, including a fine appliqué canopy that goes back to the nineteenth century.[57] The masks have not recently been repainted. The ambitious props of Dasapalla are absent here, but wooden torsos encase the bodies of the actors who play the three major demons, so that the heads rise to a height of nine feet. The acting style in 1983 was strikingly traditional, with long passages in which the royal characters simply moved

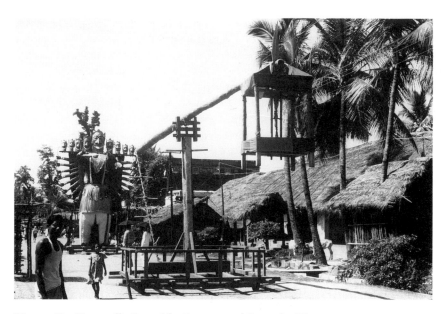

Figure 41. Dasapalla Rāmalīḷā. Rāvaṇa and Puṣpaka Vimāna.

their feet back and forth in a stylized step. In 1990 the Bisipada performance showed more of the strutting and exaggerated gestures associated with Jātrā (professional theater). In any case, it would be wrong to present any center as authoritative, for diversity must always have existed. Diverse acting styles, reflecting the alternatives of conservatism and innovation, may well have competed in the past.

Rāmalīḷās flourish along the Mahanadi, as far as Baudh and reportedly Sambalpur. Gania follows a copy of Vikrama Narendra's text, which was adopted from Dasapalla, 20 kilometers to the southwest. Yet details of staging differ from those of Dasapalla: few masks are used, and a cart wheel turned on its side serves as Puṣpaka Vimāna, with Rāvaṇa and the kidnapped Sītā seated on top, its whirling suggestive of movement through the air. Nearby Belpada follows the printed text of Vaisya Sadāśiva, an eighteenth-century work widely known in other parts of Orissa and itself directly influential for one of Orissa's greatest living painters.[58] Here an elaborate two-story stage is used, quite different from the simple canopied spaces that generally house the core of action near a shrine, with some processional movement along the streets of other towns.[59]

To the south, other theatrical genres present the story of Rāma, including the Desia Nāṭa of Khoraput District and the professional Jātrā, which remains popular throughout Orissa. But to return to the more participatory and ritually based Rāmalīḷā, we have every reason to think that it flourished in Ganjam District and those areas near Puri where most of the images to be considered were produced. Thus near Khurda a Rāmalīḷā continues to occur at a slightly later ritual date.[60] Manibandho, near Kavisuryanagar, is reported to maintain a Rāmalīḷā with masks

today.[61] In Chikiti, far to the south, the ruler Krishna Chandra Rajendra (1750–80) composed a Rāmalīlā of which one illustrated palm-leaf manuscript survives.[62] There, lively performances with masks took place during the fortnight after Rāmanavamī until 1956, when they ceased for lack of royal support.[63] And in Amrapura, near the large Rāma temple of Odagaon, the masks of a now defunct Rāmalīlā tradition are preserved, those of Hanumāna and Aṅgada still in worship on the altar of a temple (Figure 42).[64] Thus it is likely that palm-leaf illustrators and painters in the nineteenth century knew performances broadly analogous to those of Dasapalla and Bisipada.

Amid this welter of local forms, what generalizations can we make about plot structure? In Dasapalla alone, the number of daily performances has varied from ten to sixteen during the past fourteen years.[65] Moreover, the exact division of

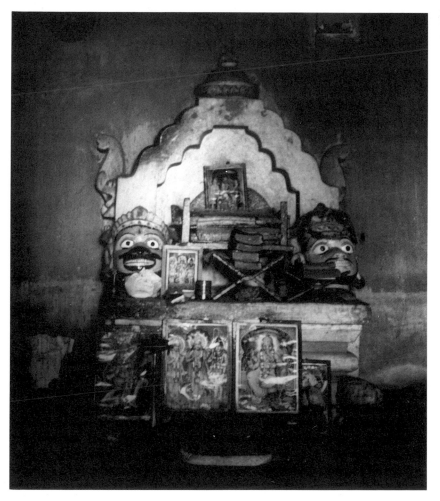

Figure 42. Amrapura. Rāmalīlā masks and palm-leaf manuscripts in worship in Mahavir Temple.

events on particular nights may vary from year to year.[66] The following schedule of Dasapalla in 1990 provides one sample:

1. Daśaratha's sacrifice, Rāma's birth
2. Protection of Viśvāmitra's sacrifice (Tāḍakī killed, Ahalyā freed)
3. Breaking the bow
4. Rāma's marriage and the meeting with Paraśurāma
5. Killing the rhino
6. Rāma's exile (and Bharata's visit[67])
7. Killing Virayudha (and Rāma's visit to Puri and to various sages)
8. Kidnap of Sītā[68]
9. Rāma's grief
10. Killing Vālin
11. First attack on the fort and finding of Sītā
12. Second attack on the fort and death of Kumbhakarṇa
13. Burning of Laṅkā and death of Rāvaṇa
14. Coronation of Rāma

Either the fourth or the fifth night has consistently been devoted to killing the rhino, an event that may come as a surprise in view of the Rāma story as a whole. The action, corresponding to only three pages of Vikrama Narendra's text, took over three hours to perform in both 1983 and 1990. Daśaratha requires meat to perform the *śrāddha* sacrifice for his ancestors. The four brothers lead the audience in procession to a market several kilometers' distance from the stage, accompanied by the deep, pulsating beat of kettle drums, a tribal instrument as opposed to the oblong *mridanga* that accompanies the normal chanting. Śabaras dance and a Śabara king comes to help in the hunt (Figure 43), when ultimately Rāma shoots a rhino, symbolized by a green coconut. The people of Dasapalla consider this event distinctive of their Rāmalīlā.[69] This is the most gratuitous case of emphasis upon tribal elements in the performance, although tribal references occur at other points as well—the Śabara king (Guha) who helps the exiles cross a river, and the Śabarī woman who offers Rāma a mango that she has tasted to be sure it is ripe. Historically these themes may reflect Krishna Chandra Deo Bhanj's effort to pacify the Khonds in Dasapalla; at the same time, their retention is made possible by the general visibility of these aboriginals living on the periphery of Hindu culture in central and western Orissa.

The interpretation of particular events often differs from town to town. For example, in Bisipada, Śiva's bow is brought in a ponderous wood chest, an occasion for extended acrobatics by Janaka's servants, preserving the gymnastic traditions of this soldier village. In Dasapalla the bow glides quickly onstage in the same sari-covered frame that had served as a boat the night before, whereas the entry of Sītā's suitors is humorously prolonged—including a mincing Napumsaka (eunuch), a foul Mleccha (foreigner with a broom as tail), and several other suitors who arrive on motorbike. The overall sequence is similar in the two towns, except that in Bisipada the first eleven events are extended over more time. Thus the

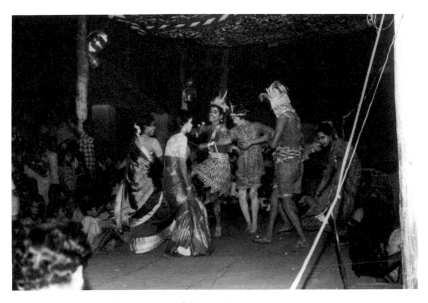

Figure 43. Dasapalla Rāmalīlā. Śabaras dancing.

burning of Laṅkā by Hanumāna occurs on the climactic penultimate day, followed by all the events of the Yuddha Kāṇḍa, squeezed into the last night. This truncated version of the story emphasizes Hanumāna's exploits in a way we shall occasionally encounter in palm-leaf illustrations.

All of the Oriya Rāmalīlās have a homey flavor by comparison with the more widely known pageant of Ramnagar, still supported by the Mahārājā of Banaras.[70] This quality follows in part from their scale: at the major pilgrimage center Banaras it is possible to assemble a crowd of 500,000, whereas at Dasapalla the audience comes from villages in the vicinity and is closer to 5,000. This in fact is as much as the town spaces can accommodate, creating a sense of bursting popular interest, a wall of spectators whose eager faces extend into the surrounding darkness. The relative intimacy of the rural setting enhances audience participation in the enactment itself, whereas the great crowds of Ramnagar move as devotees of the divine characters. In Orissa the actors are familiar townsmen. Women of the village join in Rāma's wedding, ululating as they would at an actual celebration.

The night of Sītā's kidnap at Dasapalla illustrates many compelling dramatic effects. Śūrpaṇakhā appears first as a seriously seductive woman, played by one of the most accomplished young actors, then as a comic masked demon, denosed, who brings in a lively band of other demons. Rāvaṇa in royal form without a mask (acted by a magisterial member of the old royal family) approaches the sympathetic sage Mārīcha, and a small wooden deer with two heads is pulled onstage (Figure 44). Suddenly at 3 A.M. thousands of spectators troop up the road from the primary stage near the temple to an area specifically identified as Mount Chitrakūṭa, where the acting space is a narrow passageway in the middle of the seated audience. At one end sits Sītā, joined by Māyā Sītā in ghostly form behind a trans-

lucent sari that forms the wall of the hut, as Rāma departs into the night pursuing the little wooden deer.[71] Lakṣmaṇa leaves and a mendicant appears, the illusionary form of Rāvaṇa, who drags away Māyā Sītā at 4:15 A.M. Now the audience again moves a hundred meters to the crane, where the royal form of Rāvaṇa, Māyā Sītā, and the chief singer revolve in the air, propelled by fifteen youths who weight the opposite end of the huge fulcrum. Jaṭāyu fights in vain, and Māyā Sītā drops her ornaments to a happy band of monkeys, just as dawn comes up behind the huge effigy of Rāvaṇa that had been raised with great effort the previous evening.[72] It is hard for the remaining audience not to feel both awe at the ominously whirling crane and a sense of identification with the optimistic monkeys who chatter away at its own level as another day begins.

Dāṇḍa Jātrā is categorized as a separate genre, although in fact it might be regarded as a special form of Rāmalīlā, for it takes place at night at the same time of year, the fortnight after Rāmanavamī. As far as I know, the name is peculiar to Asureshvar, a town about 20 kilometers from Kendrapara, just north of the river Mahanadi.[73] *Dāṇḍa* means "road," referring to the main street of the town, where the action originates at the Raghunātha Temple and proceeds to the Jagannātha shrine at the opposite end. The heroes are carried down the road on the shoulders of devotees and given offerings along the way, with some analogy to the great cart festival of Orissa as well as to the tradition of static tableaux, or *jhāṅkī*, found

Figure 44. Dasapalla Rāmalīlā. Magic deer.

Figure 45. Puri. Sahi Jātrā. Mahīrāvaṇa.

throughout north India.[74] The *Rāmcharitmānas* of Tulsī Dās is read in Oriya translation both day and night throughout the fortnight. The Raghunātha Temple and the entire observance were founded by Rāma Kṛiṣṇa Dāsa, a local landowner, several centuries ago.

What makes the Asureshvar event distinctive is that townsmen desiring some goal may undertake a vow, or *vrata*, at this time. To do this entails assuming the

guise of a monkey, for Hanumāna is the epitome of devotion. The believer rents a monkey costume from the temple, consisting of a wooden mask, feathered tail, and chain of bells (Plate 1). He eats only once a day, chants the name of Rāma, performs simian antics, and begs for alms during the period of the vow, which may last for a week.[75] In short, here yet more ordinary people participate in the Rāmāyaṇa story. The role of the *vānaras* (forest animals) is made vivid, with monkey-men appearing in the bazaar and running around the town.

Sahi Jātrā may represent another variant upon the Orissan Rāmalīlā. This term, peculiar to Puri, designates performances put on by the *sahis,* or districts, of the town, which are not restricted to Rāmanavamī, although a major cycle occurs in the fortnight following that day.[76] The episodes selected are not those of rural Rāmalīlās. They tend toward tableaux focused on a few characters. The same episode may be performed by different streets of Puri, with a sense of neighborhood competition, although on some nights the performance is left to one street or gymnasium (*akhaḍa*) to organize.

Thus in 1983, the Sahi Jātrā for Rāmanavamī began between nine and ten P.M. with a simple procession of the four brothers as boys, together with Riśyaśriṅga, wearing two horns (Plate 2). The second night was devoted to acrobatic performances by various demons. The first two, most popular, were called Nāka and Kāna, "Nose" and "Ear," possibly a reference to the two organs of Śūrpaṇakhā that Lakṣmaṇa was to cut off. While that action was not performed, spectators kept quoting a famous double entendre from the *Vaidehīsa Viḷāsa* of Upendra Bhañja, cited below in Chapter 4. On the third night three Durgās, played by particularly strong men, including a member of the painter community, danced on different streets for several hours, an arduous undertaking in view of their heavy masks and costumes involving multiple arms. There were also floats that bore impersonations of Gaṇeśa, Narasimha, generic warriors (Nāgas), as well as some characters specific to the Rāmāyaṇa, such as Rāvaṇa. On the fourth and sixth nights no action occurred. On the fifth, seventh, and eighth nights the action revolved around various Rāvaṇas, which some spectators called Māyārāvaṇa and Mahīrāvaṇa. These performers appeared late in the night, seemed almost to be in trance, and went on dancing into the daylight, pausing regularly to rest from the weight of their heavy costumes (Figure 45).

In short, this form, as our term "street theater" suggests, is impromptu and invites participation by the people of Puri. Narrative action is minimal, and references to the Rāmāyaṇa are haphazard. Nonetheless the dramatic image is memorable, particularly of great multiarmed characters dancing, drenched in sweat, the audience itself in a hallucinatory state.

Dance Traditions

Rāmāyaṇa themes appear throughout the gamut of Orissa's dance traditions. The Goṭipua boy dancers, as already mentioned, use Viśvanātha Khuṇṭiā's *Vichitra Rāmāyaṇa,* but their repertoire centers more on Kṛṣṇa. Likewise in the most classicized, or *mārgi,* dance form of the region, Oḍissi, the Rāmāyaṇa is present in a minor way, it being virtually impossible to distinguish long-standing local variants in the story used. Chhau, a more transitional form that includes folk or martial

elements and has been classicized in some of the courts of northern Orissa and adjoining areas, is performed particularly at the spring harvest festival of Chaitra Pūrnimā, a week after Rāmanavamī. Yet here there is no particular association of that day with Sītā's abduction, as in Oriya Rāmalīlās. Chhau themes range widely, including only a smattering of rather standard parts of the Rāmāyaṇa. For example in Seraikela, an Oriya-speaking center in Bihar, the two episodes that survive are Riśyaśṛṅga's encounter with the courtesan Jāratā and Sītā's grief in the asoka grove, both episodes that lend themselves to the aesthetic refinement and sentiment that characterize Seraikela Chhau in the twentieth century.[77]

Storytelling: Pālā, Dāsakāṭhiā

Several storytelling traditions of Orissa include many references to the Rāmāyaṇa, popularizing parts of the literary traditions already described, even if they cannot be credited with particular twists in the narrative. This is especially true of Pālā, enacted by groups of six costumed players, including musicians, a clown, and the chorus, who also take on separate dramatic roles.[78] The leader (*gāyaka*) not only directs the whole but also improvises his own commentary, combining learning and wit. In this form, the popularity of the most abstruse Oriya texts is perpetuated.

In the case of Dāsakāṭhiā, there are only two players, each of whom holds two different wooden clappers. Here, whatever the theme of the performance, the frequently interjected refrain runs,

> Rāma je, Jaya Rāma je, Nabina Sundara Rāma je.
> (Hail Rāma, Victory to Rāma, oh, handsome young Rāma.)

Thus in this genre, Rāma provides a framework often reserved for Jagannātha in Orissa.

Shadow Theater: Rāvaṇa Chhāyā

In Orissan shadow theater, known as Rāvaṇa Chhāyā (Rāvaṇa shadow), the Rāmāyaṇa provides the central subject matter.[79] Here the tenuous survival of performance tradition makes it extremely difficult to generalize backward in time. The form has been studied only from one village, Odasa, in Dhenkanal District, north of the river Mahanadi in central Orissa. A second town in the same area is reported to have puppets. Given the prevalence of shadow theater in Andhra to the south, the form may well have been widespread in Orissa in the past. It was preserved in Odasa by a single practitioner, who with state support recently taught it to a group of village men, some of whom serve as singers and musicians while others manage the puppets. Performances appear to take place when specially commissioned for auspicious occasions as a form of entertainment; today they last only a few hours, but a complete performance of the Rāmāyaṇa used to take a full night for each book, the whole extending over an entire week. The village gathers on one side of an improvised cloth screen, an earthen lamp casting light on the other side, where the puppeteers sit. While the puppets are rough, cut from deerskin

Figure 46. Odasa. Rāvaṇa Chhāyā shadow puppets of hunting the magic deer.

and without color, the effect of their eerie forms on the screen is as haunting as more elaborate shadow puppets elsewhere in Asia (Figure 46).

The story of Rāvaṇa Chhāyā is introduced by two humorous characters, apparently the kind of clowns that appear in a wide range of Sanskrit and vernacular theater in India. Aside from this frame, the story follows Viśvanātha Khuṇṭiā's popular *Vichitra Rāmāyaṇa,* including originally even the Uttara Kāṇḍa, which is omitted in other performances discussed here.[80] Again the form is one in which a literary text is vividly disseminated. It is difficult to discern a particular visual connection between the puppets and the images I discuss in subsequent chapters. Some motifs, such as the two-headed illusionary deer, are very widespread. And a shared preference for profile heads and frontal bodies prevails both in paintings and in the shadow puppets.

A Festival: Laṅkā Poḍi

Finally the Laṅkā Poḍi of Sonepur in western Orissa is a festival distinctive of one place, which has its own legendary topographic connection with the Rāmāyaṇa. Because Sonepur lies on the southern bank of the Mahanadi near a small island where the local goddess Laṅkeśvarī is worshiped, it has been suggested that this town (whose name literally means "Golden City") is to be identified with Rāvaṇa's golden citadel, Laṅkā.[81]

Another link in this chain is the festival that takes place on the new moon of Bhadra, usually in August, at the end of the rainy season when merchants are again able to begin travel. The holiday begins in the morning with children pulling a variety of wooden toys. Older girls do a simple *pūjā* (worship) that involves model cooking vessels and dishes, in reference to their later housewifely duties. But much of the town's energy is spent buying clay images from the potters, mounting these on wheels, decorating them with paint and leaves, and finally

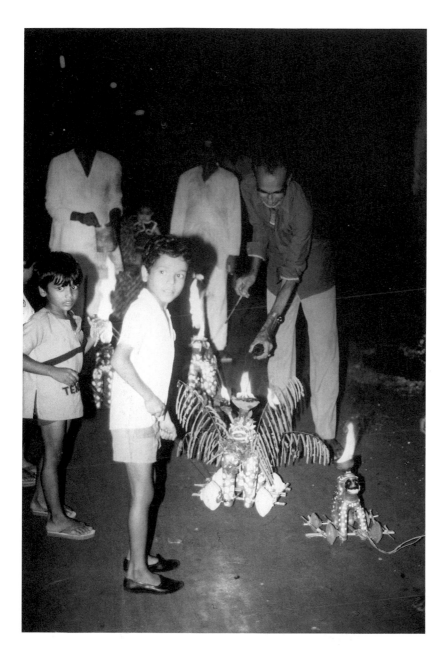

Figure 47. Sonepur. Laṅkā Poḍi. Children with images at night.

fitting them, with a can of kerosene, on the back and wrapping the raised tail with rags. By dark, every child is equipped to set the rags on fire and pull the image through the streets of the town, which flickers with flames, creating the illusion of Hanumāna darting about as he sets Laṅkā ablaze (Figure 47). Until recently the clay images were taken to the Somalāi Temple on the town's outskirts and broken

Figure 48. Sonepur. Laṅkā Podi. Hanumāna image on rooftop after festival.

at the end of the evening, although some monkey figures also ended up mounted on rooftops, where they served as apotropaic guardians throughout the year (Figure 48).

In that the traditional images, made of the clay tubes used to manufacture roof-tiles, are not particularly simian, one may wonder whether they reveal the

Sanskritization of some local cult. Wheeled horses are made in other towns in the area, and perhaps these have relatively recently become identified with Hanumāna in Sonepur. Whatever its origin, the festival gives an immensely interesting meaning to the familiar tale. On the one hand, the monkey hero is singled out as the great victor of the epic. On the other hand, there is a tolerance for the co-existence of forces of good and evil, the town itself being accepted as the home of the *rākṣa-sas,* who are also purged annually, their treatment comparable in some ways to the ambivalent glorification of Rāvaṇa in south India.[82] In short, Laṅkā Poḍi in Sonepur, combining gaiety and danger, epitomizes the rich, illusory world of the Rāmāyaṇa in Orissa. In their own way, both literary texts and performative genres in this region develop this image of flux. With some sense of the variety of possible stories, let us now turn to the pictorial discourse.

2 ∴ Two Pictorial Traditions

PALM-LEAF BOOKS

Their Manufacture and Use

One type of illustration in Orissa takes a form distinctive of this region: the incised palm-leaf book, or *pothi*. Palm fronds were widely used for writing in India from the earliest Buddhist and Jain manuscripts, being readily available and fairly resistant to insects. Some of those manuscripts also contained paintings. But the particular type of palm leaf used in Orissa, the palmyra, had its own properties, which led to an incised form of writing; this in turn was combined with incised illustration.[1]

The manufacture of a book began with selecting palm leaves that were three or four months old. These were buried for a day in wet sand, boiled briefly in rice water and turmeric, and dried in the sun. Then the pile was trimmed to uniform size, each frond was pierced, and the fronds were strung on a cord between two rectangular wooden boards of the same size that served as covers. The width was normally about 4 centimeters; the length might vary from 6 to 40. The book was next written by means of a stylus (*lekhani*), whose pointed end broke through the fibers of the frond to leave a channel that appeared as a light shadow. Thus use of the stylus required dexterity and attention to the results, which were only partly visible. When one or more pages were completed, they were inked with a solution of powdered leaves or of soot mixed in water, causing the lines to emerge clearly. Usually if the work was to be illustrated, the text was written first and space left for the pictures, which were completed subsequently along with their internal captions. These linear pictures might also be later painted.[2]

This kind of manuscript was, and still is, perfectly functional as a book to be read, although the form of the letters may be somewhat less familiar than printed Oriya today. The reader begins with the front of the first folio, proceeds to its reverse and then the second, pushing the leaves along the slack in the cord on which they are strung. One can still see a brahman performing a ceremony with palm-leaf book in hand, flipping through the leaves to remind himself of the verses he recites (Figure 49). It appears that the actual use of manuscripts as books

read both ritually and (in the case of romances) for pleasure in Orissa was fairly widespread during the nineteenth century and the early twentieth.[3] Moreover, palm-leaf manuscripts were commonly kept in temples and in homes in the room for *pūjā* and were smeared with sandal paste in respect for the book itself as an object of talismanic reverence (Figure 42 shows a pile of books on the altar of a small temple).[4] The survival of several Orissan manuscripts in collections assembled by Jain monks in Gujarat, where a very different script and language were in use, demonstrates that traditional reverence for the book did not require the actual ability to read the text.

Such circumstances of use and worship may have been physically hard on the manuscript. Moreover, palmyra itself is less durable than other types of palm used elsewhere in India; it is susceptible to depredation by the white ant, the results of which are visible in many of the books that survive even from the late nineteenth century.[5] There is a widespread practice in Orissa that after a hundred years, a manuscript is recopied and the original deposited in a river in a kind of sacred funeral. This was not mandatory, and a finely illustrated work might be carefully preserved and spared this ceremonial fate. Nonetheless, the general fragility of palm-leaf manuscripts in Orissa leads me to some initial skepticism about assertions that a particular work is many centuries old.

The stringing of the book, as opposed to the Western and Islamic tradition of binding, presents particular problems for the modern scholar. Presumably early users retained the original string and simply kept the folios in sequence. Today when these books are disassembled—for sale to collectors, for photography, or simply for preservation in a museum—the pages often get out of sequence. When the original pagination is marked, it is not difficult to reestablish it, but sometimes the pages are not numbered.

To judge from the mention of patrons in particular manuscripts, many of these were commissioned by the elite of Orissa—rulers, officials, and wealthy merchants. The price was not necessarily very high, however, to judge from the few sums recorded.[6] Perhaps a typical situation was that of Raghunath Prusti, a poor artist of trader background, who produced his chef d'oeuvre for a wealthy merchant family while sitting on the verandah of their village house, receiving his food in exchange for the two or three pages he completed each day. In such a case the artist may seem to be financially dependent upon his patron, but it is worth noting that Prusti kept one work he had illustrated in his own possession. Manuscripts, like most possessions, might also change hands—some being given as part of a daughter's dowry, some sold, and some simply borrowed and not returned.[7]

The Scribes and Illustrators

Among the illustrated books that have colophons, all but one give the name of a single person as the producer of the manuscript. Usually the manuscript is described as *likhitam,* or "written," but since the tool named from the same root, *lekhani,* was used to produce the pictures as well, no distinction between scribe and illustrator is implied. In one example, the author of a commentary on the *Gīta Govinda* is said to have made a manuscript "provided with images."[8] And in a

second, the scribe notes that the book was written in four months, and an unusual addendum, made with a brush, records that the pictures took another two months.[9] The sole documented exception to this pattern is a manuscript of the *Bhāgavata Purāṇa,* whose colophon says this: "The illustrations of books eight and nine are my work (Brajanātha Baḍajenā); the handwriting is that of my son, Ghyanaśyāma."[10] Here we also have an unusual case of the hereditary practice of the craft of writing, perhaps because this work was made in the last years of Brajanātha's life, when he was unable to produce such extraordinarily small letters as could his son. It is worth stressing that scribe and illustrator are normally one in Orissa precisely because this is not the pattern elsewhere in India.

Who were these illustrators, then? The karaṇa caste, equivalent to the kāyasths elsewhere (a high śūdra group that in fact competed with the brahmans in some kinds of status), were by tradition scribes. They may have copied the majority of unillustrated manuscripts. They also exercised their scribal functions on paper, where they developed the distinctive *karaṇi* script, a cursive form. Among important karaṇa palm-leaf illustrators were the poet Brajanātha Baḍajenā, just mentioned, and the prolific Sarathi Madala Patnaik, who is discussed below.[11]

But karaṇas had no monopoly on the illustrated book. We know of several brahman artists: Dhanañjaya, who produced the *Gīta Govinda,* with commentary and pictures; Balabhadra Pathy, four of whose works are known; and Michha Patajoshi, who specialized in illustrated versions of the *Vaidehīśa Vilāsa.* There is also a notable case of an illustrator from the merchant caste, Raghunath Prusti, son of an oil-man, whose *Lāvaṇyavatī* figures here.

In short, the making of palm-leaf books, particularly those with pictures, seems to have been taken up by a variety of literate individuals who *became* craftsmen. Many may have been professionals in the sense that they supported themselves by this craft. Yet this was only one of the skills of the poet Brajanātha Baḍajenā. Probably brahmans retained their ritual functions and income as well. Thus palm-leaf book illustration was not normally an inherited profession, passed down by intensive training in the family or subcaste workshop, a situation exceptional among book illustrators or artisans of other kinds throughout India. One result is the great diversity of images in this medium, even at a single moment and within a limited area. Lack of professional training led to a variety of standards for work, some of which we may feel is of indifferent quality. Yet it was possible for artists of real inspiration, such as Raghunath Prusti, to turn to the production of illustrated books, abandoning their expected professions. The contrast between this situation and the more uniform, hereditary, profession of painting on cloth is central to the present study.

In the case of palm-leaf manuscripts, we must note that the manufacture of this form is virtually dead today in its traditional guise, having been replaced by the printed book during this century. Occasionally rural astrologers continue to use palm leaves, the medium adding to the validity of the horoscope. Pictures on joined palm leaves are also being made by the professional painters, or *chitrakāras,* who have in the past ten years added such works to the repertoire of objects they produce for sale to tourists and pilgrims. They usually show a single scene, follow-

ing the format of their own *paṭa* tradition. Writing is minimal today, for they no longer have an Oriya audience in mind.

General History and Style of Palm-Leaf Illustration

To create a broad chronological framework, it may be helpful to sketch what is known about the general history of this genre on the basis of works not illustrated here, before focusing upon manuscripts of the story of Rāma, grouped by the text they illustrate. Possibly the oldest of all Orissan illustrated books is a *Gīta Govinda,* with a commentary, known as *Sarvāṅga Sundarī,* composed, written down, and illustrated by the brahman Dhanañjaya. The date in its colophon can be interpreted as either 1689 or 1916.[12] If the earlier date is correct, the manuscript is in remarkably pristine condition. If the date is 1916, we must accept the fact that rich, refined, and very conservative work was being done quite recently. Faces are largely but not always in profile here, and the facial type has a distinctive squareness, with a pupil that fills the center of the elongated eye.

A second questionable candidate for one of Orissa's first illustrated manuscripts to survive is also a *Gīta Govinda;* it has been ascribed to A.D. 1717.[13] Here the date in the colophon has clearly been altered from Śaka 1628 (A.D. 1706) to Śaka 1639, perhaps to correspond to the reign of the Khurda ruler Harikṛṣṇa Deva, who is also mentioned in the colophon.[14] Thus we are left with an undated but possibly early manuscript. Faces are consistently viewed in profile here, with a very large eye in which the pupil floats in isolation from the lids. The thick, skirt-like sari and the covering of both background and figures with pigment makes the pictures seem more like some paintings on wood from Bengal and Orissa than like much Orissan work on palm leaf.[15] Drawing and composition are generally simple. Some mannerisms, such as the way the scarf and the end of the sari fly horizontally make this an unusual work, whenever it was made.

The first work whose date I can accept with confidence is a copy of books 8 and 9 of the *Bhāgavata Purāṇa,* which was illustrated by the karaṇa poet Brajanātha Baḍajenā and written by his son, as described above. The colophon of this manuscript mentions what is probably the third regnal year (i.e., the second actual year) of the king Divyasimha Deva of Khurda, who ruled from A.D. 1793 to 1798.[16] This corresponds to 1795, when it is possible to reconcile the remaining information we have about this work. The illustrations, broadly similar to those of Dhanañjaya's *Gīta Govinda,* are simpler in composition, with fewer rich designs, aside from the refined patterns of Ghyanaśyāma's writing. The figures are slightly clumsy. No faces are viewed frontally; the pupil floats in the center of the eye, whose corners are consistently darkened.

After this work of 1795, the major landmarks all figure in the detailed discussion of Rāmayaṇa texts below. In brief, the Baripada *Vaidehīśa Vilāsa* of the "ingenious karaṇa Śatrughna" is dated to 1833. From the 1870s on we have a number of works by Sarathi Madala Patnaik (including several *Adhyātma Rāmāyaṇas*), by Raghunath Prusti (including a *Lāvaṇyavatī*), and by Michha Patajoshi (who specialized in the *Vaidehīśa Vilāsa*). These last three demonstrate that great diversity of style could be found among contemporary artists living no more than fifty miles

from each other. Surely this is understandable if we consider how individuals with different family backgrounds, who had not been trained in this craft, must have worked enthusiastically and with an independence unusual in the Indian artisanal tradition.

To return to our chronological framework, are we entirely at sea if a manuscript is undated or does not resemble a dated manuscript closely enough to be by the same hand? I would answer yes, at least in terms of the style of illustrations. It is a mistake to attribute to the same date in Orissa the traditional compositions, preference for profiles, and other devices that had been abandoned in Rajasthani painting in the seventeenth century.

A second basis often invoked for chronology is the writing style. In fact there is considerable difference of opinion here among Oriya pundits, and precise guidelines have never been formulated. One criterion in their discussions that may be of some use is the form of the letter (*akṣara) a,* which develops from an archaic ଐ to ଅ, the form familiar today.[17] The "modern" form goes back to at least 1795, when the two types coexist in Brajanātha Baḍajenā's *Bhāgavata Purāna.*[18] The archaic form alone occurs in Dhanañjaya's *Gīta Govinda,* just discussed.[19] It also continued in occasional use as late as the early twentieth century, for example in the works of Michha Patajoshi, who tended to use it in the text (in which he may have been copying an older manuscript), whereas he used the modern form in his own captions for the illustrations. Thus the form of the letter *a* seems to change during the nineteenth century, although neither the old nor the new version provides an infallible guide to date.

What can we say about the chronological position of an interesting manuscript that lacks a colophon, the *Amaru Śātaka* from the state of Mayurbhanj in northern Orissa, now in the Orissa State Museum? It was originally ascribed to the late sixteenth or early seventeenth century on the basis of "the characters of the script and the style of the paintings."[20] I find so early a position inherently improbable in the absence of any other illustrated works securely dated from that period. Its style indeed differs from that of all other images discussed so far—with extremely mannered definition of the body (for example the hourglass male figure) and varied textiles that often billow prominently around the heads of women. The Orissan convention of lobed hills does not appear, but rather a vertical form, curving at the top, similar to that in reliefs from the thirteenth-century Sun Temple of Konarak. Nor does it share distinctive features with another north Orissan manuscript, the 1832 Baripada *Vaidehīśa Vilāsa.* The writing of the *Amaru Śātaka* includes only the archaic form of the letter *a.* Taking all these characteristics together, I would argue that this work belongs to the late eighteenth or early nineteenth century, probably but not inevitably preceding 1832. With this note of caution, let us turn to the manuscripts in question for the present study. Their dates are known precisely in some cases, but others remain hypothetical.

Adhyātma Rāmāyaṇa. Because of its popularity in Oriya translation, it is no surprise to find that the *Adhyātma Rāmāyaṇa* was also frequently illustrated. What is remarkable is that illustrated versions of this text seem to have been a favorite of one particular artist late in the nineteenth century. Four of our seven examples were produced by the scribe Sarathi Madala Patnaik, a karaṇa by caste, who

worked largely in Chasa Limikhandi village in the small state of Badakhemundi in southern Orissa.[21] This prolific artist was by no means limited to the *Adhyātma Rāmāyaṇa* as a subject, but he repeated it more frequently than any other text. His manuscripts generally bear colophons with detailed information about when and where they were completed, showing that he worked between at least A.D. 1875 and 1908, often invoking Rāma and Sītā to bless his work, whether or not they figure in the text.

The *Adhyātma Rāmāyaṇa* now preserved in Bhubaneswar (Figures 50–55) provides Sarathi Madala's earliest date, 1875:

> Completed at the temple of Śrī Raghunātha Mahāprabhū in Shergarh taluka, Dingapadar Maṭha, in the 19th *aṅka* of Divyasimha Mahārājā, *sana* 1284 *fasli, samvatsara* 1875, the month May, date Meṣa 28, 4th day bright half of Baiśākha, Sunday, 7th hour; the scribe is the karaṇa Sārathī Māḍalā, inhabitant of Limikhandi village, Gadamuthā taluka, Baḍakhemundi.[22]

The New York Public Library *Adhyātma Rāmāyaṇa* (Figures 56–67) is dated, by equally complex and contradictory references, to what seems to be January 30, 1891.[23] A third copy in the collection of C. L. Bharany, New Delhi (Figures 68–71), is dated December 2, 1891.[24] And finally the *Adhyātma Rāmāyaṇa* in the Utkal University Library (Figures 72–74), is probably dated 1902.[25] Thus we have four examples of his illustration of the same text, one an early work, two mid-career, and one late, each differing in the precise narrative choices that the artist made.

The fundamentals of Sarathi Madala's style, however, are constant throughout these manuscripts and his other works, such as the *Durgā* and *Hanumāna Stuti* now in the L.D. Institute of Indology, Ahmedabad, discussed below. His roughly drawn figures, jerky in their movements, are easily recognized. Coarse patterns define textiles and occasionally background areas, although in general setting is minimal. A distinctive touch is a series of tassels across the top of many leaves (e.g. Figures 50, 51, 53, 57, 61, 72–74, 84–86). Pigment is added in small areas, generally black or red, in his later works to define the pupil of the eye. We shall return to the storytelling concerns and the inventive compositions of this artist— his depiction of some poignant episodes is remarkable—but at the same time it is hard to avoid a negative impression of his individual images, where verve and sheer energy displace care or sense of purpose.

Three more examples of the same text, all now in New Delhi, lack colophons but seem to be the work of unknown artists also late in the nineteenth century. None is highly accomplished, yet none shows the determined clumsiness of Sarathi Madala. For example his illusory deer (Figures 51, 60, 68) has stumpy necks and knobbed feet, whereas the other versions create more conventional and convincing depictions of the graceful ungulate (Figure 76). None includes Sarathi Madala's formulaic tassels at the top of the folio, nor does any employ pigment. The National Museum's manuscript 75.536 (Figures 75–77) has slender figures with pinched faces, their eyes occasionally slanting upward for no apparent reason.[26] An unpublished work in the collection of C. L. Bharany (Figures 78, 79) has slightly more squat figures, like Sarathi Madala's.[27] Both manuscripts include the same portion of the complete text that Sarathi Madala illustrated, but their narrative choices differ considerably from his and from each other (see Appendix

1), suggesting that none of these works has served as a model for others. We see a plethora of independent versions of this popular text.

A fragmentary work in a private collection in New Delhi is of interest because it comprises the Uttara Kāṇḍa, which is omitted from all other illustrated versions of the *Adhyātma Rāmāyaṇa* (and indeed is rarely illustrated in any circumstances).[28] The five pictures that survive are extremely simple, showing little articulation within the contours of the body (Figures 80, 81). Textiles are very flat, sometimes forming an abstract frame around a figure.

Durgā and Hanumāna Stuti. The book combining these two texts, now in the L.D. Institute in Ahmedabad, is the work of Sarathi Madala Patnaik, the same prolific artist who created the first four copies of the *Adhyātma Rāmāyaṇa* just discussed (Figures 82–86).[29] Its colophon reads,

> This book was completed in November, 1899, in the 11th *aṅka* of Vira Śrī Kṛipāmayadeva, on the fifth day of the bright half of the month of Kārttika, on the fourth day of the week (Wednesday). This book is written by Sārathi Mādalā Paṭṭanāyaka, karaṇa by caste, of the village Casā Limikhaṇḍa of the taluka Gadamuthā of Baḍakhemuṇḍī. . . . This book belongs to Satyavadi Bāṇuā of Marahatīya village, Meriyali district, Sānakhemindī of Pratāpgīri.

Thus we have a work made two years before the Utkal University manuscript illustrated in Figures 73 and 74. Sarathi Madala's slapdash style is exactly that seen elsewhere. Occasional compositions in this quite different text resemble those in the *Adhyātma Rāmāyaṇa*, although again the treatment of the same incident varies. This variation suggests Sarathi Madala's dependence upon the guidance of instinct and memory rather than upon another manuscript as a model.

Rāmalīlā. I have found only one copy of a *Rāmalīlā* with pictures, but it serves to demonstrate the most popular end of the spectrum of Oriya texts that might be illustrated. Paradoxically, its illustrations generally resemble those of the Sanskrit *Adhyātma Rāmāyaṇa* more than those of the Oriya texts discussed below, suggesting that popular culture cannot be equated with the use of vernacular language as opposed to Sanskrit.

This version of Krishna Chandra Rajendra's text, now in the National Museum, New Delhi, was copiously illustrated with a picture on both sides of almost every folio (Figures 87, 88).[30] Individual scenes are simple and the figures sketchy, although drawn with more regularity than those of Sarathi Madala. The faces show a distinctive small, rounded eye, its outer corner often prolonged in a straight line. A occurs in the modern printed form. For lack of any documentation for the date, I would guess that this manuscript was made late in the nineteenth century.

Vaidehīśa Vilāsa. A popular work by Orissa's premier poet, Upendra Bhañja, the *Vaidehīśa Vilāsa* becomes almost unmanageably long when illustrated. Moreover, its literary character depends upon wordplay that is not readily transformed into pictures. Thus it is remarkable that at least five profusely illustrated manuscripts of the *Vaidehīśa Vilāsa* are known. These five are the product of two quite

different artists who favored this text as Sarathi Madala favored the *Adhyātma Rā-māyaṇa,* indicating that the artist's own penchant played some role in the choice of subject matter.

The first *Vaidehīśa Vilāsa* (Plates 3–8, Figures 89–98) is a highly unusual work from Baripada in northern Orissa, a region less productive of illustrated palm-leaf manuscripts than was the south.[31] Pale washes of a wide range of pigments appear throughout this work, at times resembling watercolor, although there are also opaque black areas. The drawing employs an exceptionally sketchy, discontinuous line, different in character from the rough works of Sarathi Madala Patnaik, or even from the writing in the Baripada *Vaidehīśa Vilāsa* itself.

The most unusual element of this work is its format: many pages were joined at the edges by tiny pieces of string, so that the whole was folded accordion-fashion rather than in the normal succession of separate leaves that could be read in sequence, front and back. Thus some illustrations could extend over three or four folios, although the text proceeds in normal fashion from front to back of the same folio. In short, it must have been difficult to read the poem and to follow the illustrations simultaneously. A few other old examples of joined leaves exist, but all are relatively short, about ten leaves; these make no pretense of presenting so ambitious a literary text and commonly bear one short excerpt from the *Gīta Govinda.* Today this format remains in use by the professional *chitrakāras* for pictures on palm leaves that lack any text whatsoever.

The Baripada *Vaidehīśa Vilāsa* is also exceptional in the internal structure of its compositions. While generally the scene extends horizontally over the length of the folio, some scenes are drawn vertically on the folios (Plate 6, Figure 98). Moreover, the text is not neatly demarcated in rectangular panels but appears in irregular balloons with curving edges. The result is a more interwoven and pictorially complex effect, unlike the neat windows opening out from a plane clearly defined by writing that predominate in other manuscripts.[32]

I am not able to explain these remarkable characteristics by any single visual precedent in northern Orissa. Possibly joined pages had been in use previously. The occasional side view of single objects one encounters elsewhere in palm-leaf manuscripts (Figure 139), an expedient for showing tall objects on the narrow folio, may lie behind the complexity of orientation in this work. Some particular motifs are squarely within the Orissan tradition—for instance hills composed of overlapping lobes (cf. Plate 6, Figure 204). Nonetheless I am reluctantly struck by an impression of foreignness as well as novelty here. The sketchily outlined clouds of text in particular are vaguely reminiscent of William Blake. Is it possible that a copy of one of his illustrated books made its way to India early in the nineteenth century? The presence of English soldiers in the Baripada *Vaidehīśa Vilāsa* itself,[33] and the proximity of English settlements in Balasore and Bengal, make it conceivable that such outside models might have appeared. But subsequent discussion of this manuscript will show that it is also firmly rooted in Orissan traditions, visual and narrative, and is by no means an attempt to replicate a European model.

The date of this interesting work is fortunately established on its first page in neatly rhymed verse: "Know that in *samvat* 1239 [A.D. 1832/3], in the nineteenth *aṅka* of King Rāmacandra, on the third day of the bright half of Māgha, this writing

was completed. Here is the ingenious karaṇa Śatrughna."[34] The last line is intriguing. "Ingenious" (*vichakṣaṇa*) befits the unique format and the compositions of this manuscript.

Yet this is not the only work of Śatrughna. Scattered folios survive from a second, similar, *Vaidehīśa Vilāsa,* which, however, was 10 centimeters longer than the Baripada copy. Eleven of these larger leaves are preserved in the Rietberg Museum in Zurich, including several big compositions that stretch across four folios (Figures 99, 101).[35] One leaf is preserved in the Victoria and Albert Museum,[36] and three more in a private collection in New Delhi (Figure 100).[37] The drawing, figure types, and many motifs of these scattered folios are similar to those of the Baripada manuscript, yet they lack designs perpendicular to the page. Their text is also more conventionally organized in rectangular panels that fill the height of the folio. It seems probable that this dispersed *Vaidehīśa Vilāsa* represents an earlier example of the same artist's work. If so, we can follow his development from mild innovation in the use of multiple-folio compositions to audacious pictorial ingenuity.

Finally, at least one other illustrated text can be ascribed to the same artist in his audacious prime. This is a small copy of the unpublished poem *Braja Bihāra* of Kripāsindhu Paṭṭanāyaka, now preserved in the History Department of Utkal University in Bhubaneswar.[38] It employs complex compositions with the text floating in balloons as in the Baripada *Vaidehīśa Vilāsa,* and some parts of the design are at right angles to the normal horizontal layout of the page. The execution of both drawing and painting is much neater here than in the Baripada manuscript, but both may be products of Śatrughna's maturity.

A second scribe who specialized in producing illustrated copies of the *Vaidehīśa Vilāsa* lived almost a century later, 300 kilometers to the south. In 1928, the Oriya scholar Kulamani Das wrote of meeting a brahman in a village in Khallikot District who showed him a manuscript of this work:

> In this he had, with a stylus alone, illustrated beautifully the hundreds of famous incidents described in the whole of the *Vaidehīśa Vilāsa,* along with its poetry. The churning of the Ocean, Sītā's birth, Sītā's wedding, the battle between Rāma and Rāvaṇa—illustrated by him, these are living examples of his uncommon love for the art he acquired by himself and for Bhañja's poetry. I treasure the memory of how he sang the poem as he showed me the pictures. This brahman said that writing such *Vaidehīśa Vilāsas* was his second occupation. He had written many such books and is encouraged by the *rājās* and rich people of Ganjam.[39]

This account documents the way in which such an artist chose the work in which he specialized, recited it with religious devotion as did later users of the manuscript, and also gained some livelihood from local worthies who appreciated his work. The phrase "love for the art he acquired by himself" supports my argument that many palm-leaf illustrators were self-taught rather than trained in a workshop.

While Kulamani Das does not mention the name of this artist, it was surely Michha Patajoshi, a brahman who produced three surviving illustrated copies of the *Vaidehīśa Vilāsa* with colophons indicating that he worked in Balukeshvarpur

in Khallikot state. The first of these, now in the collection of the Mahavir Jain Aradhana Kendra, Koba, Gujarat (Figures 102–12), was probably completed in A.D. 1902.[40] The second work by Michha Patajoshi, now preserved in a private collection in New Delhi (Figures 113–124), was illustrated between the fifth day of the dark half of Śrāvaṇa, 1911, and the twelfth day of the dark half of Mārgaśira, 1914.[41] The third *Vaidehīśa Vilāsa* by the same artist, now in the Asutosh Museum at Calcutta University (Figures 125–139), was begun on the tenth day of the light half of Kārttika, 1918, and completed on the festival Dhola Pūrṇimā, 1926.[42] The last two identify Michha as the astrologer (*paṭajoṣi*) of the Badagada *rājā* and as the son of Krishna Mishra, living in the village Balukeshvarpur, near Khallikot. He is fondly remembered by several inhabitants of Balukeshvarpur and by a grandson, Chandrasekhara Mishra, who lives in Aska. They estimate that he died around 1930 and say he was a lively, funny person, full of *hāsya rasa* (comic sentiment). His name was bestowed by Rājā Harihara of Khallikot: Michha (Liar) for teasing the king about his ability to hunt, and Paṭajoshi (Court Astrologer) for his skill in making firework rockets. All speak with amusement of the enthusiasm with which he copied manuscripts and also carved wooden walking sticks. His modest house survives, its front now encased in cement, next to the goddess temple in this traditional Oriya village.

Neither the second nor the third copy of the *Vaidehīśa Vilāsa* forms a coherent whole. Not only are some folios missing, but also there are duplicates of some page numbers. The duplications cannot be simply a slip of the pen, for the same portion of text (and accompanying illustrations) occur earlier in the principal sequence. In short, it would seem that Michha Patajoshi was working on several manuscripts side by side, repeating some basic compositions and narrative choices, as we shall see in later chapters, although not copying each page precisely. The basic selection of incidents illustrated in his three manuscripts is so similar and so profuse that it seems unnecessary to compare them by means of a chart. His later versions of the same text became progressively longer as he expanded the illustrations. When a customer appeared, he must have hastily bundled together various leaves, by accident including some from different copies. Thus the 1911–14 manuscript (i.e. the principal sequence of pages with colophon) includes a few leaves from an additional version. The 1918–26 manuscript includes more extra leaves from three other versions. In addition, eighteen folios from yet another version are preserved in the Rietberg Museum in Zurich.[43] Thus Kulamani Das's account of the devotion of this brahman scribe to the *Vaidehīśa Vilāsa* is supported by the existence of parts of what seem to be eight different copies of that poem.

Here we have an artist comparable to Sarathi Madala, who had worked nearby just slightly earlier. While the *Vaidehīśa Vilāsa* is physically but twice the length of the *Adhyātma Rāmāyaṇa*, it appears that Michha Patajoshi took four to eight years to produce one manuscript, whereas Sarathi Madala could dash off three or more within a single year. Although both might be described as "naive," unschooled either in the conventions of Orissan professional painting or in representational modes, there is considerably more sense of purpose in Michha Patajoshi's deployment of large-headed, comical figures to illustrate particular twists of the text. The resemblance in narrative choices between all his copies of the

Vaidehīśa Vilāsa is, moreover, greater than that between Sarathi Madala's *Adhyātma Rāmāyaṇas.* This might be explained by the artist's retention of one as a model, but even had he not kept one, it would seem fair to conclude that he was attached to his particular formulation of his favorite text, so carefully and lovingly worked out. The first manuscript of 1902 has slightly more in common with the work of Raghunath Prusti, who worked about 50 kilometers away in the 1880s, than did manuscripts of Michha's later career. Yet it would be hard to argue that Prusti trained Michha Patajoshi, who at most may have felt a youthful admiration for works of the older master. Two other examples of Michha Patajoshi's work are known, both large images of the Jagannātha Temple, which demonstrate that his devotion to Upendra Bhañja's version of the Rāmāyaṇa did not preclude his occasionally depicting other subjects.[44]

Lāvaṇyavatī. Among palm-leaf manuscripts, the *Lāvaṇyavatī* is frequently illustrated, being a popular Oriya poem of moderate length, suitable for embellishment with pictures. A preliminary example is Ms. 72.109 in the National Museum. This book belongs to a distinctive group of manuscripts that include bold areas of pure red and yellow, often in the background, as in Figure 140.[45] The drawing is firm and not very detailed, with a fixed repertoire of textile and border patterns. Bodies are stiff and show a characteristic mannered treatment of the upper end of both arm and leg, visible in the elbows of Figure 140, top. This group includes two copies of the *Lāvaṇyavatī* itself that lack any illustrations of the Rāmāyaṇa section,[46] and in fact we shall see little of the National Museum copy with which we began because only one of its illustrations is devoted to the Rāmāyaṇa sequence within the larger tale. Upendra Bhañja, who wrote in the first half of the eighteenth century, provides a *terminus post quem* for these manuscripts in general. Both forms of the letter *a* occur in the texts of each manuscript. No work of this group includes a date or place in its colophon, although the British Library *Lāvaṇyavatī* does bear the name of a scribe, Nilamber. In short, their date seems to be possibly eighteenth or, more probably, nineteenth century. Their lack of attention to the episode in which the story of Rāma is performed before Lāvaṇyavatī is a significant corrective to our preoccupation with that tale.

In this book I have chosen to focus on four manuscripts of the *Lāvaṇyavatī* where the Rāmāyaṇa sequence is extensively illustrated and well preserved. Some of these are close in date and probably in the place they were produced, yet each differs in its approach to the general treatment of narrative, as well as to the depiction of individual scenes. This poetic subject attracted a diverse range of the most accomplished and purposeful Orissan artists, as if the challenge of producing one fine version of this text appealed to them.

The first manuscript at one point belonged to a dealer in New Delhi who sold leaves to many major museums and collectors around the world.[47] Hence my designation, the Dispersed *Lāvaṇyavatī* (Plate 9, Figures 141–56). This work has become a touchstone for quality in Orissan palm-leaf illustration. On the one hand it is consistently traditional, for example in preferring the profile view for faces, or in darkening one upper corner of the folio to indicate sky (e.g. Figure 141), a device found in early Rajput painting. On the other hand this work shows

unusual sensitivity in its quivering, delicate lines and in the way ordinary activities of the hero Chandrabhānu's household are described. Pigments are applied to many leaves, including black, white, a wide range of reds, oranges, yellows, blues and an occasional green.[48] Compositions are spacious, and the figures are stately and graceful. The Rāmāyaṇa section must have extended over at least ten folios.

No colophon has been found for this work, which has been ascribed to dates ranging from the seventeenth to the nineteenth century.[49] While it is tempting to consider this work a traditional and carefully wrought starting point for some of the more stereotyped examples that we know were produced in the nineteenth century, it is also impossible to view it as a direct ancestor of any other *Lāvaṇyavatī*. Admitting that there are no clear indications of a very late date, either in the writing or in the pictures, I would prefer to think of this as either eighteenth or, more probably, early nineteenth century.

Our second example, now in the National Museum, New Delhi, illustrates the Rāmāyaṇa portion of the *Lāvaṇyavatī* more amply than any other work I have come across, and hence only one-sixth of its pictures of this sequence can be reproduced here (Plate 10, Figures 157–74), whereas all of the Rāma story in other versions is included.[50] This manuscript was made by the brahman Balabhadra Pathy, whose name we know from an illustrated *Gīta Govinda* in the L.D. Institute of Indology in Ahmedabad.[51] A third work, surely by the same artist, is a copy of Śiśuśankara Dāsa's poem on an epic theme, the *Uṣābhilāsa,* now largely in the National Museum, New Delhi.[52]

In all these manuscripts, Balabhadra Pathy used pigment in a distinctive way, with black scattered throughout for hair, water, and other telling details, as well as shades of red and blue-grey applied in transparent washes. The figures are mannered, their bodies inflated to form a taut, abstract pattern of billowing curves. Thus the torso tapers from enlarged shoulders to a tiny waist, an exaggeration of the "lion chest" of Indian tradition. A sharply defined pupil dead center in the round eye makes each face seem alert. Feet are large and fringed with toes along the side. Figures whose heads tilt sharply upward show a defiant energy, while other heads turn down to suggest coyness or fear (for example Sītā at the left in Figure 162). Such subtle emotional effects reside in depictions not only of people but also of settings and animals that enhance the human moods, for example the fierce storm echoing Rāma's longing for Sītā while he waits on Mount Mālyavan (Figures 170, 171).

The colophon of Balabhadra Pathy's *Gīta Govinda* asserts that he worked in Jalantara, a small princely state in what is today northern Andhra Pradesh. In the past this area was largely Oriya-speaking and was at times included within Ganjam District, the cradle of much Oriya literature as well as of illustrated manuscripts. A ruler of Jalantara, Ramakrishna Deva Chotterai, composed a play called *Prahlāda Nāṭaka,* which forms the basis for the rural performing tradition known by that name in southern Orissa.[53] The palace today lies in ruins, and no members of any Pathy family are known in the town.[54] None of Balabhadra Pathy's works is firmly dated. The fact that both archaic and modern forms of the letter *a* occur argues for a late eighteenth- or nineteenth-century date.

Some aspects of Pathy's work suggest currents from regions to the south of

Orissa. It is tempting to compare his round-eyed faces with so-called Paithan painting, or with south Indian shadow puppets.[55] Resemblance to the latter is greater than to the Rāvaṇa Chhāyā of central Orissa, discussed in Chapter 1 (Figure 46). Yet Pathy develops settings that go beyond any of the restrained props of Indian shadow theater. Conceivably his tangled bowers of plants and the flames that dance over the walls of Laṅkā (Figures 173–74) evoke the general effects of flickering shadows as the puppets are held at an angle to the screen, rather than the literal forms of the puppets themselves.[56] Likewise Pathy's use of color, unique among Orissan manuscripts, is vaguely similar to a Telugu set of Rāmāyaṇa illustrations, where, however, there are no significant correlations of iconography.[57] Thus it seems that there are some links with the forms of Andhra in Pathy's work but that these must have permeated a bilingual area that included Ganjam District, the home of the very Orissan literature he chose to illustrate. Likewise the effect of his up-turned faces is like that of masks perched on the top of the head so that the actor can see through slits beneath the eyes, which were used in the Prahlāda Nāṭaka and Rāmalīlās of that very region.

We know more about the making of our third *Lāvaṇyavatī* (Figures 175–93) than about any manuscript discussed here. This is the work of Raghunath Prusti, an artist and scribe of whose other manuscripts at least thirteen survive.[58] Hence his development can be traced. He was the son of an oilman of the merchant caste, living in the south Orissan village Mundamarai, where the *Lāvaṇyavatī* and three more of his manuscripts were preserved by the local families that originally commissioned them. In this case we know from oral tradition that this particular work was made for a more affluent merchant patron, who paid the artist in food for the few pages he produced each day.[59] He is remembered affectionately in Mundamarai as Ulu Chakra, an odd nickname that may mean "maverick."

Prusti's style combines archaism with natural touches, the latter perhaps deliberately minimized in the Rāmāyaṇa section of the *Lāvaṇyavatī* to give this sequence a magic and legendary quality. Here figures generally appear in profile, although Prusti elsewhere in this manuscript and in others presents a certain number of heads frontally or, occasionally, from a 45-degree angle. None of his fourteen works bears color, and it is clear that a meticulous use of line, more varied than that of the Dispersed *Lāvaṇyavatī*, is central to the conception of his images. His designs seem unusually busy, with many figures about three-quarters the height of the entire page, often surrounded by air but sometimes embedded in dense patterns of landscape or flying arrows (Figures 191, 192). His facial type is quite rounded, broadly following the conventions of *paṭa* painting, which he may have derived from the early nineteenth-century wall paintings of Buguda (some 30 kilometers from Mundamarai), discussed later in this chapter. At the same time, the depiction of the human body is natural by comparison with Balabhadra Pathy's inflated mannerisms.

On the basis of two dated colophons we can be quite certain that Prusti worked in the 1880s.[60] The Mundamarai *Lāvaṇyavatī* may be among his latest works, for it is unfinished and the family that owns it preserves the oral tradition that he was an old man when he worked on it. Thus a date of 1885–95 seems reasonable. While pages of the Dispersed *Lāvaṇyavatī* could never be confused

with Prusti's manuscript, the resemblance between the two is sufficient that a dating of the two based on pictorial style would make them nearly contemporaneous. Their style is thus one reason to entertain the possibility that the Dispersed *Lāvaṇyavatī*, in many ways comparable, if with slightly fewer marks of modernity, was also a product of the nineteenth century.

Finally a manuscript in the National Museum in New Delhi whose entire Rāmāyaṇa sequence is preserved will be referred to as the Round *Lāvaṇyavatī*.[61] Its clarity led me to use it to illustrate my initial telling of the story (Figures 1–40). This manuscript has a distinctive handwriting, in which the circular elements are unusually large and regular. Curved lines similarly predominate in the illustrations, and there is striking assurance and simplicity of drawing. Thus the contour of the face often forms a clear circle, including the under-chin and the hairline. In this the resemblance to the conventions of *paṭa* painting is even more striking than in the work of Raghunath Prusti. Schematic architecture and trees separate the scenes, so that there are no ambiguities in the narrative. And yet occasional frontal heads (Figures 17, 22, 36) and irregular touches (the way the tassels of the umbrellas in Figures 36 and 40 respond to gravity) do not belong to the most conservative visual conventions.

The Round *Lāvaṇyavatī* has been mistakenly associated with the dated colophon of a second, very fragmentary, version of the same text.[62] While the date cannot now be precisely established, I regard this as a work of the nineteenth century—most probably the late nineteenth century, for its writing is extremely close to modern printing. The letter *a* occurs only in the archaic form, but this form appeared in some early printed books as well and continued in use as late as 1905.

Brahma Rāmāyaṇa. My final palm-leaf example is enigmatic both as a text and as a manuscript; yet it is clearly not peripheral in artistic terms. This sole Orissan version of the *Brahma Rāmāyaṇa* was preserved in a *maṭha*, or monastery, near Jajpur in central Orissa, and it appears to have been produced there by a Vaishnava devotee (Figures 194–99).[63]

I know of no other manuscripts that seem to be the work of this same artist, although the style falls within a general formal tradition in illustration that is also linked to the professional *chitrakāras*. This link is most clearly apparent in the figure type—stocky, round-faced, the head seen in profile except for occasional iconic types. Among palm-leaf manuscripts, the resemblance is greatest to Vaishnava works such as a copy of the *Vidagdha Madhava*,[64] in part because many pages of the *Brahma Rāmāyaṇa* show devotees who resemble Kṛiṣṇa's *gopīs*. The eye follows a standard formula—elongated, the two corners slightly darkened, the pupil extending more or less all the way between the lids to produce a staring but not a beady gaze. Small touches of black and light red pigment occur throughout the pictures. What is most distinctive in this artist's work is the decorative effect created by elaborate borders at the end of each page, as well as by strong textile patterns and elegant arabesques of foliage.

The Daśāvatāra Maṭha was founded around 1700, and if the manuscript was produced there, this date provides a *terminus post quem*. The writing of the *Brahma*

Rāmāyaṇa consistently employs the more archaic form of the letter *a*. Thus once again we can be no more specific about date than to suggest that the work belongs to the eighteenth or first half of the nineteenth century.

PAINTINGS OF THE CHITRAKĀRAS

Their Manufacture and Use

The second type of image this book considers can likewise be defined by medium: these are paintings in opaque pigment executed with a brush, often on cloth (hence the name *paṭachitra,* or "cloth picture") but sometimes on wood or on walls. Physically they differ considerably from images engraved on a neutral palm leaf, where line inevitably plays a greater role and where color is secondary.

Because this profession continues today in the hands of the same kind of makers as in the past, the *chitrakāras,* the steps in manufacturing a traditional *paṭa* have been documented in detail.[65] In brief, several pieces of washed cotton cloth (sometimes used garments) were laminated with a gum of tamarind seed, dried, sized with tamarind and chalk paste, and burnished with a stone. The pigments—traditionally ground stones, conch shell, lampblack, and indigo—were mixed with the resin of the *kapittha* tree (= *kaintha,* elephant apple) as a binder and were applied with a brush made from the hairs of a rat's tail. Such materials were locally available and relatively inexpensive, not requiring a large investment or sponsorship on the part of a patron. The work proceeded in broad stages: sketching, filling in the red background, coloring the bodies and dress, completing ornamental detail and outlines, and finally finishing the borders. Last of all, the picture was covered with a coat of transparent lac, which protected the painting and gave it a glossy finish.

The images produced by this standard procedure fulfilled diverse functions and hence had diverse relationships to their viewers. Most significant in ritual terms were the so-called Replacement Images (*anasara paṭi*) for the Puri Temple. Before the Cart Festival each summer, the sacred wooden images of Jagannātha, Balabhadra, and Subhadrā are repaired and are hence inaccessible for worship for fifteen days. Three *chitrakāras* known as *hākim,* or "appointed one," are responsible for producing anew each year paintings on cloth of the three gods, which serve as substitutes for the revered wooden images. Thus these three individuals are official servants (*sevakas*) of the great temple, and their images have the highest sacred status. Ironically, these images do not resemble the archaic wooden images of the triad, and while produced under ritualistic circumstances (i.e. the painter fasts) and following iconic canons, they are not necessarily as conservative stylistically as other images produced by *chitrakāras.*[66] The *hākims,* traditionally caste leaders, were rewarded in the past with lands; they continue to receive festival food from the temple kitchen and a token payment, whose value has declined with time.

A second function of the *chitrakāras'* work involves sale to pilgrims who visit Puri. On the one hand, the *paṭa* may become an object of worship, particularly the most common type, which depicts the Jagannātha triad enshrined in its temple. On the other hand, it may serve as a souvenir of the visit, for the entire

experience, like much in India, cannot be exclusively categorized as religious (vs. secular). These images presumably have long formed the mainstay of most artists' production and are usually taken as a standard for their style. They vary widely in size and complexity, from cheap paintings on newspaper, still sold in the bazaar in competition with chromolithographs, to large cloth depictions, which may include narrative scenes around the edges. Such images have generally been sold either via middlemen or by the *chitrakāras* themselves, an arrangement encouraging rather standard products in which price and aesthetic quality compete as criteria for success.[67] Larger works, however, were commissioned by wealthy visitors, who filled the traditional role of patrons, interacting with the artist in ordering pictures that were precisely to their taste.

A third functional category produced by the same professional artists was wall painting. Some murals were required for the Puri Temple, where the *chitrakāras* executed images on walls for ritual events such as Snāna Jātrā, preceding the Cart Festival.[68] Some painters were hired in a similar way by other temples, by *maṭhas* (monasteries), and by *akhaḍās* (quasi-religious gymnasia). They were also hired by householders to decorate the doorways of houses, particularly at the time of a daughter's wedding.[69] And for some annual festivals they executed hasty, ephemeral images on the door every year for a small set fee.[70] Wall paintings were made by the same general procedures and according to the same aesthetic as paintings on cloth. The sizing and binder included lime (burned seashells), curds, and the juice of the bel fruit, as opposed to the resin employed on cloth. While many pigments were the same, some surely differed in the two media.[71] In both cases a single artist's work might range from quick, vigorous sketches to elaborate detail, depending on the needs of the particular transaction and upon the time that the mural was expected to endure.

Other objects the same *chitrakāras* made for sale are yet further removed from a temple context. They produced *paṭas* that had nothing to do with Jagannātha, some primarily of interest for their story. We have one example of a long strip of cloth, folded accordion fashion, bearing musical Rāgamālā pictures, which may represent a separate genre.[72] The same artists regularly made playing cards for sale to the local populace. And in the past they must surely, as they do today, have produced a variety of painted wood objects, ranging from religious carts, doors, and marriage boxes (Figures 258–61), rivaling the most elaborate *paṭas*, to simple toys designed for children.[73]

The Painters

One way in which these pictures differ from palm-leaf illustrations is that their makers form a distinct subcaste of professional painters. The *chitrakāra* is a member of the śūdra group, comprising artisans and laborers, generally ranked at the bottom of the caste hierarchy. They are closely allied with the *rūpakāras*, or woodcarvers, both sharing the surnames Mahapatra and Maharana. As with all castes, the exact status of the painters was not immutable, and at times in this century, even aside from recent attempts to minimize the role of inherited occupations in general, the community has, under economic pressure, turned to other means of livelihood.[74]

Like most traditional artisans in India, the *chitrakāras* worked as a group, a practice that explains in part the relatively uniform character of their images. Today the group may take the form of a government-supported training program as in the case of Jagannath Mahapatra of Raghurajpur, or of a co-operative society such as that founded by Ananta Maharana in Danda Sahi, or of a family enterprise such as the Gauri Handicrafts Centre in Bhubaneswar. In the past, apparently the family formed the basic unit, sometimes drawing in children from other families who might be trained by a master, as in the modern government program. If several adult brothers worked together in one household, they might have constituted a workshop. The result of this system for the painting is that a single image may be a group product, the borders often finished by apprentices, perhaps the main image alone painted by a master. This result is most likely to characterize large paintings, whereas smaller works or those of a painter who was trained but who had not yet acquired his own entourage might well be produced by a single individual.

Another way in which the family basis of the occupation enters into the workmanship is the participation of women. Traditionally they burnished the cloth once it had been primed, they lacquered the completed image, and they may have ground the pigments (being accustomed to similar work in the kitchen).[75] Today it is accepted that they paint minor objects and even produce the cheapest form of pilgrimage *paṭa,* executed on newspaper. I have also been told that a particularly clever young woman in Puri actually does work attributed to her husband.[76] At any rate, it is conceivable that women painted occasionally in the past, although the very failure to acknowledge this may explain the continued use of the masculine pronoun for painters: the community *wished* its best work to be attributed to men.

Transmission of this professional tradition took place in the first place by training within the family or in the house of a master. Children were schooled first in practice tasks. Later they were allowed to paint images drawn by the teacher or to execute the borders of his pictures. Such an apprenticeship might easily last ten years.

Sketchbooks also served to perpetuate a wide variety of image types that might be forgotten because they were not frequently painted; many such drawings remained in the hands of *chitrakāra* families until recently. These sketches might take the form of folded strips of cloth painted with a variety of subjects, an example of which was kept by Dasharathi Mahapatra of Itamati.[77] Some models were simply uncompleted or unsold paintings that remained in the family for generations, today rolled up in metal boxes. Many painter families preserve loose sheets of paper that go back to the nineteenth century as part of their visual heritage. And today a few keep elaborate notebooks on modern paper that preserve a large number of iconographic types.[78] I have found no set of illustrations of the Rāmāyaṇa among such sketches and hence cannot point to any visual canon for this subject. Nonetheless one early set of wall paintings may have provided a partial model, along with sketches of individual scenes and oral tradition among the painters.

Today the largest concentration of traditional painters is found in Raghurajpur and Danda Sahi, neighboring villages 12 kilometers northwest of Puri; hence

the references above largely to practices followed there. Yet originally it seems clear that Puri was the major center for Orissan *chitrakāras*, whose work was connected with the Jagannātha Temple. Some moved to brahman villages (*śāsanas*), founded near Puri from the sixteenth century onward, to be near their brahman patrons—thus the concentrated *chitrakāra* settlements at Raghurajpur and Danda Sahi, attached to two *śāsanas* near Puri.[79] Primarily during the eighteenth century, secondary Jagannātha temples were built in the feudatory (*gaḍajāta*) states of Orissa, and at that point painters were sent out to provide replacement images and perform other services to these temples. As a result of this process, several distinct styles of painting have evolved, which are discussed below in their recent manifestations.

History and Style of Paintings

In the *paṭachitra* tradition, many major historical landmarks include depictions of the Rāmāyaṇa. Hence there is no need to trace a general chronological development before placing particular examples. In fact the majority of examples that survive were made in the past ten years.

Buguda and Other Wall Paintings. The oldest surviving example of the professional artists' work in Orissa is in the shrine of Virañchi Nārāyaṇa at Buguda, where over half the wall paintings are devoted to the Rāmāyaṇa (Plate 11, Figures 200–213). We know that this temple was built in the 1820s by a distant relative of Upendra Bhañja, Śrīkara Bhañja.[80] Having come to the throne of Ghumsar in 1790, he abdicated in 1799 to lead the life of an ascetic devotee of Rāma in south India. In 1819 the British unseated his son and successor, Dhanañjaya Bhañja, and Śrīkara came to the throne again for a decade. During this second reign, Śrīkara had an image of the form of Sūrya known as Virañchi Nārāyaṇa taken from Ghumsar town (later called Russelkonda and today Bhanjanagar) to Buguda, 25 kilometers to the southeast. A stone building was put up and was decorated with paintings said to be so fine that they looked as if the divine artisan Viśvakarman himself had made them. We can be reasonably certain the murals that survive go back to the 1820s, their condition deteriorating with time. Some labels appear to have been added later, for they do not fit into the rather careful design of the paintings. The original images have fortunately been spared the fate of repainting that often befalls living temples.

The facture of these paintings is extremely careful, the surface of the wall having been burnished so that it still shines today. In Buguda, people say that the painters came from Balipadar, a village 11 kilometers to the south. Some of the *chitrakāras* of Raghurajpur and Puri, who revere the Buguda murals as one of the models of their craft, tell the same story. At Balipadar, however, the sole *chitrakāra* who still paints and builds temples suggested that the Buguda artists had come from the nearby village of Mathura, which today remains active as a center of sculpture. In short, we cannot place the origins of the Virañchi Nārāyaṇa painters with certainty, except to say that they are likely to have belonged to a local *chitrakāra* community.

In many ways these murals represent in elegant form standards that seem to

have shaped various Orissan traditions in the nineteenth and twentieth centuries. One exceptional aspect, however, is the subdued, earthy palette. In addition to various yellow and russet ochers that appear in older *paṭas* before the introduction of bazaar pigments, a grayish green is prominent, presumably terra verde, which was not used in painting on cloth. Blue, in contrast, occurs more rarely and in a duller form than in cloth painting. Moreover, the unusual amount of white background in the narrative sections of the Buguda murals (especially Figure 201) is hard to explain. Conceivably these sections were influenced by palm-leaf illustrations with neutral backgrounds, although little else points in this direction. Possibly the painters devised this expedient simply to make the story clear.

The paintings seem to the eye to be regular, planned according to classical canons, and thus to constitute a standard not only for other *paṭa* painting but also for some manuscript illustrations. Yet the impression of regularity is subtly misleading, and there are ways in which these images are puzzling and improvisational. The first three sections of wall, organized in neat registers, in particular invite comparison with palm-leaf manuscripts as a systematic presentation of the story (Figure 201). They are also balanced as a whole with repeated elements of design: for example, Risyaṣṛṅga's fire is echoed in Viśvāmitra's above, and architectural frames are artfully disposed across the entire wall. Yet unlike that of the manuscripts of Orissa, their sequence moves at times from right to left (wall A, tiers 1 and 4), at times from left to right (tiers 2 and 3), at times from top to bottom (walls B, C), and at times from bottom to top (wall A). Nor does the horizontal movement follow a boustrophedon pattern in which the eye is led efficiently back and forth as a field is plowed. The somewhat haphazard sequence at Buguda occurs in early Indian reliefs that cover discrete rectangular areas with tiers of scenes, as opposed to continuous friezes in which patterns of worship and architectural movement would normally take over. Both the gateway panels of Sanchi and friezes depicting the epics on the Kailāsanātha at Ellora move from left to right or from right to left with no apparent regularity. On the one hand, such irregularity may reflect the illiteracy of many Indian artisans, who hence had no innate proclivity to "read" images in one direction or another. On the other hand, the irregularity seems to meet a need for variety, for not making the overall organization too predictable and boring.

Four major images on the rear of the Virañchi Nārāyaṇa Temple (walls D, E, F, G) abandon the sequence of other episodes. Each presents a single event drawn from the forest sections of the Rāmāyaṇa, following Rāma's exile. In each the principals are seated on top of a hill, which is filled with rural details. Again, it is worth noting that these scenes do not belong together in the story or fall between the narrative sequences on either side. Nor is there symmetry between the two lateral rear walls—B–C, with its four narrative tiers, and F–G, with one dominant scene above. It is hard to avoid a sense of improvisational design, however regular the impact of particular parts.

The drawing of individual figures follows conventions that are well documented in later *paṭa* painting, perhaps because Buguda provided a general model.[81] Faces are neatly round, the hallmark of the Orissan type. Most are seen in profile, although an occasional frontal view, such as Bharata's attendant in Fig-

ure 204, shows that variety was possible even early in the nineteenth century. Most heads are tilted upward, giving a deliberate and heroic cast to their actions, while the occasional down-turned position suggests pensiveness, modesty, or subservience. These are devices that we have seen exaggerated in the palm-leaf illustrations of Balabhadra Pathy. At Buguda the unclothed body is simplified with familiar conventions such as a single curve defining the leg muscle and knee joint, or the leonine male torso, its shoulders turned almost frontally. The scale of figures is adjusted to the exigencies of emphasis and composition in each individual scene, with no concern for consistency.

Landscape seems to have interested the Buguda painters to a degree unusual in India. Hills in the four iconic tableaux are defined by overlapping lobes, their edges outlined in a contrasting hue and edged with curved cross-hatching primarily to suggest volume. These multicolored lobes are cunningly populated with varied plants and animals; for example, monkeys and bears at the bottom of Figure 208 beat on a long log which appears as a white line at lower left. This log is a type of musical instrument (*dhumpa*) still found in southern Orissa.[82] Earlier Orissan sculpture and one palm-leaf manuscript employed a different convention, in which mountains are composed of elongated, vertical rocks with a swirling curve at the top, found also in some early paintings from central India.[83] Similar lobes, populated with fauna, occur in nineteenth-century paintings of both Assam and Andhra, although in both cases, as in later Orissan versions of this formula, the lobes are flatter and more regular than at Buguda.[84] This convention may be regarded as simply widespread in eastern India, rather than as stemming from a single place of origin.

Precisely because the wall paintings of Buguda are problematic in the way they treat the Rāmāyaṇa theme, it has been necessary to dwell on their particular place in the Orissan pictorial tradition. They are our first major monument of professional painting and continued to play a unique role as a model for later artists. They are carefully organized and drawn. Even without being sure of what images served as models, I find it hard to avoid the impression that the Buguda artists were devising their own forms with a sense of innovation and experiment, in which narrative concerns were part of the picture.

Other less well documented wall paintings may be roughly dated in relation to Buguda. For example the decorations of the Srikurman Temple in Andhra Pradesh seem similar in their delicacy and earthy palette; hence they have been reasonably assigned to the first half of the nineteenth century.[85] The paintings of the Jagannātha Temple in Dharakot are similar in figure style but are drawn more heavily and use more intense pigments, which point toward a somewhat later date.[86] The present *rājā* of Dharakot recalls a family tradition that the paintings were made in the mid-nineteenth century or later, sponsored by his great-great-grandfather. The Gangāmātā Maṭha of Puri contains wall paintings that may be very old, although their present form, including a scene of Rāma's coronation, must represent nineteenth-century or later repainting (Figure 214).[87] One interesting painting of Rāma in the small Jagannātha Temple on Manikarnika Sahi in Puri may go back to around 1900, when the present *pūjārī* (priest) reports that the temple was built (Figure 215). Its subdued palette and general conception

resemble those of the large scenes of Buguda, although the composition is the reverse of that in Figures 207–8, and the two differ enough in details to suggest that one was not copied from the other.

Finally it should be noted that there are pictures of the Rāmāyaṇa on the walls of the main Jagannātha Temple in Puri, the subjects of which are listed in Appendix 4. These no doubt have a kind of canonical status and may have served as models for various illustrators. Nonetheless, aside from a description of their subjects, they cannot be considered here because they cannot be seen by the non-Hindu or photographed by anyone. Moreover, by all reports they have been frequently repainted, albeit with some fidelity to older iconography, which means that the present form was not the exact model for past artists.

Paintings from the Puri Area. Paintings made for pilgrims resist chronological discussion, for they are extremely conservative. Their purpose was to memorialize Lord Jagannātha, who transcends time. Nonetheless a few that have entered collections outside Orissa at known dates provide a record of this very conservatism. Among them a fairly elaborate example with narrative scenes to the side, now in the Kapardwara Collection in Jaipur, entered that court in 1790 and hence was probably made late in the eighteenth century.[88] A small, rough depiction focusing on the Jagannātha triad, which came to the British Museum from the family of Edward Moor probably predates 1814, when Moor left India.[89] Another, similar, image, indistinguishable from very simple *paṭas* made today except in its somber pigments, was acquired by the British Museum in 1894.[90] Another *paṭa*, small and simple although more complex than those in the British Museum just mentioned, now in the Museum of Fine Arts in Boston, was collected by Ananda Coomaraswamy, probably in 1921.[91] In 1933 William Archer visited Puri and collected a large number of *paṭas* now kept in the India Office Library. One of these, which had been assigned to the nineteenth century on the basis of its apparent archaism, turns out to be painted on a newspaper that bears the date 1925.[92] While many works in that collection have been published as early nineteenth century or before, I find that dating implausible and would assign them generally to the 1920s, many to the very time of Archer's visit. On the whole, datable works demonstrate no marked chronological progression, although they differ in details.

Here I illustrate two old *paṭas* showing Puri in the configuration of Viṣṇu's conch shell (*śankha-nābhi*), in which a scene from the Rāmāyaṇa figures in the upper right-hand corner. The first is a large, elaborate work acquired by the Bibliothèque Nationale in 1894 (Figure 216).[93] The second, much smaller, entered the British Museum before 1896 (Figure 217).[94] Neither example is worn, which suggests that they had been recently made before being taken abroad, rather than being used in India. Together these demonstrate that detailed, elaborate work coexisted with rough painting in the past, as it does today. The *paṭas* in Figures 216 and 217 differ from the Buguda wall paintings in their brighter palette and somewhat more formulaic details, but not in general approach. Both *paṭas* balance the confrontation between Rāma and Rāvaṇa in the top right corner with a distinctively Orissan subject, the legend of Kanchi-Kaveri on the upper left.[95]

A last major period of professional painting in Orissa begins with the revival

of the tradition in the 1950s. In 1952, when most *chitrakāras* had turned to other occupations, Halina Zealey, a Polish woman whose husband was head of a Quaker village project, settled in Puri.[96] Her interaction for a mere two years with the elderly painter Panu Maharana and with various authorities who provided a market for the painters' work reversed the decline of the profession, which has flourished since then. Upon her departure in 1954 a competition was held in Bhubaneswar. The winning work was an extremely meticulous picture of Gaṇeśa by Jagannath Mahapatra, a *chitrakāra* from Raghurajpur who had been supporting himself as a mason and actor in a Jātrā company in Puri, and who now returned to painting, a profession in which he remains today the acknowledged leader.[97]

Jagannath Mahapatra preserves today an unfinished set of seventy-five Rāmāyaṇa illustrations, which Halina Zealey commissioned with a deposit in 1954 but never returned to collect (Figures 218, 219). These are unusual in format, being a series of small, separate scenes with wide margins, as if they were intended to form a Western book. According to the painter, Zealey originally wanted only fifty scenes, but he persuaded her to enlarge the number to seventy-five.[98] To determine the exact subjects, she sent a professor from Utkal University, then in Cuttack, who discussed the selection with Jagannath Mahapatra; the painter himself spent six months reading various versions of the Rāmāyaṇa, in the end depending upon Vaisya Sadāśiva's *Rāmalīlā*, with which he was familiar from his days of acting in Jātrā.

The dissemination of this unfinished set's influence makes an instructive story. In 1964/65, Subas De, a representative of the All India Handicrafts Board, commissioned a copy of the same set, which he took to Delhi, and which led to Jagannath Mahapatra's winning the National Master Craftsman Award in 1965 (Figure 220).[99] At some point, probably when the set was on its way to Delhi, it was copied by Bibhuti Kanungo, a Western-style painter in an art school in Cuttack (not a *chitrakāra* by caste), and published in 1977 (Figures 221, 222).[100] In June 1981 I saw the unfinished Zealey paintings and commissioned another version of the original set from Jagannath Mahapatra, which was begun in 1982 and completed by May 1983 (Figures 223–52).[101]

These four sets of Rāmāyaṇa illustrations are virtually identical in the selection of scenes and in basic iconography. A comparison of particular episodes demonstrates subtle differences of artistic effect. For example, the depiction of the *vānaras* carrying Rāma and Lakṣmaṇa to Laṅkā in both the 1954 version made for Zealey (Figure 218) and the Cuttack copy of 1977 (Figure 221) shows the bridge rising at a steep angle of 15 degrees, whereas in the 1983 set (Figure 236) the angle is reduced to 9 degrees, which is both less jarring and less dramatically effective. At the same time the 1977 artist has produced hills of radiating, loose brush strokes, which are hardly within the *paṭa* tradition, and his faces lack the insistent roundness that is characteristic of professional painting in Orissa.

In the case of Rāma's final battle with Rāvaṇa, it is clear that both the 1977 (Figure 222) and the 1983 (Figure 242) versions have altered the 1965 prototype (Figure 220) in different ways. Kanungo, in his 1977 copy, retains the basic contrast between the demon's large chariot, viewed straight from the side, and the heros', seen at a skewed angle, its light horses prancing heraldically in the center.

Yet he complicates the whole with more monkeys, arrows, and plants that set up an almost subversive sense of space. The 1983 copy both rationalizes the perspective of Rāma's chariot and makes it more supernatural, without wheels or horses.[102] Despite the demarcation of a green area of land below, the simplification of the background is as flat a design as the 1965 version.

The reason for dwelling on these examples is that the relationship among the four sets is unusually well documented. There is no reason to think that this particular lineage of models goes back to before 1954, and this may be an unusual case both in the booklike format (possibly at the behest of a foreign client) and in the fact that a major determinant of narrative choice was literary rather than visual. Certainly, aside from Buguda there is no known extended sequence of the Rāmāyaṇa in this tradition before Zealey's visit, for only one or two scenes appeared in the more elaborate *paṭas*.

"Story paintings" with multiple episodes on one *paṭa* have become popular in the past decade, a form that may go back to both large pilgrimage paintings (e.g. Figure 217 framing the central temple) and paintings made for Kṛṣṇa's Birthday, in which scenes of his childhood appear arranged either in rectangular frames or on the petals of a large lotus.[103] Four large *paṭas* of Rāmāyaṇa subjects are included in Appendix 5: (1) 21 scenes from Jagannath Mahapatra's own workshop (Plate 12); (2) 22 scenes from Danda Sahi, laid out by Jagannath Mahapatra's slightly younger contemporary Ananta Maharana (Figure 253); (3) 75 scenes made in Bhubaneswar by Jagannath Mahapatra's former pupil, Bhikari Maharana (Figure 254); and (4) 107 scenes from Danda Sahi, also made under Ananta Maharana's aegis.[104] These examples have been arbitrarily selected among the large number produced these days, but they serve to illustrate how competing prototypes (the Buguda wall paintings and Jagannath Mahapatra's set) remain in effect, albeit often indirectly and in the artist's memory. Single narrative scenes may also occupy smaller *paṭas* (Figures 255, 256). This kind of picture is particularly in demand for sale to visitors to Orissa today; I know of no very old examples.

Finally, the *chitrakāras* painted on wood, paper, and village walls as well as on cloth. The covers that enclosed palm-leaf and paper books were probably their work, although it is conceivable that occasionally the illustrator of a manuscript exchanged his stylus for a brush.[105] Among those covers that survive with scenes of the Rāmāyaṇa, the coronation of Rāma is a common subject (Figure 257), often in a form close to the same subject in *paṭas* and rural marriage paintings.[106] As an example of such work by professional painters, I include here a wooden wedding box (Figures 258–61) decorated in the 1970s by the late Bhagavata Maharana, a painter from Raghurajpur employed by the Government Training Center in Bhubaneswar.[107] In 1983 he spoke directly of his visits to Buguda, where he had also painted on cloth copies of the Virañchi Nārāyaṇa murals (Figure 256).

Among paintings on village houses in the Puri area, the only Rāmāyaṇa subject I have found is the coronation of Rāma, which commonly surmounts the doorway decorated for a daughter's wedding. For instance, the work in Figure 262 is said by the people of Danda Sahi to have been executed in the 1950s by Panu Maharana. Today such work, done on various ritual occasions for little money, is not undertaken by the more respected painters, but it seems to have been part of a *chitrakāra's* profession in the past.

Regional Subschools of Professional Painting

As I have mentioned already in connection with the history of the painters, when new Jagannātha Temples were established in the lesser feudatory states of Orissa (known as *gaḍajāta* kingdoms), *chitrakāras* were also sent out from Puri as temple servants. While the dispersal, which led to the growth of distinctive regional styles of painting, may go back to the sixteenth century, most of these subschools cannot be documented before the very recent past. One of the most elegant centers of painting in the nineteenth century may have been the area of Nayagarh, about 80 kilometers west of Puri, but because no examples of the Rāmāyaṇa have been found there, I do not consider the area here.[108]

Sonepur. One of the oldest *gaḍajāta* Jagannātha centers, Sonepur, 300 kilometers inland on the upper Mahanadi, nourished a local school of painting. Today *chitrakāras* report that their forefathers migrated here seven generations ago, that is, early in the nineteenth century.[109] Sonepur is known for its playing cards (*ganjifā*), made even today by one of three surviving painter families. These, like the cards of the Puri area (generally Daśāvatāra sets) and of Parlakhemundi discussed below, are made by the same general procedures as *paṭas,* although they must be somewhat stiffer. The Sonepur cards are distinctive among Orissan types in their small size, in the way designs are not always arranged around the center, and in the very angular, jerky drawing of the figures (Figure 263). All Sonepur sets are based on the Rāmāyaṇa, but in a unique form with twelve suits—six on Rāma's side (Rāma, Lakṣmaṇa, Sugrīva, Jāmbavan, Hanumāna, and Vibhīṣaṇa) and six on Rāvaṇa's (Rāvaṇa, Kumbhakarṇa, Indrajita, Kālī, Śiva, and Durgā).[110] The symbol of the Hanumāna suit (Figure 263, bottom) is a mountain that assumes, not the rounded lobes common in both palm-leaf manuscripts and *paṭas,* but rather an unusual tall shape that curves at the top, which appears also in the early manuscript of the *Amaru Śataka.*[111] This, as well as stylistic anomalies and the uniqueness of the game itself, indicates that Sonepur painting goes back as far as any Orissan school as an alternative to the Puri tradition. While this town does not preserve true narrative treatments of the Rāmāyaṇa, the entry of the epic into the town's identity, in the Laṅkeśvarī Shrine and in the festival of Laṅkā Poḍi described in Chapter 1, suggests that the Sonepur *ganjifā* cards were part of a bigger pattern of local tradition.

Parlakhemundi. On the boundary between Andhra and Orissa, Parlakhemundi is a lively, complex cultural center. The eight *chitrakāra* households active today report that they have been here about a hundred years; they intermarry with families elsewhere in Ganjam District as well as around Puri. A wall-painting cycle of the Rāmāyaṇa here has recently been lost.[112] Several sets of playing cards from Parlakhemundi now in the Victoria and Albert Museum go back to at least 1918, including a Rāmāyaṇa game (Figures 264–68).[113] Unlike the Sonepur type, there are eight suits here. Each card (except for rather standard face cards, which show a chariot and an elephant composed of women) bears arrows above to indicate numerical value. Below are scenes from the story, in short an eighty-episode version from Rāma's birth to his coronation, each episode with a brief caption. The

style of painting resembles the sketchy subsidiary figures in some of the large pilgrimage works from the Puri area. The details of particular scenes, such as Hanumāna seated before Rāvaṇa, discussed below, are unique within Rāmāyaṇa iconography. Thus this exceptional set seems to represent the adaptation of established traditions to new subject matter on the part of an inventive artist.

Parlakhemundi is particularly interesting because painting there has a polyglot clientele. For Oriya patrons the most common commissions are wall paintings or paper versions of the same subjects, required for major rituals in each lifetime, such as the sacred thread ceremony and marriage of a daughter. Telugu patrons prefer paintings on cloth for the worship of particular divinities, required for annual festivals; these paintings are executed on unsized thin cotton, and the background is left bare, so that the effect differs from that of the typical Puri *paṭa*. Both communities also buy paintings on wood. It would be a mistake to see a complete break in the style of a single artist's work for these two different kinds of patron. Much Parlakhemundi work is sketchy and vigorous, with more dependence upon line and with fewer flat areas of color than even the rough paintings done on houses around Raghurajpur.[114] This style can be understood as a variant on the Puri style, occasioned by local purchasers as opposed to pilgrims, some of whom may require more permanent and densely built-up work. Nonetheless in Parlakhemundi, especially in painting on cloth and wood, a preponderance of frontal over profile heads as well as particular motifs (south Indian women's costume, lack of lobed hills) leads to an effect that differs from the Orissan mainstream as we have seen it around Puri.

Jeypore. Almost 200 kilometers west of Parlakhemundi and located on the edge of tribal tracts, Jeypore illustrates the linkage among the various painting subschools as opposed to dependence directly upon the center of Puri. The present small community of *chitrakāras* was brought from Parlakhemundi about ninety years ago, replacing previous painters whose work for the Jeypore Jagannātha Temple was found inadequate.[115] The style of painting here represents a variant upon the vigorous, linear forms of the painters' original home. One old example of their work is a *paṭa* depicting the marriage of Rāma and his brothers, which the records of the Orissa State Museum say was made in 1903 (Figure 269).[116] The neutral background and linear forms here suggest that the Parlakhemundi substyle goes back at least to the beginning of this century. The Jeypore painters continue to support themselves by painting wedding pictures like those made for Oriyas in Parlakhemundi and by making masks for the active dance-drama tradition of this town. The artists say they are able to paint narrative scenes, but these seem to be uncommon.

Chikiti. Finally the small princely state of Chikiti, roughly 70 kilometers northeast of Parlakhemundi, brought *chitrakāras* from Ranpur as long as two hundred years ago. Wall paintings of Kṛiṣṇa themes in the Chaitanya Maṭha may have been painted about seventy years ago.[117] While here and in wedding paintings minor southern intrusions occur (notably a tall type of crown), on the whole the Chikiti style does not differ as radically from that of Puri as do the styles of other subschools. Nonetheless one living painter in Chikiti has developed his own ver-

sion of the broader tradition. This is Apanna Mahapatra, born around 1920, the son of a painter who was given the title Ratna ("jewel") by the Rājā of Chikiti. On the one hand, Apanna preserves traditional effects more fully than most painters in Raghurajpur—notably a rich, somber palette and a lacquered surface. On the other hand, he paints with sophistication and a fine brush, as in the fly whisk held aloft in Figure 270, and some illusionistic effects creep into his more recent work (Figure 271). His faces follow the Orissan formula, but because the pupil is large and the chin delicately drawn, they are more representational than those in the work of contemporaries. Apanna Mahapatra supports himself by painting, particularly Daśāvatāra playing cards, in which his wife assists him. He is also a well-read individual, able to quote the *Vaidehīśa Vilāsa* and potentially to illustrate it. Here, as in the case of Jagannath Mahapatra in Raghurajpur, we see a strong and talented artist who takes his tradition in new directions.

Two very different kinds of picture making have existed side by side for at least the past two centuries in Orissa. The one, palm-leaf illustration, was linked to the book and practiced by a variety of literate individuals. The other, professional painting, was often linked to religious cults and practiced by a hereditary caste. I know of no case before the 1970s of a *chitrakāra* taking up the stylus of the book illustrator. Nor does a painting on cloth by a brahman, karana, or merchant survive. Yet Brajanātha Baḍajenā described himself as producing *chitras* as well as works on paper and palm leaf, and Michha Patajoshi's joined palm-leaf images of the Puri temple were labeled *paṭas*. Perhaps the best candidate for a transitional figure is Jadumani Mahapatra, a *chitrakāra* born at Itamati early in the nineteenth century, whose descendents say that he painted. He was a literate individual, remembered in the history of Oriya literature for his wit and poetry, who might well have written on palm leaves.[118] Jadumani reminds us that the professional painter did not exist in a ghetto, isolated from the world of letters. Likewise it is worth remembering that the various illustrators of palm-leaf manuscripts saw the wall paintings of Buguda and other buildings, used wooden objects produced by the *chitrakāras,* and saw *paṭas* in homes and annually in the Jagannātha Temple. While social status may have set some manuscript illustrators apart from professional painters, it is precisely the lack of training or inherited sense of his own visual tradition that would have made the scribe susceptible to the model of the *chitrakāra.*

3 ∴ Orissan Sculpture of Rāmāyaṇa Themes

Earlier sculpture would seem to be a promising source for the pictures upon which this study focuses. On the one hand, sculpture preserves what we do not have in painting before the eighteenth century, or in texts before the fifteenth century—versions of the Rāma story current in the region of Orissa itself. On the other hand, we are used to the assumption that art feeds upon art, and that artists are more open to visual than to verbal models. Particularly in India, where the artist is generally an artisan, often a relatively low-caste śūdra, not necessarily literate, his hereditary or professionally taught tradition is likely to be passed on by images studied as models.

In the present situation, however, early sculpture does not get us very far. There is a large gap between reliefs of the tenth century or before and pictorial traditions that survive only from the eighteenth century. That one fourteenth-century example is close to some recent paintings suggests that the little-explored intervening period might supply more links between the two traditions. Moreover, the early relief cycles seem to have their own questionable relationship to texts, and we cannot be sure how much of their rendition of time sequence and detail results from local versions of the story as opposed to the particular choice of sculptor and architect. In fact later manuscripts, where we can identify what text the artist knew, may be more useful for understanding ancient sculpture than vice versa. At any rate, I find few significant connections in narrative between the examples discussed here and later pictures. Yet it is worth considering these early sculptures, both "for the record," to demonstrate the antiquity of this subject in Orissa, and for the problems they present, which are comparable to those posed by later pictures.

ŚATRUGHNEŚVARA TEMPLE AT BHUBANESWAR

The first carvings of the Rāmāyaṇa in Orissa occur on one of the oldest intact temples in Bhubaneswar, the Śatrughneśvara, which may go back to around A.D. 600.[1] Here the five dentil-like blocks below an image niche bear scenes leading up to the death of Vālin (Figure 272). Such dentils elsewhere on the same

70

temple bear figures that do not have particular narrative content, which means that the story becomes an unexpected, incidental overlay here. Each block bears only a few figures, read from the left: (1) Sugrīva imploring Rāma; (2) Rāma garlanding Sugrīva; (3) Rāma, Lakṣmaṇa, and Sugrīva walking; (4) Rāma drawing his bow, with Sugrīva; (5) Vālin fighting and collapsing. This sequence introduces an event favored in early Orissan reliefs. Here the actual fight is not very striking by virtue of the division of the two monkeys on separate panels and the placement of the event at one end of the series. Because the entire space covered is small (c. 1 meter), the direction in which the temple was circumambulated need not have determined its left-to-right reading: it was seen at one glance. The direction in which short narrative sequences are read is not consistent in early Indian art, although the movement from left to right follows what seems to be a natural proclivity based on the movement of indigenous Indian writing systems.[2]

SVARṆAJĀLEŚVARA TEMPLE AT BHUBANESWAR

The Śiva shrine in Bhubaneswar traditionally known as Svarṇajāleśvara is among the earliest freestanding temples in Orissa, probably a work of the early seventh century.[3] Despite its ruined condition, which necessitated the addition of many new blocks of stone when it was restored in 1979, great elegance of design is visible. Plain walls alternate with elaborate niches, and boldly carved decorative members stand out against flat patterns. A narrative frieze is part of this orchestrated effect, leading the eye around the square building and at the same time demarcating the top of the straight wall (a portion known as *baraṇḍa* in local terminology) from the gently curved superstructure. The subject matter of this frieze includes the story of Arjuna's confrontation with Śiva in the form of a Kirāta from the Mahābhārata,[4] as well as part of the Rāmāyaṇa.

As the plan (Figure 273) shows, the scenes are not arranged in straightforward order of plot. The first sequence occurs on the north wall and its events seem to proceed from right to left (Figures 274, 275), whereas the second occurs on the north corner of the west wall and proceeds, like the remainder of the west wall, from left to right (Figure 276). One might expect the viewer to circumambulate the temple clockwise, the more auspicious direction of movement, with the right shoulder facing the object of worship, and hence to see the right end of each frieze first. Yet counterclockwise movement or even a complex path involving backtracking is conceivable.[5] The direction of ritual movement is, in all honesty, not known here, and hence we must entertain both hypotheses.

If the worshiper moved clockwise, the Rāmāyaṇa began on the west wall with the episode of the death of Vālin in reverse order, first the fallen monkey, then the events that lead up to his fall. This entire sequence forms a kind of flashforward, followed by the main events of the kidnap, presented in chronological sequence. This prolepsis would serve to emphasize the death of Vālin, where Rāma plays a dubious role, yet it explains that episode by returning to the mainstream of the epic.[6]

If circumambulation was counterclockwise, the story began with the entire section on the north wall told as a series of flashbacks. One might imagine Sugrīva

asking Rāma, "What brought you here?" This would lead to narration in reverse—
"Jaṭāyu told me that Rāvaṇa took Sītā, while I was killing the demon-deer that the
three of us had seen." This analepsis would subordinate the kidnapping to the role
of the monkeys as allies, proceeding on to the death of Vālin, which cemented the
alliance, on the west wall.

It may never be possible to answer the question which direction the viewer
moved here. In either case, we must take for granted some achronic principle of
organization that does not follow any verbal version of the Rāmāyaṇa yet identi-
fied. The large dislocations are not difficult to rationalize and have counterparts
in Indian literature, whereas the serial reversal of sequence is more unexpected.[7]
We shall see in recent palm-leaf manuscripts some cases in which the artist delib-
erately departed from the sequence of events in the text he himself had copied.

Order aside, there are some noteworthy parts to these reliefs. The magic deer,
quite naturally carved, cavorts gracefully in two scenes in which the forest setting
is included (Figure 275, top). Shot by Rāma, it rears upward so that Mārīcha
emerges as a human torso, in a centaur-like form that resembles later images in
Bengal but not in Orissa.[8]

The eastern portion of this same north wall includes many monkey figures
to the left of Sugrīva (Figure 274, left). Possibly these are simply his followers, or
possibly three confronting pairs of monkeys represent the quarreling Vālin and
Sugrīva.[9] Clearly the Kiṣkindhā sequence is central here, whichever direction the
frieze is read. The monkeys continue to play a major role in Orissa, albeit in sev-
eral different forms.

The sequence of Vālin's death is told with emphatic clarity on the west wall
(Figure 276). At the left, Sugrīva's leaning pose conveys to the more relaxed broth-
ers the urgency of his concern. Only four trees appear, not necessarily reflecting
a text that did not specify the number.[10] Such abbreviation contributes to the taut-
ness of this frieze. Rāma's diagonal stance before the trees is repeated as he shoots
at the symmetrically paired monkeys. Vālin's prostrate form must have stood out
boldly against curving forms that probably represent hilly earth but may also
evoke clouds, with two flying monkey mourners to the right. Whatever the ex-
pected movement of the viewer, this sequence is paired with the confrontation
between Arjuna and Śiva on the other side of the same west wall.[11] In both the
hero draws his bow dramatically at the very center of the frieze. In both the hero
is involved in an action in which he does not appear in an entirely admirable light,
although in both legends responsibility is displaced. Thus we are reminded that
the sculptor or planner of the temple could capitalize upon the particular physical
situation in which he worked to add meaning to familiar stories.

SIMHANĀTHA TEMPLE

The Simhanātha Śiva Temple on Simhanātha Island in the Mahanadi was probably
built in the ninth century.[12] Its plan, which includes a full porch, and its decor,
which is profuse, are developed beyond the Svarṇajāleśvara (Figure 277). The
carving is inventive in subject matter, irregular in design, particularly on the
porch, and somewhat coarse in execution. Friezes occur not only atop the shrine
wall but also above niches and along the lower edge of the porch roof in long

sequences that baffle identification.[13] The wealth of carving, relatively uniform in scale and with simple figures against a plain background, makes the friezes slightly less prominent than on the Svarṇajāleśvara. Elephant hunts occur on the north and south sides of the shrine and a polo game on the front of the porch, indications that generalized depictions of royal life were gradually replacing mythological subjects.

Nonetheless, the Rāmāyaṇa does clearly occupy a significant place on the west face of the Simhanātha shrine. Once again the death of Vālin appears, here as at the Svarṇajāleśvara on the rear of the temple (Figure 278). This time the scene occupies a band above the central niche, which houses an image of Śiva with the River Ganges. Possibly the sculptor was aware of the earlier temple, some 50 kilometers to the east at Bhubaneswar, for more or less the same events occur there—the approach to the conflict, Rāma taking aim to the left of the battle, and the death of Vālin mourned by monkeys (cf. Figure 276). Comparison of the two underscores the Simhanātha carver's simplified and less dramatic treatment. Here Rāma drawing the bow is not contrasted in pose with the figures on either side of him. The fighting monkeys posture less vividly. Vālin's body is extended in a more natural and less emphatic position. Nor does the center of the composition correspond to that of the band below, a *liṅga* under worship.

Slightly more than a meter above this band, the *baraṇḍa* frieze at the top of the wall appears to be entirely devoted to the great battle for Laṅkā (Figure 279). Individual events cannot be distinguished, with the possible exception of Hanumāna bearing the mountain to a fallen Lakṣmaṇa, at the left end of the central projecting facet, or *rāhā* (marked x in Figure 279). At the left end of the entire frieze and again at the right of the central *rāhā*, the heroic brothers appear as archers. At the far right Rāvaṇa appears with five heads visible, riding in a chariot. Similar confrontations occur in later paintings (e.g. Figures 212, 213). Most of this frieze consists of confrontations between monkeys and figures without tails, presumably demons, creating a generalized impression of battle. The resemblance between these fights and that between Vālin and Sugrīva below is visually effective and may constitute a justification by these sculptors for Rāma's seemingly unheroic action in the lower scene: Vālin was comparable to the demons. In short, we see some continuity of narrative choice here, and at the same time a recasting both of content and of form in this vigorously carved temple. Decorative standards have shifted from stressing the clarity of individual parts, as in earlier monuments, toward the maximum enrichment of the entire temple.

VĀRĀHĪ TEMPLE AT CHAURASI

The Vārāhī Temple at Chaurasi, halfway between Bhubaneswar and Konarak, takes us into the later ninth or early tenth century.[14] This shrine is Śakta, that is dedicated to a goddess, and shows tantric concerns in some of its carvings, which, however, I do not see particularly reflected in the Rāmāyaṇa friezes.[15] Its design is complex, with multiple wall planes and crisply articulated moldings, interweaving vertical and horizontal lines. The *baraṇḍa* frieze at the top of the shrine wall is absorbed into a rich and three-dimensional superstructure, a continuing development that removes the occasion for narrative subjects in this position. The porch,

however, retains a simple two-layered structure, as opposed to the subsequent multitiered and rounded roof where friezes later come to lose their visibility and significance. The Chaurasi porch thus has two friezes, although the upper one is hard to see and its subject matter hard to identify. The scale of these friezes is proportionally smaller than on earlier temples, reducing complex narrative opportunity and connecting them with the lavish, small-scale decor, against which occasional large elements stand out. Yet despite their scale and some repetitive portions, more care seems to have been used in the carving of these friezes, with elements of setting and multiple relief planes, than at Simhanātha. In general there is great sensitivity in the carving of the large images at Chaurasi, for example the soft, fleshy treatment of the main icon of the goddess Vārāhī, which carries over even into tiny figures.

The Rāmāyaṇa frieze commences to the right side of the door and proceeds counterclockwise (Figures 280, 281). First on the east wall the exiles encounter Śūrpaṇakhā, where damage and repetition make it difficult to distinguish events until we see the magic deer, which leads into another puzzling scene.[16] Around the corner on the north appears a centaur-like Mārīcha whose torso emerges from the deer's body, as on the Svarṇajāleśvara, showing the continuity in the interpretation of that element, which was later to change in Orissa (Figure 282). Jaṭāyu's battle with Rāvaṇa is divided by what seems to be landscape from Jaṭāyu's final encounter with the heroes. The novel image of a large figure fallen on a hill flanked by a monkey may represent Dundubhi's corpse thrown by Vālin, a flashback that is appropriate, if unusual; both in sculpture elsewhere and in pictures, it is virtually always Rāma's lifting of this corpse rather than the initial episode that is depicted. Thus here we seem to have visual analepsis that corresponds to most verbal versions of the story, in which Vālin's exploits are recounted to test the hero. Rāma's shooting through the seven trees is shown clearly,[17] whereas the killing of Vālin is minimized and the accusatory body of the slain monkey (present at both the Svarṇajāleśvara and Simhanātha) is absent. Thus the moral issue seems submerged in storytelling. The remainder of the north side of the porch may continue the Rāmāyaṇa, probably the monkeys' assistance to Rāma.[18] The south side of the porch continues more scenes of monkeys, and its upper tier includes a stretch of water (the large fish at the top left of Figure 283), flanked by monkeys carrying something, perhaps building the bridge to Laṅkā. Here again, we seem to confront an unfamiliar version of the story that emphasizes the monkeys' activities, one thread in Orissan Rāmāyaṇa celebrations.[19] At the same time, it is worth recognizing that even in familiar portions of the story, figures appear whose presence can hardly be required in any version of the story. For example, at the right of Figure 281 (top), a running female figure is twice flanked by men with bows who seem to accompany her; usually the bow indicates the heroes, although one would expect Lakṣmaṇa alone to confront Śūrpaṇakhā, who is called for at this point in the story. Could these groups represent Sītā with the two brothers, or might the archers be the demonic forces of Khara and Dūṣaṇa? The point is that the Chaurasi sculptors were not aiming at clarity of communication in such hard-to-see friezes that merge with the rich decor of the temple. This does not imply that storytelling did not matter to them, but rather that its goal was one of embellishment rather than didactic address to the viewer.

ISOLATED CARVINGS, FROM NARRATIVE TO ICON?

No doubt other early temples had friezes of this subject.[20] Clearly the Rāmāyaṇa was widely depicted in ancient Orissa, and the narrative was adapted to its particular setting and to the evolving design and concerns of the temple. On the one hand, as we have seen, the nature of the frieze itself changed in a way that altered its suitability for clear storytelling. On the other hand, the imagery of the temple, revolving around a somewhat flexible pantheon, came increasingly to evoke general well-being and often the world of a royal or noble patron, so that activities from everyday life, such as capturing elephants, occupied the friezes that remained. This evolving concern of temple sculpture leads at the great mid-thirteenth-century Sun Temple of Konarak to an allusive scene of a marriage with monkeys below. Other chlorite reliefs in this general position represent the founder of the temple, King Narasimha Deva. Possibly the monkeys signify a comparison between him and Rāma, for in fact his wife's name was Sītā.[21]

Rāma continued to be shown as one of the major forms of Viṣṇu. Thus it is no surprise that he should appear in isolation, flanked by his brother, wife, and two monkeys on a porch window of the later thirteenth-century Ananta Vāsudeva Temple at Bhubaneswar.[22] This is part of a pan-Indian process in which separate images of the god appear, reflecting the standardization of Viṣṇu's major avatars rather than a cult of Rāma himself. Such images are obviously most likely to appear on Vaiṣṇava temples, whereas our earlier examples in Orissa were Śaiva or Śākta. The same is true in other regions. The evolution of literary texts would suggest that a Śaiva context for the Rāma legend is a late development, visible in the *Adhyātma Rāmāyaṇa* discussed above, as well as in Tulsī Dās's *Rāmcharitmānas* in Hindi. The earlier sculpture would suggest, however, that in fact the Rāmāyaṇa was not only compatible with the cult of Śiva but that there may have been oral versions in which the whole had a Śaiva frame.

More remarkable than isolated images of Rāma are isolated images of other characters in the story. Hanumāna is the most likely candidate for this position, for he comes to represent the epitome of religious devotion, or *bhakti*. Throughout north India the roadside image of the heroic monkey carrying the entire Mount Gandhamādana in order to bring Lakṣmaṇa a life-saving herb is a familiar sight. In Orissa large, isolated carvings of this subject go back at least to the tenth century. For example, one in the compound of the Gaurī Temple in Bhubaneswar, apparently contemporary with that shrine, shows Hanumāna striding upon a demon on which a female figure sits, a distinctive local version of the monkey's heroic act (Figure 284).[23] While the accomplished carving of the woman below demonstrates that this carving lies within the classical tradition of Orissan sculpture, the worn surface of the upper part, covered for centuries with red lead, is a reminder of the potency of this image type as an object of popular worship.

Such images may suggest the predominance of the iconic over the narrative, yet this polarity is by no means absolute, an issue to which we shall return. A fine fourteenth-century relief that probably decorated a window in the ruined syncretic Somanātha Temple at Vishnupur (about 2 kilometers from Chaurasi) demonstrates the combination of types (Figure 285). Rāma dominates the composition, surrounded by monkeys, almost indistinguishable except for the crowned

Sugrīva who kneels at his feet. No wonder this has been generically described as "Rāma flanked by monkeys."[24] Yet the panel below suggests a particular sequence in the story. There a second archer holds an arrow, a subject later represented in painting (Plate 11) and described in Oriya texts, when Lakṣmaṇa, angry at Sugrīva's drunkenness, straightens his arrows, preparing to assault Kiṣkindhā. Thus the monkeys flanking this figure must be the solicitous monkeys who sought to assuage Lakṣmaṇa, while the oblivious Sugrīva turns away at the far left. It follows that the upper scene represents the awakened, penitent monkey king delivering his followers to Rāma, leading ultimately to the return of Sītā. Here at last we see a distinctively Oriya version of an incident that occurs pictorially later, a case of local continuity that is to be expected, particularly between late sculpture and subsequent painting. Its very status as an image combines the narrative and object of worship in a form we may for the time being describe as an "iconic tableau."

Finally, one last example of sculpture is a wooden window screen, similar to the one just described in its physical function and in its focus on a single static moment (Figure 286). This was probably carved where it is now preserved, at Dharakot, one of the small courts in southern Orissa not far from major centers of manuscript and professional painting upon which this book dwells. This undocumented carving may belong to the late eighteenth or early nineteenth century, to judge from its resemblance to the Buguda wall paintings of the 1820s.[25] As in the Vishnupur relief, the composition is dominated by a large image of Rāma surrounded by worshipers, with a more incidental scene in the panel below. The overall subject is the coronation of Rāma, a favorite, as we shall see, in recent periods, when it comes to epitomize the entire epic. Rāma is enthroned in Ayodhyā, with Sītā his queen, surrounded by his brothers and his former allies, including Vibhīṣaṇa (upper right), Hanumāna rubbing his foot, and the bear Jāmbavan, who plays a prominent role in recent images. The panel below includes musicians and others coming to celebrate the auspicious event.

The Vishnupur and Dharakot carvings are probably but a small sample of many Rāmāyaṇa images that were executed in both wood and stone between the fourteenth and the nineteenth centuries.[26] One would expect other iconic tableaux to lie behind the large wall paintings at Buguda. In fact wood carving was and still is frequently executed by the same families that produce paintings. Although the artisans themselves use the terms *rūpakāra* and *chitrakāra* to distinguish sculptors and painters, they say that the two can intermarry; these may be descriptive labels rather than immutable castes.

One last reason for including the Dharakot scene is its high aesthetic quality, surely typical of many art objects produced for courts. The upper scene is united by the exuberant yet clear curves of architecture, garlands, umbrella staff, and the stance of figures. The actors below overlap and interact with sophistication. There is freshness and delicacy in the execution of foliage and drapery. In terms of sheer elegance this reminds us that the past two centuries, which will concern us for the rest of this study, are by no means a backwater or period of decline in relation to ancient sculpture.

Looking back over our range of sculptural examples, we may conclude that art does feed on art in many situations. In the apparent copying of the Svarṇa-

jāleśvara death of Vālin at Simhanātha, we see not only the continuing popularity of a theme but also some continuity in the way it is rendered (Figures 276, 278). Likewise the survival of the last two compositions in paintings of Lakṣmaṇa straightening his arrow and of the coronation of Rāma is credible. Yet as we move on, it is remarkable how little in recent pictorial traditions can be accounted for by our handful of surviving early carvings.

To dwell upon continuity of imagery or even of local versions of the Rāmāyaṇa story from the seventh to the nineteenth century would be facile and misleading. Indeed sculpture, recent festivals, and an occasional manuscript all show a general predilection for events involving monkeys. But this simian emphasis is not the rule at any point. Thus I would prefer to admit some regional identity but to stress that it changes with time and remains pluralistic at any moment.

4 ∴ The Pictures—Scene by Scene

This chapter compares selected depictions of the same event. My choice of incidents to illustrate my points is no less arbitrary than that of the scribes and *chitrakāras* to illustrate theirs. From the appendices and the following chapter, the reader will discover that there is no universally shared list of major incidents, and that what one might easily take to be a critical point in the plot may not have been depicted by a particular artist. My own choice has been guided in large part by interest in scenes that are more emphatically illustrated in Orissa than elsewhere or that are given a unique twist there. I am also attracted to episodes where we can put our finger on the derivation of artistic imagery. This leads to the inclusion of some events that may seem trivial or idiosyncratic and to the omission of what might be considered more important episodes in the story. Some reasons for various choices of emphasis will appear in the final chapter.

RIŚYAŚṚIṄGA'S SEDUCTION AND DAŚARATHA'S SACRIFICE

In Vālmīki's Rāmāyaṇa, the story of the young ascetic Riśyaśṛiṅga ("Antelope horn") is interpolated as a prelude to his performance of the sacrifice for sons that produces the divine food distributed to Daśaratha's queens, which in turns leads to the birth of Rāma.[1] Even Vālmīki's relatively restrained account of Riśyaśṛiṅga's seduction by courtesans who entice him from the forest was abbreviated in some later versions of the epic—such as the *Adhyātma Rāmāyaṇa* (where the ascetic is simply brought),[2] or Tulsī Dās's Hindi (where he does not appear at all).

But in many vernacular texts, the full legend is retained or even expanded, as in Orissa.[3] Thus in Upendra Bhañja's *Vaidehīśa Vilāsa* one entire canto (of fifty-two) is devoted to the ascetic's seduction by the courtesans (*veśyās*), led by the intelligent and charming Jāratā, who were enlisted by King Lomapāda to relieve the drought in his kingdom. Their first visit to the forest typifies the double entendres for which Upendra is known. Riśyaśṛiṅga, who grew up without any women, asks,

"Oh sages, tell me what spells you chant.
Do you worship Viṣṇu or Śiva?"

Giggling and flirting, the amiable women
Replied with spirit, their nostrils flaring,

"You dwell in the forest [*vana*], we in a grove [*vanī*];
So you are called recluse [*vanokā*] and we are women [*vanitā*].

We say the same spell to Rāma as you,
But instead of Rā we substitute Kā [i.e. Kāma, Love].

Because Śiva is our god, we bear him over our heart."
Then quickly they revealed pairs of breasts.

(4.14–18)

The image of the young ascetic seeing women's breasts for the first time under the illusion that they were *liṅgas* might make the sternest Freudian smile. Subsequently Riśyaśṛiṅga disobeys his father, follows the courtesans to their boat, and is carried away blissfully to Lomapāda's kingdom, where he brings rain. Daśaratha in turn offers his beautiful daughter Śāntā[4] in marriage and takes the sage to Ayodhyā to perform a sacrifice for sons, producing the divine food (*pāyasa*) that impregnates the queens.

Why is the Riśyaśṛiṅga episode expanded in this account? On the one hand, the role of the *veśyā* in conferring religious status upon the king is broadly visible in Orissa, as the anthropologist Frédérique Marglin has argued.[5] The sexuality of such women, while arguably impure, is associated with water, agricultural fertility, and the king's right to rule. The institution of the *devadāsī*, or temple courtesan, provided a ritual mechanism for this connection, which endured until very recently in Puri. On the other hand, this episode is certainly grist for Upendra Bhañja's literary mill, eliciting the erotic passages and humorous wordplay for which he is noted. Whereas Vālmīki's Rāmāyaṇa is built around the pathetic sentiment (*karuṇa rasa*), the *Vaidehīśa Vilāsa* gives equal play to the romantic (*śṛṅgāra*) and at times the comic sentiment (*hāsya*). The fourth canto, devoted to the Riśyaśṛiṅga episode, develops these moods with ingenuity and elegance.

In the earliest paintings of the *chitrakāras*, the wall paintings of Buguda, Riśyaśṛiṅga initiates the action by performing a sacrifice and handing the religious food to Daśaratha, but his seduction is absent (Figure 201, lower right). Subsequently, since at least 1954, the sage appears surrounded by courtesans in a boat in the repertoire of the *chitrakāras* (Figure 223).[6] Inclusion of the seduction is not surprising in view of the broad popularity of this episode in most Oriya texts. The boat scene in particular may be understood as a sub-episode that alludes to the particularly Orissan association of the courtesans with water and hence fertility in a generalized sense.[7] The wooden wedding box made in the 1970s by Bhagavata Maharana of Bhubaneswar includes the same scene as one of four events selected from the entire epic, suggesting its importance (Figure 258). The *chitrakāra* views this event in a more regular and static way than most of the palm-leaf illustrators to be considered.

Even in Orissa not all texts include this sequence. In Oriya translations of the *Adhyātma Rāmāyaṇa,* as in the Sanskrit original, Riśyaśṛiṅga is abruptly and

briefly introduced in connection with Daśaratha's sacrifice for sons. Hence it is no surprise that the seduction does not feature in any illustrated version of that text (Appendix 1). Likewise we have no scenes of this episode in the *Durgā* and *Hanumāna Stutis* or the *Brahma Rāmāyaṇa*.

Upendra Bhañja's *Vaidehīśa Vilāsa,* whose ample account of the episode has been summarized above, invited copious illustrations. Those of the Baripada manuscript made by the karaṇa Śatrughna are difficult to piece together with precision, but at least nine leaves seem to have been devoted to events between the courtesans' departure and Daśaratha's sacrifice. The illustrations, characteristically overlapping several folios, show a small, hieratic Riśyaśṛṅga accompanied by larger women, depicted as conventional dancers (Figure 89). By contrast, Michha Patajoshi's courtesans have a housewifely quality, and he captures the fun, if not the literary punning, of the verses quoted above (Figure 125). His pictures follow the text fairly closely, two per side of most leaves, increasing in number in his latest work.[8] The landing of the courtesans' boat (from which Riśyaśṛṅga disembarks, bringing an end to Lomapāda's drought) illustrates the way this artist repeats a general composition but not every detail (Figures 102, 113, and 126).

In Upendra Bhañja's *Lāvaṇyavatī,* the Rāmāyaṇa synopsis begins with Lomapāda's drought and Jāratā, the chief courtesan, embracing Riśyaśṛṅga, events that are illustrated in three of our versions. The Round Manuscript shows the sage seated apart from two women in the boat and then performing sacrifices for the two kings, focusing lucidly on his role in the main plot sequence (Figures 1, 2). Raghunath Prusti depicts the amorous situation in the boat, the court of Lomapāda, the sage's farewell to Jāratā, and Daśaratha's sacrifice (Figures 175, 176), in closer correspondence with the generally risqué character of Upendra Bhañja's text. Balabhadra Pathy's version is as usual most expansive, including characters not mentioned in either of Upendra's poems and weaving all parts of the sage's progress to the courts of Lomapāda and Daśaratha across six pages (Figure 157). It is interesting that all three artists include the courtesans' boat, not mentioned in the *Lāvaṇyavatī* itself, although no doubt familiar from various Oriya accounts; only Prusti enumerates the charms of this vessel, as did the poet in the *Vaidehīśa Vilāsa.*

The Dispersed *Lāvaṇyavatī* begins its account of the Rāmāyaṇa with a characteristic ellipsis. The caption on the left half of Figure 141 mentions the magician's performance and also king Lomapāda. Yet the illustration jumps to Śāntā, presented by her father to the ascetic. This event is consummated on the right with their marriage, attended by Lomapāda as well as Daśaratha. Rain is ingeniously worked in to form what might seem to be a tasseled canopy, did it not descend from a dark corner of sky. In short, from Upendra's verse 20, the artist has selected and condensed his elements to give particular dignity to Riśyaśṛṅga, who goes on to function dramatically on the reverse, paired with Viśvāmitra in Daśaratha's sacrifice (Figure 142). It is Riśyaśṛṅga who turns his head to focus on Vālmīki (identified in the label), who hands the porridge to Daśaratha at the very middle of the folio, the string-hole underscoring this momentous act. This is a unique version of this event, giving the ur-narrator Vālmīki a pivotal role in this episode as well as demonstrating the daring and artistry of this anonymous artist. Ellipsis and flashback (the rain) serve to clarify yet enrich the images.

I have deliberately omitted mention so far of the widely varying manner in which Riśyaśṛṅga himself is depicted. Here the Oriya texts that were actually illustrated give no guidelines: he is described merely by his name "Antelope horn." Earlier versions of the story from other parts of India explain that his mother was an antelope, and it has been suggested that the ultimate prototype is the European unicorn.[9] Indeed, the unicorn model is that of Buguda (Figure 201). This depiction of the youthful ascetic with a single horn perpendicular to the crown of his head, along with the spiky sacrificial fire, may have influenced Raghunath Prusti (Figure 176). The suggestion that this careful artist, working only 30 kilometers from Buguda, should have appreciated such models is plausible, despite his having chosen (with some help from Upendra Bhañja) to give his narrative a different twist. By contrast, the single-horned Riśyaśṛṅga of the Round and the Dispersed *Lāvaṇyavatī* is an older ascetic (Figures 2, 141). Balabhadra Pathy adopted a very distinctive ascetic type, with no concern for Riśyaśṛṅga's youth and with no horns distinguishable among the many pointed locks of hair (Figure 157).

Despite the historical assumption that a single horn is appropriate, the authoritative Oriya Rāmāyaṇa of Balarāma Dāsa says explicitly that the sage had two.[10] That is how Michha Patajoshi depicted him, possibly without visual models (Figure 125). And more recently *chitrakāras* have adopted this version, with long twig-like horns (Figures 223, 258). Most distinctive of all was the solution of the ingenious scribe Śatrughna, who endowed the sage with the entire head of a blue deer (Figure 89). This representation in fact corresponds to the description in Śarala Dāsa's *Mahābhārata:* "The body of a man and the head of a deer."[11] In all these depictions of Riśyaśṛṅga surely we must see independent efforts by each artist, guided by little sense of shared visual traditions except in the case of an unusually scrupulous craftsman like Raghunath Prusti, who drew selectively upon the model of nearby Buguda.

TĀḌAKĪ, AHALYĀ, AND THE BOATMAN

Rāma's encounters with Tāḍakī, Ahalyā, and the Boatman form a closely linked sequence in Orissa in several texts, performances, and, particularly, pictures. Tāḍakī was the principal scourge against whom the sage Viśvāmitra enlisted the aid of the young prince, and Rāma's success in felling her provides a preview of his subsequent success at demon slaying. In both the *Adhyātma Rāmāyaṇa* and the *Vaidehīśa Vilāsa,* two works radically different in literary character, a beautiful woman emerges from Tāḍakī's huge corpse, released from a curse.[12] Then, minimizing other demons, these versions move on immediately to another tale of an accursed woman, Ahalyā.[13] This luckless beauty had committed adultery with Indra. Her husband, the sage Gautama, cursed the god to bear a thousand wombs (hence Indra's thousand eyes), and he turned his own wife to stone until she should be liberated by the touch of Rāma's foot. In the *Adhyātma Rāmāyaṇa* this release ushers in Ahalyā's long devotional hymn to the pervasive power (*māyā*) of Rāma. Here and in Upendra Bhañja's versions, the event is juxtaposed with the story of the boatman, who insists on washing Rāma's feet before he steps aboard the boat lest the boat that he needs to make his living turn into a woman (who would also be expensive to support). This brief episode is both a humorous hu-

man touch, catching the simple man's naïveté, and a profoundly moving statement of the devotional theme that links this entire sequence of events.[14] In the Dasapalla Rāmalīlā, the second night is regularly devoted to these three episodes alone. Tāḍakī's frenzied fight culminates in her deathbed worship of Rāma. Ahalyā emerges from a mysterious papier-mâché rock to pray while her story is recited. The boatman appears in a simple boat, a plain sari stretched over an oblong frame, and his washing of Rāma's feet concludes the evening with humble reverence.

Several of these events are commonly depicted not only recently in Orissa but also in earlier sculpture of other regions.[15] At Buguda the three incidents follow in sequence, although the scene of the boatman (Figure 201, third tier, left) is separated from Ahalyā. The figure of Tāḍakī is badly abraded, but it is mainly her size and the tree with which she threatens Rāma that indicate the fear she inspired (Figure 201, second tier, right). Her pose and general configuration resemble those of the small, meek Ahalyā to the right, as if Tāḍakī and Ahalyā were the same figure transformed.

In this depiction of the demoness, later *paṭa* painting is no less obviously heir to Buguda than are some manuscripts. In Jagannath Mahapatra's set, Tāḍakī takes the form of a standard *rākṣasī*—naked, disheveled, with blue skin and a grotesque face. Yet she, like Ahalyā in the next scene, rises from a hill of rounded lobes, which lends continuity to the two events (Figures 224, 225). His straightforward version of the boatman scene appears fairly commonly on separate small *paṭas*, reflecting the popular appeal of this devotional theme (Figure 226).

Among manuscripts, even the *Brahma Rāmāyaṇa*'s cursory narrative includes Tāḍakī and Ahalyā (Figures 195, 196). The two occur on opposite sides of the same leaf, and the arrow-filled fight on one side does not necessarily invite comparison with the sedate, hieratic composition on the other. Tāḍakī has fangs and a hooked nose like demons in many palm-leaf illustrations, although other details are unusual.[16] The skillful artist of this manuscript uses a dark rectangle to define Ahalyā's rock, a vivid device unique in Orissan images, quite possibly of his own devising.[17]

In the *Adhyātma Rāmāyaṇa* we have a text that juxtaposes the three incidents in question as examples of Rāma's *māyā*. While Sarathi Madala Patnaik illustrated Ahalyā's devotional hymn (replacing Rāma with Viṣṇu) in three of his four preserved versions of this favorite text, in none did he include all three incidents (Appendix 1). His two quite unrelated versions of Ahalyā's release (Figures 50, 56) demonstrate his freedom from any visual formula. This freedom, the diversity of incidents selected, and the unfinished drawing of the figure of Viśvāmitra to the right in Figure 50 may all indicate a lack of deliberation on the part of Sarathi Madala. It is worth underscoring as we search for conscious or unconscious programs in illustration that some artists worked too haphazardly to meet our expectations.

In the case of the *Vaidehīśa Vilāsa*, the Baripada master Śatrughna included Tāḍakī in the form of a black animal-headed monster spread over five folios (Plate 3), and he also depicted the boatman (Figure 90), but this manuscript is too jumbled to reveal the original effect of the sequence. From the same artist's other, probably earlier, copy of the same text we have the Ahalyā episode pre-

served in a distinctive form (Figure 99).[18] Above the rock, letters are decoratively arranged to read,

> Offering
> lotus flowers,
> Ahalyā worshipped
> Rāma, son of
> Kausalyā
> with
> great
> pleas-
> ure.

This seems to be a case of Śatrughna's vaunted ingenuity in welding together image and text.[19]

Michha Patajoshi meticulously depicted each turn of events, spelling out Tāḍakī's apotheosis (Figure 103). He included amusing details from Upendra Bhañja's poem such as Indra's slinking past the irate Gautama in the guise of a cat (Figure 105).[20] As usual, this artist follows his own compositional formulas, such as the rounded rock from which Ahalyā rises, without repeating every detail (Figures 104, 114, 127). From this point on, one example of his depiction of a single subject will suffice.

The abbreviated text of the *Lāvaṇyavatī* in general grants great freedom to its illustrators. Balabhadra Pathy draws the clearest parallel between Tāḍakī and Ahalyā, for the two figures occur on successive leaves and would be viewed together (Figures 158, 159). The sequence of Viśvāmitra, Lakṣmaṇa, Rāma, and a woman in a thicket is identical in the two. Thus differences stand out—the arrows released in the first and Tāḍakī's rapacious form. Pathy, in his element here, uses the spreading plants to underscore Tāḍakī's frenzy, as opposed to Ahalyā's modest pose, echoed by drooping branches. This is one of the few Rāmāyaṇa sequences in Orissa that omits the boatman, although the incident is mentioned in the text of this very poem.

The Round *Lāvaṇyavatī* organizes these events similarly on successive pages, but the two compositions attract less immediate comparison (Figures 6, 8). Tāḍakī here combines some attributes of an attractive woman with demonic face, hair, and dugs. Rāma strides from Ahalyā's rock to the boatman with identical pose, displaying a clarity of action that is the forte of this manuscript.

In the Dispersed *Lāvaṇyavatī,* Tāḍakī and Ahalyā occur at opposite ends of successive leaves (Figures 143, 145). There is a dramatic continuity between Rāma, who grows from a baby to a heroic adult before our very eyes, striding from the role of executioner to that of savior and ultimately of divinity. Again this anonymous artist uses ellipsis effectively. Ample surrounding space and subtle scenery serve to emphasize Rāma's heroism in these three scenes, following the import of Upendra Bhañja's longer poem, or for that matter the *Adhyātma Rāmāyaṇa.*

In Raghunath Prusti's version Ahalyā follows Tāḍakī on the reverse of the same leaf, which makes direct comparison impossible for the viewer of the manu-

script (Figures 177, 178). Yet the general similarity of the main actors conveys some relationship. The demoness is distinguished only by her hooked nose, in which this artist may again have been influenced by the Buguda wall paintings, although he does not follow their composition. One unique element is the inclusion of Bharata (as identified by label, second from the left in Figure 177). I know of no Oriya text or other illustration that included him in this expedition, although it is conceivable that some oral version did.[21] Even if Prusti had such a basis, one must credit him with originality in introducing a character not included at Buguda or in the *Lāvaṇyavatī* itself. The neat interlocking of Ahalyā and the boatman and the elegant structure of the page, with the dark river in the center, are characteristic of his pictorial skill.

In general, one might argue that the parallels presented between the release of the two cursed women in many manuscripts and in the *chitrakāras'* tradition represent no more than the use of stock figures, common in both literary and visual traditions. In the texts, the emphasis upon the two female characters, at the expense of the male demons who play a larger role in Vālmīki, strengthens the comparison, which in turn befits the later authors' concern with Rāma's transforming *māyā*.[22] On the whole I am most convinced of a similar intent in pictures when added details enhance the similarity and when Tāḍakī is not presented in her predictable demonic form. Certainly this linkage is more appropriate to visual images, where similarity can be grasped at a glance, than to words, where repetition must be remembered or pointed out.

BHARATA'S VISIT

After major turning points in the plot, such as marriage and exile, Rāma settles with Sītā and Lakṣmaṇa on Mount Chitrakūṭa. When Daśaratha dies, Bharata brings his entire court, hoping in vain to bring Rāma back to rule in Ayodhyā. This visit of Bharata forms a significant and long sequence in Vālmīki and many other Indian versions of the tale. It has been suggested that Rāma's moral advice to his brother constituted a deliberate counterpart to Kṛṣṇa's famous sermon, the *Bhagavadgītā*.[23] This episode is treated with the same weight and sententious tone in the *Adhyātma Rāmāyaṇa*. In Balarāma Dāsa's *Jagamohana Rāmāyaṇa*, however, Daśaratha's death is followed by a description of the idyllic life of the exiles, including tender moments when Rāma makes a red mark on Sītā's brow as befits a married woman, using ocher earth as a substitute for luxurious pigment. He protects his wife from a marauding crow by shooting its eyes. These events originate in the northern recension of Vālmīki, and one can trace their expansion in Orissa at the expense of Bharata's visit.[24] Thus Upendra Bhañja reduces the visit to twenty verses in the *Vaidehīśa Vilāsa*, whereas the entire following canto of forty verses of elaborate puns treats love sports on Mount Chitrakūṭa and includes the incidents of the ocher mark and the crow.[25] The list of events in the same author's *Lāvaṇyavatī* follows this emphasis, although only the charming Chitrakūṭa and the crow are mentioned, and these precede Bharata's visit. This general sequence reveals the interplay between high moral tone and delight in the sensual that often characterizes the Indian tradition.

The top of the first wall devoted to the Rāmāyaṇa at Buguda includes a much

damaged painting of a hill with three figures, probably Rāma, Sītā, and Lakṣmaṇa on Mount Chitrakūṭa (cut off in Figure 201). A similar scene with Rāma touching Sītā's brow also appears on wall E in large form, along with Bharata's visit to the right (Figures 205, 206). I would infer that the planners intended to treat the mandatory visit in separate iconic form and hence did not include it among the initial narrative scenes. Possibly they only subsequently decided to add the separate depiction of Rāma applying ocher to Sītā to make a balanced wall with two scenes set on the same hill.[26] This decision might also reflect the guidance of Oriya literature, such as the *Vaidehīśa Vilāsa*, to be expected in view of its composition by a family member of the temple's patron, although that poem is not followed literally throughout those paintings. At any rate, if there is a duplication of Mount Chitrakūṭa here and on the first wall, it suggests extemporaneous planning of the kind mentioned in Chapter 2 in connection with directionality at Buguda.

These large, clear, and rich scenes seem to have had considerable impact upon later *paṭa* painting. Jagannath Mahapatra's version of Bharata's visit is a simplified mirror image of the general composition, reducing Bharata to a humbler position (Figure 227). His text here, as in general, opts for moral homily over human detail and thus omits scenes of Chitrakūṭa aside from Rāma's meeting with Vālmīki. The artist Bhagavata Maharana, acknowledging his admiration for the Buguda murals, created variations upon this version of Bharata's visit on the wedding box in Figure 260 as well as in separate *paṭas* (Figure 256). Although similar in general configuration to the wall paintings, his versions are far from direct copies. Bhagavata Maharana seemed to enjoy adding landscape details, which are somewhat more clichéd than those of the original—two peacocks and a pond with ducks. The poignant group of the three pale widowed queens to the right at Buguda is reduced to two stereotypic women at the bottom of the *paṭa*. Yet Bhagavata Maharana excelled in meticulous (*saru*) work valued by the *chitrakāras* themselves, for example in the border with two serpents' heads neatly worked in at the center of the top.

In manuscripts of the *Adhyātma Rāmāyaṇa*, the textual concern with Bharata's devotion to Rāma invites ample illustration of the visit. Sarathi Madala Patnaik, as one might expect, devoted about four scenes to this sequence in his complete manuscripts.[27] Unusual for him is the repetition of a single formula for the final, weighty event, Bharata's worship of Rāma's sandals or footprints (Figure 57). The appearance of a lotiform emblem with the auspicious footprints in the center in other illustrators' *Adhyātma Rāmāyaṇas* as well (Figures 75, 78) suggests that this image was peculiarly linked to this text. The obvious explanation would lie in the artists' copying from other illustrated manuscripts, although it is also possible that the worship of a stone icon of this type took place at a shrine particularly influential in the dispersal of this text.

In the *Vaidehīśa Vilāsa*, Michha Patajoshi likewise faithfully follows his text, devoting one page to the visit and two or more to events on Mount Chitrakūṭa. The visit concludes, not with the emblem favored by the artist's neighbor and immediate predecessor, Sarathi Madala, but rather with a scene of Bharata bending to touch Rāma's feet (Figure 115), like the tradition of Buguda, but not necessarily following that visual model.[28] In both of Śatrughna's versions of this same text, the shooting of the crow survives (Figure 91).[29]

The *Lāvaṇyavatī* of Raghunath Prusti is particularly indebted to the Buguda murals in this section, beginning with the taut image of the royal brothers tying up their hair as ascetics (Figure 183; cf. Figure 201, fourth tier from bottom, to the right).[30] Prusti incorporated the Buguda composition, which had originally been viewed from right to left; Upendra Bhañja's second text presents the events in reverse order, so that the folio in fact can be read from left to right. Ascetics are ingeniously worked into Mount Chitrakūṭa, as described in other texts, and the shooting of the crow occurs just above Bharata's entourage. Here one can see the skillful illustrator spreading out his composition to fill the palm leaf and adapting parts of the model to include, for example, several of his distinctive Maratha-costumed courtiers, who are absent at Buguda.

The Round *Lāvaṇyavatī* likewise includes the incident of the ocher mark, although it is not mentioned in this text, following it with the blinding of the crow and the visit of Bharata—devoid of all retinue (Figures 13–15). These images are different enough from Buguda and Prusti's to suggest that they are independently derived. As usual, this artist illustrates the story simply and directly, in a slightly choppy, episodic manner.

Balabhadra Pathy, on the other hand, works against the text of the *Lāvaṇya-vatī*, making this story as much Bharata's as Rāma's. Thus three pages depict the visiting party richly, if repetitiously, introducing the sight of Rāma's footprints on the road from Ayodhyā (Figure 160, far right). There is less of the charms of Mount Chitrakūṭa. Finally Bharata is shown worshiping the sandals back in the village of Nandigrām (Figure 161).

The Dispersed *Lāvaṇyavatī* makes as bold a jump in the selection of incidents, as does my selection in this chapter, for one page moves from the encounter with Paraśurāma after Rāma's marriage to the meeting with Bharata (Plate 9, Figure 147). Both the entire mechanism of the exile and the charms of Chitrakūṭa are omitted: the reverse of this page proceeds to the killing of the demon Virādha (Figure 148). While the use of a hill for the visit may suggest comparison with Buguda and Prusti, the subtle emotional effect here differs. Sītā sits modestly in the center, and Bharata bows his head alone, delicately inducing the mood of compassion and suggesting the theatrical stage rather than the anecdotal storytelling of many manuscripts.

On the whole, depictions of this sequence of episodes are shaped by two different lineages of interpretation: the devotional tradition, clearest in the *Adhyātma Rāmāyaṇa* but also informing Balabhadra Pathy's version of the *Lāvaṇyavatī*, which takes Bharata's worship of the divine foot emblem as the crux; and the human response to exile, which the Buguda artists and many palm-leaf illustrators develop.

THE ILLUSORY DEER AND SĪTĀ'S ABDUCTION

The basic plotline of this section, critical in causal terms, follows Vālmīki in most versions: Lakṣmaṇa denoses Śūrpaṇakhā; her demonic brothers unsuccessfully attempt to avenge this insult; Rāvaṇa enlists Mārīcha to take the form of a golden deer, which Rāma hunts; Sītā is kidnapped by Rāvaṇa in the guise of an ascetic; and Jaṭāyu tries to prevent their escape, in which the bird is mortally wounded.

Rāma, upon discovering his loss, grieves, rages, and encounters both the accursed Kabandha and a Śabarī, a forest woman, who point him on his way.

Whereas in Vālmīki, Mārīcha argues at length with Rāvana about the whole undertaking, in the *Adhyātma Rāmāyana* (and other late Sanskrit versions) he accedes quickly, realizing that he will benefit from being slain by Rāma. Here, in keeping with *bhakti* sentiments that require an entirely pure Sītā and in conformity with this text's particular concern with *māyā*, Rāma orders his wife to place an illusory form of herself outside the hut to be kidnapped and to hide her true self in the fire, where she remains for the rest of the story. This Māyā Sītā also appears in most Oriya versions from Balarāma Dāsa onward.

In the *Vaidehīśa Vilāsa,* Rāvana approaches Mārīcha for assistance more ingratiatingly. That demon is in mourning for the loss of a family member, so Rāvana bathes in the ocean as if he were a brother of Mārīcha performing ritual purification. Mārīcha obliges with alacrity.[31] As one might expect, Upendra Bhañja heightens Śūrpanakhā's sexual provocation of the brothers.[32] Rāma writes a note to Laksmana, which includes one of the poet's most widely quoted puns, a verse that can be translated in either of two ways:

> You should take this woman and embrace her, the source of heavenly
> pleasure, in the forest.

or

> Cut off this woman's nose and ears, and don't touch her.
> (23.58)

The *rāksasī* continues to imagine that Laksmana is engaging in a violent style of love play as he prepares to mutilate her. In this account, after the abduction Jatāyu swallows Rāvana's chariot but spits it out to save Sītā, an incident found in some Bengali folk versions also.[33] Finally, Upendra Bhañja, like many Oriya authors, follows Rāma's grief with not only the slaying of the long-armed demon, Kabandha, but also with two incidents that may seem anticlimactic to us, although they increase the sense of popular devotion to the bereft hero. One is the story of rude cowherds, only one of whom offers the brothers milk; Rāma grants him the boon of being born as Krisna's adoptive father, Nanda.[34] A second incident concerns the forest woman, a Śabarī, who appears as a simple ascetic in Vālmīki. Oriya versions emphasize her tribal identity, for she gives Rāma a mango she has tasted to ensure that it is sweet, which he accepts gratefully although this acceptance might horrify a purity-conscious Hindu, loath to eat something bitten by one of lower caste.[35] As throughout, Upendra Bhañja's poem, while shorter than Vālmīki's, embroiders the epic's urgent sense of tragedy with a variety of other moods.

At Buguda this portion of the story is not particularly vivid or clear (Figure 202), perhaps partly because these paintings are damaged. Yet with their placement in a dark space under the eaves, roughly five feet above eye level, they could never have been as prominent as, for example, the episode of Kabandha. This sequence was apparently determined by the conclusion of wall A with Śūrpanakhā at the top, although the eye was not led immediately to the first scene of wall B.[36] Moreover, the scene of Rāma and Laksmana carrying the deer's body on a pole, while not placed anachronically (it occurs simultaneously with the

abduction), breaks up the sequence of action and is not described at this point in any text I know. In short, direct storytelling may not have been uppermost in the mind of these artists. What they did do well was to cover the wall in a balanced manner with arresting, elegant images.

Later *pata* paintings do not follow the model of Buguda for this sequence. One incident popular for inclusion in large depictions of the Puri Temple as well as for independent illustration—Rāma shooting at the illusory deer—does not occur at Buguda, for the top of Figure 202 shows a figure turning away from the deer.[37] The prevalence of a composition moving to the right, with the deer atop a hill (Figure 230), suggests some common lineage—whether oral tradition, a painting in the Jagannātha Temple (Appendix 4), or sketchbooks (although none of this subject have come to my attention) perpetuated this form among the *chitra-kāras*. It has become an emblem, but not on the basis of the Virañchi Nārāyaṇa wall paintings. The subsequent events in Jagannath Mahapatra's set differ individually from those at Buguda, although both versions show Jaṭāyu in the form of a bird that is not particularly a vulture.

In his various manuscripts of the *Adhyātma Rāmāyaṇa*, Sarathi Madala Patnaik at least twice depicts the creation of Māyā Sītā, an event central to this text (Figure 59).[38] He as usual illustrates the episode a bit carelessly and seems more concerned with the physical event than with the idea.[39] This artist depicts the deer in a variety of ways, albeit always with two heads. In January 1891 it was endowed with a second upper body and the two sets of horns crossed (Figure 60). In December 1891 the long necks and small heads looked almost like those of serpents (Figure 68). It is interesting that Sarathi Madala included this creature twice in the *Durgā Stuti,* perhaps his most naturalistic version, which differs again slightly in showing the rear head below (Figure 82). The charming ungulate also occurs in other artists' illustrations of the *Adhyātma Rāmāyaṇa*, consistently with two heads (Figure 76). Other scenes in this section are not radically different from those of *pata* painting, except that Jaṭāyu always has the body of a man, perhaps on the model of Garuḍa, his father. The Śabarī is included in all copies, indicating that this incident was taken particularly seriously in Orissa.[40]

The unique illustrated Rāmalīlā of Krishna Chandra Rajendra includes one unusual textual detail faithfully followed in the text. It is the fantastic form of Kṛṣṇa known as Navaguñjara, pitted against Rāvaṇa after the abduction (Figure 87). This substitution for the pan-Indian Jaṭāyu may reflect the popularity of the enigmatic creature in Orissa, which goes back to Śāralā Dāsa's *Mahābhārata*.[41] For us, the interest is in its demonstration of the way an illustrator may follow his idiosyncratic text despite the resemblance of his other pictures to those of the *Adhyātma Rāmāyaṇa*.

The two artists who specialized in the *Vaidehīśa Vilāsa* were even more clearly, if in different ways, concerned with their own distinctive text. The scribe Śatrughna locates his illusory deer in a rich forest, emphasizing the chase it led Rāma (Plate 4, Figure 93). It is clearly Māyā Sītā who confronts Rāvaṇa the beggar, for her true form lurks in the fire (Plate 5, Figure 92). The incident of the cowherd becomes a bucolic scene within a circle, suggesting a Rāslīlā or other image of Kṛṣṇa, who is alluded to in Rāma's boon (Figure 94).[42] Here we can clearly see this ingenious artist capturing some of the intellectual flavor of the poet.

PLATES

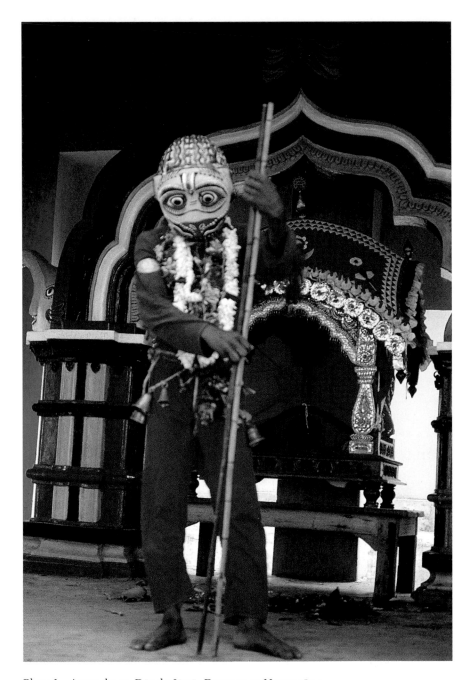

Plate 1. Asureshvar. Dāṇḍa Jātrā. Devotee as Hanumāna.

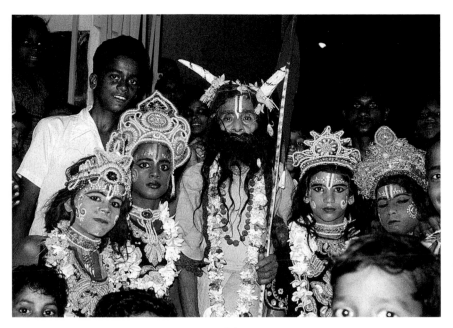

Plate 2. Puri. Sahi Jātrā. Riśyaśṛṅga and four princes.

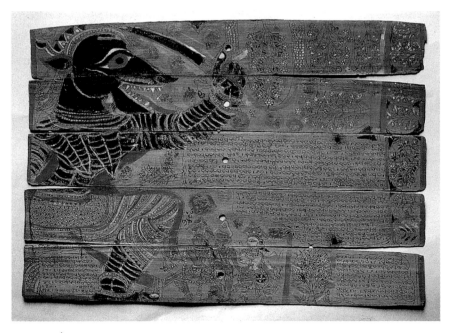

Plate 3. Śatrughna, *Vaidehīśa Viḷāsa* (courtesy Jubel Library, Baripada, dated 1833). Tāḍakī and Rāma.

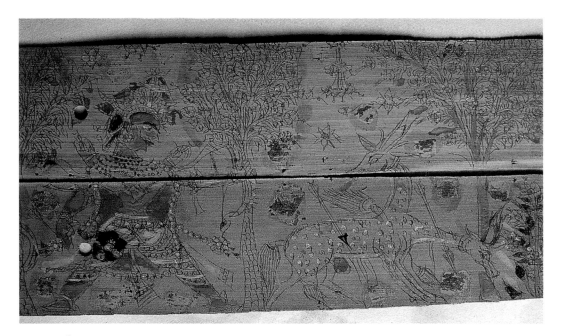

Plate 4. Śatrughna, *Vaidehīśa Vilāsa* (Baripada, 1833). Rāma hunts the magic deer (detail of Figure 93).

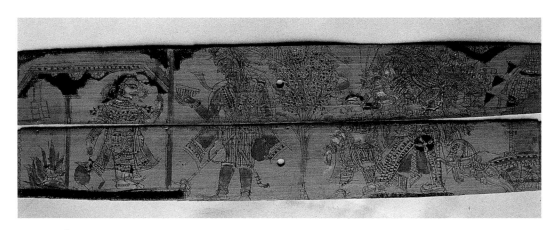

Plate 5. Śatrughna, *Vaidehīśa Vilāsa* (Baripada, 1833). Sītā in fire, kidnap of Māyā Sītā.

Plate 6. Śatrughna, *Vaidehīśa Vilāsa* (Baripada, 1833).
Rainy season on Mount Mālyavan.

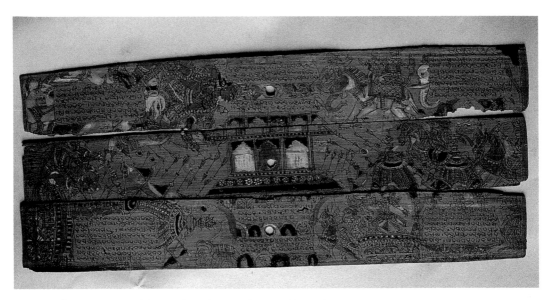

Plate 7. Śatrughna, *Vaidehīśa Viḷāsa* (Baripada, 1833). Battle scene.

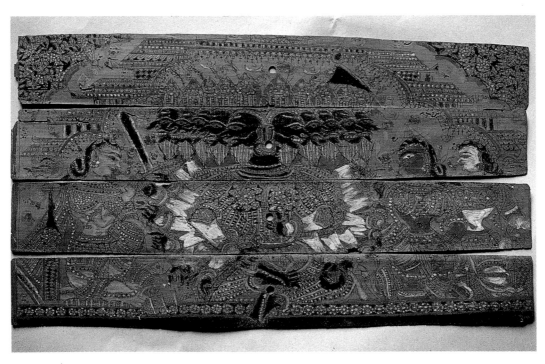

Plate 8. Śatrughna, *Vaidehīśa Viḷāsa* (Baripada, 1833). Rāvaṇa and his wives.

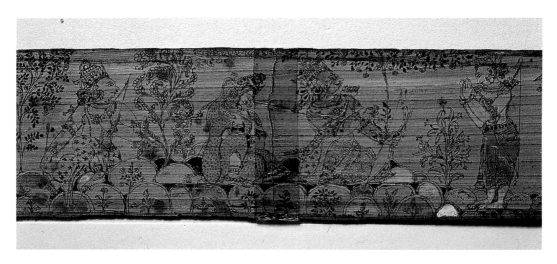

Plate 9. Dispersed *Lāvaṇyavatī* (Jean and Francis Marshall Collection, San Francisco). Bharata's visit.

Plate 10. *Lāvaṇyavatī* illustrated by Balabhadra Pathy (courtesy National Museum of Indian Art, New Delhi). Rainy season on Mount Mālyavan, f. 173.

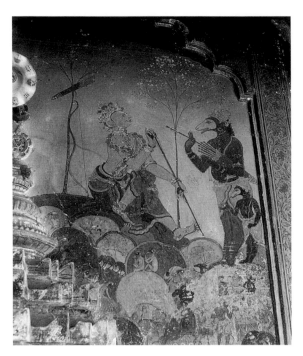

Plate 11. Buguda, Virañchi Nārāyaṇa Temple, wall F.
Lakṣmaṇa straightening his arrow.

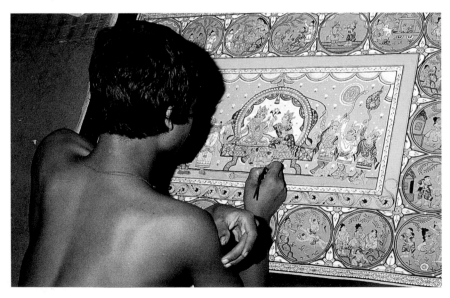

Plate 12. Apprentice at work on Rāmāyaṇa *paṭa* in Jagannath Mahapatra's
house, Raghurajpur (cf. Figure 289A).

There is no reason to think that Michha Patajoshi knew the work of Śa-trughna, produced seventy years earlier, yet his copious and literal illustrations of this section include similar themes, along with an amusing whimsy. Rāvaṇa's bath, taken to win over Mārīcha, is scrupulously shown in all three major manuscripts of this artist (Figure 108). Michha Patajoshi's deer is our most winsome version of this subject, disporting itself playfully in the forest (Figure 116). Māyā Sītā is again appropriately indicated by the presence of the true Sītā in a fire while the illusory one is kidnapped (Figure 109). Jaṭāyu, a somewhat comic bird, swallows and then spits out Rāvaṇa's chariot, which incidentally has the same form, with a giant head below, as that of Buguda (Figure 117).[43] The swallowing is depicted in the contemporary, conceivably influential *pats,* or pictorial scrolls, that were car-ried around south Bengal by itinerant storytellers; but their composition consis-tently differs from Michha Patajoshi's.[44] I would therefore conclude that what may have been known in Orissa was the theme but not the Bengali images. Two scenes of the cowherds in each manuscript become an occasion for rural details. Thus the brothers chug their milk with gusto in Figure 129, and the Śabarī offers them a mango with wide-eyed enthusiasm in Figure 118.[45]

In the brief account of the *Lāvaṇyavatī,* Raghunath Prusti's prolongation of these events is striking. Illustration of the last couplet of verse 24 occupies folios 77v and 78r (Figures 186, 187), a space generally devoted to two or three cou-plets. Thus Prusti seems as charmed as Sītā was by the frolicking deer, which he depicts twice with animation and accuracy, neatly graduating the size of spots on its extremities. Folio 78r places the main event in the center (Lakṣmaṇa's depar-ture, leaving Sītā to Rāvaṇa) and the two simultaneous offshoots on either side. The same three episodes occur side by side at Buguda but in the order in which most texts describe them—first on the right the hut, then the brothers with the deer, then Jaṭāyu's battle with Rāvaṇa (Figure 202). Prusti seems to have deliber-ately rearranged them according to the logic of place (movement in relation to the hut) rather than a logic of time. His version of the brothers emphasizes the deer, and Sītā stands more starkly alone in his depiction of the hut as an elegant cage. The telling device of the empty hut in the next scene seems to be Prusti's own invention,[46] effectively balancing Sītā's sorrow in the crowded asoka grove with Rāma's stark loneliness (Figure 188). The single missing leaf that follows must have illustrated a total of four couplets, whose more succinctly depicted events might have set off this emphatic sequence.

By contrast, the careful artist of the Round *Lāvaṇyavatī* tells his story with the regularity of clockwork, each line occupying one-quarter or one-third of the space in every frame (Figures 17–20). In the case of the Śabarī's gift of a mango, her extended arm serves to emphasize the difference in status between her and Rāma (Figure 23) but lacks the simple sense of devotion found in Michha Patajoshi's version (Figure 118).

In the case of the Dispersed *Lāvaṇyavatī,* a missing folio makes it impossible to assess this sequence as a whole. On the next folio that does survive, it is clear that this artist once again took great liberties with the plot sequence (Figure 149). Either this page must be read from right to left (an order virtually unknown in palm-leaf manuscripts, whose writing runs from left to right), or the order of the kidnap and the Śabarī's gift has been reversed. This lady has little of the tribal

about her, and the impact of both scenes, with their delicate tracery of leaves, is courtly and elegant. Here prolepsis may underscore the parallel between feminine generosity in the two cases, establishing for the viewer that Sītā did no wrong in giving alms to this stranger.

Balabhadra Pathy's *Lāvaṇyavatī* is no more expansive for this portion than for the Rāmāyaṇa in general. Some scenes are particularly vivid, such as the denosing of the scampering, bug-eyed Śūrpaṇakhā (Figure 162). The fact that Rāvaṇa's discussion with Mārīca takes place by the ocean suggests that Pathy had in mind the *Vaidehīśa Vilāsa,* where bathing is part of enlisting assistance. The illusory deer, a fanciful creature, more like an antelope than those of other versions, is shown repeatedly—cavorting in a narrow clearing, bounding through a thicket with magical ease while Rāma struggles after it, and looking ruefully at the arrow shot through its neck with horizontal insistency (Figures 164, 165).[47] The ten-headed Rāvaṇa and the cowherd's cows (Figures 166, 167) produce variety within the often mannered tracery of Pathy's work.

This manuscript is the only one I know in which the deer has a single head, although that is the case in about 40 percent of the recent *paṭa* paintings. Certainly the two-headed type prevailed in Orissa in the nineteenth and early twentieth centuries, although it was never mandatory, witness a *paṭa* from before 1814, now in the British Museum.[48] Neither chronology nor region seems to explain its adoption. In fact, while the two-headed form of the illusory deer is more common in Orissa than elsewhere, it does occur with some frequency in western India from the fifteenth century on.[49]

I know of no three-headed version of the deer in this particular episode, although India is rife with multiheaded animals and the two-headed motif is part of that broad spectrum. One example of a three-headed deer occurs in an Orissan palm-leaf manuscript of the *Adhyātma Rāmāyaṇa* as an unexplained space-filler at a later point when the surrounding text concerns Rāma's adventures in Kiṣkindhā (Figure 79).[50]

If we search for a textual explanation for the two-headed form, none of the works explicitly illustrated in Orissa describes this detail. Yet it is mentioned in at least two other texts, one the prestigious early fifteenth-century *Mahābhārata* of Śāralā Dāsa.[51] The second is one of numerous Rāmalīlā texts, that of Vaisya Sadā-śiva, composed in the eighteenth century.[52] These may represent, not a conclusive source for the motif, but rather indications that this image was widespread, particularly in the context of popular theater. In the Rāmalīlās still performed in central Orissa, the deer is frequently represented by a two-headed wooden model pulled on wheels (Figure 44, Frontispiece).[53] Neither performance nor images suggest unanimity about the form of the deer, but the two-headed version was widely accepted in both theater and art. Popular performance might at least have reinforced the artists' tradition or choice.

The question remains, what do the two heads mean? In Gujarat, a straightforward explanation has been adduced: the deer moved fleetingly, one moment grazing, the next looking back.[54] This is to understand the motif as an extreme example of simultaneous narration, exceptional both in western India and in Orissa. I asked repeatedly about the meaning in Orissa and never received that answer, which is not to rule out the possibility that the image may also at times suggest

darting movement. Yet two-headed form is neither necessary nor sufficient for that interpretation. On the one hand, Pathy's slender single-headed deer creates a similar effect, demonstrating that this motif is not required to create a sense of motion. On the other hand, the dead body of the deer regularly retains two heads whenever it is shown, and in that situation motion is surely not intended (Figures 20, 88, 187, 215—the skin on which Rāma sits—and 265).

In fact, both the *chitrakāras* and the public were generally stumped at first for an explanation. One might conclude that the *real* meaning has been lost. Given the variety of forms, I wonder if there ever was a single *real* meaning. The eminent Oriya scholar S. N. Rajguru supplied a precise and elegant interpretation, that the two heads correspond to the two sides of Mārīcha's nature, both good and bad. Others, however, concluded that it was simply the essence of illusion: the deer should be odd. Whether we opt for the specific, intellectual allegory or for the more generalized, popular interpretation may have more to do with our own ideological proclivities than with reasoned argument. Both rest on a respect for illusion, for ambiguity, for double entendre, and for divine power at work in confusion that is central to several texts we have been considering. This entire sequence of action becomes significant less as simple crux of plot than as the epitome of illusion. When Māyā Sītā confronts the Māyā Mṛiga and is kidnapped by Māyā-Rāvaṇa, the entire story rises to a level of complex relativism that dizzies even the postmodernist. I would like to argue that the very open-endedness of the symbolism of the two-headed deer best explains its tenacity in Orissa.

THE SEVEN TREES AND THE DEATH OF VĀLIN

In the fourth book of Vālmīki, the Kiṣkindhā Kāṇḍa, when Rāma meets Hanumāna and allies himself with the monkey king Sugrīva, we are led deeper into the jungle of fantasy. Sugrīva's exile is explained by the story of his elder brother, Vālin, who was assumed to have been killed by a demon but subsequently reappeared to reclaim the kingdom abruptly, usurping Sugrīva's wife, Rumā. When Rāma promised to defend Sugrīva, to assure his new allies of his strength he kicked the skeleton of the demon Dundubhi, whom Vālin had killed earlier, and he shot through seven sal trees to equal another exploit of Vālin's.[55] Reassured, Sugrīva challenged his brother to a fight, in the first round of which Rāma could not tell the two monkeys apart. Therefore he gave his ally a garland and in the second round shot Vālin from behind a tree. The dying monkey reproached him for duplicity but came to understand that his own untoward behavior to Sugrīva and Rumā justified the action. After much grieving by Vālin's own wife, Tārā, Sugrīva was crowned and Vālin's son Aṅgada became heir apparent. Rāma spent the rainy season on Mount Mālyavan, lamenting Sītā's absence. Finally Lakṣmaṇa returned to Kiṣkindhā to rouse Sugrīva from a drunken stupor. Thus we return to the quest for Sītā. The *Adhyātma Rāmāyaṇa* gives a much abbreviated version of this section, with some difference of detail (Dundubhi's head rather than his skeleton is kicked by Rāma), that also minimizes any censure of Rāma by Vālin, as one might expect in this deeply devout text.

Oriya literature alters this story in details, one of which is given a weighty local interpretation. Shooting through the seven trees becomes more than a simple

proof that Rāma's strength equals Vālin's. Thus in Baḷarāma Dāsa's *Jagamohana Rā-māyaṇa,* part of the monkey's strength is said to be located in the sal trees, which had to be cut for him to die.[56] Moreover, the trees bent in different directions and Rāma had to bring them into a single line; hence he stepped on the tail of a snake under the trees, and the snake became rigidly straight in fright. For Upendra Bhañja, the serpent was part of the initial problem:

> The trees are huge and hard as adamant, leafy as lotus plants.
> They are neatly arranged in a knot, firmly borne by a serpent.
> Although loaded with fine new leaves, because of the venom they have no
> birds.
> At the touch of Rāma's lotus feet, the snake with the seven trees was
> humbled.
>
> <div align="right">(Vaidehīśa Vilāsa 28.30–33)</div>

These verses are inscribed in the form of a *bandha,* or rebus puzzle, within the knotted body of the serpent itself (Figures 95, 100, 110, 130); the reader figuratively straightens it out by deciphering it, just as Rāma straightens it out literally by compelling the serpent to uncoil.

The inclusion of a snake in this episode is by no means limited to Oriya literature, although it may be more common in Oriya than in other vernaculars. In Sanskrit it goes back at least to the tenth-century *Mahānāṭaka* and occurs in the widely popular fifteenth-century *Ānanda Rāmāyaṇa.*[57] Moreover, reliefs of the Hoysala period from twelfth- and thirteenth-century Karnataka depict a snake beneath the seven trees, suggesting that other versions were known in the south.[58] A mythographer might be most interested in the migration of this motif and its general meaning as an emblem imbuing the arboreal forms with animal life. The student of Orissan literature is struck by the way Upendra Bhañja combined the relatively straightforward element of plot with a local tradition of challenging imagery. *Chitra-kāvya,* or picture-poetry involving sets of rebuses (*bandhas*), was a popular genre in Orissa that appealed to Upendra's particular poetic virtuosity.[59] This is "visual poetry," a twentieth-century phenomenon in the West, in which the physical act of reading the image enters into the meaning of the poem.

A second local twist to this part of the story is that Tārā in the *Vaidehīśa Vilāsa* ultimately curses Rāma: "He who has caused the death of my husband will not fully enjoy his own wife" (28.153). The curse reminds us of the problematic nature of the entire episode: Rāma, in killing Vālin by means of a ruse, from behind, is himself open to criticism. Much has been made of this moral problem in Sanskrit; in a general way we can see the adjustment of the story to minimize Rāma's guilt as he becomes progressively more and more a divinity. In the highly devotional Hindi version of Tulsī Dās, Vālin hardly rebukes Rāma at all from his deathbed, and Tārā's deluded grief is easily dispersed. But Upendra Bhañja admits an element of blame. This ultimately leads to the tragic final chapter of the entire story, which sets this portion of the Orissan tradition somewhat apart within broader Indian religious developments.[60]

The Buguda painters illustrate this portion of the story in an increasingly succinct way, moving from a discursive to an iconic approach (Figure 203). Thus each of the first four scenes occupies an entire register. The shooting of the seven

sal trees, the best preserved section of this wall, is an emblematic composition that could almost be borrowed from sculpture, and one whose textual source could be any Oriya Rāmāyaṇa in which a serpent supports the trees from Balarāma Dāsa onward.[61] The entire wall seems deliberately composed to move downward from a hilly forest scene (cut off in Figure 203) to one framed by two trees, to the massed sals, to the intense enclosure in which Rāma shoots Vālin. Dundubhi's corpse, an element lying outside standard artistic vocabulary, becomes an eerie, anatomically unrecognizable combination of bones and wrinkled skin.

Lakṣmaṇa straightening his arrow is the most surprising narrative selection at Buguda (Plate 11). This event can be reconciled with various textual sources, which credit the loyal brother with considerable anger that the monkeys did not readily come to Rāma's aid. In Balarāma Dāsa's *Jagamohana Rāmāyaṇa* and in Viśvanātha Khuṇṭiā's *Vichitra Rāmāyaṇa*, at the end of the rainy season Rāma himself sent Lakṣmaṇa off with the very arrow that had killed Vālin as a warning to Sugrīva that this arrow might be used on him too. In the Dasapalla Rāmalīlā, Lakṣmaṇa, put off by the doorkeeper at Kiṣkindhā, shoots at the palace, a loud firecracker conveying the force of his anger. The stone window screen from Vishnupur (Figure 285) indicates that some version of this incident was current in the fourteenth century. The location of the scene on a hill, like the four great tableaux in Buguda, opens up the possibility that a visual tradition may have guided the painters as much as the story per se.

Nonetheless all these precedents do not fully explain the selection of this scene for such prominence at Buguda, or the inclusion of Jāmbavan the bear as an assistant while Lakṣmaṇa straightens out the quill of the old arrow. Here, as with ancient sculpture, we are at a loss to decide whether the scene represents some lost tradition—possibly oral, possibly visual—or whether the artist devised it to balance the remaining three scenes that are "sanctioned" by actual texts. The only other similar version of this episode I have discovered is in the *Lāvaṇyavatī* of Raghunath Prusti, where its placement makes it yet more puzzling (Figure 191, bottom). The rareness of the subject suggests that it is idiosyncratic, either in story or in form, and hence not widely acceptable to later artists.

Within this sequence in general, Buguda does not fully "explain" the narrative choices of recent *paṭa* painting. Jagannath Mahapatra's set of illustrations focuses on Hanumāna and Sugrīva as models of devotion, omitting Dundubhi's bones, the seven trees, and Lakṣmaṇa's approach to Kiṣkindhā. In the poem that accompanies them, Vālin is made the villain, and it is understandable that his death should be neglected in favor of his righteous brother's coronation. In all of this, the *chitrakāras* seem to work in tune with the pan-Indian currents of Tulsī Dās. Perhaps non-Oriya patronage for their work has reinforced this tendency.

In illustrated manuscripts of the *Adhyātma Rāmāyaṇa*, the most interesting incident in this section is the shooting of the seven trees. Sugrīva addresses Rāma:

"See, Rāghava, seven sal trees; Vālin can shake the leaves from each one.
If you can shoot them with one arrow, I trust your strength."
Rāma acceded, took his bow, and shot through them and the hill behind.
The arrow returned to Rāma's quiver, and Sugrīva was delighted.

(4.1.72–75)

To this simple account, Sarathi Madala Patnaik adds a serpent in the form of a knot (Figures 61, 69).[62] Both examples follow the configuration used for the *bandha* in the *Vaidehīśa Vilāsa*, but without any text inscribed on the body. In December 1891 Sarathi Madala placed the snake beyond the trees, as if equating it with the hill (Figure 69). In January of the same year he had placed the seven trees at the corners of the knot in the pattern associated with Upendra Bhañja, with Dundubhi's head on the far side (Figure 61). Both this head and the massed foliage of the trees suggest that the artist was following details specific to the *Adhyātma Rāmāyaṇa*. Yet the serpent suggests that this unpredictable artist was generally familiar with the *Vaidehīśa Vilāsa* and chose to interpolate an element from that. Neither version of this same text by another artist includes the serpent; in fact the manuscript National Museum *Adhyātma Rāmāyaṇa* by another artist gives an extremely literal treatment of the event, including the hill beyond the trees (Figure 77). Comparison with other versions underlines Sarathi Madala's more playful treatment of his text.

The *Vaidehīśa Vilāsa* account summarized above seems almost tailor-made for the palm-leaf illustrators, who follow it with fidelity. Our two very different artists show precisely the same configuration for the snake, determined by the need to make the verses cross on the same syllables. Śatrughna's first version reads succinctly from the text on the right to the left (Figure 100). His second composition is reversed and more hieratic, with the serpent *bandha* dominating the scene (Figure 95). All of Michha Patajoshi's versions are more relaxed and filled with narrative verve, spreading over two full pages the scenes of the knot, the shooting of the trees in a row, and the subsequent invocation of Viṣṇu in the form of a wheel (Figures 110, 111). Characteristically Michha creates similar but not identical compositions: the trees shown as standing in 1902 (Figure 110) in later manuscripts topple over, their trunks severed (Figures 119, 130). That the serpent's head touches Rāma's foot and that its body weaves among the trees distinguish this version from the somewhat similar configuration at Buguda.

For the fight between Vālin and Sugrīva, Śatrughna again places the main event centrally, emphasizing the monkeys by scale over Tārā to the left and Rāma's party to the right (Figure 96). Michha Patajoshi, on the other hand, separates out each turn of the plot episodically and with equal weight (Figures 131–33). The beautiful Tārā is made fully human by both artists, and her curse is explicitly and emphatically depicted by Michha (Figure 133).[63] Śatrughna goes on to develop the scene of Rāma's grief in the rainy season vividly, with one of the first extended sections of the manuscript that is depicted at right angles to the palm fronds themselves (Plate 6). Painted black and outlined with white, the lobes of Mount Mālyavan resemble the clouds above. Diagonal gusts of rain convey emotional tension.

Among illustrated manuscripts of the *Lāvaṇyavatī*, Raghunath Prusti's unfortunately lacks the folio that would presumably have included the seven trees. When we can follow his version, with the death of Vālin, we find one of Prusti's complex compositions, forming a subunit that balances the building of the bridge at the opposite end of the same leaf (Figure 189). Prusti interweaves Rāma's shot at the pair of fighting monkeys with Vālin's collapse in the middle, breaking the tyranny of chronological sequence. The central scene, in which Rāma and Lakṣ-

maṇa seated on Mount Mālyavan address two monkeys, takes us well beyond the incidents we have been considering.[64] But possibly the inclusion of the standing Jāmbavan indicates that this is Prusti's reinterpretation of the unfamiliar scene of Lakṣmaṇa straightening his arrow at Buguda (Plate 11), given this artist's other references to those nearby wall paintings.

The unknown illustrator of the Dispersed *Lāvaṇyavatī* moves with his characteristic selectiveness through this portion of the story.[65] Thus Dundubhi's bone, a single stark tibia, rests between Rāma and his target, in a continuous composition that gathers momentum to the left (Figure 151). The delicate pattern of the seven trees is embroidered with various animals, including birds, which indicate that this artist was not guided by the statement in the *Vaidehīśa Vilāsa* that the serpent had frightened away birds. On the reverse of the same leaf, the usual fight between the monkeys is absent; instead, Rāma leans over the dying Vālin (Figure 152). Hanumāna holding a hill both reflects the canonical role of the subsequent Gandhamādana incident, discussed below, and evokes by a flash-forward the fact that Vālin's death was the price paid for the heroes' later safety. Finally to the right we find the same combination of incidents—the cock, the rainy season, and Rāma's news of Sītā—that we saw in Prusti's crowded drama, although the effect here is more lyrical.

The artist of the Round *Lāvaṇyavatī* neatly reduces each scene to the essentials and presents them with fidelity to the abbreviated list of this text (Figures 26, 27). For example, because the sal trees are mentioned before Dundubhi's bones (a limp skeleton here), they appear first. The rains become a fringed dark corner of the sky. And the crowning of the cock is as prominent as Vālin's death.

Balabhadra Pathy, on the other hand, emancipated himself from his text in order and in detail. Dundubhi's bones, an odd scaly mass to the left in Figure 168, precede the seven trees, which, while clearly labeled *sāla*, are shown with the fan-shaped leaves of the *tāla* palm. Pathy chose to emphasize the death of the monkey king, shown shot, reproaching the heroes, mourned by his wives, and finally cremated (Figure 169). This artist was in his element with Rāma's reaction to the rainy season, where dotted lines suggest both teardrops and tense energy (Plate 10, Figures 170, 171). Birds, frogs, and the lowering sky evoke the sounds of a storm, one of the most emotionally compelling images of this master dramatist.[66]

The brevity of this sequence in the *Lāvaṇyavatī* itself permits some of the differences just indicated. At the same time, it is worth underlining the similarity in the three surviving images of what is only mentioned as "splitting the trees." Despite their diversity of detail, there are obviously seven in every case, and all rest on the back of a serpent. This image had become firmly fixed in the mind of most Oriya illustrators, whatever their prescribed text.

HANUMĀNA IN LAṄKĀ

The fifth book of the Rāmāyaṇa in Vālmīki's Sanskrit centers on the grief of Sītā, captive in the asoka grove, and thus directly evokes the emotion of pity (*karuṇa rasa*) around which the entire epic is built. The plot here includes Hanumāna's great leap to Laṅkā,[67] his dialogue with Sītā, his confrontation with the *rākṣasas*

in which he is captured by Indrajita (who uses an enigmatic device identified only as a "Brahma-weapon"), the setting fire to his tail bound with oil-soaked rags, and his ultimate use of this blazing tail as a torch, with which he burns Laṅkā. This last event is emphasized in performances such as the Rāmalīlā of Bisipada and the Laṅkā Poḍi festival of Sonepur, in both of which this event constitutes *the* destruction of Laṅkā. Various factors may be at work here: local associations of the story; the theatrical possibilities of this event; *bhakti* currents, for which Hanumāna is a model. At any rate, we note repeatedly, if not universally, in Orissa an emphasis upon the monkeys as central heroes.

In Balarāma Dāsa's influential *Jagamohana Rāmāyaṇa,* some parts of Hanumāna's exploits are further embroidered. He is challenged by the local goddess Laṅkeśvarī at the gates of the town, he assumes other animal forms such as that of a bee, and he proves his bona fides to Sītā by recounting minor events known only to her and Rāma. The *Vaidehīśa Vilāsa* includes most of these details and adds particulars congruent with Upendra Bhañja's own intellectual taste.[68]

At the same time, in a few later texts we see a reduction of Hanumāna's entire visit to Laṅkā, which may also have multiple explanations: the competing development of the subsequent Book of Battle, Yuddha Kāṇḍa, or perhaps a certain weariness on the part of the author that leads to haphazard selection. At any rate, even in the *Adhyātma Rāmāyaṇa,* the Sundara Kāṇḍa is relatively brief and simply retains most elements from Vālmīki. Upendra Bhañja's *Lāvaṇyavatī* reduces this entire episode to a single elliptical phrase about Rāma: "To get news of his wife he sent a messenger." Thus Orissan tradition by the nineteenth century lacked consensus on the weight given to this part of the story, and a single poet might vary greatly in his emphasis.

No illustrations of the Sundara Kāṇḍa are preserved at Buguda.[69] In extended recent cycles in the *paṭa* form, however, scenes of Hanumāna with Sītā and of the burning of Laṅkā are common (Figures 234, 235; Appendix 5). The actual pictures of the city on fire are fairly diverse, some including a form of linear perspective in the diagonal walls and illusionism in the painting of the flames. The artist of the Parlakhemundi playing cards develops the chthonic form of the flaming tail, omitting rectilinear architecture, as is appropriate to his circular format (Figure 267). From this diversity I would infer that what is at work is the idea of this scene rather than any visual model, hence the ready acceptance of elements not in the Orissan tradition to illustrate it.

In illustrating the *Adhyātma Rāmāyaṇa,* Sarathi Madala Patnaik did not neglect this portion of the story, despite its abbreviated place in the text.[70] In a single copy we see Indrajita shooting Hanumāna with his Brahma-weapon in the form of a serpent knot (Figure 70) of the kind the artist also added to the shooting of the seven trees (Figure 69), perhaps once again conflating the *Vaidehīśa Vilāsa,* which mentions a Nāgapāśa, with this text, which does not. Sarathi Madala's own lack of consistency in illustrating this entire sequence is characteristic of him.

Michha Patajoshi illustrates the three cantos of the *Vaidehīśa Vilāsa* devoted to Hanumāna's visit to Laṅkā with his usual enthusiasm.[71] For the final burning, it is clear that this artist is at his best in depicting the human situation—the glee of the *rākṣasas* as they light the tail, Hanumāna's equally eager escape, the conster-

nation of the women of Laṅkā fleeing with their children (Figure 135). On the other hand, his version of the burning city, its roofs lit by tiny flames, is not particularly vivid, whereas Sarathi Madala Patnaik dramatically juxtaposes bold spikes of fire with empty space (Figure 52).

The scant mention of this sequence in the *Lāvaṇyavatī* makes its omission in most illustrated manuscripts no surprise. What is unexpected, and in fact constitutes a major reason for dwelling on this episode, is that one manuscript goes overboard in depicting this section despite its absence in the text. This is the work of Balabhadra Pathy from Jalantara, who devoted twenty-four folios to illustrating Hanumāna's visit to Laṅkā. Nor does his text interpolate any verses here. In fact this is the end of what we have of this copy of the *Lāvaṇyavatī*. While subsequent folios may be missing, it is conceivable, because of the discrepancy between text and images, that either Pathy or his patron lost interest in the project.[72] The images of Hanumāna's exploits show a vigor that relieves Pathy's sometimes mannered compositions (Figures 172, 173). And two of his most effective scenes depict the burning of the city, compositions that put other illustrators in the shade (Figure 174). Long colonnades licked by seething pink flames set off Hanumāna's ebullience and the multiple limbs of Rāvaṇa, heightening the drama of the conflagration. It is again remarkable that Pathy devoted almost fifty images to a sequence of events mentioned in less than a line of the text he himself copied.

BUILDING THE BRIDGE

The sequence of episodes in which Rāma defies the Ocean, the monkey Nala directs his cohorts in building a causeway (*setu*), and the entire army crosses over to Laṅkā is a favorite one for illustration in sculpture. The sequence includes Rāma's heroism, Nala's skill as an engineer, and the community effort of the monkeys and leads into the final victory over Rāvaṇa. Thus this episode was the principal subject of the Prakrit poem *Setubandha*, where description surpasses narrative action.[73]

In later texts in general, two kinds of additions are made to this episode. First, the bridge itself was embellished with a Śiva *liṅga*, for example in the Sanskrit *Adhyātma Rāmāyaṇa*, where the Śaivite frame for the entire story makes this element understandable.[74] In the Oriya translation of that work, however, yet a further invocation of Jagannātha was added before the building of the bridge, reflecting local religious priorities.[75] A second addition in various vernacular and folk versions is the story of the squirrel. This humble creature helps in building the bridge by shaking off the sand that sticks to his fur. Rāma rewards him with the sacred stripes on his back that characterize the Indian squirrel.[76] Both incidents are present in Balarāma Dāsa's *Jagamohana Rāmāyaṇa* and are common in other Oriya versions.

The *Vaidehīśa Vilāsa* gives a particularly charming account of this episode, beginning with the curse that made anything Nala dropped into water float; here the *setu* is clearly conceived as a bridge rather than as a solid causeway, as in Vālmīki.[77] The great mountains such as Mount Meru are caught off guard by the monkeys coming to rob them of the peaks.

and here, as in other late versions, the monkey is detained on the way by the demon Kālanemi, a master of disguise, who offers him water from a pond inhabited by a crocodile that attempts to devour him. Hanumāna kills the beast, again brings back the entire mountain, and rescues Lakṣmaṇa.[90] Balarāma Dāsa and Upendra Bhañja (in his *Vaidehīśa Vilāsa*) ascribe the first rescue to Garuḍa and make both Rāma and Lakṣmaṇa victims of Indrajita in the second case. They also include the Kālanemi episode with the crocodile. Subsequently in both accounts Bharata sees Hanumāna flying back with the mountain and shoots at him by mistake, an incident that the two keep secret.[91] In general, Oriya (and other vernacular) authors depart considerably from Vālmīki in the Yuddha Kāṇḍa, introducing complex episodes such as the story of the *rākṣasa* Mahīrāvaṇa, which in turn involves the goddess Durgā as protector of the heroes.[92] It would seem that the chaos of seesawing battles on the one hand gave the teller fewer guidelines for the plot and on the other hand made the intrusion of local concerns appropriate.

At Buguda, two long panels under the eaves (hence hard to see and today abraded) as well as the entire prominent south wall are devoted to the melee (Figures 212, 213). Amid flying arrows, the large figures of the heroes and Indrajita, Kumbhakarṇa, and finally Rāvaṇa are visible. On the lower wall at the viewer's level, beneath the first battle, stands the isolated figure of Hanumāna holding the mountain (Figure 211), paired with Garuḍa with a snake on his head (Figure 210).[93] The juxtaposition of these two isolated profile images and the two virtually identical figures of Viṣṇu, seen frontally, that flank the second battle in the same way, suggests a departure from the narrative context, in which both Hanumāna and Garuḍa take part in the fighting. While appropriate to the battle, they also evoke the iconic form in which both may have been commonly worshiped in rural Orissa. In the case of Hanumāna, images smeared with red lead, such as that in the Gaurī compound (Figure 284), provide a generic model, cast in elegant form by the Buguda painter.

Among the isolated *paṭa* paintings produced today, the same image is popular, as one might expect. What is unexpected is the frequent depiction of Bharata shooting Hanumāna (Figure 255). Perhaps this minor incident, seemingly peculiar to eastern India, appealed as an illustration of the confusion of alignments during the fighting, which led Bharata and Hanumāna themselves to hush up their confrontation as putting them both in a bad light.

In the *chitrakāras'* longer cyclical treatments of the story, the first incident with the snake-weapon is common, but Jagannath Mahapatra is alone in introducing the second felling of Lakṣmaṇa by Rāvaṇa (as in the *Adhyātma Rāmāyaṇa*) and Hanumāna's return with the herbs (Figure 238). In fact a monkey appears flying with a small hill and/or a tree in the two pictures preceding his rescue (and in Figure 242 as well), indicating the centrality of this event to Hanumāna's identity. He has become eternally the bearer of the mountain. Jagannath Mahapatra also unexpectedly follows this event with the Mahīrāvaṇa episode (Figures 239–41), which is limited to two textual sources in Oriya discussed in Chapter 1. Here he may well have been influenced by the prominence of Mahīrāvaṇa in the Sahi Jātrā performances of Puri (Figure 45). In recent years his son-in-law, Sridhar Mahapatra, has acted the role of Durgā in the Sahi Jātrā, and the particular connection of the Raghurajpur painter community with that celebration can be documented.

This connection may be limited to the past three decades, but it is significant because it suggests how personal ties might lead to the inclusion of a distinctive version of the story.

In 1875 Sarathi Madala Patnaik amply illustrated this sequence in the *Adhyātma Rāmāyaṇa* with three images of the Kālanemi episode as well as Hanumāna carrying Mount Gandhamādana (Figure 53). In both manuscripts made in 1891 he eliminated the mountain-bearing form of the monkey altogether and reduced the story to Rāvaṇa's attempt to lift Lakṣmaṇa and one scene with Kālanemi (Figures 65, 66). By 1902 there were no images of this section at all. While this artist had consistently been unpredictable in his narrative choices, it does seem that in his later copies of this text the number of pictures progressively decreases, as if he had lost interest.

His 1899 *Durgā Stuti* and *Hanumāna Stuti* concern this portion of the Rāmāyaṇa, albeit from a different angle. Here Indrajita's serpent-weapon is illustrated by the same serpent *bandha* that Sarathi Madala inserted in the *Adhyātma Rāmāyaṇa,* as well as by separate, more naturalistic, serpents in the air (Figures 83, 84). Durgā precedes Garuḍa as deliverer. In the *Hanumāna Stuti,* the monkey carries a small token hill (Figure 85). In several scenes here, his tail is depicted as ending in the head of a snake (Figure 86). Vālmīki compares his tail to a snake,[94] and this *stuti* itself praises Hanumāna—"You who have Nāgarājā in your tail, the earth at your feet, Brahma in your navel."

Michha Patajoshi illustrated this portion of the *Vaidehīśa Vilāsa* with inventive detail. No flagging spirits for him, unlike Sarathi Madala Patnaik. Thus he continued to add details to the visit to Kālanemi's ashram as late as his 1926 manuscript (Figure 137). While Hanumāna holds the mountain aloft, his pose varies and is rooted in specific situations, suggesting that Michha Patajoshi was not particularly guided by the popular icon type (Figure 112). Nor was Śatrughna in the Baripada *Vaidehīśa Vilāsa,* where amid many large iconic groups spread over multiple folios, a small Hanumāna with the mountain is unobtrusively tucked away on a single leaf.

The *Lāvaṇyavatī,* brief as its account is, mentions a number of sequential details: the serpent-arrow was checked by Garuḍa; Indrajita used his Brahma-weapon, Hanumāna brought Mount Gandhamādana, Bharata saw him, and Lakṣmaṇa was saved. These details are clearly rendered by the artist of the Round *Lāvaṇyavatī,* along with the intervening death of Kumbhakarṇa (Figures 30–33). The artist of the Dispersed *Lāvaṇyavatī,* on the other hand, willfully conflates these episodes, so that Rāma and Lakṣmaṇa both lie bound with serpents, and then we see one of the heroes, presumably Rāma, battling *rākṣasas,* while a tiny Hanumāna flies through the air with tree and mountain (Figure 154).[95] The contrast between the prostrate heroes and the active scene to the right is effective, and the imagery seems almost deliberately ambiguous and open to plural interpretations.

Finally, Raghunath Prusti also handled his given text with freedom, in part borrowing from Buguda, in part altering that model. His folio 81 includes the two battles with Kumbhakarṇa and Indrajita, each with a dense rain of arrows, as in the wall paintings (Figures 212, 213); but they occur on opposite sides of the leaf so that each balances a scene constructed with very different texture (Figures 191, 192). Garuḍa and the serpent-arrow are omitted altogether. The fallen Lakṣmaṇa

is accompanied by Rāma and his allies. Then Hanumāna flies with the mountain and stands, confronting Rāma again in a clear selective version of this episode. The resemblance between the mountain and the rocks held by monkeys building the bridge on the previous page might be understood as a convention, although the accomplished Prusti, able to depict hills with many variations, seems also to develop a deliberate continuity in the devoted activity that the monkeys undertake. His repetition of Hanumāna in two successive images evokes the bridge scene and also enables him to include the generic flying icon alongside the neatly balanced dialogue between Rāma and his devotee. The subsequent scene labeled "monkeys attacking Laṅkā" with Mandodarī seated inside is unexplained by this or other versions of the story, although not inappropriate. Again Prusti seems motivated by desire for visual drama rather than by a given narrative agenda.

THE CONCLUSION

What is the conclusion to the Rāmāyaṇa? The most pressing question raised by the final illustrations is not a matter of variant versions of the story, upon which I shall not dwell, but of selection and emphasis among broadly agreed-upon events. Vālmīki's plotline for the fighting leads up to Rāma's shooting of Rāvaṇa. After various lamentations in Laṅkā, Vibhīṣaṇa is crowned. Sītā must undergo an ordeal by fire to prove that her virtue did not suffer during her abduction. Rāma is installed as king of Ayodhyā. Then follows the seventh book, the Uttara Kāṇḍa, in which Sītā is banished because of the mere rumor of her infidelity with Rāvaṇa. Her banishment leads to the meeting of the twin sons, born when she is sheltered by Vālmīki in the forest, with Rāma's forces, and ultimately to her final vindication and return to her mother, the Earth. The Uttara Kāṇḍa includes other topics, such as an elaborated version of the previous history of Rāvaṇa, but it is the arguably unjust treatment of Sītā that has garnered literary comment and has led to the general omission of this entire book from depiction in sculpture.[96]

These events are largely present in late Sanskrit versions such as the *Adhyātma Rāmāyaṇa*. The fire ordeal becomes an occasion for the exchange of the real Sītā for the illusory one who has taken her place since the abduction. In the Uttara Kāṇḍa, the banishment of Sītā is again explained as an illusion that enables her to escape from this world and to be joined eventually with Rāma in Vaikuṇṭha, or heaven; in this version there is no direct conflict between father and sons, born in exile. Balarāma Dāsa's *Jagamohana Rāmāyaṇa* is broadly similar, as is Upendra Bhañja's *Vaidehīsa Vilāsa*, which, however, omits the events of the Uttara Kāṇḍa altogether. Likewise the Rāmalīlās as they are actually performed conclude with Rāma's coronation at the end of the Yuddha Kāṇḍa.[97]

In the *paṭa* tradition, there is some diversity as to where the story ends, although the coronation of Rāma is often presented climactically. The last identifiable scene at Buguda is the great battle between Rāma and Rāvaṇa on the south wall; the detail illustrated in Figure 213 conveys the dense texture of the melee. Among the damaged portions whose subject is unclear here and on wall L there is no large, hieratic group that seems a likely candidate for the coronation. Yet that event is singled out for depiction in the murals of the Gaṅgāmātā Maṭha in Puri, which may go back to the nineteenth century (Figure 214).[98] The coronation

also figures prominently in narrative *patas,* both of the Puri area (Appendix 5) and the far southern school of Chikiti (Figure 270). In both areas it is standard that Rāma sits with Sītā to the right, that Hanumāna rubs his foot in devotion and that Lakṣmaṇa is included as an attendant. This is precisely the form that this event takes in the wood carving of Dharakot (Figure 286), whose style in general seems close to that of the Buguda paintings. In central Orissa, the coronation has also become a standard part of rural wedding pictures, painted above the door by members of the same community who produce *patas* (Figure 262).[99] This common usage may have reinforced the role of this event in *patas* also.

What meaning did the coronation of Rāma hold? A connection between a current ruler and Rāma enthroned as king may go back to the carving of Konarak mentioned in Chapter 3. This scene is also prominent as a conclusion and epitome of the Rāmāyaṇa in south India, where political significance contributes to its selection in the context of a temple. Rāma-rāj signifies the return of the righteous ruler. In the context of wedding paintings, the event may evoke the happy reunion of the couple more than the consecration of Rāma as king, although that is indeed depicted. In folk theater, including the Rāmalīlās in which action prevails over such static scenes, the coronation is often presented as a *jhāñkī,* or tableau, in which the audience prays to the actors as the gods incarnate. On the whole, this scene is fully auspicious at a macrocosmic (political) and a microcosmic (personal, emotional) level.

On the other hand, an exceptional, if influential, lineage of the *chitrakāras'* work, Jagannath Mahapatra's set of seventy-five pictures, does not stop with or particularly emphasize the coronation.[100] Here thirteen images are devoted to the subsequent Uttara Kāṇḍa, emphasizing an Oedipal conflict between the two young sons and Rāma's forces (Figures 245–52, Appendix 5). Nor is there any slackening of the artist's skill and enthusiasm in this section; witness the clever treatment of flying monkeys who carry rocks not only in their hands (the old image of Hanumāna with Mount Gandhamādana), but also wrapped in the tail (Figure 248).[101] The final two scenes are unique, to my knowledge, aside from later copies of them. Sītā disappears pathetically, if oddly, into the cracked earth (Figure 251). And Rāma ascends to heaven atop a large lotus, with the small figure of what may be a celestial *apsaras* in the center (Figure 252).[102] Both demonstrate that within this tradition there was freedom to improvise new images (albeit in both cases colored by the model of the coronation), which in turn entailed some risk of incomprehensibility.

In his illustrations for the end of the *Adhyātma Rāmāyaṇa,* Sarathi Madala Patnaik is, once again, inconsistent. For example, the treatment of even so straightforward a detail as the way Rāvaṇa's twenty arms are attached to his body might lead one to question whether various works with his name in the colophon are indeed by one hand.[103] His versions of Sītā's ordeal do not place her in the fire, but rather seat her to the side or in what seems to be a sacrificial pit, or *kuṇḍa* (Figure 67). In all his manuscripts the Uttara Kāṇḍa is included and the illustrations become increasingly sparing and depict static dialogues between a few figures. His 1875 manuscript follows the Uttara Kāṇḍa with a large coronation on three joined folios, accompanied by a single Sanskrit *śloka* (Figure 55).

What survives of yet one more copy of the *Adhyātma Rāmāyaṇa* is the Uttara

Kāṇḍa alone. Its artist selected different scenes but the effect is as static as that of Sarathi Madala's version.[104] The difference between the two somewhat amateurish but inventive styles is visible in a comparison of their final images. Sarathi Madala frames a conventional coronation of Rāma with stiff, standing attendants (Figure 55). The second artist weaves a pattern of concentric wavy lines around his squat figures, which is hard to read but does suggest the celestial realm (Figure 81). In the five surviving images from this work we see a selection of those portions of the Uttara Kāṇḍa that have nothing to do with Sītā's sad story.

The two illustrators of the *Vaidehīśa Vilāsa* predictably give different twists to the end of the poem. Śatrughna, with his penchant for large formal scenes overlapping several folios, provides several striking renditions of the coronation in both his manuscripts (Figure 101). Variants on the same scene seem devised as excuses for elaborate architecture and decorative touches. Michha Patajoshi, on the other hand, takes more interest in individual events, such as the way Rāvaṇa's body is transported (Figure 138). Sītā's form, during her ordeal, appears hauntingly within the fire (Figure 122); in visual as well as thematic form it recalls the creation of Māyā Sītā halfway through the epic (Figure 109), and hence leads back to the realm of reality. The final pictures show the coronation, less as a static emblem than as an event accompanied by processions and festivities, spread across the horizontal format of the folio (Figure 123).[105] Even Puṣpaka Vimāna, carrying the happy couple, may be shown on its side, an exceptional expedient for the straightforward Michha that does justice to the rich form of the chariot (Figure 139).

The *Lāvaṇyavatī* text refers to the following incidents: Rāma hits Rāvaṇa's navel; Vibhīṣaṇa is crowned; Sītā is purified; and they return to Ayodhyā, where Rāma becomes king. The final illustrations of this section are missing in two of our manuscripts, the works of Balabhadra Pathy and of Raghunath Prusti. The artist of the Round *Lāvaṇyavatī* illustrates all five incidents—devoting a full page to the vividly isolated death of Rāvaṇa and uncharacteristically reversing the sequence of Vibhīṣaṇa's coronation and Sītā's test (Figures 34–40). The latter event is shown as dramatically as in any version, with Sītā rising above the flames and extending a Michelangelesque gesture toward the sage who performs the ceremony.

In the Dispersed *Lāvaṇyavatī,* a full page is devoted to the test, with Sītā enclosed but not hidden by the flames in a delicate image, while Rāma and his followers await the results (Figure 155).[106] The reverse bears his coronation, spread out horizontally to emphasize the relatively large Hanumāna, who holds Rāma's foot (Figure 156). This is less an iconic group, as in the *paṭa* tradition, than a chain of linked figures, emphasizing the central relationship between Hanumāna and Rāma, whose glances connect poignantly across a void.

In both these *Lāvaṇyavatī* manuscripts, and apparently in Prusti's as well, the entire Rāmāyaṇa sequence is clearly embedded within the framework of the larger poem. The story constitutes a kind of Rāmalīlā, performed by a magician, in which Lāvaṇyavatī is led to identify herself with Sītā, giving her love for Chandrabhānu, whom she sees in Rāma, both a literary and a religious cachet. While a missing page prevents our full appreciation of Prusti's treatment, we do have his unique scene (not found in the other manuscripts) of the princess rewarding the enter-

tainers, who throw their scarves in the air, demonstrating the theatrical status of the preceding ten pages (Figure 193). In the dispersed manuscript, Lāvaṇyavatī sits watching the coronation of Rāma, framing that as a performance (Figure 156). The round manuscript follows this same pattern, repeating the actual coronation three times as if to spell out the relationship between its actors and the characters in the main story (Figures 38–40).

On the whole, the four illustrators of this text considered here take the entire Rāmāyaṇa sequence seriously, more than the poet's own attention to it might require. It is to be underscored that this is not the case with all illustrated copies of the *Lāvaṇyavatī*. Thus in the brightly colored National Museum manuscript, the coronation alone stands for the whole story, and this scene is not emphasized above others such as the immediately preceding illustration of the framing story (Figure 140). The images of the four manuscripts that do elaborate the Rāmāyaṇa performance within this tale represent diverse responses to the plot and to other traditions of depiction of these religiously weighted events. At the same time, each grants the sequence a kind of hallucinatory status, which is in keeping not only with Upendra Bhañja's poem but also with the broader meaning of the Rāmāyaṇa in Orissa.

5 ∴ Narrative Strategies

To apply the terms "narrative" and "strategy" to the making of pictures requires some defense. "Strategy" may seem to imply deliberation on the part of the artist. Yet in the case of the Indian artisan, other forces are usually assumed to override the will or problem-solving role of the individual maker. On the one hand, one might expect the high-caste patron or a learned intermediary such as a *rāj-pandit* to play a guiding role. Chapter 2 should have made it clear, however, that such guidance is demonstrable neither for the artisanal *chitrakāra* nor for the Orissan book illustrator. On the other hand, one might expect revered artistic tradition, known in India as *paramparā*, to guide particularly the professional painter. In fact, even for him there were choices among models, although he may not always have articulated the way he reached his own decision. The palm-leaf illustrator was more likely to work without specific visual models. The very diversity of illustrated books produced in one small area and at one time is a central theme of this book. At the very least, "strategy" may be understood as a shorthand for choices implicit in the work itself and the way *it* addresses its problems, whatever the human locus and process by which such decisions were made. Precisely because we might wonder whether choices are not made in response to earlier images, it will be necessary to keep visual models in mind.

The problems "narration" presents are great enough when applied to words, let alone to images. From the Latin root *narro*, "to tell," the term has diverse implications, much discussed in the subfield of narratology. In Indian languages there seems to be no exact equivalent. In Oriya perhaps the closest word is *vivaraṇa,* which, however, is more literally translated "coloring," hence "description."[1] Yet in English, "description" has been thought to concern a static condition, diametrically opposed to "narration," which concerns action.[2] This polarity does not really exist in India, hence a less consistent concern there with action, sometimes equated with "narrativity" in Western critical writing. At the same time Oriya, Sanskrit, and most north Indian languages freely use the word *kathā*, from a verbal root "to tell," which can be equated with "story," a basic form of narrative.[3] Thus it is possible to consider Indian literature as narration without expecting the categories of Western analysis to fit precisely. Let me say at the outset that I do not

conceive of narrative as a distinct genre but rather as a procedure (telling a story) found in various types of poetry and prose, both read and heard, including theater.[4] In an effort not to impose inappropriate standards from a foreign evaluative tradition, or even from other Indian traditions, I shall avoid using "narrativity" as a criterion for artistic success.

Surely some fundamental elements in the structure of telling are universal. In the first place there is a *narrator,* the teller of the tale. The narrator has long been recognized as a feature of Indian literature, implying an awareness of the subjectivity of the account that has only recently been made explicit in the West. Thus in the Sanskrit epics authors are encoded in the action (Vālmīki in the case of the Rāmāyaṇa), in drama the director (*sūtradhāra*) appears onstage, and in Indian stories a commentator often links the sequence of episodes. In the case of Tulsī Dās's Hindi version of the epic, there are four symmetrical narrators, who in turn correspond to four interpretations of the same events and accommodate the pluralism of the Indian tradition.[5] The *Adhyātma Rāmāyaṇa* is comparable, if less symmetrically constructed. Oriya literature seems even less systematic in general, yet the Rāmalīlās may present as their teller Vālmīki, Śiva, and also the particular historical author, such as Vikrama Narendra, whose name recurs constantly in the chanting at Dasapalla.

In the second place, there is the *tale* itself, with subcomponents such as plot, characters, and language. Here we may turn to the theoretical writing about drama, admitting that not all narrative is drama and that at least some recent drama is minimally narrative. The component of plot has preoccupied Western theoreticians from Aristotle onward, with attention to time span and sequence (both actual and narrated).[6] Indian theoretical literature dwells more on language and an elaborate system of tropes, whereas plot is a secondary element.[7] Yet in both traditions there are some normative codes governing action, which vary with genre and with the taste of particular periods.

The third major component of narration is the *hearer* of the tale. Indian literary theory accords a more important role to the audience than has usually been granted in Western writing, albeit a role responsive to the work of literature itself. The point of classical Indian literature, whether narrative or not, is to evoke sentiments in the hearer. These sentiments, usually numbering eight or nine, are known as *rasa,* literally "flavor" or "essence," for they are distillations of ordinary human emotions. Experiencing them is in itself pleasurable and uplifting for the ideal connoisseur (*rasika*); their effect is thus unlike catharsis, which purges the audience's undesirable and real feelings of pity or fear. Suspense plays a small role in general in a tradition such as India's, where most plots are already familiar. Yet the mood of awe and wonder (*adbhuta*) is comparable to suspense when an outcome is remarkable.

Rasa is one key to the Sanskrit Rāmāyaṇa, often described as built around the distilled sentiment of pity or pathos.[8] What is important is not whether cut-and-dried systems in fact govern all works of literature, but rather the way in which Indian tradition has long incorporated the listener into the tale, as in recent Western reception criticism. Moreover, recognizing the centrality of mood helps us to understand the prolongation of sequences that present relatively little infor-

mation or action but convey emotion in a way that the West has sometimes dismissed as sentimental.

Can we transfer such a framework to visual images when we talk about narrative pictures? Obviously it would be a mistake to project the elements of one artistic medium upon another, even though they may at times intersect in function, such as in telling stories. India generally recognized an immense gulf in social status between the makers of images and authors, as well as a gulf in the way images and texts are viewed. Still I shall argue that pictures may imply the same three fundamental components as verbal narration.

There is a teller, ultimately the artist, who may call attention to his presence by a signature or, in the recent West, by his very brushwork, as in action painting. In India the intrusion of the artist is often minimal, yet one of the two Orissan traditions considered here, the palm-leaf manuscript, frequently records his name in the colophon. The fact that he is identical with the scribe makes clear his status as narrator, repeating an oft-told tale. Moreover, the author of the text may appear in Indian painting when he plays a prominent role in the story.[9]

Likewise pictorial narration assumes an audience. This component of narrative may seem more largely implicit for images than for words, although a device such as linear perspective literally predicates where the ideal viewer stands, which in turn affects the emotional impact of the image. If the beholder's viewpoint is at ground level, the scene is almost inevitably awesome and overwhelming. At least one revered Indian text on painting, the Chitrasūtra of the *Viṣṇudharmottara Purāṇa,* describes *rasas* in particular images and prescribes some moods as suited to pictures on the walls of ordinary houses, some only to those of palaces.[10] Again the palm-leaf book that includes poetic text and images seems devised for an informed audience, the *rasika,* or connoisseur. The *paṭa chitra,* on the other hand, addresses any visitor to Puri.

The central element, the tale, may be equated not only with sequences of images, which are the principal concern of this book, but even with individual pictures. In that case we may be tempted to distinguish the narrative picture from the iconic (in India) or from the descriptive (in the West), although there are many mixed examples of both. If only one moment is depicted, multiple events may nonetheless be evoked. Because some elements of the story seem almost inevitably more ambiguous in a single image than in a linear verbal account, one may doubt whether such images are ever truly narrative. Plot sequence cannot necessarily be deduced when we see two figures side by side. Yet it should be remembered that even in a verbal story the order of telling need not correspond to the order in which events occur and that deliberate ambiguity is a legitimate literary device. Likewise we have some rules by which an image is to be read, although many pictures flout these rules. Sequential images are usually seen in a particular order, although we are not prevented from altering that order, whereas reversal is difficult in hearing a story, viewing a play, or reading a novel. Sequence in turn may have implications for causation and for interpreting what happens; hence words often produce a stronger causal certainty than do images.

Other constituents of the tale, such as Aristotle's categories of character and spectacle, are on the other hand often less ambiguous in a picture than in verbal narrative. It is almost impossible to avoid saying *something* about where an event

takes place or what a character looks like in a picture. The element of "language" is obviously replaced by the physical materials of the image or, more generally, by color and line, which follow their own systems of metaphor and associated meaning.

Finally, in the case of images explicitly accompanying a text, as in an illustrated manuscript, one might expect the text itself to determine narrative choices. "Illustration" implies some dependency upon a pre-existent written story, which leads me to avoid that loaded term as much as possible.[11] This study is fortunate in presenting several situations that test this assumed dependency. We have four examples of a single text (the *Adhyātma Rāmāyaṇa*) made by the same artist, as well as a second and quite different text (the *Durgā Stuti*) illustrated by the same person. There are also multiple examples of another text (the *Vaidehīśa Vilāsa*) by two different artists. Finally we have four examples of the same concise text (the *Lāvaṇyavatī*) illustrated by four purposeful and very distinctive artists. For the theoretically inclined, all these examples may seem unnecessary to my basic contention, that the artist *must* be regarded as a narrator himself. For the empiricist, however, they may at least demonstrate the variety of relationships possible between the artist and his text. The issue here is not whether he understood the text but rather whether he told his story in the same manner that it did. With this framework in mind, let us examine each of our works or cycles of images as a tale in which events and details are selected, presented in a sequence, and in the process emphasized and interpreted for the viewer. Here, unlike the previous chapter, we will look at each cycle as a whole or in long sequences, rather than dwelling on individual pictures.

SARATHI MADALA PATNAIK'S *ADHYĀTMA RĀMĀYAṆAS*

I shall begin with cases where we can discern the artist's role as narrator most clearly. Sarathi Madala Patnaik's copious oeuvre from the late nineteenth century includes four illustrated manuscripts of the *Adhyātma Rāmāyaṇa*. As the table in Appendix 1 shows, there is surprisingly little consistency among the four in the choice of scenes to be depicted. When a scene does appear in several versions, it is rarely very similar in composition or detail, as I argued in Chapter 4.[12] Clearly Sarathi Madala did not retain one of his own works, nor did he work from another illustrated manuscript that served as a model.[13] He may be compared to an oral performer who varies each telling of a tale, improvising rather than attempting to replicate a previous version.

Given this procedure, what particular slant can we discern in his various performances? First, the pace of illustration in his manuscripts follows a certain pattern. There are many illustrations in his works, certainly more than in the work of a second artist who illustrated this same text (C. L. Bharany Collection, ms. no. 2; see Appendix 1, column 6, [Bharany Collection anon.], Figures 78–79), although roughly the same number as in the work of a third (anonymous, National Museum 75.536; Appendix 1, column 5, Figures 75–77).[14] Sarathi Madala's first manuscript has the most pictures, often one on each side of every folio. In all his manuscripts the ratio of images to text decreases toward the end, when more and more pages are devoted to text alone. Like other scribes, he seems to have copied

the text first, leaving blanks for the images; in his third manuscript, several blanks in the last quarter of the text have not been filled in. Thus the slackening pace of pictures is in part deliberate and not directly the result of exhaustion on the artist's part. One gets an impression that Sarathi Madala produced illustrated books primarily as commodities, although he gradually lost interest in the pictures during the course of work on each manuscript and during his own lifetime.

Some of the distinctive characteristics of the *Adhyātma Rāmāyaṇa* outlined in Chapter 1 are not particularly visible in any artist's illustrations for this text. Perhaps the abstract doctrines of monistic Vedānta would have been difficult to depict, and it is no wonder that long devotional sermons such as Ahalyā's paean appear as uninterrupted passages of text. In one manuscript Sarathi Madala does show the creation of Māyā Sītā, albeit not in a visually self-explanatory form (Figure 59), and the illusory deer is repeated emphatically with the two heads that might serve as an emblem for illusion. Nonetheless, flipping through the illustrations of this text, one would not guess it is a particularly philosophical or devotional version of the story of Rāma. Nor do all of Sarathi Madala's pictures tally with what the text says. For example in his image of the seven sal trees done in December 1891, the knotted serpent must be drawn from some separate illustration of a *sarpa-bandha* and has no particular place in the *Adhyātma Rāmāyaṇa* account. In short, Sarathi Madala seems to have paid scant attention to the words he repeatedly copied.

The impact of his pictures is fairly uniform, more so than is that of two anonymous illustrators of the same text. He is more likely than the other two to omit actions that might seem central to the story, such as Lakṣmaṇa cutting off Śūrpaṇakhā's nose (absent in both 1891 versions) or Jaṭāyu's battle with Rāvaṇa (absent in both 1891 versions and in 1892). When action is depicted, the effect is rather static. For example, Rāma merely confronts the magic deer, and in the one case when he shoots it, the two stand squarely and a horizontal arrow connects them (Figure 51). Many scenes consist of several figures confronting each other in a row. Nor does a sense of action emerge from successive pictures that include the same figure in a different pose. Settings are rarely elaborated unless they are an essential part of the event, as in the building of the bridge to Laṅkā. Many symmetrical compositions center on Rāma, corresponding to particular situations but emphasizing their iconic character. And there are many "frame" scenes in which we see the narrator of the story, generally Śiva and Pārvatī. Such compositions produce an effect like that of storytelling that abounds in repetitions, so that the content is easily assimilated. While plot development and action are not stressed, the result is a legitimate form of oral narrative.

I must also grant that all I have said applies less fully to Sarathi Madala's manuscript of January 1891 than to his other works. Here settings are more elaborated and compositions more varied, with few simple series of standing figures. Some scenes are memorable, such as the mutilated and disheveled Śūrpaṇakhā kneeling before her distraught brother Rāvaṇa, framed by twisted trees (Figure 58). We do not know the precise circumstances under which Sarathi Madala produced this manuscript, the patron or the price that might have encouraged a greater concern with individual images. There seems no reason to look to some

biological framework of the artist's development for an explanation, for both earlier and later works fall into the more repetitive type. Perhaps the folklorist concerned with constant variations in oral traditions that have multiple existence or the musicologist concerned with performance traditions such as India's, where improvisation is mandatory, could provide a better framework than the art historian for such diversity. At any rate, Sarathi Madala does emerge as a village storyteller, much like the itinerant performer of rural Orissa today.

SARATHI MADALA PATNAIK'S *DURGĀ* AND *HANUMĀNA STUTIS*

This prolific artist was by no means limited to a single text. The *stutis* to Durgā and Hanumāna, while based on Rāmāyaṇa themes, do not present a coherent version of the plotline, nor do they include the metaphysical underpinnings of the *Adhyātma Rāmāyaṇa*. A generic devotee shown worshiping Hanumāna in the final illustration is conceivably to be read as Sarathi Madala himself, for the last verse of the text leads directly into the colophon, which begs indulgence for any mistakes by the scribe-illustrator.

The pace of illustration in this manuscript is entirely regular, with pictures on both sides of every page. This may be partly explained by the brevity of the text, with two *stutis* combined as they are in one *pothi*. Many illustrations are necessary to bring it up to the standard thickness of a book, in this case thirty-three folios. Similarly, the reduced number of illustrations in some *Adhyātma Rāmāyaṇas,* especially toward the end, may have to do with the cumbersomeness of the *pothi* bundle itself, particularly when the dimensions of each leaf are small, so that many leaves are required to cover the text.

Some details in the illustrations of the *stutis* bear out Sarathi Madala's awareness of the verses he had copied, for instance the depiction of Hanumāna's tail ending in a serpent head (Figure 86). At the same time, stock motifs are added that are not called for by the text, such as the two-headed deer (Figure 82). The serpent-weapon with which Indrajita enthralls Rāma and Lakṣmaṇa appears in the air as the familiar *sarpa-bandha* of the episode of the seven sal trees, which makes less sense here than would a composition in which the knot enveloped the brothers (Figure 83). This image is not easily read in connection with the next three pictures, in which Rāma and Lakṣmaṇa pray, standing before Durgā, and are subsequently felled by a number of actual serpents (Figure 84). In short, the artist borrows imagery from other kinds of narratives in an allusive way, without attempting to adapt it to the particular action of this story.

The compositions of these pictures are as repetitive and static as in any of Sarathi Madala's work. In the many scenes of the goddess or monkey with worshipers, such effects are entirely appropriate to the repetitive verses of the text itself. Scenes of confrontation, such as the serpents engulfing the brothers, are presented conclusively (Figure 84); this is not the indeterminate, tragic struggle of the Laocoön. Figures tend to simple vertical or horizontal positions. Such principles also govern Sarathi Madala's other works, such as the lyric poetry of the *Daśapoi* or the devotional images of the *Ārtatrāṇa Chautiśa.*[15] Thus despite the

improvisational character of his particular images, he was remarkably consistent in overall effect. As a storyteller he showed an enthusiasm and simplicity that would not tax the audience.

THE *RĀMALĪLĀ*

The unassuming manuscript of the *Rāmalīlā* composed by Krishna Chandra Rajendra must be considered briefly here as comparable to the work of Sarathi Madala Patnaik (Figures 87, 88). Like Sarathi Madala's shorter books, this one is illustrated profusely and with regularity, for a single picture occurs on each side of every leaf that survives. The unknown artist appears to follow the idiosyncrasies of this particular text, for example in substituting Navaguñjara for Jaṭāyu as the creature that attempts to stop Rāvaṇa (Figure 87).

The compositions, simple and with minimal settings, are similar to those of Sarathi Madala. None are as ambitious as some parts of his *Adhyātma Rāmāyaṇa* of January 1891. Nor are they quite as repetitive as most of his work. The figure drawing is slightly more adept and the poses slightly more varied. Nonetheless such a work shows what may have been the most common pattern of manuscript illustration—motivated by a desire to turn out illustrated works rapidly. These must have been acceptable if they reproduced the desired text and enlivened that with pictures. But no single picture seems to have caught the attention of the artist for long or to have been designed for the viewer/reader to linger over. Although Krishna Chandra Rajendra's text was utilized in performances, the illustrations of this manuscript have no more (and no less) to do with actual Rāmalīlā enactments than do other images under discussion.

ŚATRUGHNA'S *VAIDEHĪSA VILĀSAS*

Upendra Bhañja's long, demanding poem, filled with verbal conceits, is not the sort of text one might offhand expect to be depicted. In fact such ornate *kāvyas* in general and his work in particular were more commonly illustrated in Orissa than were many straightforward pieces of writing, perhaps reflecting both the general popularity of Upendra's work and the predilections of particular artists. Two artists preferred to work on the *Vaidehīsa Vilāsa* over other texts. The two differ radically in what they make of this complicated literary work.

Śatrughna, a karaṇa of northern Orissa, working early in the nineteenth century, was apparently unique in the way he organized his pictures. They frequently overlap several folios, surround irregular cartouches in which the text floats, and are oriented so that the entire manuscript must be turned perpendicular to the normal direction of reading. Each novel characteristic has its own effect in narrative terms.

The use of joined leaves to extend the composition beyond a single narrow palm frond enabled later artists to make complex iconic scenes in which a large number of figures gather around a deity and little or no text is included. The extended height of such pictures provides a break from the restricted format that had encouraged repetitive rows of figures or sequences of action. Indeed Śatrughna also created many large iconic scenes that stand out as "showstoppers"—

emphatic, courtly moments in the story such as Rāma and Sītā on Mount Chitra-kūṭa, Rāma's grief in the rainy season, Sītā's captivity in Laṅkā, or the final corona-tion (Plates 6, 8; Figure 101). His use of color adds to the broad resemblance between such compositions and the hieratic paintings of the *chitrakāra,* although there is no particular connection in figure style.

Yet Śatrughna's work is not consistently static to the extent that Sarathi Mada-la's was. The Baripada version of Tāḍakī lunges across five folios, dwarfing the brothers and creating wonder about the outcome (Plate 3). In many scenes a river winds across several leaves to create an unusually developed landscape, in the same way that Upendra Bhañja uses the setting as a mirror and foil to human action. There are several strikingly diagonal compositions (Figure 90).

Moreover, the device of orienting some scenes perpendicular to the normal way of holding the leaf produces variety, complexity, and at times confusion—the last surely deliberate in some of the final battles, where it is hard to pick out individual participants in the melee (Plate 7). In general the shifting orientation of various parts of the manuscript creates an effect analogous to the illusion that is one of the poem's concerns. In the same way, the vivid image of Māyā Sītā in the fire underscores this theme (Plate 5). The dispersed manuscript of the same text discussed above as an earlier work by Śatrughna lacks such effects, at least in the pages so far located. If my historical hypothesis is correct, the artist would seem to have achieved this bold and deliberate chaos in his maturity.

The prominence of color as well as the sheer wealth of images makes the Baripada *Vaidehīśa Vilāsa* exceptional among Orissa's manuscripts in the way the pictures tell the story. This effect is clearly not achieved at the expense of the text, as I have already suggested. The floating cartouches of writing play a more integral physical role in the impact of the book than does the usual format of separate panels that can be read independent of the pictures (or vice versa). In Plate 6 they function uncannily as clouds or mist. Their content, which of course must be grasped by holding the leaves perpendicular to the picture's orientation, is more effective in linking sky and earth than it would be if the writing issued from the mouths of the actors like the balloons in a comic strip.[16] In Figure 99, a line of commentary rises out of Ahalyā's rock. I find it hard to imagine the production of such a manuscript by the normal procedure of completing the text first with blanks for the pictures that are executed in a second "campaign," for the blank spaces here are clearly designed with specific compositions in mind, which might well be forgotten after a lapse of several months.

It is difficult to assess today the full impact of this manuscript, many of whose leaves are out of sequence. Even originally, it must have been difficult to read the text on joined leaves, which seems to require that one scrutinize the front and back in sequence, although the pictures compel one to look at one group together without turning them over. On the one hand, this may be viewed as an experi-ment, perhaps as an unsuccessful one, for no other artist took up the same format for a full manuscript. Later examples employ joined leaves as a coda to a conven-tional manuscript (Figure 55) or as a single one-sided picture with a brief text, composed of only a few leaves.[17] Śatrughna's own use of the adjective *vichakṣaṇa,* "ingenious," to describe himself, may be a more positive way of presenting the same phenomenon of novelty. At the very least, his work demonstrates that even

the seemingly conservative genre of palm-leaf manuscripts could tolerate experiment.

On the other hand, one might view the demanding nature of this work as a deliberate puzzle, analogous to Upendra Bhañja's poem. The audience was challenged to read the *bandha* (knot) in the same way that Rāma was challenged to straighten out the seven sal trees. The audience was yet further challenged to follow this manuscript, to figure out which way to hold it and which side of the leaves to look at next.[18] It worked like a complicated anagrammatic crossword puzzle, in which a literary passage is rearranged and can be reconstructed by solving partial clues and by a broader familiarity with the background text. If narrative is conceived exclusively in terms of action, this work shows inconsistent narrativity and would frustrate hasty attention to plot. Yet if narrative is a tale told to an audience, this work must have been effective in involving the viewer in its rich and subtle imagery.

MICHHA PATAJOSHI'S *VAIDEHĪŚA VILĀSAS*

This same text seems to have exercised an even greater attraction for the brahman Michha Patajoshi, who worked in southern Orissa in the first third of the twentieth century. The description by Kulamani Das quoted in Chapter 2 mentioned the illustrator's pleasure in showing an illustrated copy of the *Vaidehīśa Vilāsa* that he had made and in chanting its verses, suggesting that he both depicted and performed his story. Moreover, parts of eight versions of this text by Michha Patajoshi survive, and it appears that he kept previous copies with him, so that his pictures were consistent over time. The other two known works by this artist, *paṭas* on joined leaves depicting the Puri temple, were far less ambitious than the illustrated *Vaidehīśa Vilāsas* that he manufactured prolifically.

Michha Patajoshi's pictures for each copy of this text were copious. His books were large in scale, being among the thickest and longest Orissan manuscripts, as if he felt none of the restrictions that may have led Sarathi Madala Patnaik to reduce the number of illustrations toward the end of most of his works to keep them manageable. In fact Michha's pace of illustration is consistent in each work, and his later copies grew progressively longer as he expanded the number of pictures for some episodes.[19] There are more pictures in proportion to the amount of text than even in Śatrughna's highly pictorial work, to judge from the number of scenes devoted to each event.[20] One has the impression that this zesty illustrator saw no physical or artistic reasons to limit the number of pictures he could include.

Michha certainly did not struggle against the constraints of the palm-leaf format but rather welcomed them at a time when printed books must have formed an alternative, even in a traditional village like Balukeshvarpur. There is no difficulty in following his story, which proceeds regularly from left to right, front to back of every folio. Flashbacks are not distinguished—for example Ahalyā's tale of sin, which follows her liberation from the curse that followed it (Figures 104, 105)—for these may be assumed to be familiar to the audience. The pictures present events straightforwardly in terms that would make sense to people in rural Orissa during the early decades of this century. A detail such as the stretcher on

which Rāvaṇa is carried away is not so much an anachronism as a logical solution to the problem of transporting the body (Figure 138). Top hats and violins appear already in the 1902 manuscript. In case the images themselves are not clear, they are supplemented by the scribe's own chatty captions, which differ from Upendra Bhañja's text in their colloquial language and even in the use of more modern script forms. These captions float unframed within the pictures, whereas the text forms a counterpoint of more regular panels demarcated by small decorative borders.[21]

As the examination of individual scenes demonstrates, Michha Patajoshi seemed fully to follow the meaning of his favorite poem. There are virtually no discrepancies between pictures and text, although details may be embroidered, such as the squirrel at the building of the bridge to Laṅkā (Figure 120). In canto 19, a "garland of wordplay" (*jamakas*) devoted to the charms of Mount Chitrakūṭa, the artist does not attempt to render the poet's wordplay but does present two tender actions of Rāma—marking Sītā's brow with ocher (Figure 107) and shooting the crow that attacked her. The image of Māyā Sītā leaving her true counterpart in the fire is emphasized by the bold, dark form of the flames, if not by the scale of the main actors as in Śatrughna's picture (compare Figures 92 and 109). There is generally a sense of zany good humor rather than solemnity in Michha Patajoshi's figures. One imagines him repeating his favorite tale with gusto, aware of the literary complexity of the written text but opting for a good story in his own visual telling.

I cannot help seeing the difference between these two versions of the *Vaidehīśa Vilāsa* as a matter of personal temperament, for there is no uniform regional or period style in the small part of Ganjam District that produced Raghunath Prusti, Sarathi Madala Patnaik, and Michha Patajoshi in quick succession. At the most, Śatrughna's remarkable originality might be ascribed to his having worked in isolation at a time and in an area where there were few other palm-leaf illustrators.

FOUR VERSIONS OF THE *LĀVAṆYAVATĪ*

Upendra Bhañja's second and yet more frequently illustrated work provides a particularly neat situation in which to consider various pictorial strategies for presenting the same literary story. In the first place, the Rāmāyaṇa is told here with virtuosity but succinctness, and the reader can easily consult my relatively pedestrian English translation in Appendix 3 to get a sense of the words. In the second place, we have four ample, distinct, interesting, and fairly well-preserved sets of pictures of the *Lāvaṇyavatī*, whose narrative choices can be seen at a glance in the table in Appendix 2.

At the outset, we must recall that this Rāmāyaṇa is embedded in a longer and less familiar tale. The magic performance described has a function in the longer plot, serving to arouse the love of the heroine, who identifies the hero with Rāma and herself with Sītā. Moreover, the presentation of the well-known epic as an ephemeral and illusory performance serves as a commentary upon the very nature of that story. We must also remember, in our enthusiasm for this subject, that it was not mandatory that this brief episode be lavishly illustrated. It was not

depicted at all in some manuscripts of the *Lāvaṇyavatī*, and in others it was reduced to a single formulaic scene of Rāma's coronation (Figure 140).

One remarkable artist whose attention was caught by this subplot was Balabhadra Pathy, working in Jalantara at the southern extreme of Orissan culture. He devoted more folios to the Rāmāyaṇa than did any other illustrator, elaborating upon the terse text of the *Lāvaṇyavatī* yet not pursuing most of its verbal conceits. For example, in the line "He made short work of the monkey (*śarabha*) with an arrow (*śara*)," the central pun and the speed of Rāma's action are not depicted. Yet the death and the monkey's reaction are prolonged over several folios (of which Figure 169 is only the last) with events not spelled out by the poet. Pathy indeed seems to be completely carried away by the episode of Hanumāna's visit to Laṅkā, which figures in the text only with the single line "To get news of his wife he (Rāma) sent a messenger." It is tantalizing that the manuscript ceases at this point, so one will never know how or even *if* Pathy returned to the substance of the poem. At least we can say with assurance that this episode was emphasized in the context of his generally expansive treatment of the Rāmāyaṇa.

The puppet-like character of figures in this work has already been mentioned, although no one would argue that the prolific scenes are literal transcriptions of shadow theater as we know it today in Asia. The exaggerated poses have a generally theatrical effect, similar to that of many Indian dramatic forms in which gesture and movement surpass facial expression in conveying emotion. If Sarathi Madala Patnaik and Michha Patajoshi bear comparison with oral storytellers, Pathy orchestrates his pages like the director of a drama, and it is tempting to search for connections with the genre of Prahlāda Nāṭaka, which originated in his home town, Jalantara. The massed figures that enlarge and comment upon some scenes (Figure 173, right) form a chorus. Although the chorus as an institution is not part of the Indian theatrical tradition, this visual device is comparable to the group of *gāyakas,* or singers, who repeat the lines read by the chief chanter in the Rāmalīlās of Orissa.

One distinctive aspect of Pathy's narrative forms is certainly pictorial or perhaps broadly literary and not borrowed from the relatively simple staging of Indian theater. More than any of our artists, he uses setting inventively to reflect or enlarge upon the human situation. Thus he gives us three vivid scenes of Mount Mālyavan in the rainy season, vignettes devoid of human figures, in which the natural elements are not only appropriate (frogs and a rainbow in Plate 10), but also independently expressive of Rāma's sorrow. Pulses of lightning dart and wriggle like living organisms against the black sky. Dotted lines of rain suggest tears and rage, particularly when they cross (Figures 170, 171). These scenes come as close as those of the most subtle Pahari painting to evoking the *karuṇa rasa* by means of landscape, a phenomenon akin to the pathetic fallacy of Western Romanticism. Thus while the artist does not choose to illustrate the poet's verbal tropes literally, he creates his own visual metaphors that have a comparable effect. There is also artful variety in the scenes, which include starkly ordered buildings (Figure 161), the tangled thicket in which the magic deer moves (Figure 164), and the immense conflagration in Laṅkā (Figure 174). In general, Pathy's version of this story is energetic, emotional, at times overwrought, and wearing for its audience.

The anonymous artist of the Dispersed *Lāvaṇyavatī* probably devoted at most ten folios to the Rāmāyaṇa sequence (as opposed to Pathy's more than sixty) and illustrated only events mentioned in the poetic text. Thus the pace of narration here is rapid-fire. This version is nonetheless idiosyncratic for reasons that go beyond the accident of pages missing today. On the eight folios I have located, there are several unexpected omissions. The jump from the birth of the princes to the killing of Tāḍakī, occurring on a single side of a page, omits only one incident mentioned in the text but leads the viewer suddenly from Rāma as a baby to the full-grown hero (Figure 143). On the next-to-last surviving folio, depictions of Garuḍa, Kumbhakarṇa, and all fighting are omitted (Figures 153, 154).[22] Most amazing is the jump from the encounter with Paraśurāma to that with Bharata, side by side on a single leaf (Figure 147), omitting any explicit image of the banishment, which one might take to be a critical turning point in the plot.

There are also several alterations of the sequence of events presented in the *Lāvaṇyavatī,* largely prolepses, or flash-forwards. The two most striking cases are the inversion of Sītā's kidnap with the Śabarī's gift (Figure 149), and that of Lāvaṇyavatī's final observation with Rāma's coronation (Figure 156). In this assertion, I assume that the pictures are intended to be read from left to right like the writing, as is true generally in manuscript illustrations. In earlier Indian sculpture, however, we have seen inconsistent directionality (see Chapter 3). It is probable that this artist was his own scribe and hence literate, therefore predisposed to compose his work from left to right. But perhaps our expectation of consistency is at fault. What alternatives are there to saying he acted entirely on the basis of whim?

In all these narrative surprises, I discern several principles at work, of which the last example may exemplify the simplest—a choice to "foreground" the episode shown first. Obviously Lāvaṇyavatī is watching the coronation while giving her final interpretation; placing her first may simply bring us back emphatically to the primary plotline of the poem. This interpretation does not contradict our reading of the opposite side of the same leaf, where Sītā's test is shown first, to the left, as the remarkable event that Rāma watches.[23]

A second principle that may enter into the surprising omissions is that of deliberate pairing on a single page, to make a point of similarity, contrast, or another connection that images convey more subtly than words. Thus the jump from the infant Rāma to his killing Tāḍakī makes the point that he was precocious. The encounters with Paraśurāma and Bharata are comparable cases of submission to Rāma's virtue by a potential opponent. The inversion and pairing of Sītā with the Śabarī underscore the piety of both women, who gave generously to strangers, with quite different results. Similarly on two sides of a single folio we move from Tāḍakī to Ahalyā (both cursed, one evil, one virtuous) and from Rāvaṇa being well advised by Mandodarī to the heroes ensnared by serpents. What is important is not the precise point of each comparison, which must remain conjectural, but rather that some such comparison would explain the selection and placement of events.

In one case, we have noted an insertion not found in any verbal account of the story I know: Vālmīki's presence as an actor in Daśaratha's sacrifice (Figure 142). Whether or not this scene is the invention of this particular illustrator, his treatment of the sage seems purposeful—paired with the king at the center of the

folio, presenting the sacred porridge dramatically just above the string-hole, and emphasized by the way the second sage, Riśyaśṛṅga, turns to look at him. On the final leaf of the Rāmāyaṇa sequence a sage-like figure appears to the left of center, but this is surely the magician talking to the king of Simhala at the end of the performance. In both cases a narrator of the tale is gratuitously brought into the telling, calling attention to the fictive status of this telling of the sacred tale. In each scene the folio begins on the left with a small, demure female figure who observes the scene and mediates between the male narrator and his story.[24]

In general the goal of this artist seems to be interpretative: he does not wish to tell the story, assuming its familiarity to his audience, but rather aspires to use it inventively. And his use reflects his visual medium, as the comparisons above suggest. In the same way, he embroiders many scenes with natural details that are appropriate but do not necessarily allude to other events. Squirrels climb the seven sal trees as well as the bridge to Laṅkā. There are never more than two events on a page in this section of the manuscript, and space surrounds the large figures, giving the scenes a certain mythic grandeur.[25] There is a general alternation between scenes of action, with strong diagonals, and more sedentary episodes, which, however, are not stock tableaux but rather embroidered with delicate and varied detail. The elegant drawing and composition of this manuscript may explain why it has often been selected as the acme of Orissan manuscript illustration. This judgment, while perhaps unfair to other illustrators who had other goals, reflects the independence of this artist from his text and his great accomplishment as a draftsman.

The illustrator of the Round *Lāvaṇyavatī*, also anonymous, provides an extreme contrast with the artist of the dispersed set. Here twelve pages are used to tell the story, and these bear all ten stanzas of the text, unlike the dispersed set, where this portion of text presumably occurred on a previous folio. Thus in an equally restricted space, this third artist worked in almost every event mentioned in the text.[26] No selection occurred here, and only one minor inversion of events—Sītā's test occurring to the left of Vibhīṣaṇa's coronation, for which I see no particular explanation (Figures 35, 36). The seven sal trees precede the lifting of Dundubhi's bones (Figure 26) as in the *Lāvaṇyavatī* itself, a reversal of the standard sequence of these exploits even in Upendra Bhañja's other poetry and unlike other illustrated versions of this text. The only episode included here that does not appear in the text is the minor and ubiquitous addition of the squirrel at the building of the bridge to Laṅkā (Figure 29). In short, this was an unusually literal illustrator.

The pace of his pictures is consistent, with two to four scenes on a page. Thus the exceptional single image of Rāvaṇa's death in isolation stands out climactically and effectively, by Aristotelian standards. The Rāmāyaṇa sequence as a whole is emphasized in the manuscript, not as in the dispersed set by the mythic quality of its images, but rather by their snappier pace, for elsewhere there are usually one or at most two scenes per page, with longer passages of text. The small scenes of the Rāmāyaṇa sequence are separated by frames at the beginning, but those disappear after the exile, accelerating the speed of the action.

While in general one can find a visual continuity between the writing of most texts and accompanying images executed by the same artist, there is particular

harmony between the rounded hand of this scribe and his drawing of the figures. Individual pages are neatly composed, for instance the framing of Viśvāmitra's calm sacrifice by the slaying of frenzied demons on either side (Figures 6, 7). Staccato beings surround the kidnap of Sītā (Figure 19). Each part is pleasing, but no detail is embroidered at the expense of clarity.

The maker of this manuscript certainly worked with great artistry; I would characterize him as the optimum "illustrator." Thus he seems devoted to his text, as was Michha Patajoshi to the *Vaidehīśa Vilāsa*. His interest, even more than Michha's lay in the plot rather than in Upendra Bhañja's wordplay. He was also perhaps more adept as a craftsman; but in preferring not to let any distinctive slant in interpretation intrude, he also dispensed with the whimsy that gives Michha's work its charm.

Finally Raghunath Prusti, working near Sarathi Madala Patnaik in central Ganjam District in the last two decades of the nineteenth century, made the *Lāva-nyavatī* his masterpiece. This volume was longer and more profusely illustrated than any he produced. The Rāmāyaṇa portion, comprising eleven or twelve folios, is as dense with pictures as any we have seen.[27] Among the events mentioned in Upendra Bhañja's poem, only the rain in Lomapāda's kingdom and Riśyaśṛiṅga's marriage are not depicted. These omissions are worth mentioning because so many episodes *not* in the *Lāvanyavatī* text are included. In fact Prusti shows extraordinary independence of the text, although his motivations are different from those of Balabhadra Pathy or from those of the artist of the dispersed manuscript.

A significant factor in Prusti's images was the model of Buguda, roughly 30 kilometers away. Our security in dating both the illustrator and the wall paintings, as well as the esteem in which the Virañchi Nārāyaṇa Temple continues to be held, makes unusually convincing the suggestion that this particular monument directly influenced him in some instances. One striking case is the image of Rāma and Lakṣmaṇa binding up their locks of hair as they begin their exile (Figure 183). This incident, mentioned in the *Vaidehīśa Vilāsa* and not in the *Lāvanyavatī*, is depicted at Buguda (Figure 201, tier 4, left) and in Michha Patajoshi's first copy of the *Vaidehīśa Vilāsa* (Figure 106).[28] Prusti showed the two brothers in poses very similar to those at Buguda. He did not, however, simply reproduce the entire scene but spread it out to accommodate the palm-leaf format, shifting Sītā to the left so that she introduces the group, as in the mural, which was read from right to left in this tier.

Prusti's *Lāvanyavatī* seems also to borrow from several large and vivid compositions set on hilltops at Buguda. Prusti is able to present the scene of the lovers on Mount Chitrakūṭa and Bharata's visit in the slightly unusual sequence in which they occur in this poem while retaining the composition of the mural, which was read from right to left beginning with Bharata, the sequence of the *Vaidehīśa Vilāsa* (compare Figures 183, 205). Prusti condenses this hill into a single dome and only once depicts Rāma, shown marking Sītā's brow with ocher in precisely the same pose as at Buguda. Thus Lakṣmaṇa alone receives Bharata in the manuscript, holding an arrow that suggests his initial alarm at the approaching party. Here again we see a skillful adaptation of the almost square mural composition to the narrow, horizontal palm frond. Prusti also includes the incident of the crow (mentioned in the *Lāvanyavatī*), omits the three mothers, and converts the small ele-

phant from the bottom of the wall into a more integral part of the courtly proces-
sion and hence of the story.

Prusti's second scene set on a hill depicts the brothers' meeting with *vānaras*
on Mount Mālyavan, together with the end of the bridge to Laṅkā, presumably
Mahendragiri (Figure 189). The former scene is somewhat indeterminate as a mo-
ment in the story; its presence is explained by its mirroring a composition at Bu-
guda that is also paired with the building of the bridge. Here the later artist has
reversed the sequence of Buguda, which was viewed in circumambulation from
right to left. At the same time he retains the direction of movement on the bridge
toward the left, a point of irrationality that perhaps would trouble only the most
pedantic viewer.

Prusti's third hill scene follows the Buguda paintings most precisely, pres-
enting problems in interpretation and suggesting that the later artist was as puz-
zled as we are about the precise meaning of events to the right (compare Figure
190, Plate 11). Questions arise because the artist here reproduces the mural com-
position, which places this episode after the scene of cutting Rāvaṇa's umbrellas
and hence presumably too late in the plot for Lakṣmaṇa's threat to the monkeys
to make sense. I know of no version in which Lakṣmaṇa would straighten an
arrow proffered by Jāmbavan during the Yuddha Kāṇḍa.[29] In the scene to the left,
Prusti extends the mural's dramatic central grouping across the narrow format of
the page, thereby rendering the falling umbrellas more vivid than at Buguda.

Some scenes in the Mundamarai manuscript are clearly not borrowed from
Buguda. Nor are they mentioned in the *Lāvaṇyavatī* itself, although they occur in
other texts, which may account for Prusti's inclusion of them. For example, the
three Śabaras in Figure 182 are explained if we remember that in the *Vaidehīśa
Vilāsa* Guha, whom the exiles meet at this point, is called Guhaśabara.[30] The pair
of vases labeled *pūrṇa kumbha* in Figure 181 may allude to the long metaphor in
that same text that compares Kaikeyī to a milkmaid, Ayodhyā to a pot, and the
peace of the city to milk that is churned (17.32). This conceit is implicit in the
wordplay of the *Lāvaṇyavatī*, Mantharā-*manthana* (literally, her churning), al-
though that poem does not mention a pot in particular. A similar vase, flanked by
auspicious fish (a common enough motif in wedding paintings in rural Orissa)
had appeared in Prusti's illustrated divination cards, the *Praśna Chuḍamāṇi*.[31] Pos-
sibly the appeal of the crisp emblem supplemented the artist's admiration for
Upendra Bhañja's metaphor.

Two more "added events" present slightly greater problems. No version of
the death of Tāḍakī includes Bharata along with Rāma and Lakṣmaṇa (Figure
177). Perhaps Prusti drew on some lost oral tradition, or perhaps he invented this
variant himself. His scene of monkeys running over the roof of the palace in Laṅkā
is another interpolation, whose rationale in terms of design has been suggested in
Chapter 3 (Figure 191). Here it is also possible that he incorporated some image
of Hanumāna's escapades from the Sundara Kāṇḍa, otherwise absent here.

In two places we can be sure this inventive illustrator departed from the sim-
ple narrative sequence of any version of the story to compose his pages artfully,
without direct dependence upon the Buguda model. One is the kidnap of Sītā,
where I have argued that logic of place takes precedence over that of time, so that
scenes at the two ends of the leaf occur on either side of Sītā's hut (Figure 187).

The second example is Vālin's death, where Rāma and the fighting monkeys frame the dying Vālin, the result inserted between two components in the action (Figure 189, left). One can imagine Prusti reasoning, "It is so clear *what* happened in each case that I can throw chronological caution to the winds."

And yet I must confess that of all versions of the Rāmāyaṇa, I have greatest difficulty following and remembering Prusti's. This may be partly a result of his very inventiveness, as he gave the story new twists. It is also the result of his complexity as an artist and the several distinct principles that underlie his work. He must have admired the Buguda paintings and copied many of their dramatic compositions and rich details. But he also adapted the model to the narrow format of the palm leaf, normally read from left to right. He further enriched the visual detail and devised his own vivid forms. Moreover, he presented the narrative inventively, so that neither the story nor the images were repetitive. The story is told in fits and starts, but at the same time no static iconic intrusion interrupts the plot. This entire portion is denser, less embroidered with clever contemporary touches, and less realistically descriptive than his illustrations for the *Lāvaṇyavatī* story proper. Once again this performance is set off from the poem in which it is embedded. To sum it up simply, Prusti seems to have been impressed by the elegant paintings of Buguda but to have adapted their model quite freely to his own visual and narrative requirements.

On the whole, the four versions of this text considered here all set the Rāmāyaṇa sequence apart from the rest of the story and emphasize its role by various formal means. In all, the pace of narration picks up as the rate of illustration increases vis-à-vis the condensed text. The artist of the Round *Lāvaṇyavatī* followed the plot of the text most faithfully and conveys with clarity every part of the action actually mentioned. Balabhadra Pathy was moved by narrative gusto to go beyond Upendra Bhañja's words and is perhaps most captivated by the moods of the story, which his pictures convey. The artist of the Dispersed *Lāvaṇyavatī* felt yet more independence from the text, selecting and rearranging the events to create new points by visual means. Raghunath Prusti was perhaps most independent of his text in this section, captivated by an effective visual model as well as by his own perception of the problems of the palm-leaf form.

THE *BRAHMA RĀMĀYAṆA*

Our last manuscript is the least narrative literary work considered here in the sense of presenting a sequence of actions. This by no means leads to a lack of images, for it is profusely illustrated. Of 132 pages, 63 bear pictures with no text. While 23 bear text alone, on many of these the amount of writing is small, occasionally a single line surrounded by empty space and ornate end-borders. The designer was clearly concerned with the visual elegance of every page.

Because the standard story of the Rāmāyaṇa is confined to folios 12 to 26, one might regard this portion, like the *Lāvaṇyavatī* account, as a capsule version of the entire epic, albeit truncated. Unlike the versions of Upendra Bhañja's poem that we have just considered, however, this portion of the story does not particularly stand out in the manuscript. The artist of the *Brahma Rāmāyaṇa* resembles that of the Round *Lāvaṇyavatī* in his fidelity to his text, which is illustrated verse

by verse, a simple phrase such as "He liberated the distressed Ahalyā from the curse of Gautama," being fleshed out with an effective image of Rāma extending his foot toward a square rock followed by a worshiping woman (Figure 196). The enumerative series of events in the verses is comparable to the discrete, abruptly separated pictures.

The general nature of the forms and their import, however, are perhaps as close to those of Balabhadra Pathy as to any work we have seen. Thus the figures are stylized, if less radically so than Pathy's, drawn with assurance and not repetitive. Elements of setting are detailed and related in design to the human action, although not quite in Pathy's expressive manner. For example the tangled arrows of fighting in Figure 195 and the flowers showering upon the wedding in Figure 197 convey distinct dramatic situations.

Other devotional parts of this manuscript may use setting with even greater inventiveness. To the right in Figure 194, the panel sprigged and surrounded by small plants forms an elusively haunting image of Brahma's garden, appropriate enough but not described in the actual verses. The next-to-last folio bears one of the most charming and decorative landscapes in Orissan manuscript illustration (Figure 199). Possibly this is a rising sun, appropriate to the sacrifice performed by the brahmans to the right, or possibly the sun is setting to indicate that the *Brahma Rāmāyaṇa* is complete (*samāpta*).[32] In any case the reference is obscure and the image itself haunting.

The bulk of this work is broadly similar to the *Gīta Govinda* in expressing devotion to God in the guise of a romantic relation between *sakhīs* and lover. Thus as with many illustrated versions of Jayadeva's poem, we see a series of scenes of the hero with one or more devotees in amorous situations. Variations are small and subtle but deliberate, and most scenes are carefully composed. Clearly plot is irrelevant to the artist, although these images do revolve around the literary sentiment of Love (*śriṅgāra rasa*). While not strictly narrative in Western usage, these pictures develop the emotional element that is present in many Indian stories.

JAGANNATH MAHAPATRA'S PAINTED SET

Turning to the *paṭa* tradition, we begin with the set of seventy-five paintings made by a living artist as most straightforward in storytelling (Figures 223–52). This set was to some extent designed as a book, to be seen sequentially with text probably appearing below and certainly clearly formulated in the mind of the painter. Yet it differs from a palm-leaf manuscript in the way the picture has primacy, dominating every page, so that only one image is visible at a time. Moreover, the "text" was the creation of the artist, on the basis of oral and theatrical versions of the Rāmāyaṇa. Jagannath Mahapatra was indeed the narrator of this tale, like any village storyteller.

This painter was not especially indebted to Buguda, although that was in some sense part of his professional heritage. Nor have I found any other particular extended group of images from which he borrowed. Viṣṇu Anantaśayaṇa and the coronation of Rāma were common enough subjects for the *chitrakāra,* and his compositions resemble previous versions of these subjects painted on walls.[33]

Certainly he worked within the visual language of his tradition. On the whole, however, he invented this set for a specific patron, Halina Zealey, who was generally interested in the story and brought in a professor from Bhubaneswar for guidance, but who ultimately seems to have given Jagannath Mahapatra carte blanche.[34] I would urge that this situation not be understood as unique to the twentieth century but rather as a circumstance that might have existed at times in the past. Even the "lowly" artisan was able to devise his own narrative and visual strategy.

In addition to the selection of some unusual parts of the broad cycle to illustrate (Mahīrāvaṇa, the Uttara Kāṇḍa), as already discussed, the pace of this set of paintings is its most striking narrative feature. Often two or more scenes illustrate what might be thought of as one episode, sometimes an episode that even the palm-leaf illustrators, less constricted in space, showed within a single frame. Thus the birth of the four sons occupies three quite similar pictures. Kumbhakarṇa's waking and his death are separated. Rāma's decision to hold an Aśvamedha takes place in two scenes of no great distinction in terms of image or plot. On the whole one senses more "stretching" of the story at the beginning (when the planner perhaps worried how he would fill seventy-five frames) and at the end (when he found himself left with thirteen frames for the Uttara Kāṇḍa), whereas in the middle he chose to omit the shooting of the seven sal trees. In short, his spatial constraints were a bit like the time constraints of an oral performer who must fill an agreed-upon period but not go beyond.

In the treatment of individual scenes, there often seems to be a deliberate alternation between the static and the active. This resembles Indian drama, which traditionally includes nonactive sequences that develop the mood but not the plot. Some scenes are symmetrically composed like the tableaux of the theatrical tradition of *jhāṅkī*, to be savored and even worshiped in iconic form, rather than played for action (Figures 223, 240, 244, 249, 250–52). At the same time the static does not dominate, and the artist is clearly motivated by a desire to achieve visual variety as well as to get significant parts of the story across.

Finally, it is interesting that some part of the audience did not regard the sequence of events as an unalterable causal chain. The Cuttack publication of the same seventy-five episodes begins with Anantaśayana, as a standard frame, whereas Jagannath Mahapatra had logically placed this episode after Riśyaśṛṅga's sacrifice, when Viṣṇu's decision to be born as Rāma was brought about. Likewise, his placement of Sītā's birth before Rāma's is true to the Oriya tradition, whereas the Cuttack authors followed the more generally acceptable Indian pattern, in which the bride is younger. We see how this freedom of attitude toward plot, characteristic of India, arises from multiple versions of one story and from the absence of the compulsive reasoning *post hoc, ergo propter hoc.*

THE PARLAKHEMUNDI PLAYING CARDS

Sequence is yet more problematic in the set of playing cards made in Parlakhemundi before 1918, which belongs to the professional *chitrakāra* tradition in the technique by which it was painted and in its general appearance. Yet the version of the story clearly has little to do with that of Jagannath Mahapatra, lacking

for example the Mahīrāvaṇa episode and the entire Uttara Kāṇḍa. Its eighty-eight numbered cards cover the story up to Sītā's banishment, to which the Raghurajpur set devoted sixty-three scenes. Since there is no "stretching" of a single episode over several pictures, substantially more events are included in the Parlakhemundi set. Nor does the specific narrative selection of this set particularly resemble that of the manuscript of Balabhadra Pathy, which was probably produced 50 kilometers away. There was no south Orissan consensus. Qua story, this version follows a widely shared outline that cannot be specifically traced to any written text, with some idiosyncratic touches—the names of demons Hanumāna encounters on his visit to Laṅkā (Chhāyā and Grāma Devī), or the way he is seated before Rāvaṇa on something that may combine coiled tail and serpent (Figure 266), as discussed in the preceding chapter. Thus it seems that the painter of these cards drew and perhaps embroidered upon a local oral version of the Rāmāyaṇa in presenting his version of the story.

The images themselves are remarkably varied and dramatically effective, considering their small circular format, to which the compositions are neatly adjusted. Rāvaṇa, with one eye in each of his ten faces, resembles a sinister beetle (Figure 266). Hanumāna's exuberant tail winds like a vine around demons in an unusually heraldic version of the burning of Laṅkā, suitable to the small card, where rectilinear architecture would work against the round format (Figure 267). Parts of some scenes are tilted to suggest onward progress against obstacles, as well as to accommodate the round format (Figures 264, 265). While some motifs are widely shared in the professional painting tradition, I am struck by many unique solutions in these cards.

The sequence of episodes seems to proceed in chronological order, from card one through card ten of the successive suits—except for the end of the second suit. There, after Daśaratha's death we find on card ten the label, "Sri Rāma, having been given the turban [i.e. crowned] sits on the throne with Sītā in his lap" (Figure 268). The picture is a standard version of the coronation, including monkeys, which one would expect to conclude the Rāmāyaṇa. The third suit begins with four scenes that would in standard sequence precede the coronation—the revival of Lakṣmaṇa, the fight between Rāma and Rāvaṇa, the coronation of Vibhīṣaṇa, and Sītā's test by fire. The story then resumes with a second scene of Bharadvāja's ashram and proceeds in more accepted order. The final card of the eighth suit shows Hanumāna carrying the mountain, and subsequent events already shown in the second and third suits are not repeated.

Two explanations present themselves. On the one hand, this sequence might represent some accidental circumstance or miscalculation on the part of the artist that we cannot precisely reconstruct. On the other hand, it may constitute a deliberate prolepsis, perhaps a prediction made in Bharadvāja's ashram (hence the exceptional repetition of this scene) of the hero's ultimate future. The coronation also forms a visual parallel to the scene of Rāma and Sītā in the same pose on Mount Chitrakūṭa, alone except for Lakṣmaṇa and one unidentified figure in a chariot.

In either case, this unusual sequence must also be understood in view of the actual use of these pictures as playing cards. In fact, as the cards were shuffled and used, the story would not normally be seen in sequence. One need not discuss the

intricacies of the Orissan game to imagine wild conjunctions of parts of the plot in the course of ordinary play. Inevitably the narrative structure here would be more fluid than in other texts or sets of images, and it may be a simple matter of convenience that most of the deck is in chronological order: the artist would have worked this way to be sure of getting all the major events in. The arrangement of these images was in part determined by the user, making them like computer hypertext or children's books that offer alternative plots, described as "make your own story." This is literally a playful version of the sacred tale used to embellish the afternoon hand of cards, no doubt glossed with wisecracks on the part of the players.

LARGE *PAṬAS*

The traditional *ṭhiā baḍhiā,* or detailed plan, of the Jagannātha Temple included one scene from the Rāmāyaṇa in the upper right corner, often the final fight with Rāvaṇa (Figures 216, 217). In such *paṭas,* scenes from the life of Kṛṣṇa sometimes flanked the temple in vertical rows (Figure 216), and these also occurred in a circle in the type known as Kṛṣṇa's Birthday pictures.[35] From such sources, paintings devoted to telling an extended story in multiple panels have become particularly popular in recent years. Perhaps the circular format of the small panels can be attributed to the model of playing cards as well. I have selected four examples, admittedly at random among the wide number produced today, to demonstrate diversity of patterns of organization (Plate 12, Figures 253, 254, and 289 in Appendix 5).[36]

One feature shared by all the modern story *paṭas* of the Rāmāyaṇa I have seen is the placement of the coronation in the center. This may seem natural enough as the auspicious conclusion, especially if the Uttara Kāṇḍa is omitted (as it is not in the last two examples). The regular execution of wedding paintings on the walls of houses by the *chitrakāras* and the centrality of this subject there (Figure 262) may have made it particularly appropriate as the focus of the *paṭa.* It was the most prominent iconic form for Rāma. A *paṭa,* by virtue of its origin as a picture sold to the pilgrim and as a replacement image made for the Puri Temple, is conceived of as a stand-in for the *mūrti,* literally the "body," of a major divinity.

As Appendix 5 indicates, the selection of events is not consistent among the large examples, nor does it correspond to Jagannath Mahapatra's set. Among the episodes on which there is complete consensus, some may seem natural choices: Rāma's birth, his encounters with Tāḍakī and Ahalyā, the golden deer, Jaṭāyu's attack, Hanumāna and Sītā in the asoka grove, and Rāma's final fight with Rāvaṇa. Mahīrāvaṇa and Durgā appear in the larger Danda Sahi painting, in the work of Bhikari Maharana, and in Jagannath Mahapatra's set. The inclusion of these events, which were not in the mainstream of Orissan texts or manuscript illustrations, may reflect the Sahi Jātrā tradition of nearby Puri. The Raghurajpur *paṭa* with twenty-one small scenes (Figure 289A) and the Danda Sahi one with twenty-two (Figure 289B) treat events through Hanumāna's visit to Laṅkā at a fairly consistent pace, but both compress the conclusion into two or three battles.[37]

The sequence of scenes follows some general principles. Events usually proceed clockwise, whether organized in a circle or in a square.[38] The beginning of

the sequence is on the lower left in Figure 289C and 289D, but on the upper left in Figure 289A. Vertical panels are apparently read downward. The greatest inconsistency in sequence occurs in the multiple vertical rows, which progress inward toward the coronation in different ways in Figure 289C and 289D. A painting such as that in Figure 289B is complex and sophisticated in the way it reconciles chronology with placement on the canvas. Despite some shared principles, each *paṭa* differs somewhat. Surely we may entertain the possibility of such plural patterns in the past.

BUGUDA WALL PAINTINGS

Finally we return to the oldest cycle of paintings of the Rāmāyaṇa, possibly contemporary with the earliest palm-leaf illustrations as well, for it is clearly dated in the 1820s. No text accompanies the Buguda murals, nor does my analysis suggest fidelity to one written version. It is tempting to connect this cycle with Upendra Bhañja, a member of the family of the builder of the Virañchi Nārāyaṇa Temple. While many scenes resemble the account in the *Vaidehīśa Vilāsa,* some do not. Thus the distinctive image of the seven sal trees knotted by a serpent is absent (Figure 203, center), and the Buguda version of Lakṣmaṇa straightening his arrow outside Kiṣkindhā is explained neither by that poem nor by the *Lāvaṇyavatī* (Plate 11). In general we may surmise both that the artists knew Upendra Bhañja's works along with additional texts and oral tales and that they may have introduced their own interpretations in ways we can never precisely reconstruct. Moreover, damage to some of the paintings creates difficulties in interpretation. Here, in fact, we must proceed backward to understand these images in light of the greater certainty, or at least lesser uncertainty, of more recent manuscripts and paintings.

Another complication most striking at Buguda among all our examples is the likelihood that the artist or artists worked on one wall at a time without an overarching plan in mind from the beginning. Possibly a plan was altered on an ad hoc basis as the painting proceeded, which is not to imply that the result was therefore less successful. In fact one might argue that it was more creative to make adjustments while the work was in progress. We cannot be certain that the painting was executed in the sequence of circumambulation, and it remains possible that several parts were under way simultaneously, worked on by different painters.

Thus walls A, B, C, and presumably L follow a pattern of depicting many incidents sparely to create a running narrative. The effect of each register is similar to that of a palm leaf, and it is conceivable that the painters worked from an illustrated manuscript. If so, however, they did not follow it slavishly. The vertical sequence on the first three walls moves logically enough from bottom to top, top to bottom, then again bottom to top. Yet the horizontal movement is irregular on wall A, the most complex of the first three. Wall B does follow a boustrophedon course, and C has only one incident per tier. From this sequence one might deduce that the complexity of A was regarded as excessive. If wall L were preserved, it would confirm or deny this hypothesis. At least we can say that while working on wall A, the designer did not take it as his primary task to present the story clearly, as if from scratch. Indeed, because the viewer would surely have been presumed to

have some familiarity with the Rāmāyaṇa, the artist was cast in the role of someone retelling a well-known story creatively, to entertain and please his audience.

Walls D through K make simple sequential reading yet more difficult. Thus the scenes at the top of D and E take place in the section of the story covered on wall A and might conceivably have been omitted there with such emphatic treatment in mind. Wall F follows after the events of C, and the scenes at the bottom of D and E follow that, preceding wall G. This is the point at which improvisation may have taken place, and any precise explanation for changes in plan is speculative.

Nonetheless, some general motivations seem to be at work. Perhaps the most natural explanation for the large scenes is that they are iconic, as opposed to the preceding narrative portions. In fact, only one of the actual images here corresponds to a type standard in images of worship, and that is relatively minor in its placement here—Hanumāna with Mount Gandhamādana (Figure 211). In the other scenes Rāma is no larger than other actors and is sometimes entirely absent (Plate 11). Thus the term "iconic" is not entirely appropriate.

An alternative literary concern is apparent, however: that of mood, or *rasa*, as opposed to plot. Thus the first large scene, Bharata's visit (Figure 204), is played for sentiment, mainly pathos, rather than as a simple statement of religious devotion, which would be implicit in the worship of Rāma's shoes. Here one feels the sorrow of the court, including the widowed queens, bereft of ornament. Bharata confronts his brother as an equal human being, his humbly hunched pose contrasting with Rāma's energetic ebullience despite his modest circumstances. This is high drama in the Indian tradition, and even though the scene lacks physical action, it is packed with emotion that tells a story.

The neighboring scene on Mount Chitrakūṭa combines pathos with romance, as Rāma decorously yet tenderly touches Sītā's brow with red earth because he lacks the red lead that a princess could expect to use as ornament (Figure 206, top). The isolation of the figures underscores not only the intimacy of the moment but also their impoverished situation. The demotion of the building of the bridge to Laṅkā, often regarded as a pivotal event, to the position of a footnote on this wall suggests the greater interest in more emotional episodes on the part of this designer.

The next two major scenes on walls F and G lead us toward the heroic sentiment. Lakṣmaṇa straightening his arrow evokes compassion again, that the brother of the heroic Rāma should be ignored by a mere monkey (Plate 11). The cutting of the umbrellas is Rāma's first major humiliation of Rāvaṇa, as opposed to the building of the bridge, which forms a major turning point in military strategy (Figures 208, 209). Vibhīṣaṇa's dramatic gesticulation and the forlornly fluttering umbrellas underscore the triumph inherent in this episode. An element of humor is woven in as monkeys accompany the heroic event on a rural type of drum below.

The pace of battle quickens in smaller scenes of the fight with Kumbhakarṇa and Indrajita, laced with arrows (Figure 212). Then the epic confrontation between Rāma and Rāvaṇa occupies the maximum area of any of the Rāmāyaṇa scenes, its original impact only dimly glimpsed today because of the much dam-

aged condition of the south wall (Figure 213). And yet this vivid triumph of the heroic forces did not conclude the sequence, for it was followed by the smaller scenes of wall L, which, whatever their content, might seem anticlimactic. This sequence serves to remind us that the structure of the paintings, however dramatic, did not follow an Aristotelian pattern, structured by norms of unity. This is the world of *rasa,* or sentiment, in which the goal is emotional richness, a linked sequence of moods.

Yet surely visual goals were also felt. The selection of four events set on hills for the major scenes of walls D through G is partly a matter of composition and balanced appearance. The form of a mountain would have interrupted the rapid sequence of scenes on the earlier walls, hence the omission of these events there.[39] Here the hill connects the entire wall despite the presence of an architectural niche in the center. The small natural touches worked into the base of the hills, visible because they are placed close to eye level, provide a chance for the artist to show off his refinement and invention in a way less appropriate in the registers of the initial walls, which imply uniform scale all the way to the top.

On wall A, Viśvāmitra's sacrifice, Sītā's wedding, and an unexplained scene set in a shrine are aligned, suggesting a relationship of three sacred events (Figure 201). This connection shows an appreciation of the visual properties of images, making comparison between the three ceremonial fires possible in the same way the artist of the Dispersed *Lāvaṇyavatī* manuscript compared Sītā and the Śabarī. Moreover, a vertical series of architectural forms connects the three horizontal tiers in the same way that the flames of Riśyaśṛṅga's and Viśvāmitra's sacrifices connect the lower two tiers. The result is not a tightly constructed unified composition but rather various chains that link the wall in pieces, lest it dissolve into a mere series of unrelated registers.

In short, we may view the designer at Buguda as an inventive storyteller, whose medium, of course, was pictures rather than words. The effectiveness of individual images as elegant pieces of design is borne out by the impact they had on subsequent artists. Thus the wall painting of Manikarnika Sahi in Puri (Figure 215) and the wedding box of Bhagavata Maharana (Figures 258–61) demonstrate the exemplary status of the Buguda murals. And at least one palm-leaf illustrator, Raghunath Prusti, seems to have used these compositions as a point of departure for illustrations in a quite different genre.

Many strategies are at work in Orissan narrative pictures, which begin with different versions of the story and follow these versions with different degrees of fidelity. Some present action as clearly as possible, creating a sequence of events that may be read as causally linked. Some take that familiar action for granted and weave around it a commentary in philosophical or emotional terms. Both story and commentary may be long-winded, embroidered, and allusive or terse and direct.

Why? ∴ 6

We have considered the history or story behind the images, as well as the discourse or manner of telling, both in the treatment of individual events and in the sequential effect of pictures. These concerns do not exhaust the topic of storytelling, however. As the author Ursula Le Guin once put the question to a group of scholars analyzing narrative—

> It was a dark and stormy night
> and Brigham al-Rashid sat around the campfire with his wife
> who was telling him a story in order to keep her head on her shoulders,
> and this is the story she told:

> The *histoire* is the what
> and the *discours* is the how
> but what I want to know, Brigham,
> is *le pourquoi.*
> *Why* are we sitting here around the campfire?[1]

"Why" inquires after the motivating force behind the story. Like any question, this one has different meanings depending upon its formulation and emphasis. One may ask, what does the *Arabian Nights* represent for audiences from Harun al-Rashid to the present? Thus "Why was *the story of Rāma* depicted as it was?" calls attention to the impact of those same images upon other people, and particularly to the meaning of this tale in Orissa. On the other hand, one might inquire, why did Scheherazade prolong her tale for 1,001 nights? Similarly, "Why was the story of Rāma depicted as it was *by the artists of Orissa?*" calls attention to the practical production of images. In the third place, "Why" may surreptitiously inquire about the success of the entire enterprise. Was it worth sitting around this particular campfire? Did they spin a good yarn, or whatever they were trying to do?[2]

WHAT DOES IT ALL MEAN?

One expectation invoked in various symposia that have been devoted to the great epic of Rāma is a demonstration of the wide appeal of the heroic divinity. I have,

frankly, taken that appeal for granted. Inherently, as what semiotics terms an index, each copy of the Rāmāyaṇa and scholarly study of the subject constitutes a sign of the god's power. This book does not dwell upon universal elements or make pan-Indian comparisons systematically because either course would become unmanageable and would detract from careful consideration of the Oriya forms. There remain many interesting, wide-reaching problems, such as the general growth of the Uttara Kāṇḍa in written texts at the same time that it languished in the hands of illustrators. To explore that convincingly would require another book.

In particular, the contemporary images most relevant for comparison are those of the eighteenth century and later, a period that demands further work on unstudied art in many regions. Here I have paid attention to exceptional motifs, common in Orissa but occasionally found elsewhere, such as the two-headed deer or the snake linking the seven sal trees. In both cases, a shared form took on different content in Orissa, hence its particular significance and prominence there.

Given that we are concerned with the meaning of images of the epic in one region, what general conclusions can we draw? An obvious one is that events are put into a local context. The Rāmāyaṇa is conceived as set in Orissa itself and is not relegated to a historical past. This is in fact so common in the Indian visual and religious tradition that it hardly requires comment: the past is inevitably interactive with the present and is identified with the world around us. It is no surprise that for Oriyas both Mahendragiri and Laṅkā should appear as local places or that occasional images of Jagannātha, the supreme regional divinity, should be worked into a seemingly unrelated religious context.

The ethnic mix of Orissa is reflected in a more unexpected and hence interesting way in the participation of tribal characters in the royal story to which they might be considered marginal. Many authors and artists in Orissa give particular play to the story of the Śabarī, describing her nonstandard behavior in biting into the fruit she offers Rāma and Rāma's acceptance of this act as a sign of her devotion. The prevalence of tribal subjects, music, and dance in the Rāmalīlā of Dasapalla may be ascribed to the deliberate pacification of the Khonds early in the nineteenth century when the performance began. Surely this situation was not peculiar to that small state. Accommodation of indigenous forest dwellers is common throughout Orissan history. Even the major regional cult of Jagannātha constitutes an early example in slightly different form—a tribal god identified with a member of the mainstream Hindu pantheon.[3] The role of peoples from the interior hilly regions as a threat to the more settled coast and the sheer number of *ādivāsis* (literally, aboriginals) in the population of Orissa surely contributed to the prominence of tribal elements within the Rāmāyaṇa there and also lay behind the stress upon the portions of the story that take place in the forest. The *vānaras*, forest animals, are emphasized here. Hanumāna is of course a widespread epitome for devotion throughout Indian culture, but the way he takes over the story in Balabhadra Pathy's *Lāvaṇyavatī* manuscript is exceptional.

In many pictures we have considered, as well as in Oriya texts, Rāma is treated as an object of devotion comparable to Kṛṣṇa. This current is most striking in the *Brahma Rāmāyaṇa*, which at first glance might be taken for a *Gīta Govinda*. It is implicit in the *Adhyātma Rāmāyaṇa*, whose illustrators likewise acknowledge

the power of Rāma's grace in saving those he slaughters. The squirrel's part in building the bridge to Laṅkā is a particular case in which devotion is rewarded by a boon, and the squirrel is often worked into images whether or not it is explicitly mentioned in the text they illustrate. The episode of the cowherds, depicted in manuscripts of the *Vaidehīśa Vilāsa,* both connects the two avatars directly and evokes Kṛiṣṇa visually with images of cows.

Bhakti themes abound throughout north India in the eighteenth and nineteenth centuries. Particularly in eastern India, with the impact of Bengali Vaishnavism, it is natural that art should treat Rāma as an object of emotional devotion. In the eighteenth century, a wealthy Bengali introduced in the Puri Temple a Raghunāth Veśa, in which Lord Jagannātha was dressed as Rāma, one of his manifold guises of the ritual year.[4] That practice was abandoned, although the painters occasionally still depict this *veśa* (dressing of the god). The point is not that the cult of Kṛiṣṇa has replaced or dominated that of Rāma but rather that the two run parallel.[5] Ultimately it is unrealistic to try to compare their weight and importance. They are compatible, whether Lord Jagannātha is invoked as prelude to Rāma's story (Figures 62, 72) or Rāma's victory is made pendant to an image of the Puri Temple (Figures 216, 217). Max Muller termed this long-standing Indian acceptance of different gods under different circumstances henotheism, a concept useful to the Westerner who sees only the stark alternatives of a monotheistic God and a fragmented, polytheistic pantheon of competitive divinities.

One major theme in the Rāmāyaṇa as told and depicted in Orissa is present in other regions but is developed with particular consistency here. This is an overarching concern with the illusory nature of the empirical world.[6] Artists frequently emphasized visual emblems of this illusion more than in other regions where the same text, the *Adhyātma Rāmāyaṇa* with its Vedānta ideology, may also be illustrated. Nonetheless, as we have seen, the most prolific Orissan illustrator of that text, Sarathi Madala Patnaik, did not particularly dwell upon illusion in his pictures.

Some vivid visual motifs themselves are central to this particular interpretation of the epic as a whole. The two-headed deer catches our eye as an emblem of illusion. What are the implications of this image? The golden deer was part of a trick that enticed Rāma away from Sītā. To endow it with an extra head is, in the words of living painters, to emphasize that it is no ordinary deer. The two-ness of the heads implies duplicity, yet that interpretation may in fact lead us to exonerate Mārīcha for assuming this form and enabling the divine story to unfold. The images also bear out the charm of the creature, which in the first place captivated Sītā and which both puzzles and amuses us. Thus the deer reminds us in a playful way of uncertainty and the difficulty of making judgments. This is true of the motif as it appears in Orissa, whereas in Gujarat the same form implies primarily rapid movement, also appropriate to the deer but less specifically evocative of *māyā.*

The hiding of Sītā in the fire while Māyā Sītā was kidnapped is an equally complex, weighty emblem. In the first place, for the intended audience, familiar with the story in advance, it is reassuring to find that the real heroine is safe, her purity protected from contact with Rāvaṇa. Her safety undercuts the plot only if we impose expectations that the story should constitute pure tragedy. In the sec-

ond place, this event builds drama, implying that something disastrous is about to happen, conveyed by the picture of the true Sītā in the flames or by the enacted concealment of both forms behind a ghostly veil in the Dasapalla Rāmalīlā. It is a vivid and ominous moment as depicted by both Śatrughna and Michha Patajoshi (Figures 92, 109). In the third place, this particular image evokes what the informed audience knows will occur again later, Sītā's immersion in fire as a test of her virtue. The implications of this test were not necessarily those felt by a viewer led to expect the Uttara Kāṇḍa and her rejection by Rāma. Nor were they those felt in the late twentieth century by viewers who think of the yet more ominous spectacle of dowry burnings. But the event is part of a repeating pattern, a cycle in which doubts are raised yet we are reassured that the story will all turn out all right.

I cannot resist reflecting on a comparable piece of literature, Euripides' *Helen*, though with no implication of any historical relationship between Greek drama and much later medieval Indian literature. At the risk of essentializing both Western and Indian traditions, we may see a neat contrast between the recast versions of the *Iliad* and the Rāmāyaṇa. In both epics a woman is the cause of war. In both recastings, we discover that an illusion was in fact kidnapped; hence the real woman is freed of the guilt of promiscuity (a charge more justified in Helen's case than in Sītā's). In both versions an obsessive gemination (doubling) ultimately calls attention to the author's own craft and hence to the self-reflexive identity between his writing and his subject matter.[7] But Euripides' illusion is a thing of the past and he focuses upon the arrangements by which Menelaus and Helen escaped from Egypt, where she had in fact been kidnapped. The Greek play has not challenged Homer's version of events, whereas at least in Orissa the versions of the *Adhyātma Rāmāyaṇa* and *Vaidehīśa Vilāsa* predominate. Euripides retains a tension between the good and bad effects of deception, whereas in the Indian tradition *māyā* is fruitful and distinguished from mere *moha,* or confusion. In fact in the Oriya masterpiece of Upendra Bhañja and in the Rāmalīlā of Dasapalla, the motif of the phantom Sītā is presented powerfully and the doubling logically clears her name from final suspicion.

So in Orissa *māyā* itself has many different implications in different instances or in a single instance. The piling up of such references is to make the entire story into a complicated game. The *bandhas,* or puzzles, that appear in manuscripts as part of the sal tree episode or Indrajita's snake-arrow provide a similar puzzlement and testing. In the *paṭachitra* images of the Mahīrāvaṇa episode, it is significant that we see, not just the conflicting powers of demon and goddess but rather a series of tricks: Hanumāna's tail-fort (see p. 30), the disguises Mahīrāvaṇa assumed to sneak in, and finally the ruse that enables Kālī to slay him (Figures 239, 240). All of this could be explicated both in terms of philosophical relativism, of the kind verbalized by Vedānta, and in terms of wit or aesthetic whimsy. When we ask, "What does the story of Rāma mean in Orissa?" the plural meanings are themselves an answer: there is no single meaning. The particular twists given to the story here and the stress with which some parts are presented, visually as well as verbally, make vagueness, uncertainty, and ultimately *māyā* a central theme.

One artistic implication of this theme is an acceptance of many meanings in a single story, which may yield a different interpretation in the mouth of each new

teller. The *Lāvaṇyavatī* itself presents the story of Rāma as a performance put on by a magician, which both gives it a kind of dramatic weight and at the same time emphasizes the notional nature of this particular version of the story. The phenomenon of the Rāmalīlā, in which a story is performed afresh each year by actors who assume their parts and remain familiar citizens of the town, adds another layer to the fabric of retelling. The artist who repeats familiar themes, himself producing many illustrated manuscripts of a single text or many *paṭas* for sale in the bazaar is particularly akin to a performer, be it actor or raconteur. Thus the iterative, non-unique nature of the Indian image, as opposed to the concept of a masterpiece that is sui generis often maintained in the West, accommodates the theme of *māyā*.

Multiple meanings also result from multiple readings of a single image. The artist's reading may not constitute the ultimate authority, yet at the same time it is not to be neglected. Other figures guiding production can be imagined, the director of a play or the *rāj-pandit* who intervened with the artist in some miniature painting. Yet even the director of Orissan Rāmalīlās is hardly in control of every detail of the improvisatory staging, nor is he more than one of several authorities about the interpretation of events. In both professional painting and manuscript illustration, we may admit the possibility that some guide may have intervened. But in actual cases in which a learned man has been consulted, it is not clear that his opinion was particularly decisive: the Utkal University professor involved in the selection of incidents for Jagannath Mahapatra's set of paintings (see p. 65), or S. N. Rajguru's interpretation of the two-headed deer (see p. 91).

There is also the audience—as diverse as society in general—which has been described as achieving many different desires from the image, itself a kind of boon-granting Aladdin's lamp or, to invoke an Indian image, a wishing cow (Kāma-dhenu).[8] My own study does not explicitly pursue different readings of a single picture, although their possibility must always be admitted. The multiple visual-izations of a single written text, for example the pithy story of Rāma in Upendra Bhañja's *Lāvaṇyavatī* illustrated in four discordant ways, may remind us of the Rashomon nature of all interpretation. And for a motif such as the two-headed deer, surely we may accept a number of different formulations of the meaning as correct, while rejecting a few. Thus the Gujarati notion of movement is not applicable in Orissa.

The diverse images of Orissa, taken as a whole, present the familiar story with an overarching consistency. On the one hand, the tale is filled with religious significance. The characters are moral models, although specific actions even by the hero may be called into question. Human emotion and divine status are constantly in balance. This story, different in its origin, becomes part of broad devotional currents of *bhakti* and specifically of the regional cult of Jagannātha. On the other hand, this remains a story told with sophisticated relativism. Tragedy and moral values are both illusory. The action is a knot to be untied, a puzzle to which different solutions are possible. This is not merely a rebus to be decoded by the knowing viewer, confirming his or her own intellectual skill. This is a puzzle to be felt.

At this point it might be tempting to present two contradictory themes, the religious and the aesthetic/secular, as consciously interwoven. Here I must balk.

To project such a dialogic structure on Orissan thought and image making is to assume a dualistic antithesis between the two spheres that I do not recognize in the Indian tradition. The polyphonic model, so fashionable these days in the West thanks to Mikhail Bakhtin, does not seem fully appropriate to a culture whose music itself knows no harmony. Rather we might think of the analogy of concurrent rhythms, followed by different instruments and ultimately resolved on a single beat. What one seeks is an image that does justice to the complexity and yet coherence of multiple themes that are in the end not separate and hence not played against one another. Thus the devotional character of the *Brahma Rāmāyaṇa* is on a continuum with the aesthetic character of the *Vaidehīśa Viḷāsa*. As is generally true in South Asian culture, the extremes are not unmediated.

Finally, this double function of clarifying divinity and presenting the rich matrix of *māyā* is as actively fulfilled by certain visual images as it is by words. In Vedānta philosophy, the metaphor of a rope mistaken for a snake is fundamental to verbal argument.[9] Our central image itself has been invoked by Edward Dimock along with a poem by the Bengali author Jibanānanda Dāś to convey the multiple nature of the world as a whole.

> In that poet's eyes the Bentinck Street section of Calcutta is at least two realities: it is full of Bengali businessmen by day, and swarming with whores and foreign sailors by night. It is not the change from day to night that makes the difference, although it seems so to our experience, for both Calcuttas are present all the time. It is like the famous Orissi painting of the deer, one head grazing, the other staring fearfully backwards. Two-headed deer are not in our experience.[10]

The picture says it all. At least for this study, concerned with sequences of images, meaning must be accepted as residing there (and deduced by attempting to see these images in appropriate ways), rather than sought in outside verbal authority.

WHAT EXPLAINS THE ARTISTS' CHOICES?

Issues of how artists work have been central in the present study, for I feel an urgent need to address the circumstances of production in Indian art, which have been too readily neglected or shrouded in mystical obscurantism. Let us review how the *chitrakāra* and the scribe proceeded when they set about telling Rāma's story. The painter was limited by the dimensions and hence the price of his *paṭa*. He presumably had visual models, some immediately before him in the form of sketchbooks, some within the broad tradition of his community. Yet he had considerable leeway in the selection of scenes, in pacing, and in interpretation. The illustrator of manuscripts, on the other hand, would seem to have had his particular text as a brief. Yet he was able to interpret that text in a variety of ways, to work against it, and to depart from it. His "text" in fact was a combination of the words of the manuscript with many other versions that he knew both in written and in oral form. Both artists made complex choices at a preliminary stage—the underdrawing of the *paṭa* or the copying of the manuscript text with blanks left for pictures. Some, such as Michha Patajoshi or Jagannath Mahapatra, followed an initial template with consistency. Others, such as Raghunath Prusti, Sarathi

Madala Patnaik, or the Buguda painters, seem to have improvised along the way. Śatrughna prided himself on ingenuity, which in fact the uniqueness of his images bears out. In all this work, the artists functioned as narrators themselves.

Amid the panoply of effects, can we discern overall patterns that explain how various artists worked in telling the Rāma story? Caste might seem to be an obvious candidate as a guiding category in India. In manuscript illustration, I have repeatedly indicated that there is no overall association of style or narrative approach with the community of the maker. Śatrughna and Sarathi Madala Patnaik, both karaṇas, have little in common. Nor do the brahmans Balabhadra Pathy and Michha Patajoshi share visual or conceptual concerns.

There remains, however, a gulf between the hereditary artisans who painted *paṭas* and the various people of other castes who engraved palm leaves. It goes deeper than the physical difference between the two media, for the pictures produced today on joined palm leaves are more akin to painted *paṭas* than to earlier palm-leaf illustrations. One kind of image works in conjunction with written words while the other does not. Moreover, there is a fundamental difference in the function and procedures of the makers. Cases of borrowing by manuscript illustrators such as Raghunath Prusti from the work of painters at Buguda do not invalidate the conclusion that on the whole the *chitrakāra* was more clearly part of a hereditary pictorial tradition.

Nonetheless, I would contend that in two particular instances the professional painter told his story with as much freedom and deliberation as the scribe/illustrator. One case, the Buguda murals, is reconstructed from the images themselves, both in their chronological sequence, which does not follow any standard version of the Rāmāyaṇa, and in their treatment of unusual events. Notably the scene of Lakṣmaṇa straightening his arrow before Kiṣkindhā (Plate 11) is given an emphasis that is not explained by previous images that survive (Figure 285). A second case, Jagannath Mahapatra's set made in 1954, is reconstructed from the painter's own memory, which of course is open to question. Our analysis of both is indeed hypothetical. Moreover, each itself became a model for later artists and thus the two are exceptional within a tradition where copying often played a role. It seems fair to say that the position of the *chitrakāra* was not inevitably more passive than that of the scribe-illustrator, although that was often the case. There was a continuum between the two, and I have avoided distinguishing the two as professional and non-professional, for some scribe-illustrators surely depended upon their picture books for their livelihood. Today illustrators are regarded as artisans, as opposed to the literati who composed poetry. But in the past Brajnātha Baḍajenā (by birth a scribe, or karaṇa) and Jadumani Mahapatra (a painter, or *chitrakāra*) were both writer and artisan.

A second candidate as a basis for artistic variety is region or subregion. Here again, I am struck by the plurality of approaches at play concurrently within the tiny area occupied by Raghunath Prusti and Michha Patajoshi, who might well have known each other. There was clearly no "central Ganjam school" of palm-leaf manuscripts. The *chitrakāra* would seem somewhat more localized in his lineage. General distinctions of drawing and technique are visible between the *paṭas* of Puri and of Parlakhemundi, although members of these painter communities also traveled and intermarried with families from other towns. As for the version of

the Rāmāyaṇa presented by these two schools, Jagannath Mahapatra's set and the Parlakhemundi playing cards are both original in overall organization. Each has some idiosyncratic twists of plot, which may be ascribed to local folklore and performances, for instance Mahīrāvaṇa and Durgā, known to the Raghurajpur painters from the Sahi Jātrā of Puri. Yet regional style does not constitute a significant difference in storytelling between the two.

Chronological development is a favorite concern of the art historian. Hence I have taken pains in Chapter 2 to indicate dates when these are known. Again, I fail to see a broad pattern in either pictorial tradition during the relatively brief period considered. At most one might argue that pan-Indian themes have become more common among paintings of the last decade, in large part as the result of the popular media, which make Tulsī Dās's version readily available. Yet that process goes back several centuries in the Danda Jātrā of Asureshvar described in Chapter 1. Pan-Indian currents need not, moreover, override characteristically Oriya themes as well, notably the two-headed deer. I am reminded of the situation at Dasapalla in 1990, when a crowd gathered on the Rāmalīlā stage around a television set at 10:00 P.M., watching cassettes of the popular television Rāmāyaṇa series, which had already been viewed many times in the town after its initial broadcast in 1987–88. Yet I found no instance in which the subsequent Rāmalīlā performance revealed the impact of that series, by comparison with what I had seen in 1983, before the series was made. The two versions were both acceptable.[11]

Finally, the Indian tradition of narrative structure provides a unifying framework that itself encourages diversity of effect. This structure obviously differs from Western literary norms. As I indicated in Chapter 5, I use the term "narrative" to refer to the procedure of telling a story, rather than to a particular literary or artistic genre. The primacy of oral traditions may have accommodated a rambling, discursive form as opposed to one embodying Aristotelian unities. Structure often centers upon mood, or *rasa,* distilled emotion that is evoked in the audience. The standard list of nine moods permits variety rather than giving consistently privileged status to one sentiment. Thus the Rāmāyaṇa is usually identified with pathos, *karuña,* and that is indeed the emotion evoked in many major images, beginning with the dramatic forest scenes at Buguda. Yet the Oriya poet Upendra Bhañja could stress the erotic, *śṛṇgāra,* and set this off by means of the comic, *hāsya.* Illustrators such as Michha Patajoshi followed this lead. The epic also lends itself to the mood of wonder, *adbhuta,* which an artist like Śatrughna chose to stress. And the heroic, *vīra,* dominates the vivid scenes of battle as well as Rāma's final coronation. The complex images of the Dispersed *Lāvaṇyavatī* evade neat classification according to the major moods, and yet each has complex emotional content.

Thus sentiment, ascribed to the characters depicted and communicated in an abstract form to the viewer, provides the governing structure. Sentiment does not require action, hence the acceptability of static scenes. Sentiment must be developed, hence much direct repetition at the expense of climactic structure. Sentiment may be intense, at the risk of what the West calls sentimentality. In such emotional concerns we have a general code whose goal is not to convey information or causal sequence.

What then of the diverse forms that the pictorial story takes? Roland Barthes disparages references to the storyteller's "art, talent, or genius—all mythical forms of chance." Yet he writes feelingly of diverse stories:

> There is, of course, a freedom of narrative (just as there is a freedom for every speaker with regard to his or her language), but this freedom is limited, literally *hemmed in:* between the powerful code of language [*langue*] and the powerful code of narrative a hollow is set up—the sentence. . . . "what happens" is language alone, the adventure of language.[12]

The adventure of pictures would seem to result in a similar way, one of its sides defined either by the visual language of the professional *paṭa* tradition or by that of the palm-leaf book.

Ultimately we may recognize a variety of approaches that befit individual circumstances. On the one hand, there is the temperament of the artist himself, who chose a *rasa* and devised the means to realize it. On the other hand, the result had to be acceptable to an immediate patron or potential buyer. Both Raghunath Prusti and Jagannath Mahapatra seem to have called the shots initially and to have been content with their ultimate compensation, which was never princely. It seems to me important to regard the creators of images in India as people rather than as puppets of a tradition. Their sense of individuality may not have been a Western one, but their choices cannot be predicted in detail from their social, regional, historical, or intellectual tradition, although each of these contributed to the code within which they worked.

This may be the most original and controversial aspect of the present study. Obviously the deck is somewhat stacked by my choice of palm-leaf illustrations as a topic, for unusually large numbers of individual artists are identifiable here. But I see the same sense of distinctive temperament in anonymous illustrations such as the Dispersed and Round *Lāvaṇyavatīs,* in the unsigned *paṭas,* and ultimately throughout traditional image making in South Asia. This position contradicts received opinion going back to Coomaraswamy, who stressed the subordination of selfhood on the part of the Indian artist. That viewpoint could be traced to logocentric brahmanical texts that present buildings and images as the gross material counterpart to a purer realm of ideas. Such an intellectual heritage leads the modern student of Indian art to focus upon cases in which images do correspond neatly to verbal constructs and upon widely shared visual traditions. As I have lectured about this material to various audiences, I have noticed most puzzlement over Śatrughna, not only because of his remarkable images but also because of the epithet he chooses for himself. *Vichakṣaṇa,* or "ingenious," goes against the grain of our expectations for Indian art. Yet there it is in writing. It is high time that we grant the maker of the image more respect, let us hope without making him sound like an Indian version of Van Gogh.

This brings us to another question that combines the last two. How is a visual artist to depict illusion? Art is itself a form of illusion, but that does not mean that representation per se need question its own reality.[13] In those Western traditions that have sharply distinguished the real and the unreal, it may be a discrepancy in the use of an illusionistic system of representation that calls attention to something other than apparent reality (as in Surrealist paintings) or to the artificiality

of representation itself (as in the work of M. C. Escher). We cannot simply equate with such positions, however, any departure from the norms of illusionistic representation familiar to us.[14]

A worldview that frequently asserts the illusory nature of all phenomena seems to have a more complicated task, for in that view discrepancy from familiar illusionistic standards is impossible. In India, Mughal painting provides several fascinating cases in which such ideas, drawn from Hindu patterns of thought, were depicted using the relatively illusionistic pictorial technology of court studios that fed upon Western, Persian, and Indian traditions simultaneously. Thus it is ironic that our only illustrated copy of the *Yogavāsiṣṭha,* a major work of Vedānta philosophy comprising parables embedded in a dialogue between Rāma and the sage Vāsiṣṭha, is a Mughal manuscript, apparently made in A.D. 1602 for Prince Salim, who was soon to become Emperor Jahangir.[15] Here it could be argued that the painters have addressed the central theme of illusion by depicting real and unreal events in the same "realistic" style.[16] It could also be argued that they did not address that theme in the written text at all, choosing rather to tell a good (that is, moving) story. In principle it seems important to entertain this possibility when moving from philosophical discussion to pictures. We need not take the congruence of text and image for granted, which is one reason for my tedious concern with particulars in Chapter 4.[17]

Hindu-Buddhist art in India spoke a different language. Throughout its long history, there are countless images whose reading forms a kind of game. An early Orissan example shows four bodies in acrobatic poses sharing a single head, set into frothy foliage that itself turns into two monster heads (Figure 287). Perhaps visitors to the temple in Bhubaneswar who saw this work in the nineteenth century, like those today, had their attention called to this part of the carving as "a wonder." It would be tendentious to identify such a subordinate part of the decor as an image of *māyā.* This decorative band and other passages elsewhere do, however, assert the ingenuity of the sculptor and remind the viewer that images in general are artificial constructs. As the temple cicerone asks today, "Which body does the head belong to?" The *bandhas,* or puzzles, that appear in Rāmāyaṇa manuscripts as part of the sal tree episode or Indrajita's serpent-arrow likewise constitute tests in iconic form for the viewer.

Another motif in later Orissan art that carries a similar significance is the Navaguñjara, or ninefold beast, a form assumed by Kṛiṣṇa to test his devotee Arjuna, who was able to recognize this curiosity as the god himself. Images of this creature occur in paintings from the Himalayan princely states and of south India.[18] Yet the only written version of the story so far found occurs in Śārala Dāsa's fifteenth-century Oriya *Mahābhārata.* This creature is particularly prominent in Orissa; witness its inclusion in place of Jaṭāyu in Krishna Chandra Rajendra's *Rāmalīlā* (Figure 87) and in the wedding paintings of Danda Sahi (Figure 262). Illusion is auspicious.

WAS IT SUCCESSFUL?

Ultimately yet another question is encoded in "why": "What is the image attempting to accomplish, which in turn enables us to assess its success?" As the

introduction suggested, this study began with a desire to question the standards by which isolated leaves from sequential manuscripts had been judged. They are not individual, framed pictures, although occasionally they may serve that end today. There is particular danger in formalist appreciation, unconcerned with the particular content of the image, which this study has attempted to redress. The cycles considered here are groups of images intended to be seen in sequence. This sequence tells a story and/or constitutes a commentary upon a familiar story. In fact the self-sufficient image in isolation may effectively punctuate the entire cycle, like the *jhāṅkī* tableau in folk theater, but too many showstoppers would impede the show as a whole.

Here again the painting tradition works differently from the manuscript, and it seems important to recognize the diverse organization of each. The traditional large *paṭa* and the wall paintings of Buguda are generally too complex to be seen as a whole, and hence overall composition is not necessarily relevant to their success. The way in which they are read is quite varied, as Figure 200 and the analysis of Buguda suggest. Thus richness or variety may be as important as clarity. At the same time, the wall paintings include some images that slow the pace of storytelling. Likewise *paṭas* normally include the Jagannātha image in the center as a portable object of worship, compatible with the narrative and cartographic functions of the painting as a whole. Hence the category of iconic tableau can be accepted as an appropriate part of the picture, rather than condemned as an impediment to storytelling. It is important to accept these unexpected aesthetic standards and to remember the wide range of refinement in the execution of the *chitrakāras'* work, lest we succumb to the assumption that their painting is inferior as a whole to other kinds of images. I find it plausible that Raghunath Prusti, a very gifted illustrator, might have learned from the murals of Buguda, which he admired.

Turning to palm-leaf images alone, by what standards are we to assess quality? Ultimately we must view artists such as Michha Patajoshi or even Sarathi Madala Patnaik as more than inept draftsmen. If the former is more successful, this may be a matter of the richness and density with which his pictures add another layer to Upendra Bhañja's poem. In Sarathi Madala's work, the pictures do not seem to tell a purposeful story or to develop any coherent version of their content. However hard I try, I often fail to work out a rationale for them either as isolated images or as sequential art. Yet his copious works must have appealed to some patrons in late nineteenth-century Ganjam District, and he cannot be dismissed.

In evaluating Raghunath Prusti and Michha Patajoshi, we can fortunately compare our assessment with those of people who recall them today and with written accounts by quasi-contemporaries. Here conflicting standards would lead to two different assessments. Prusti's work stands out by virtue of its rich, elegant, and assured design and draftsmanship. It is harder to follow his story, although sometimes we can see narrative inventiveness and a density of meaning comparable to his pictorial qualities. Michha Patajoshi excels in narrative enthusiasm, reconciling visually the qualities of humor and sensuousness combined in Upendra Bhañja's poetry.

Today in their home villages, both are remembered warmly. A kind of awe surrounds Prusti's name, no doubt enhanced by the number of visitors from afar who have inquired about him and come to photograph his works preserved in

Mundamarai. He is also known, however, as Ulu Chakra, best translated "maverick," and is described as a humble person whose inspired work was remarkable.[19] Michha Patajoshi evokes good-humored amusement and respect rather than awe. None of his work survives in Balukeshvarpur.

Moving back half a century, we have a record that the great Oriya musicologist Kalicharan Patnaik used guile to acquire Prusti's illustrated Rāgamālā in 1936. He wrote, "My Dharakot stay was truly a divine blessing. . . . [In the worship room of a female relative of Prusti, I] discovered the illustrated *rāga-chitra* manuscript. I cannot express in words my happiness then."[20] In 1928 the distinguished scholar Kulamani Das visited Balukeshvarpur, writing enthusiastically of the brahman illustrator whom he met, identifiable with Michha Patajoshi, and of his "uncommon love for the art he acquired by himself and for Bhañja's poetry," which he sang while showing the pictures.[21] These passages might be analyzed to confirm my own aesthetic preference for the work of Raghunath Prusti, qua physical object. But it is more significant that both artists were admired and taken seriously as human beings. To compare their stature is perhaps unnecessary.

In the end are we left with complete relativism and the equality of all images? I would resist this as *moha,* or confusion, as opposed to fruitful *māyā,* or illusion. Surely Sarathi Madala's work or that of yet more inept draftsmen and storytellers is not successful by its own standards, even though the sanctity of the palm-leaf medium may lead to the survival of many examples of his work. While the living *chitrakāras* today find aesthetic judgments difficult and at times are shy about expressing them, they do make them spontaneously, and not merely from self-interest. Thus my conclusion is not entirely relativistic, that *any* set of images must necessarily be regarded as successful, but rather that many alternative interpretations and radically different artistic means to these ends may also have their rationale. Our experience is enriched by trying to follow such diverse pictorial storytellers, different from each other and perhaps from us.

APPENDIX 1

Adhyātma Rāmāyaṇa Illustrations: Sequence from Śūrpaṇakhā's Attack to the Death of Vālin (Multiple x's indicate multiple illustrations)

Event	Orissa State Museum 81 Sarathi Madala Patnaik 1875	NY Public Library Sarathi Madala Patnaik Jan. 1891	Bharany Collection Sarathi Madala Patnaik Dec. 1891	Utkal Univ. Library Sarathi Madala Patnaik 1902	National Museum, New Delhi 75.536 anon.	Bharany Collection anon.	National Museum, New Delhi 75.556 anon. (Rāmalīlā)
Rāma meets Śūrpaṇakhā	x	x	x			x	
Lakṣmaṇa & Śūrpaṇakhā					x		x
Śūrpaṇakhā denosed	x			x	x		x
Khara & Dūṣaṇa						x	x
Śūrpaṇakhā & Rāvaṇa	x	x		x	x		x
Rāvaṇa & Mārīcha	x		x (& deer)		x		xxxx
Rāma & Māyā Sītā	x	x		(missing pp.)			

Subject							
Rāma & deer	x				xx	x	xx
Rāvaṇa, hill, monkey							x
Sītā & Lakṣmaṇa	x				x		
Sītā & ascetic	x	x	x (Rāvaṇa ten-headed)		x	x	xx
Rāma, deer		x					x
Rāma, Lakṣmaṇa				x			
Return to empty hut	x				x	x	attack of Navaguñjara
Rāma with dead deer	x				x		x
Jaṭāyu meets Rāma	x	x		x	x	x	Rāma, Lakṣmaṇa, sage, plain deer; last surviving page of ms.
Kabandha	x		x		x		
Śabarī	x	x (& Sītā)	x	x	x	x	
Hanumāna appears as man	x			x	x		
Hanumāna lifts brothers	x				x	x	

Adhyātma Rāmāyaṇa Illustrations, *continued*

Event	Orissa State Museum 81 Sarathi Madala Patnaik 1875	NY Public Library Sarathi Madala Patnaik Jan. 1891	Bharany Collection Sarathi Madala Patnaik Dec. 1891	Utkal Univ. Library Sarathi Madala Patnaik 1902	National Museum, New Delhi 75.536 anon.	Bharany Collection anon.	National Museum, New Delhi 75.556 anon. (Rāmalīlā)
Sugrīva & brothers	xx				xx		
Sugrīva & Tārā		x		x			
7 sal trees & head of Dundubhi							
Vālin & Sugrīva fight	x		x	(1 p. missing)	x		
Sugrīva garlanded					x		
Vālin & Tārā					x		
Rāma shoots Vālin	x	x		x	x	x	
Tārā mourns Vālin	x				x		

Illustrations of Rāmāyaṇa in Four Manuscripts of Upendra Bhañja's
Lāvaṇyavatī (Number of sides of folio devoted to each scene)

Event (in parentheses = not in text)	Dispersed	NM 80.1276 Balabhadra Pathy	Mundamarai Raghunath Prusti	NM 72.156/I "Round"
Lāvaṇyavatī and Magician		1	¼	½
Lomapāda		1	½	¼
Riśyaśṛṅga & Jaratā	½	2	¼	¼
Sacrifice, Rain				¼
Marriage to Śāntā	½	2		
Daśaratha & Riśyaśṛṅga in cart		1	¼	¼
Sacrifice, distribution of rice from sacrifice	1	1	¼	½
4 births	½	3	¼	½
(Boys play)		1		
Viśvāmitra's request		1		½
Tāḍakī killed	½	½	¼	¼
(Viśvāmitra's sacrifice)			¼	¼
Subāhu killed & Mārīcha knocked out	1	½	¼	½
Ahalyā liberated	½	½	⅓	¼
(Viśvāmitra's sacrifice)		½		
Boatman washes feet	½		⅓	¼
Breaking Śiva's bow	½	1	⅓	½

147

Upendra Bhañja's *Lāvaṇyavatī*, *continued*

Event (in parentheses = not in text)	Dispersed	NM 80.1276 Balabhadra Pathy	Mundamarai Raghunath Prusti	NM 72.156/I "Round"
Marriage to Sītā	½	6	1	½
Paraśurāma	½	1	1	¼
Preparation for coronation		4	¼	¼
(Brahma sends Nārada to Rāma)		1		
(Rāma & Sītā play game)			¼	
Mantharā		1	¼	½
(Pūrṇa kumbha)			¼	
Departure		4	1½	¼
Chitrakūṭa		2	½	¼
(Daśaratha's death)		2		
(Bharata & queens)		2		
Crow		½	¼	⅓
Bharata's visit	½	5	¼	⅓
(Exiles with sages)		1		
Virādha killed	½	1	⅓	⅓
Atri gives Brahmāstra	½	1½	⅓	¼
(Rāma meets Viśvāmitra & disciple)			⅓	
Śūrpaṇakhā denosed	missing folio?	1½	½	½
Khara et al. killed		2	½	¼
(Śūrpaṇakhā & Rāvaṇa)		1		
(Rāvaṇa & Mārīcha)		1		
Magic deer		2½	1	¼
Kidnap	½	3	⅔	¼
Attack of Jaṭāyu		½	⅓	¼
Sītā in asoka grove		1	½	¼
Rāma returns to hut		½	¼	¼
Jaṭāyu dies		½	¼	¼
Kabanda killed				¼
Śabarī's gift	½	½	missing folio	¼
Cowherd		½		¼
Rāma & sages		½		¼

Event (in parentheses = not in text)	Dispersed	NM 80.1276 Balabhadra Pathy	Mundamarai Raghunath Prusti	NM 72.156/I "Round"
Chakravaka bird		½		¼
Sugrīva meets Rāma	1	1		¼
Sal trees	½	1		½
Dundubhi's skeleton	½	½		¼
Death of Vālin	½	4	⅓	¼
(Rāma leaves monkeys)		1		
Mt. Mālyavanta in rains		2		¼
Cock crowned	½	1	⅓	¼
(Lakṣmaṇa goes to Sugrīva)		1		
Messenger sent		16		¼
Bridge	1	end of manuscript	⅓	½
Siege of Laṅkā, umbrellas cut			⅔	½
(Lakṣmaṇa straightens arrow)			⅓	
Garuḍa & Nāgasāra				½
Battle			1	
Kumbhakarṇa killed			½	½
Hanumāna & Gandhamādana	1		½	1
Rāma kills Rāvaṇa			missing folios	1
Vibhīṣaṇa crowned				½ (follows Sītā test)
Sītā's test	1			½
Return in Puṣpaka chariot				½
Coronation of Rāma	½			½
Lāvaṇyavatī's illusion	½			2

APPENDIX 3

Translation of *Lāvaṇyavatī*, Book 15, Rāmāyaṇa Episode (Numbers at left indicate verses)

A magician, skilled in tantra, has come from Karṇāṭa. The king of Simhala has him perform the Rāmāyaṇa so that Chandrabhānu can see Lāvaṇyavatī, and the performance in turn has a magic effect upon her.

(19) The princess's face adorns the large balcony.
 With her are only her dear companions.
 She with the sensuous gait of an elephant makes this plan her own.
 As she watches Rāma's story, her desire will be filled.
 The magician says, Close your eyes.
 And when they are shut, he produces this world of illusion (*māyā*).

[At this point the wordplay becomes denser, with puns, internal rhymes, and allusions (some indicated below).]

(20) Feeling his hair erect (*lomādgama*) at Lomapāda's instigation,
 Riśyaśṛiṅga was aroused by Jāratā.
 He produced rain (*vṛṣṭi*) in that land; the king was pleased (*tuṣṭi*).
 Given Śāntā as a wife (*kāntā*), he performed the divine worship.
 Daśaratha, in order to fulfill his longing (*manoratha*),
 Went seated in a chariot (*ratha*), together with the sage.

(21) Viṣṇu manifested himself in the charming (*chāru*) rice of the sacrifice
 (*charu*).
 Kauśalyā, Kaikeyī, and Sumitrā ate it and conceived.
 Rāma the handsome (*abhirāma*), Bharata devoted to bliss (*subharata*),
 Lakṣmaṇa with auspicious signs (*sulakṣaṇa*), and Śatrughna were born.
 In order to protect his sacrifice, Viśvāmitra came and took them.
 In the forest, they dispatched Tāḍakī to the land of Death.

(22) The long-armed (*subāhu*) Rāma struck down Subāhu.
 Mārīcha he sent to the sky and to glory, by means of an arrow.

150

On the road, he made a stone happy by turning it into a woman.
He who is affectionate to devotees (*dāsas*) had his feet washed by a
 fisherman (*dāsa*).
Breaking the bow of Śiva (Khaṇḍaparaśu) in two pieces (*khaṇḍa*),
And accomplishing marriage with Sītā, he vanquished the pride of the
 kings.

(23) Like a thunderbolt, he pierced the mountain (*bhṛgu*) of Paraśurāma
 (Bhṛgupati).
His father formed the wish to perform his coronation.
Because of Mantharā's machinations (*manthana*), taking his wife and
 younger brother,
He roamed happily on the wondrous (*vichitra*) Chitrakūṭa.
He caused the eyes of crows to squint.
Bharata, consoled, left the mountain with enlightenment.

(24) The hero with his weapon (*virayudha*) brought Virādha to death.
They got spotless clothing and the Brahmāstra [from Atri & Anasuyā].
He brought adornment (*maṇḍi*) to the Daṇḍaka forest as well as
 punishment (*daṇḍi*) to Śūrpaṇakhā.
Quickly (*khara*) he cut off the heads (*śira*) of Khara, Dūṣaṇa, and Triśira.
By means of the play (*raṅga*) of a golden deer (*sāraṅga*), the king of Laṅkā
Took moon-faced Sītā from her leafy cottage.

(25) On the way he killed a bird (*khaga*) with his sword (*khaḍga*).
Sītā dwelt in the asoka grove with sorrow (*śoka*).
Not seeing the lovely one (*sumukhī*) in the hut, Rāma was hit with grief
 (*mahādukhī*).
Who can measure (*māpa*) the host (*kalāpa*) of his sorrows (*vilāpa*)?
The bird reported (*sandeśa*) that she had gone to the land (*deśa*) of demons.
Caught (*bandana*) by Kabanda, Rāma killed that ogre.

(26) The Śabarī, by her gift of fruit, got the fruit of release.
Drinking milk from the best (*vara*) cowherd (*vararajara*), he fulfilled his
 wish.
Rāma caused desire to arise in the mind of the sages.
In Pampā Lake he was the cause of sorrow (*śoka*) to the Koka bird.
Rāma, descendent of the Sun (Mitra), became friends (*mitra*) with Sugrīva,
 son of the Sun (Mitra).
He pierced the sal trees and hurled Dundubhi's bones without effort.

(27) The monkey king (*śākhāmṛgarājā*) was strong as ten million lions
 (*mṛgarājā*),
But he was quickly destroyed by an arrow (*śara*) in the form of a Śarabha.
Having made his camp on Mount Mālyavanta,
Raghuvīra lived in separation throughout the rainy season.
He gave the cock a crown on the crest of the hill.
Getting (*labhi*) news of his wife (*vallabhī*), he sent a messenger.

(28) Nala became noted for building a bridge with boulders in the water.
Surrounding Laṅkā, they brought terror to the race of demons.
Garuḍa (Vīśa) removed their fear of the serpent (*viṣadhara*) arrow.
In the battle countless troops were trounced.
Ghaṭakarṇa left his body (*ghaṭatyāga*) and his huge corpse was destroyed.
Indrajita was killed after the Brahmāstra was used.

(29) Hanumāna playfully went to Gandhamādana.
Bharata got news of this, and Lakṣmaṇa was saved.
King Rāmachandra, taking the serpent-arrow,
Filled up the belly-measure (*aṅkapeṭi*) inside Rāvaṇa (Laṅkāpati).
The calm (*abhīṣaṇa*) Vibhīṣaṇa was crowned.
Vaidehī was purified in the fire like gold.

(30) In Puṣpaka Chariot, he went through the sky (*puṣka*) with his army.
The mighty warrior (*yoddhāvara*) became king of Ayodhyā.
While he thus made the great celebration of the coronation,
The moon-faced Lāvaṇyavatī saw completely different things.
Chandrabhānu stood in front of Rāma,
Like the beauty of Kandarpa (Viśvaketu) in front of Viṣṇu (Viśvambhara).
When the princess had heard all this, she said,
I need no other groom than this.

APPENDIX 4

Paintings of Rāma Themes in Jagannātha Temple, Puri (As recorded by Sri Purna Chandra Mishra, Puri; see Figure 288)

1. Naṭamandir
 a. Rāma and Sītā standing (east wall)
 b. Paraśurāma bows to Rāma, with Lakṣmaṇa, Sītā, Daśaratha (triangle on wall)
 c. Ahalyā seated on rock at Rāma's feet (ceiling)
 d. Hanumāna tears open chest to reveal Rāma (west wall, south end)
 e. Rāma's coronation (triangle on west wall, north end)
 f. Śabarī feeds Rāma and Lakṣmaṇa (north wall)
 g. Relief of Sītā and Hanumāna, female demons painted; to right, Rāma and Lakṣmaṇa get the news (northwest pillar)
 h. Pañcamukha Hanumāna

2. Rāma Temple
 a. Rāma, Sītā, Lakṣmaṇa with two-headed deer (north wall)

3. Gopapura Temple
 a. Ardharāmasītā-Rāma to viewer's right (wall of veranda)

4. Charidham Temple
 a. Rāma, Lakṣmaṇa, and monkeys establish Rāmeśvara Temple, and Rāvaṇa worships there (west wall)

5. Paschima Dwāra Hanumāna Temple
 a. Monkey musicians (east wall, bottom)
 b. Sītā garlands Rāma (above a)
 c. Sītā goes to Patala (top)

6. Temple of Lakṣmī-Narayaṇa
 a. Battle of Rāma and Rāvaṇa (north wall)

7. Lakṣmī Temple
 a. Rāma's marriage (east wall)
 b and c. Coronation of Rāma (north wall and north side of passage)

8. Bhadrinath Temple
 a. Battle between Rāma and Rāvaṇa (east wall)
9. Jagannātha Vaidik Sikṣanasthano
 a. Rāma and Sītā seated (north wall)
10. Pratihāra Nijoga, with coronation of Rāma

APPENDIX 5

List of Rāmāyaṇa Scenes in Paṭas and Related Sets of Paintings (Boldface numbers are figure references; multiple x's indicate multiple illustrations)

Jagannath Mahapatra set of 75	Jagannath Mahapatra list of 34	Parlakhemundi 88 cards	Raghurajpur paṭa (**Plate 12**, Figure **289A**)	Danda Sahi paṭa (Figures **253**, **289B**)	Bhikari Maharana paṭa (Figure **254**)
1. Ṛśyaśṛṅga & Jaratā (**223**)	x	x (suit 1, # 2)			Ṛśyaśṛṅga alone
2. Ṛśyaśṛṅga, Daśaratha, Lomapāda		x (suit 1, # 1)			
3. Ṛśyaśṛṅga's sacrifice	x	3 queens take rice from sacrifice			x
4. Prayer to Viṣṇu (#1 in Kanungo)*					
5. Sitā's birth (#2 in Kanungo)*	x (+ 7, 8)		x (+ 7, 8)	x	x (+ 7, 8)
6. Rāma's birth					
7. Bharata's birth					
8. Birth of Lakṣmaṇa & Śatrughna		All 4 births			

						Childhood scene
9. Naming of the sons	x					x
10. Viśvāmitra with Rāma & Lakṣmaṇa	x				Viśvāmitra & Daśaratha	
11. Slaying of Tāḍakī (**224**)	x				x	x
12. Liberation of Ahalyā (**225**)	x				x	x
13. Boatman washes Rāma's feet (**226**)	x		Rāma crosses Gangā		x	
14. Rāma breaks Śiva's bow	x	x	Sitā garlands Rāma	Sitā garlands Rāma	Sitā garlands Rāma	x
15. Rāma & Paraśurāma		x	Marriage	x		x
16. Preparation for the coronation						
17. Kaikeyī & Daśaratha	x	x				x
18. Rāma & Daśaratha						x

Rāmāyaṇa Scenes in *Paṭas*, *continued*

Jagannath Mahapatra set of 75	Jagannath Mahapatra list of 34	Parlakhemundi 88 cards	Raghurajpur paṭa (**Plate 12**, Figure **289A**)	Danda Sahi paṭa (Figures **253**, **289B**)	Bhikari Maharana paṭa (Figure **254**)
19. The departure					
x		Rāma crosses River Sarayū Rama meets Guha Śabara (suit 2, #6)	x	x	x Rāma crosses River Sarayū
20. The ashram of Bharadvāja					
		xx (suits 2, #7; 3, #5) Charms of Chitrakūṭa (suit 2, #8)	x	x	
21. Daśaratha's death					
		x (suit 2, #9) suit 2, #10 Rāma's coronation suit 3, #1 Hanu brings medicine			x Bharata strikes Mantharā

#3 Lakṣmaṇa crowns Vibhīṣaṇa

#4 Agni gives Sītā to Rāma

#5 Rāma & Sītā in forest

#6 Hanu meets Bharata in Nandigrām

xx (suit 3, #7, #9)

#8 Mothers meet brothers

suit 4, #1 Sita & the crow

#2 Rāma meets Agasti

#3 Rāma kills Virādha

x

x

Rāma fights Khara, Dūṣaṇa, Triśiras

Rāvaṇa with Mārīcha

x

22. Bharata's visit (**227**) x

23. Sitā offers piṇḍa for Daśaratha (**228**) x

24. Lakṣmaṇa denoses Śūrpaṇakhā (**229**) x

25. Śūrpaṇakhā before Rāvaṇa

26. Shooting the magic deer (**230**) x

Rāmāyaṇa Scenes in Paṭas, *continued*

Jagannath Mahapatra set of 75	Jagannath Mahapatra list of 34	Parlakhemundi 88 cards	Raghurajpur paṭa (**Plate 12,** Figure **289A**)	Danda Sahi paṭa (Figures **253, 289B**)	Bhikari Maharana paṭa (Figure **254**)
27. Kidnap of Sītā (**231**)	x	x	x	x	
28. Attack of Jaṭāyu (**232**)	x	x	x	x	
		Sītā drops her ornaments			
		Rāma faints at Sītā's loss			
		Sītā in the asoka grove			
29. Death of Jaṭāyu	x	x		x	
		Śabarī gives a mango			
30. Rāma meets the monkeys	x	x	x	x	
		7 sal trees			7 sal trees
31. Death of Vālin (**233**)	x	x	x		
32. Coronation of Sugrīva		x			
		Rāma on Mt. Malyavanta			
		Lakṣmaṇa wakes Sugrīva			
33. Rāma sends monkeys to search	x	x			
		Monkeys search			

Rāmāyaṇa Scenes in Paṭas, *continued*

Jagannath Mahapatra set of 75	Jagannath Mahapatra list of 34	Parlakhemundi 88 cards	Raghurajpur paṭa (**Plate 12,** Figure **289A**)	Danda Sahi paṭa (Figures **253,** **289B**)	Bhikari Maharana paṭa (Figure **254**)
45. Crossing to Laṅkā (**236**) x		x	x		x
46. Rāma in camp		Rāvaṇa sees Rāma			
47. Aṅgada's embassy (**237**) x				x	x (artist identified as Hanumāna)
48. Battle	x	Rāvaṇa shows Sitā false head of Rāma / Battle (suit 7, #10)	x		x
49. Indrajita shoots Rāma & Lakṣmaṇa with nāga pāśa		x (suit 8, #3)	x (Lakṣmaṇa only)		
50. Garuḍa rescues					
51. Kumbhakarṇa awakened		x (suit 8, #1)			x
52. Kumbhakarṇa killed x		x (suit 8, #2)	x		x
53. Taraṇisena killed x / Bharata shoots pellets		x (suit 8, #4) / Rāvaṇa shows māyā to Rāma			x / Durgā

						Vibhīṣaṇa's coronation
54. Lakṣmaṇa kills Indrajita	x					
55. Rāvaṇa shoots Lakṣmaṇa			x / Rāma kills Khāra			
56. Hanumāna brings Mt. Gandhamādana (238)			Hanumāna kills Kālanemi			
57. Mahīrāvaṇa at Hanumāna's tail-fort (239)			Hanumāna meets Bharata while carrying mountain			
58. Mahīrāvaṇa bows to Durgā (240)			(events from suits 2 & 3, above)			
59. Rāma offers his eye to Durgā in gratitude (241)	x					
60. Rāma fights Rāvaṇa (242)	x			x	x	x
61. Sītā's test (243)		x (suit 3, #4)		x	x	x
62. Rāma's coronation (244)		x (suit 2, #10)		x (center)	x (center)	x (center)
63. Rāma banishes Sītā						x

Rāmāyaṇa Scenes in Paṭas, *continued*

Jagannath Mahapatra set of 75	Jagannath Mahapatra list of 34	Parlakhemundi 88 cards	Raghurajpur paṭa (**Plate 12,** Figure **289A**)	Danda Sahi paṭa (Figures **253**, **289B**)	Bhikari Maharana paṭa (Figure **254**)
65. Sītā with Vālmīki					x
66. Lava & Kuśa shown to Vālmīki (**245**)					x
67. Rāma declares aśvamedha					
68. Śatrughna & the horse					
69. Lava & Kuśa defeat Śatrughna (**246**)					
70. Lava & Kuśa defeat Lakṣmaṇa & Bharata (**247**)					
71. Lava & Kuśa defeat Rāma (**248**)					x
72. Sītā & her sons (**249**)					
73. Rāma reunited with his sons (**250**)					x
74. Sītā descends into the earth (**251**)					x
75. Rāma & Sītā reunited in heaven (**252**)					

*For Kanungo, see Chapter 2, text at n. 100.

NOTES

Introduction

1. J. Williams, "Sārnāth Gupta Steles." My "From the Fifth to the Twentieth Century and Back," moreover, suggests a rationale for what might be called ethno-art history.

2. Another dimension of the problem is the diverse placement of the picture: displayed on the wall (rare, but not unknown, in Rajasthan or in Orissa); collected with unrelated pictures in an album (a Mughal tradition that flourished in the later Rajput context); and as part of a book or numbered sequence of pictures (the case for the *Rasikapriyā* and for Orissan illustrated manuscripts).

3. For a lucid analysis from the viewpoint of the maker, see W. Eisner, *Comics and Sequential Art*. The Amar Chitra Katha comics of India, which deal with a wide range of traditional myth, literature, and history, deserve a comparable account of their own.

4. A. K. Ramanujan, "Three Hundred Rāmāyaṇas," 46.

5. For example, N. Goodman, "Twisted Tales; or, Story, Study, and Symphony." There is much scholarly writing about narration in ancient and early Christian art. Because such works raise doubly complex questions about applying both verbal and pictorial models from the West to Indian forms, I shall not allude to them, preferring to make my own mistakes.

6. This is in general the stance of Vidya Dehejia, who concludes her systematic account of this topic in early Buddhist sculpture as follows: "Ajanta's narrative networks must have required a competent 'reader' in order to function in the manner in which they were intended" ("On Modes of Visual Narration in Early Buddhist Art," 392).

7. R. Barthes, "Introduction to the Structural Analysis of Narratives," 258–59.

8. Barthes, "Introduction," 251. Yet in distinguishing articulation (of separate units) from integration (gathering these "into units of a *higher* rank") he reverts to an Aristotelian hierarchy. Art historians may recall a comparable distinction between additive and organic treatments of the human body, a distinction that likewise accepts the formula of Athens or of Renaissance Florence as superior to all alternatives. In general Barthes struggles against the weight of Western narratological (and aesthetic and historical) assumptions in an instructive manner.

9. Barthes, "Introduction," 252–53, where he refers to "the storyteller's (the author's) art, talent, or genius—all mythical forms of chance"; and 293–95.

10. G. Genette, *Narrative Discourse: An Essay in Method*; see also his *Narrative Discourse Revisited*.

11. M. Bal, *Narratology,* 102–14; cf. Genette, *Narrative Discourse Revisited,* 72–78.

Chapter 1

1. P. Richman, *Many Rāmāyaṇas;* R. Thapar, "The Ramayana Syndrome."

2. I find Sahoo's work more helpful than other surveys of this kind in Hindi and Oriya.

3. Bulke acknowledges his debt to K. C. Sahoo, his student, for Oriya references (238–43 in the 3rd edition).

4. W. L. Smith focuses upon Baḷarāma Dāsa and Viśvanātha Khuṇṭia for Orissa, dismissing Upendra Bhañja as very difficult (34). His entire framework seems to privilege Vālmīki as canonical. Nonetheless this work includes invaluable references to "apocryphal" vernacular variants in eastern India.

5. A. K. Ramanujan describes this role as faithful or iconic ("Three Hundred Rāmāyaṇas," 44). I shall not use the semiotic terminology of Charles Sanders Pierce because "iconic" has such divergent connotations in common usage.

6. These dates, and some alternatives, are cogently presented by Robert Goldman in his introduction to vol. 1 of the Princeton University Press translation of Vālmīki.

7. Vālmīki, *Rāmāyaṇa,* ed. G. H. Bhatt.

8. The eastern recension is most easily accessible in the text and Italian translation of Gaspare Gorresio.

9. For a fuller discussion of the theory of eight (or nine) *rasas* and the distinction between this kind of abstracted sentiment and *bhāva,* or actual human emotion, see D. H. H. Ingalls, *An Anthology of Sanskrit Court Poetry,* 13–17.

10. W. L. Smith, *Rāmāyaṇa Traditions in Eastern India,* especially chap. 3. Smith's argument for the Oriya reflects his focus upon Baḷarāma Dāsa, and Smith's summary of Vālmīki's structure includes precisely those events upon which the eastern vernacular versions do agree, omitting others.

11. At least twenty-five appear under the title Ārṣa (= Riṣi) Rāmāyaṇa in the Orissa State Museum: K. Mahapatra, *Descriptive Catalogue of Sanskrit Manuscripts of Orissa,* 3:6–15. One, catalogue no. 13, was sent to Baroda for the compilation of the critical edition of Vālmīki's Rāmāyaṇa. The term Ārṣa Rāmāyaṇa may also designate translations of Vālmīki into Oriya.

12. B. C. Mazumdar, *Typical Selections from Oriya Literature,* 1:xxiii. It has been argued, however, on the basis of passages that are directly translated from the Sanskrit, that Baḷarāma Dāsa must actually have known Vālmīki in written form: K. C. Sahoo, "Indian Rama Literature and Jagamohan Ramayana," 176.

13. P. Lutgendorf, "Ramayan: The Video." Lutgendorf stresses the relationship to the *Rāmcharitmānas* of Tulsī Dās but discusses ways in which the serial departed from it as it both drew upon diverse traditions and remained embedded in concerns of the 1980s.

14. P. C. Bagchi, Introduction to *Adhyātmarāmāyaṇam,* 76. Cf. K. Bulke, *Rāmkathā,* 166–67; F. Whaling, *The Rise of the Religious Significance of Rāma,* 113 (denying the tradition that Rāmānanda came from the south); J. L. Brockington, *Righteous Rāma: The Evolution of an Epic,* 252–57; B. L. Baij Nath, *The Adhyatma Ramayana* (although this translation is not always accurate, because of its accessibility my text citations follow its numbering system).

15. K. Bulke, *Rāmkathā,* ch. 12.

16. G. S. Ghurye, *Indian Sadhus,* 172–74. Whaling, *Rise of the Religious Significance of Rāma,*

177. While the *Adhyātma Rāmāyaṇa* has been ascribed to Rāmānanda, the founder of the sect, this attribution is open to question. Evidence about the Rāmānandins is conflicting; for instance, they are said to follow a qualified dualism, although the *Adhyātma* is unabashedly monistic (Ghurye, 165).

17. F. Whaling, *Rise of the Religious Significance of Rāma,* 217, and chaps. 14 and 16 in general.

18. P. C. Bagchi, Introduction, 60.

19. F. Whaling, *Rise of the Religious Significance of Rāma,* 198.

20. K. C. Sahoo, "Oriya Rāma Literature," 175–76. I have worked from the Sharada Press translation of Gopala's translation of the *Adhyātma Rāmāyaṇa,* published in Berhampur, n.d.

21. The illustrated one, from the Daśāvatāra Maṭha near Jajpur, Cuttack District, is discussed below in Chapter 2. A second, from Madhupur, also Cuttack District, is in the Orissa State Museum, Bhubaneswar, no. P/182A: K. Mahapatra, *Descriptive Catalogue,* 3:38.

22. The only copy I have seen is in the Library of the City Palace, Jaipur (Rajasthan). G. N. Bahura, *Literary Heritage of the Rulers of Amber and Jaipur,* 65 (no. 2767). This *Brahma Rāmāyaṇa,* like the illustrated Oriya copy, comprises only five books (numbered 13 to 17), although Bulke's account suggests that more complete manuscripts must exist.

23. K. Bulke, *Rāmkathā,* 178–79.

24. Lutgendorf discusses this religious movement, known as *rasik sādhanā,* making clear that the form devoted to Rāma is not derivative from the more familiar Kṛṣṇa form ("The Secret Life of Rāmcandra," 219–28).

25. M. Mansinha, *History of Oriya Literature,* 50–69. I concur with K. C. Sahoo ("Oriya Rāma Literature," 31–36) in rejecting the *Vilankā Rāmāyaṇa* as a work of the same author. In the case of both Śāralā and Balarāma Dāsa, I make no pretense of having read the entire work in Oriya.

26. For example, Daśaratha is cursed by the divine cow in the same way that Dilīpa was Kālidāsa's *Raghuvaṃśa* (W. L. Smith, *Rāmāyaṇa Traditions in Eastern India,* 20).

27. C. Das, *A Glimpse into Oriya Literature,* 65.

28. M. Mansinha, *History of Oriya Literature,* 62–63.

29. Smith, *Rāmāyaṇa Traditions in Eastern India,* 56 (although Śāralā describes the demon as meditating in an anthill, not a mound of earth as Smith says). I cannot share Smith's assumption of direct influence from the Jain *Paumacariyam,* as opposed to shared oral sources.

30. K. Bulke, *Rāmkathā,* 238–39.

31. W. L. Smith, *Rāmāyaṇa Traditions in Eastern India,* 38–40.

32. B. C. Mazumdar, *Typical Selections from Oriya Literature,* 1:xxiii.

33. K. C. Sahoo, "Indian Rama Literature," 176. The tellers (Brahmā, Śiva, Jagannātha, and Vālmīki) are not identical with Tulsī Dās's. Cf. Philip Lutgendorf, "The View from the Ghats."

34. Sahoo, "Oriya Rāma Literature," 93, and "Indian Rama Literature," 176–78. In general Sahoo stresses the plurality of sources synthesized by Balarāma Dāsa.

35. K. Bulke, *Rāmkathā,* 241. W. L. Smith, *Rāmāyaṇa Traditions in Eastern India,* 121, 125. For example, the curse of the Phalgu River for the rapacious behavior of the Gāyā brahmans (an antiestablishmentarian theme) occurs in Bengali written texts. The Śabarī's gift of fruit she has tasted and the assistance of a squirrel or mouse in building the bridge to Laṅkā are found in Telugu folklore.

36. M. Mansinha, *History of Oriya Literature,* 96.

37. W. L. Smith, *Rāmāyaṇa Traditions in Eastern India,* 167.

38. K. C. Sahoo, "Oriya Rāma Literature," 67–70; K. Bulke, *Rāmkathā,* 239–90.

39. L.D. Institute (Ahmedabad) Ms. 20, discussed below in Chapter 2.

40. Nilambara Dāsa, sixteenth century; Maheśvara Dāsa, mid-seventeenth century. W. L. Smith, *Rāmāyaṇa Traditions in Eastern India,* 33.

41. K. C. Sahoo, "Oriya Rāma Literature," 36. W. L. Smith, *Rāmāyaṇa Traditions in Eastern India,* 142–44. This episode had occurred in the Sanskrit *Adbhūta Rāmāyaṇa.*

42. K. C. Sahoo, "Oriya Rāma Literature," 167.

43. The headquarters of Ghumsar was called Russelkonda from 1837 until after India's independence, when it was renamed Bhanjanagar. Royal families titled Bhañja go back to the fourth century A.D.

44. K. C. Sahoo, "Oriya Rāma Literature," 138–39.

45. Smith gives Upendra's dates as 1670 to 1720, a year that seems too early for his death (*Rāmāyaṇa Traditions in Eastern India,* 33). Kedarnath Mahapatra suggests that he lived until 1753 (*Khurudha Itihasa*), as does Dandapani Behera (*Freedom Movement in the State of Ghumsar in Orissa,* 6). Upendra's claims to have undertaken tantric practices to obtain poetic power need not be taken at face value (M. Mansinha, *History of Oriya Literature,* 116). Mansinha presents a generally positive view of the poet's work, whereas B. C. Mazumdar is broadly damning (*Typical Selections from Oriya Literature,* 2:xvi–xxv).

46. M. Mansinha, *History of Oriya Literature,* 118.

47. I have found no correspondence between this story and various Sanskrit tales in which the names Lāvaṇyavatī and Chandrabhānu appear.

48. The performer is called an *indrajālaka,* usually translated "magician," although the illustration in Raghunath Prusti's manuscript of the *Lāvaṇyavatī,* which I discuss later in Chapters 3–5, shows a troupe of people (Figure 193), perhaps something like the Gujarati *bhavai,* which consists of conjuring and other entertainments, including folk drama.

49. B. C. Mazumdar, *Typical Selections from Oriya Literature,* 2:xii. Sahoo, "Oriya Rāma Literature," 158–61. Smith, *Rāmāyaṇa Traditions in Eastern India,* 34.

50. W. L. Smith, *Rāmāyaṇa Traditions in Eastern India,* 148–51.

51. Daniel H. H. Ingalls originated this translation (a propos of Kṛṣṇalīlā), the implicit pun ("jest") referring to the literal meaning of *līlā,* "sport."

52. Dashahra designates the tenth day of the bright half of the lunar month of Aśvina. Rāmanavamī is the ninth day of the bright half of the lunar month of Chaitra. A life of Chaitanya suggests that in the sixteenth century Rāmalīlā took place in Puri at Dashahra time (N. Hein, *Miracle Plays of Mathurā,* 109–10).

53. K. C. Sahoo mentions him in "Oriya Rama Literature." In 1983 I was told that Vikrama Narendra was from Ghumsar. The text on paper now in use was copied from a palm-leaf manuscript about twenty years ago.

54. N. Bisoi, *Dasapalla Itihasa* (in Oriya), 10. The temple bears a plaque that dates its consecration to December 23, 1903. From 1884 to 1886 the Oriya writer Fakirmohan Senapati was diwan of Dasapalla, and his autobiography says that most of the rural population of the state was Khond or Khaira, i.e. aboriginals (*My Times and I,* 81).

55. For the origin of this *Lakṣmaṇa-rekha* in a minor work by Tulsī Dās and its propagation as part of restrictions put on women, see U. Chakravarti, "The Development of the Sita Myth: A Case Study of Women in Myth and Literature," *Samya Shakti* 1, no. 1 (1983), 73.

56. Local legend has it that the headman of Bisipada 160 years ago had seen the Dasapalla Rāmalīlā and wished to emulate that. Rāma came to the brahman Janārdana Dāsa, who agreed to write a text and required that he be allowed to meditate for twenty days uninterrupted in a temple near the town. At the end of that time, the villagers found that he had vanished, leaving a completed manuscript.

57. This canopy was made by a visiting artisan from Pipli, the Muslim appliqué center between Bhubaneswar and Puri. The canopy must already have been old in 1923, the date of repair embroidered on it. Concerning the Pipli tradition in general, see B. C. Mohanty, *Appliqué Craft of Orissa.*

58. See Chapter 2 for the story of Jagannath Mahapatra of the *paṭa* tradition. Vaisya Sadāśiva may have lived in the later eighteenth century (K. C. Sahoo, "Oriya Rāma Literature," 192–93); his text is widely available today.

59. In no Orissan version have I seen the systematic conversion of an entire town into the landscape of the play that characterizes the peripatetic Rāmalīlā of Ramnagar in Uttar Pradesh. Cf. S. Bonnemaison and C. Macy, "The RamLila in Ramnagar." Thus in Dasapalla, the stage serves as Chitrakūṭa until Rāma leaves to shoot the illusionary deer, when suddenly audience and actors move to a spot 300 meters away and the hut is relocated. After this, Laṅkā is generally located 500 meters further down the road, although some action in Laṅkā also takes place on the original stage.

60. This Rāmalīlā begins on Akṣaya Tirtha, the third day of the lunar month of Vaiśakh (following Chaitra), a significant moment in the Jagannātha ritual calendar. My source for this information is Purna Chandra Mishra of Puri.

61. My source for this information is the late lamented Dhiren Dash of Bhubaneswar.

62. The manuscript in the National Museum, New Delhi, is discussed in Chapter 2. Cf. K. C. Sahoo, "Oriya Rāma Literature," 167.

63. My source for this information is Raghunath Panigrahi of Chikiti, who had himself acted under the guidance of his father, a major singer (*gāyaka*) and exponent of the tradition, in which the last king's son also took part. The paper manuscript in use in the 1950s, preserved by Raghunath Panigrahi, appears to be a version of Krishna Chandra Rajendra's text, simplified by a later ruler. After the Rāmalīlā ceased, Jātrā troupes continued to perform occasionally in Chikiti.

64. I visited this village on April 14, 1990, and my information comes from several local people, who said that the performance used to be based on Vaisya Sadāśiva, Vikrama Narendra, and Ananga Narendra (another nineteenth-century author). The patrons were local Khandayats, but there was no royal family. In Dasapalla, the Hanumāna mask is likewise kept in the Mahāvīr shrine and worshiped.

65. The Temple Endowment Board kindly allowed me to check their schedule of performances, which goes back to 1977. Some variation might be explained by weather, although in 1990 in the event of rain they read the text while canceling the enactment, sticking to schedule. Moreover, Thursday is an inauspicious day and performance was often, but not consistently, suspended then, spreading the entire Rāmalīlā over a longer period.

66. Such variations occurred both in Dasapalla, as documented by records, and in Bisipada, where in 1983 I saw the breaking of Śiva's bow combined with Rāma's marriage, whereas in 1990 the first event had taken place on the previous night and the marriage led directly to the encounter with Paraśurāma.

67. In the printed program, Bharata's visit was listed for the seventh night, but this was said to be a mistake. Some such variations may result from the direct reading of the text by the *gāyakas*, who literally have the last word, whereas the program is the work of the temple

administrator. This division need not imply disagreement; it may rather indicate an accepted diversity of function.

68. The kidnapping must occur on the full moon of Chaitra, a requirement in Dāṇḍa Jātrā as well.

69. Killing the rhino is in fact a major event in Bisipada, where it occurs on the main stage, rather than in procession. Gania, near Dasapalla, borrowed Vikrama Narendra's text but does not perform this event. The rhino itself is probably not the key to the incident. Although rhinos have not been found in Orissa for at least a century, people still speak of rhino meat as a precious substance suitable for *śrāddha.* Those early *dharmaśāstra* texts that permit the consumption of meat mention that the ancestors are particularly gratified by the offering of rhino flesh: P. V. Kane, *History of Dharmaśāstra,* 4:422. Cf. J. Bautze, "The Problem of the Khaḍga."

70. L. Hess, "Rām Līlā: The Audience Experience." R. Schechner, *Between Theatre and Anthropology,* chap. 4, "Ramalila of Ramnagar." Lutgendorf makes clear the variety of performances in the Banaras area, demonstrating that the smaller ones are not merely scaled-down versions of Ramnagar (*The Life of a Text,* chap. 5).

71. Māyā Sītā must be played by a brahman in Dasapalla, thus intensifying Rāvaṇa's sin, that he kidnaps a brahman woman. The narrow stage in this portion of the performance reminds me of Prahlāda Nāṭaka, the drama of Narasimha's victory over Hiranyakaśipu, which flourished in Ganjam District, where the innocent victim Prahlād paces up and down in a similar passageway in the midst of the crowd.

72. The effort of hoisting the image involves a large number of youths and carpenters and is part of the whole drama of Rāmalīlā. The effigy is not supposed to be raised before dusk; one year when it was raised earlier in the day to accommodate a visit by the chief minister, it fell over.

73. My information is dependent upon the late Dhiren Dash of Bhubaneswar (who kindly told me about the form initially) and upon Omshankar Sarangi of Asureshvar, which I visited during the daytime. I have not actually seen the evening performance, nor has anything been written about it.

74. N. Hein, *The Miracle Plays of Mathurā,* 17–30; P. Lutgendorf, *The Life of a Text,* 256–57.

75. There are thirty masks for rent today, according to the temple authorities. The vow begins with the kidnap of Sītā on the full-moon day, when Hanumāna's services become necessary.

76. D. Mukhopadhyay, "Sahi Yatra." Mukhopadhyay suggests that Sahi Jātrā is linked to many of Jagannātha's *veśas,* or festive ornaments, throughout the year, although his suggestion is not borne out by my own observation in Puri. It is difficult to get a clear account of the performance from the temple priests, for they are not centrally involved. My impression is that Sahi Jātrā varies considerably from year to year, its form determined in part by the initiative of the *sahis* and *akhaḍas* themselves. The performances are related to the military skills of the town, in the past fostered by the Puri Temple for its own defense; hence the prominence of Nāgā warriors.

77. The repertoire here has been shaped by cosmopolitan royal dancers and patrons, influenced by Uday Shankar and Javanese troupes that visited Calcutta. I am unable to see any particular connection between Seraikela or Baripada Chhau as they survive today and one illustrated manuscript produced in this area, the Baripada *Vaidehīśa Viḷāsa* of Śatrughna, discussed in Chapter 2. For example, in Seraikela Chhau, Riśyaśṛṅga's mask consists of a human head with the ascetic's hair twisted upward to form a conical knot that

vaguely resembles a horn; Śatrughna depicts the sage with the full head of a two-horned blue antelope.

78. D. Dash, *Jatra*, 13–15, and *Pālā Itihāsa Pālā*, an ingenious history of Pālā in Pālā-style Oriya verse.

79. J. Pani, *Ravana Chhaya*. The late puppet master Kathinanda Das preserved a set of puppets from the Mahābhārata, although the equation of the entire genre with the name "Rāvaṇa's Shadow" suggests the centrality of the Rāmāyaṇa. I saw performances in 1982 and 1983.

80. J. Pani, *Ravana Chhaya*, 21–31, provides a detailed summary of the episodes correlated with the text. Pani notes that the Uttara Kāṇḍa used to be performed, although it is not today.

81. N. K. Sahu, state editor, *Balangir District Gazeteer*, 493–96. There are other shrines to Laṅkeśvarī in the region, for example a larger temple at Sambalpur. While one may not accept the historical identification of Sonepur with an actual Laṅkā in the epic, this theory points to an interesting cluster of local beliefs.

82. P. Richman, "E. V. Ramasami's Reading of the *Rāmāyaṇa*."

Chapter 2

1. For a full account of attitudes associated with this seemingly archaic form and of the process of bookmaking, see J. P. Das, *Chitra-pothi*, chaps. 2 and 5. Incised manuscripts, generally without pictures, were made throughout south India, although at least one illustrated fifteenth-century *Adhyātma Rāmāyaṇa* is known (personal communication, Sobha Menon, Dept. of Art History, M.G. University, Baroda). The illustrated manuscripts of Bali (Indonesia) are engraved with a knife rather than the pointed stylus used in Orissa.

2. It is possible that another person added pigment to the palm-leaf pictures, although sometimes the scribe/illustrator himself did so, as in the case of Balabhadra Pathy, discussed on page 55 (J. Williams, "Jewels from Jalantara").

3. John Beams's statement that not one man in a hundred was literate in Orissa (*Comparative Grammar of the Modern Aryan Languages of India*, 1:89) is an assessment of ability to write orthographically and grammatically correct (i.e. standard) Oriya; Beams did not consider the nature of a vernacular language in an age before printed tools provided standards for uniformity. Oriya, moreover, interfaced with other languages on all three sides of Orissa. Surely the audience of readers was fairly wide, however varied their ability to write.

4. The 1936 account of how Raghunath Prusti's illustrated Rāgamālā (N.B.: not a sacred text) was kept by his heirs vividly describes this smearing with sandal paste: Kalicharan Patnaik, *Kumbhāra Chaka*, 258–59; J. P. Das and J. Williams, *Palm-Leaf Miniatures*, 6.

5. Cf. J. Williams and J. P. Das, "Raghunātha Prusti: An Oriya Artist," plates 29–31 (a work by an artist most of whose oeuvre fared better).

6. J. P. Das, *Chitra-pothi*, chap. 4. Unillustrated manuscripts were made for Rs 1.25, in exchange for a window frame, or for rates such as an anna (1/16 of a rupee) per chapter. Brajanātha Baḍajena asked the Rājā of Dhenkanal for Rs 100 for an illustrated work. J. P. Das and J. Williams, *Palm-Leaf Miniatures*, 8.

7. J. P. Das, *Chitra-pothi*, 36, 48–49; J. P. Das and J. Williams, *Palm-Leaf Miniatures*, 21.

8. "*Ṭīkāṃ puttalikānvitaṃ vililikhitaṃ Śrīgītagovinda.*" This manuscript is the work of Dhanañjaya, discussed later in this chapter in connection with its date. J. P. Das, *Chitra-pothi*, 38.

9. J. Williams, "Jewels from Jalantara" (the work of Balabhadra Pathy discussed below).

10. P. K. Mishra, *The Bhāgavata Purāna;* J. P. Das, *Chitra-pothi,* 41. The colophon concludes, "E pothi aṣṭama navama charita pittula mo kamā. Ghanaśyāma je putra mora tā lekhā pustaka akṣara."

11. Other karaṇa illustrators included G. B. Pattanayaka and Chakradhara Mohanty. See S. Pani, *Illustrated Palmleaf Manuscripts of Orissa,* 81–83.

12. Orissa State Museum Ext. 166; J. P. Losty, *The Art of the Book in India,* 137; S. C. Welch, *India,* 62; S. Pani, *Illustrated Palmleaf Manuscripts,* 19–22; J. P. Das, *Chitra-pothi,* 38; J. P. Das and J. Williams, *Palm-Leaf Miniatures,* 40. That the akṣara *a* occurs only in the archaic form in this work does not rule out a late date but makes it less probable. The akṣara *a* occurs in its modern form in the *Rādhākrisna Keli* manuscript, British Library Or. 11612, which appears to be another work of Dhanañjaya, as Losty has pointed out (loc. cit.). The use of such an *a* again is improbable but not impossible in the late seventeenth century.

13. Orissa State Museum Ext. 46, now renumbered Ext. 334. K. Vatsyayan, "The Illustrated Manuscripts of the Gita-Govinda from Orissa," 279, plate CVIIIa. The older form of *a* occurs in the text here, but the modern one occurs in the colophon.

14. His *aṇka* 4 (= year 3) is also given as the date when the manuscript was completed. The sole Harikṛisna Deva of Khurda ruled from 1715 or 1716 until 1720. This entire colophon remains problematic and may possibly be a later addition to the text.

15. D. P. Ghosh, "Eastern School of Mediaeval Indian Painting (Thirteenth–Eighteenth Century A.D.)," figures 215–17, 330–36. These paintings on wood are also undated.

16. See note 10 above. The colophon has been read as the twenty-third regnal year (nineteenth actual year) and equated with November 20, 1799: S. Pattanayak, *Brajanātha Granthāvalī,* viii. This information is repeated by J. P. Das (*Chitra-pothi,* 41), by P. K. Mishra (*The Bhāgavata Purāna,* 12), and by J. P. Das and J. Williams (*Palm-Leaf Miniatures,* 40). In 1795 the seventh day of the dark fortnight of Kārttika began on Wednesday, as the colophon says; but in 1799, the date Pattanayak gives, it did not (cf. L. D. Swamikannu Pillai, *An Indian Ephemeris,* 6:393, 401). In any case 1799 is not the twenty-third regnal year of any Khurda ruler, and Brajanātha is usually said to have died in 1798.

17. The former is in fact known as a *karaṇi* form; it is used exclusively in the archaic scribal script employed on paper.

18. Mishra, *The Bhāgavata Purāna.* I am indebted to Dr. J. P. Das for patiently checking my observations about handwriting and for discussing these issues with me.

19. The "modern" *a* also occurs in a *Rādhākrisna Keli* (British Library Or. 11612), which has been ascribed to the same Dhanañjaya on the basis of style (J. P. Losty, *The Art of the Book in India,* 137).

20. S. Kramrisch, "The Hundred Verses of Amaru Illustrated," 226. Cf. S. Mahapatra and D. Pattanayak, *Amarusatakam,* 2. Kramrisch is to be applauded for recognizing the interest of this entire subject. It is small wonder that for lack of a local framework in which to place the manuscript, she resorted to a pan-Indian one.

21. J. P. Das, *Chitra-pothi,* 37. In addition to the four manuscripts discussed here, at least one more *Adhyātma Rāmāyaṇa* by Sarathi Madala has been partially published in Bansidar Mohanty's *Oḍiya Sāhityara Itihāsa,* 1966.

22. Orissa State Museum Ext. 81, 136 folios, 37.5 × 4.2 cm. The nineteenth *aṇka* is equivalent to the sixteenth year. Thus because the reign of Divyasimha III of Khurda began in A.D. 1859, this is the same as *samvatsara* (here indicating Christian year) 1875, when the

solar date, lunar date, and day of the week also concur. *Sana* (Muslim or Hegira era, adding 593) 1284 (= A.D.1877) appears to be miscalculated.

23. Spencer Collection, Indian Ms. 14, 146 folios, 29 × 4 cm. The colophon gives the dates *samvat* 1891, *fasli* 1298 (= A.D. 1891), Śāka year 1812 (= A.D. 1889/90), *anka* 12 of Mukunda Deva of Khurda (the beginning of whose reign is often taken as 1880), and *anka* 51 of Lakṣmīnārāyaṇa Deva of Badakhemundi.

24. The C. L. Bharany copy has 182 folios, 26.5 × 4.5 cm. The colophon gives the dates 1301 *fasli* (= 1894, presumably wrong), *samvatsara* 1891, December 2, Wednesday (the last two concurring in 1891), eighth day of the bright half of Mārgaśira (not concurring with December 2 or Wednesday in either 1891 or 1894), fifty-second *anka* of Lakṣmīnārā-yaṇa Deva of Badakhemundi.

25. OL 121, 88 folios (the last numbered 155), 37 × 4.5 cm. This colophon reads "*samvat* 1992 [which appears to be a slip of the pen for 1892], thirteenth *anka* [= eleventh year] of Kṛipāmāyadeva [of Badakhemundi], the first of Kumbha, the fourth day of the bright half of Māgha, Tuesday." Kṛipāmāyadeva apparently came to the throne in 1891 (after December 2). In 1902 the first day of the solar month Kumbha was indeed the fourth day of the lunar month Māgha, but this was a Wednesday. Here, as in most of Sarathi Madala's colophons, there seems to be confusion about some part of the complex dating system; such confusion occurs more consistently in his work than in that of any other scribe I have encountered.

26. National Museum 75.536, 53 folios, 33 × 4.5 cm.

27. C. L. Bharany, 237 folios, 36.5 × 4 cm. This version is more sparsely illustrated than any other *Adhyātma Rāmāyaṇa* I have seen.

28. Thirteen folios preserved, original pagination 189–201 (which was not the end of the text), demonstrating that the earlier books were also included; 26.3 × 4 cm.

29. L.D. Institute Ms. 20 (currently catalogued as *Adhyātma Rāmāyaṇa*, A.D. 1703), 34 folios, 24 × 4 cm.

30. National Museum 75.556, 58 folios (the last of which is paginated 60), 39.5 × 4.5 cm.

31. This manuscript has 281 folios, 28.5 × 3.8 cm. The Jubel Library in Baripada recorded that this manuscript was collected in Kuamara (Mayurbhanj District) by Padmasri Padma-nanda Acharya in the 1930s. It was mentioned by Klaus Fischer in his article "Orissan Art in the Evolution of Postmediaeval Indian Culture," 27. It is now in the Orissa State Museum in Bhubaneswar.

32. The closest parallel I know is the Zurich manuscript of the *Rasika Haravalī*, where in two cases a band of foliage frames a rounded section of text (E. Fischer and D. Pathy, *Die Perlenkette dem Geliebten*, 34).

33. J. P. Das and J. Williams, *Palm-Leaf Miniatures*, plate 76.

34. *Samvat* here must indicate the Muslim or *fasli* era, beginning in 593. The nineteenth *anka* is equivalent to year 16, and Rāmachandra Deva III of Khurda came to the throne in 1817. Here the colophon dates referring to two different eras can be reconciled, unlike Sarathi Madala Patnaik's.

35. The Rietberg folios are 39 × 4.4 cm. (as are the Victoria and Albert and the New Delhi leaves). R. Skelton, *Indian Miniatures from the Fifteenth to Nineteenth Centuries*, 23–25, plate 5. E. Fischer, S. Mahapatra, D. Pathy, *Orissa*, 245.

36. The Victoria and Albert leaf is unpublished. One side bears text alone; the other depicts Rāma and Sītā in Panchavati and the encounter with the crow.

37. The New Delhi leaves are unpublished; folios are numbered 22 (Rāvaṇa and gods), 66 (my Figure 100), and 104 (battle between monkey and *rākṣasa* in chariot).

38. The poem has 110 folios, 17.5 × 4.2 cm. The name Karaṇa Śatrughna is legible on the final leaf.

39. K. Das, *Kavisūrja Granthāvaḷī,* 9. I am indebted to Dr. J. P. Das for this reference and for invaluable assistance in reading the colophons.

40. The first *Vaidehīśa Viḷāsa* by Michha Patajoshi has 215 folios, 40.5 × 5.5 cm. The artist is identified as Michha, son of Krishna Mishra Sharma. In one place *samvatsara* 192 appears, and in another Christian Era 1102 is written. I would deduce that Michha was young at this point (not yet given the title Patajoshi), hence mistakes in the figures for which he was responsible. The date also includes *aṅka* 24 (= year 20) of Mukunda Deva of Khurda, which might be anytime between A.D. 1896 (counting from 1876, his actual accession) and 1908 (counting from 1888, his father's death).

41. Michha Patajoshi's second work has 151 folios preserved (originally 245 according to the pagination of colophon folio), 41.6 × 4.6 cm. This manuscript was acquired from the historian Kedarnath Mahapatra in Bhubaneswar. The 1911 date, definitely in Michha Patajoshi's own handwriting on the final folio, says that the *pāṭha* (literally "reading") of the book was finished then. Afterward, a slightly different hand has written "the inscribing [*lekhā*] was completed on the twelfth day of the dark half of Mārgaśira, 1914." Possibly this indicates that the illustrations of the manuscript took over three years to complete.

42. Asutosh Museum Ms. 5, 302 folios preserved (the major manuscript had 283, according to the pagination of the colophon), 39 × 4.5 cm.

43. E. Fischer, S. Mahapatra, and D. Pathy, *Orissa,* 250. One wonders whether these and the interpolated leaves in the more complete copies might not come from the same copies. My suggestion that these represent eight different versions comes from some duplication of the same events in various sequences, as well as a comparison of the rate of narration as indicated by the pagination. For example folio 117 in the Asutosh 1918–28 manuscript shows Rāma and Lakṣmaṇa with Kabandha, whereas an interpolated page 117 shows Rāma, Lakṣmaṇa, and Sītā with Virādha, an event covered about 17 pages previously in the main sequence; thus this interpolated set would presumably have been substantially longer than 283 pages.

44. One is Bhubaneswar, Orissa State Museum, Ext. 13, 12 joined folios, measuring 51 × 31.5 cm. as a whole. The second, slightly smaller, is in the Asutosh Museum and is composed of ten joined leaves. Notes on both describe them as *paṭas* made by Michha Patajoshi of Balukeshvarpur; they are dated only by month.

45. In all these works, there is consistency throughout the manuscript in the use of pigment as well as in figure style and composition. Thus I would infer that they were painted as part of the original production of the manuscript, perhaps by a single maker, rather than considerably later, and hence that the resemblance is not merely adventitious. Two of these works are erotic texts, and in the remainder many erotic scenes appear, perhaps as the forte of this artist or group of artists. One *Chauṣaṭhi Rati Bandha* is in the Orissa State Museum (J. P. Das, *Chitra-pothi,* 93; S. Pani, *Illustrated Palmleaf Manuscripts of Orissa,* 63), and a second erotic text is in the collection of Sachi Rautroy in Cuttack. A *Chitrakāvya Bandhodaya* is in the Orissa State Museum (OL 530; J. P. Das, *Chitra-pothi,* 83–84; S. Pani, *Illustrated Palmleaf Manuscripts,* 61–64).

46. That illustrated here in Figure 140 National Museum 72.109, measures 25.5 by 4.25 cm. British Library Or. 13720 measures 35.5 by 3.5 cm. In both cases the manuscripts are complete, and it is clear that the scribe chose to leave no space for pictures.

47. All measure ca. 41 × 4.5 cm. No pagination is preserved; I assume that only one folio from the Rāmāyaṇa sequence (Śūrpaṇakhā, the magic deer) is missing, although it is possible that more have been lost. In addition to the Rāmāyaṇa sequence discussed here, folios from other parts of this manuscript are found in the following collections:

National Museum, New Delhi

Poonam Bakliwal, New Delhi

Jagdish and Kamala Mittal Museum, Hyderabad

Museum für Indische Kunst, Berlin I/5675, no. 130a, b (E. Waldschmidt and R. L. Waldschmidt, *Indische Malerei,* 196)

British Museum, London, 1963–11–11

Metropolitan Museum of Art, New York, 1974.220

Edwin Binney 3rd, San Diego, 53 N, O

George Bickford Collection, Cleveland (S. Czuma, *Indian Art from the George P. Bickford Collection,* no. 132)

Anonymous private collection (S. C. Welch, *Indian Drawings and Painted Sketches,* 30–31)

Elvehjem Museum, Madison, Wisconsin (P. Chandra, *Indian Miniature Painting in the Collection of Earnest C. and Jane Werner Watson,* 10–11; J. P. Das and J. Williams, *Palm-Leaf Miniatures,* color plate L)

48. Some leaves lack any pigment. The great diversity of transparent washes and intense, opaque colors suggests that at least some pigment may have been added long after the manuscript was made.

49. For a discussion of previous dating (and confirmation of an early nineteenth-century position), see E. Fischer and D. Pathy, *Die Perlenkette dem Geliebten,* 53–54.

50. National Museum 80.1276, 197 folios, 33 × 4.5 cm. This *Lāvaṇyavatī* was acquired from the collection of Sachi Rautroy of Cuttack.

51. L.D. Institute Ms. 15, 28 folios, 28.5 × 4.5 cm. J. Williams, "Jewels from Jalantara." Since writing this article, I have found another Vaishnava work by the artist in the Elvehjem Museum, Madison, Wisconsin (66.13.3).

52. National Museum 72.108, 32 folios, 26 × 4 cm. The British Museum has a folio from this same manuscript (1968–12–04), as does the Chandigarh Museum. The *Uṣābhilāsa* is firmer in drawing and writing than the *Lāvaṇyavatī* or the *Gīta Govinda,* and the facial type is slightly less elongated, suggesting that this may be an early work by the artist, whose subsequent drawing is yet more fanciful and daring. Folios 12v and 15r show the distinctive treatment of a storm, although without the diagonal lines for some gusts of rain in Plate 10 (in this book), which seems to me an advance in dynamism.

53. I am grateful to Dr. John Emigh of the Department of Theatre Arts at Brown University for this information. See D. Dash, *Jatra: The People's Theatre of Orissa,* 26–27.

54. Dr. Dinanath Pathy informs me that Pathy is a very rare brahman name in Orissa, and that only one family of that name survives in Digpahandi and two in Bhadrak. One might infer that the artist was brought from the outside to the court of Jalantara.

55. For illustrations of comparative material, see E. Ray, "Documentation for Paiṭhān Paintings," and V. Stache-Rosen, "On the Shadow Theatre in India."

56. In later Javanese temple reliefs, often described as in a "wayang" style, the interstices

between figures are similarly filled in by natural and even abstract forms that have no direct counterpart in the shadow theater of Indonesia.

57. J. Mittal, *Andhra Paintings of the Ramayana,* e.g. figure 23 (the seven sal trees, with no serpent). Here royal figures consistently wear tall southern-style crowns, absent in Orissa generally and in Balabhadra Pathy's work in particular.

58. J. Williams and J. P. Das, "Raghunātha Prusti: An Oriya Artist"; J. P. Das and J. Williams, *Palm-Leaf Miniatures.* An additional work, a copy of the *Ārtatrāṇa Chautiśā* recently discovered in Digpahandi, has been published by E. Fischer and D. Pathy, *Die Perlenkette dem Geliebten,* 55–56.

59. Folios of this *Lāvaṇyavatī* measure 32.5 × 4.5 cm. All remain in the Subuddhi house in Mundamarai, except for two in the Bharat Kala Bhavan, Varanasi (10927 and 10928, Figures 189–92 here), and ten in the Rietberg Museum, Zurich (R. Skelton, *Indian Miniatures from the Fifteenth to Nineteenth Centuries,* 25–28). Since the original pagination is clear, we can be certain that folio 79 is missing.

60. J. Williams and J. P. Das, "Raghunātha Prusti," 138–39; J. P. Das and J. Williams, *Palm-Leaf Miniatures,* 32–38.

61. National Museum 72.165, I–II, 80 folios, 33.5 × 4 cm. Western pagination has been added along with the museum's acquisition number, visible at the left in my Figures 1–40. The new numbers are out of sequence and in many cases obliterate the original pagination, which I have reconstructed from those cases where it is visible. Fortunately there is no question about the actual sequence of folios, for the verse numbers are clearly visible in the text.

62. That colophon is part of National Museum 72.165, III–IV, 48 folios, 35.3 × 4 cm. The date is 1305 Śāla, or A.D. 1898. This second manuscript lacks the Rāmāyaṇa portion. The eyes of its figures open wide, with a dot for the pupil isolated in the center.

63. This work, 66 folios, 4 × 27 cm., belongs to the Daśāvatāra Maṭha of Jajpur subdivision. I am indebted to R. P. Das of Bhubaneswar for showing it to me and enabling me to photograph it. A notation in the text suggests that it was made by *sakhī,* which in the context of *Viṣṇu-bhakti* implies a generic devotee rather than a female companion. (Williams and Das, "Raghunātha Prusti," 137, plate 48.)

64. S. Pani, *Illustrated Palmleaf Manuscripts,* 31–38; J. P. Das, *Chitra-pothi,* 71, 101.

65. The most accurate account of the Raghurajpur procedures is J. P. Das, *Puri Paintings,* chap. 8. See also E. Fischer, S. Mahapatra, and D. Pathy, *Orissa,* 231–35 (using playing cards as an example); and B. C. Mohanty, *Patachitras of Orissa,* 11–15. My description here is in the past tense because the procedures today are rarely followed exactly as I describe them. For example, bazaar pigments are used except to demonstrate the older procedures to visitors; lac is rarely applied, and when it is, it takes the form of commercial shellac.

66. J. P. Das, *Puri Paintings,* 36–39, plates 3–6, color plates 1–3; B. C. Mohanty, *Patachitras of Orissa,* 6, plates 1–4; E. Fischer, S. Mahapatra, and D. Pathy, *Orissa,* 220–23.

67. These images follow more general rules for image making not peculiar to Jagannātha, who appears here as a standard divinity. The frontal view of the heads follows patterns for depicting iconic deities that do not apply to the lesser figures usually shown in profile in *paṭachitras.*

67. J. P. Das, *Puri Paintings,* 81–83.

68. J. P. Das, *Puri Paintings,* 36.

69. J. Williams, "Marriage Paintings in South and Central Orissa."

70. J. P. Das, *Puri Paintings,* 55.

71. D. Pathy, *Mural Paintings in Orissa,* 7–8; Pathy draws on present oral tradition of the painters. The technique appears to resemble the fine plastering with ground shells known as *goṭāi* in Rajasthan.

72. J. Williams, "A Painted Rāgamālā from Orissa."

73. The *chitrakāras'* contributions to the Jagannātha Temple included painting parts of the carts built each year for Ratha Yātrā.

74. In the 1950s, most painters were working as agricultural laborers and masons (J. P. Das, *Puri Paintings,* 88).

75. J. P. Das, *Puri Paintings,* plates 23, 24, 26.

76. J. Williams, "Criticizing and Evaluating the Visual Arts in India: A Preliminary Example," 10.

77. J. Williams, "A Painted Rāgamālā from Orissa," figure 10.

78. Jagannath Mahapatra of Raghurajpur has a large notebook that includes 120 images; he made it roughly thirty years ago. Another made in 1928 by Kenduri Mahapatra of Nayagarh is in the hands of his nephew, Udayanath Mahapatra.

79. J. P. Das, *Puri Paintings,* 51.

80. The account I present here is documented in the records of the Virañchi Nārāyaṇa Maṭha itself and is also found in T. C. Rath, *Ghumsar Itihāsa,* 36–38. Virañchi (or Viriñchi, as it occurs in other parts of India) is an epithet of Brahma. For a systematic discussion of the Buguda murals, see D. Pathy, *Mural Paintings in Orissa.*

81. J. P. Das, *Puri Paintings,* chap. 9. Cf. figure 31 there and sages at Buguda such as Viśvāmitra or Paraśurāma (Figure 207 here).

82. D. Pathy, *Mural Paintings in Orissa,* 82.

83. That convention appears in the elephant-hunting friezes on the base of the Sun Temple at Konarak and in one illustration of the *Amaru Śataka* (S. Mahapatra and D. Pattanayak, *Amarusatakam,* verse 92). This resembles the Jain *Mahāpurāṇa* painted at Palam in 1540 (K. Khandalavala and M. Chandra, *New Documents of Indian Painting—a Reappraisal,* 74).

84. J. P. Losty, *Krishna,* plate 2; S. Czuma, *Indian Art from the George P. Bickford Collection,* plate 125.

85. E. Fischer, S. Mahapatra, and D. Pathy, *Orissa,* figures 456, 464, 578–84; D. Pathy, *Mural Paintings in Orissa,* plates 23–28.

86. E. Fischer, S. Mahapatra, and D. Pathy, *Orissa,* figures 457–58, 585–90; D. Pathy, *Mural Paintings in Orissa,* plates 27–37.

87. J. P. Das, *Puri Paintings,* 54, plates 9–10. D. Pathy, *Mural Paintings in Orissa,* 86, plates 39–41. An inscription reads *Sam[vat] 1323,* which Pathy ascribes to the Śaka era (= A.D. 1400), although that seems unlikely; possibly the *Sana* or Muslim era is intended (= A.D. 1916). Pathy also reports recent repainting. In his plate 40, the mountains to the left are much more regular than those of Buguda.

88. G. N. Bahura and C. Singh, *Maps and Plans from Kapardwara* (Jaipur), no. 260. It remains questionable whether the royal worshiper depicted is Man Singh of Jaipur, who had ruled a century before the painting was collected by the Rajasthani brahman Manikram Paliwal. A *paṭa* of Jagannāth dated 1670 in the Victoria and Albert appears to me to be entirely the work of Nepali artists.

89. J. Williams, "From the Fifth to the Twentieth Century and Back," figure 7. British Museum 1940–7-13, 0152, 32.4 × 58 cm. It was not included in Moor's book of 1810, *The Hindu Pantheon.* No catalogue of his own collection is preserved, and it remains possible

that some other member of the family added it later.

90. J. P. Das, *Puri Paintings,* plate 27.

91. Boston, Museum of Fine Arts 25.525, given to the museum in 1925.

92. M. Archer, *Indian Popular Painting in the India Office Library,* 123; J. P. Das, *Puri Paintings,* 171. Over the past fifteen years, I have found that painters rarely keep examples of old, completed work in their possession.

93. Bibliothèque Nationale 1041, 270 × 150 cm. L. Feer, "Introduction du Nouveau Catalogue," 371 (information that the collection was presented in 1894), 379 (description of this image, whose original provenance Feer did not know). The image is reproduced in color in S. Gole, *Indian Maps and Plans,* plate 23.

94. British Museum 1880–303, c. 65 × 35 cm. The reverse bears the initials of A. Franks, keeper of Oriental Antiquities, who retired in 1896.

95. See J. P. Das, *Puri Paintings,* 120–21. Other *paṭas* include Rāma's pursuit of the magic deer or the cutting of Rāvaṇa's umbrellas in the upper right corner.

96. J. P. Das, *Puri Paintings,* chap. 7.

97. J. P. Das, *Puri Paintings,* plate 22 (the Gaṇeśa). Halina Zealey herself must have played a major role in the award, and her taste may be discerned in the pale, grayish palette of this picture, which is exceptional even for Jagannath Mahapatra's work. The refinement, however (for example in the middle border composed of rats), is not new or exceptional—cf. the Bibliothèque Nationale nineteenth-century painting (Figure 216).

98. Jagannath Mahapatra's notebooks contain an unillustrated list of thirty-four Rāmāyaṇa subjects, all of which are included in the final set of seventy-five. The Uttara Kāṇḍa is entirely absent in the list. It is not clear whether this list goes back to before Zealey's days or is a subsequent condensed version of the large set.

99. I have been unable to locate this set in Delhi. Figure 220 is a photo of a photo that Jagannath Mahapatra had kept.

100. K. C. Kar, S. K. Das, and K. S. Sahu, *Ramayana in Ordisi Pata Painting,* Jagannath Mahapatra's role is not mentioned in this book. In 1989 he claimed that his paintings had been directly published, although I am inclined to believe his account from 1982 that they were copied.

101. I paid Rs 2,000 for the entire set of seventy-five. Jagannath Mahapatra said that Zealey was to have paid Rs 2,000 for her set (the deposit was 200) and that Subas De paid the same amount on behalf of the Handicrafts Board. I am aware that these figures may have been cited to justify the price my research assistant negotiated for me. The 1982–83 set was surely in part the work of Jagannath Mahapatra's assistants, whom I occasionally saw at work on it. Dinabandhu Maharana of Raghurajpur claimed that he had executed some of the initial scenes in 1981. Less than half of the set was completed in early 1983, when the approaching marriage of Jagannath Mahapatra's daughter may have provided an incentive for its prompt completion (which meant final payment); the master himself was thus involved more toward the end. The style is remarkably uniform throughout, demonstrating the "quality control" of workshop production.

102. This 1983 set was based more directly upon the 1954 Zealey sketches. Only one photo of the now missing 1965 scene of this particular event (Figure 220) was in Jagannath Mahapatra's hands.

103. J. P. Das, *Puri Paintings,* 73; B. C. Mohanty, *Patachitras of Orissa,* plate 13.

104. My documentation of the last, which was being painted during my visit, is largely verbal (backed up by bad photographs).

105. Here I have in mind particularly Raghunath Prusti, three of whose works have similar yellow covers with delicate floral designs. (J. P. Das and J. Williams, *Palm-Leaf Miniatures,* plate B). Even here it is possible that the similarity results from continued collaboration between the illustrator and a single professional painter.

106. The cover (Figure 257) and a second cover that belongs to a paper manuscript are in the Orissa State Museum, Bhubaneswar. The palm-leaf *Lāvaṇyavatī* in the British Library, Or. 13720, in which, paradoxically, the text sequence of the Rāma story is not illustrated, bears on its covers simple scenes of the bending of Śiva's bow, the release of Ahalyā, Sītā garlanding Rāma, and the coronation.

107. Bhagavata Maharana was the elder brother of Banamali Maharana of Raghurajpur. This box was under consideration by the purchase committee of the National Museum in New Delhi in 1982 as an older object. When I showed the photos in Raghurajpur, there was a consensus that it was Bhagavata Maharana's work, and he concurred himself that he had made it about ten years before.

108. J. P. Das, *Puri Paintings,* 50–51, 163; J. Williams, "The Embassy." Both these discussions treat the paintings of Nayagarh, Ranpur, and Itamati as within the mainstream of Orissan style, in part because of their refinement, a viewpoint I would now question. It would seem that more objects were made for courtly patrons in Nayagarh than elsewhere. This is the home area of Jadumani, the *chitrakāra* poet and wit who served the *rājās* of Nayagarh and Ranpur.

109. B. C. Mohanty, *Patachitras of Orissa,* 7. I know of only one example of a *paṭa* proper from Sonepur; the painter who owned it said it was roughly forty years old, an unpublished wedding scene in a private collection, found tied around a post in the artist's house. Unlike Puri *paṭas,* it has no painted background. The figure style is a large version of the playing cards discussed below.

110. B. C. Mohanty, *Patachitras of Orissa,* 11; R. von Leyden, *Ganjifa: The Playing Cards of India,* 108.

111. S. Mahapatra and D. Pattanayak, *Amarusatakam,* verse 32. This detail might suggest that this elusive manuscript was made in western Orissa.

112. E. Fischer, S. Mahapatra, and D. Pathy, *Orissa,* figure 594. The cycle was in the Radhakantha Maṭha, which was whitewashed in 1981.

113. Victoria and Albert IS 46–1963, 9.5 cm. diameter. R. von Leyden, *Ganjifa,* 102–3, color plate 9. The Victoria and Albert Museum records that this set of cards was donated in 1918 by Rev. H. W. Pike, a retired Baptist missionary. The cards show no signs of wear, and I see no reason to assign a nineteenth-century date to the set.

114. The difference between Puri and Parlakhemundi painting is visible if one compares photographs of the process of work on playing cards (often relatively coarsely painted) in Raghurajpur with similar photographs of the process of making a Parlakhemundi wall painting (E. Fischer, S. Mahapatra, and D. Pathy, *Orissa,* figures 516–27 and 620–53). In the playing cards the background is painted first, opaque areas of color are filled in, and delicate outline is added only as a final stage. In Parlakhemundi wall paintings, some initial work is linear and sketchy, no background is provided, and more time is spent on lively outlines.

115. Here as in Parlakhemundi I interviewed several *chitrakāras* about their genealogies, the nature of their work, and iconographic details. Gopinatha Mahapatra was one of the most informative in Jeypore.

116. J. P. Das, *Puri Paintings,* plate 48.

117. E. Fisher, S. Mahapatra, and D. Pathy, *Orissa,* figures 585–93. My information about dates comes from Apanna Mahapatra, mentioned below, as well as a second local *chitrakāra.*

118. M. Mansinha, *History of Oriya Literature,* 130–32.

Chapter 3

1. K. C. Panigrahi, *Archaeological Remains at Bhubaneswar,* 28; possibly latter half of the sixth century; V. Dehejia, *Early Stone Temples of Orissa,* 183:650–80; T. E. Donaldson, *Hindu Temple Art of Orissa,* 1:31: late sixth century. The scenes in question are reproduced in Donaldson (figure 29) and in D. Desai, "Narration of the Ramayana Episode—Vali-Vadha—in Indian Sculpture," plate 40.

2. Inconsistency of direction is visible on the Great Stūpa at Sanchi, where most lintels read from left to right, but a few in reverse (e.g. the Vessantara Jātaka on the North Gate). In some architectural friezes, the direction of circumambulation may explain the reading of reliefs from right to left, but this does not explain the inconsistency at Sanchi. In tiered panels, boustrophedon organization (e.g. some Sarnath Gupta steles, or the epic friezes of the Kailāsanātha at Ellora) may respond to the efficiency of eye movement back and forth.

3. K. C. Panigrahi, *Archaeological Remains at Bhubaneswar,* 69: a cognate member of the Paraśurāmeśvara group; S. C. De, "Svarna Jāleswar, One of the Early Temples of Bhubaneswar": same period as Śatrughneśvara, late sixth century; V. Dehejia, *Early Stone Temples of Orissa,* 88: formative group, seventh century; T. E. Donaldson, *Hindu Temple Art of Orissa,* 1:43–50, figures 12–56: first decade of the seventh century.

4. T. N. Ramachandran, "The *Kirātārjunīyam* or Arjuna's Penance in Indian Art," 22–26; M.-A. Lutzker, "The Celebration of Arjuna—the Kirātārjuniya and the Arjunawiwāha in South and Southeast Asian Art," 38–41. I concur with Ramachandran in reading this section from left to right.

5. The case for *apasavya,* or counterclockwise, circumambulation as part of the Pāśupata ritual has been made by C. D. Collins, *The Iconography and Ritual of Śiva at Elephanta,* 136. Devangana Desai has suggested an occasional form of worship involving counterclockwise movement up to the water chute on the north side of the shrine, followed by return to the east, clockwise movement, and final counterclockwise movement: "Placement and Significance of Erotic Sculptures at Khajuraho," 148. The early Chola temple at Puñjai combines clockwise sequence (north and south walls) and counterclockwise sequence (west and part of south walls) in its reliefs: D. T. Sanford, *Early Temples Bearing Rāmāyaṇa Relief Cycles in the Chola Area: A Comparative Study,* 141.

6. Gérard Genette connects prolepsis, relatively rare in Western narrative, with predestination (*Narrative Discourse,* 67). In the present case, one might expect Rāma's victory over Rāvaṇa, rather than one of his dubious deeds, to figure first by philosophical or religious logic.

7. Flashbacks occur, for instance in the Uttara Kāṇḍa of Vālmīki or in the *Uttararāmacarita* of Bhāvabhuti (the retelling of the entire story seen painted on the wall), but not, as far as I know, in reverse sequence or inverting the order of books 3 and 4. Reversed-sequence narration does occur in Indonesian shadow-puppet theater and might be found in some performance or oral tradition in India also.

8. Kramrisch, *Unknown India,* plate 33.

9. This section is clearly visible in T. E. Donaldson, *Hindu Temple Art of Orissa,* vol. 3, figure 4156. His excellent plate shows the Svarṇajāleśvara as it existed before 1979, and my older

photos confirm that placement. The present restoration has moved this section from the corner to the central facet, or *rāhā* portion of the wall (where no frieze existed originally), and one stone with three monkeys has been shifted to the left end of the flanking *anurāhā*, visible at left in Figure 274 (bottom).

10. D. Desai, "Narration of the Ramayana Episode—Vali-Vadha—in Indian Sculpture," 82.

11. T. E. Donaldson, *Hindu Temple Art of Orissa*, vol. 3, figures 4160–62.

12. V. Dehejia, *Early Stone Temples of Orissa*, 116–20, 185: formative phase B, 680 to 750 (which seems very early); T. E. Donaldson, *Hindu Temple Art of Orissa*, 1:166, figures 369–400: late ninth century.

13. Donaldson identifies one scene from the east end of the south side of the porch as Sītā, Rāma, and Lakṣmaṇa, presumably because two male figures hold bows (*Hindu Temple Art of Orissa*, 3:1416, figure 4172). I find it difficult to identify the remainder of this continuous frieze (e.g. three Gaṇeśas side by side) with the Rāmāyaṇa. Some figures with tails may indeed represent monkeys. Perhaps one large figure attacked by monkeys represents Kumbhakarṇa, in which case another large reclining figure to the left may represent the giant's awakening (Donaldson, figure 4171). Rāmāyaṇa or not, this seems to illustrate an unfamiliar story.

14. D. Mitra, "Four Little-Known Khākara Temples of Orissa": between the Paraśurāmeśvara and the Mukteśvara; V. Dehejia, *Early Stone Temples of Orissa*, 125–28: advanced transitional phase, up to 850; T. E. Donaldson, *Hindu Temple Art of Orissa*, 1:274–81, figures 693–713: first quarter of the tenth century.

15. A. Boner and S. Rath Śarmā, *Śilpa Prakāśa*, xxiv. Donaldson notes the role of erotic imagery elsewhere on the temple (*Hindu Temple Art of Orissa*, 1:280–81).

16. Donaldson identifies Rāma and Lakṣmaṇa seated on the ground, although these slightly corpulent figures without bows at the left of my Figure 281 (bottom) may represent Rāvaṇa and Mārīcha (*Hindu Temple Art of Orissa*, 3:1416, figure 4177). To the right Lakṣmaṇa may appear twice, seated, conversing with Sītā.

17. In a careful examination with binoculars on the spot, I saw no human aspect in these trees, mentioned by D. Desai ("Narration of the Ramayana Episode—Vāli-Vadha," 83); cf. Donaldson (*Hindu Temple Art of Orissa*, 3:1417, figure 4180).

18. Donaldson suggests that repeated scenes of a monkey conversing with a human in front of a small building with a flag (*Hindu Temple Art of Orissa*, 3:1417, figure 4181) represent the monkeys reporting back to Rāma the results of their fruitless search. It seems equally possible that these are Hanumāna's exploits in Laṅkā.

19. Cf. the discussion of the Sonepur Laṅkā Poḍi and the Asureshvar Dāṇḍa Jātrā in Chapter 1. Among later illustrations, Balabhadra Pathy's *Lāvaṇyavatī*, in particular, picks up this thread. Not all images of monkeys invoke the Rāmāyaṇa—witness Pañchatantra illustrations on the Mukteśvara Temple (K. C. Panigrahi, *Archaeological Remains at Bhubaneswar*, figure 73).

20. There are detached panels representing Rāma, Lakṣmaṇa, and Hanumāna from Sukleśvara. Friezes on the Śiśireśvara at Bhubaneswar and the Pañcha Pāṇḍava at Ganesvarpur (two archers with monkeys) may represent the Rāmāyaṇa, although no full identification of particular scenes has been proposed (T. E. Donaldson, *Hindu Temple Art of Orissa*, 3:1169, figures 4175–76).

21. D. Mitra, *Konarak*, 67. It is difficult to identify this as Rāma's marriage per se, for of course monkeys were not yet associated with him at that point in his life.

22. Panigrahi identifies one figure as Vibhīṣaṇa, but to me it appears to be the crowned Sugrīva (*Archaeological Remains at Bhubaneswar,* 86, figure 137).

23. These elements occur in a tenth-century image from Benūsagar whose details are clearer (T. E. Donaldson, *Hindu Temple Art of Orissa,* vol. 3, figure 3784). It is tempting to suggest an identity for these figures appropriate to the Gandhamādana incident, perhaps the demon Kālanemi and the woman-crocodile who attempt to destroy Hanumāna in the *Adhyātma Rāmāyaṇa* and many Oriya versions. Yet the generalized use of this iconic type makes it equally possible that these are simply generic opponents. Outside Orissa separate male and female figures may appear under each foot: K. C. Aryan and S. Aryan, *Hanumān in Art and Mythology,* plates 2, 52, 56, 57, 59, 62, 63.

24. T. E. Donaldson, *Hindu Temple Art of Orissa,* 2:726, and 3:1371, figure 3781. The absence of Sītā rules out identification as the coronation.

25. This relief is roughly a meter square. Similarly refined wood carvings from Nayagarh have been published in E. Fischer, S. Mahapatra, and D. Pathy, *Orissa,* 205–6; see also J. P. Das, *Puri Paintings,* plate 12. Those carvings were preserved by a descendant of *chitrakāras,* who said they were made by his ancestors about 150 years ago.

26. A scene of Rāvaṇa in his chariot from Jajpur appears to me to have been made at least as late as the seventeenth century (T. E. Donaldson, *Hindu Temple Art of Orissa,* vol. 3, figure 3783). Rāma's coronation occupies the lintel of a wooden door, probably nineteenth century, that recently appeared on the New York art market (*Sotheby's Indian and Southeast Asian Art,* New York, June 2, 1992, 177).

Chapter 4

1. R. P. Goldman, ed., *The Rāmāyaṇa of Vālmīki,* 1.75.139–57.

2. B. L. Baij Nath, *The Adhyatma Ramayana,* 9.

3. Śāralā Dāsa's *Mahābhārata* makes Riśyaśṛiṅga the son of a demoness and makes the courtesan Jāratā the mother of his child. In Balarāma Dāsa's *Jagamohana Rāmāyaṇa,* he is the son of a celestial *apsaras* and his wife, Śāntā, the daughter of Daśaratha, as in many Oriya versions (apparently based on some recensions of Vālmīki). Here the seduction and the boat journey are described at length. (K. C. Sahoo, "Oriya Rāma Literature," 213–15).

In the Rāmalīlā performances I know, Riśyaśṛiṅga appears as a sage, his *jaṭā mukuṭa* suggesting a single horn; but his dalliance with the courtesans is not prolonged, perhaps because this is a prelude to the actual birth, which must take place on Rāmanavamī itself, the first night of the entire cycle. For this event I would not suggest that performances outweighed the ornate literary tradition in guiding many artists.

4. In this relationship, most Oriya texts follow the Bengali recension of Vālmīki, as opposed to other recensions, where Śāntā is the daughter of Rompāda (or Lompāda).

5. F. A. Marglin, *Wives of the God-King.* Marglin presents the Riśyaśṛiṅga story as explaining the nexus between auspiciousness and political status (pp. 100–101).

6. In Kanungo's version, published in 1977, the boat does not have a swan prow and the figures are asymmetrically arranged (K. C. Kar, S. K. Das, and K. S. Sahu, *Ramayana in Ordisi Pata Painting,* figure 3). This event follows Sītā's birth in the published form, as it does in the *Vaidehīśa Viḷāsa,* whereas in Jagannath Mahapatra's sets it occurs first.

7. The boat of the *veśyās* is more fully described in the Sanskrit Mahābhārata and in most Oriya texts than in Vālmīki's Rāmāyaṇa.

8. The 1902 manuscript devotes 5 1/2 folios (13a through 18a) to this sequence. From the 1914 version, folios 15 (showing the *veśyās'* arrival) and 17 are preserved in the Rietberg

Museum, Zurich. Folio 20v (in Delhi) depicts Daśaratha's sacrifice, which suggests a total of six pages for the whole episode. The 1926 version devotes 10 1/2 pages to the same events.

9. R. P. Goldman, *The Rāmāyaṇa of Vālmīki,* 1:75.

10. Balarāma Dāsa, *Jagamohana Rāmāyaṇa,* 1:1.

11. K. C. Sahoo, "Oriya Rāma Literature," 211.

12. B. J. Baij Nath, *Adhyatma Ramayana,* 14; Upendra Bhañja, *Vaidehīśa Vilāsa,* 6, 43. In Oriya the name generally appears as Tāḍakī, although Tāṭakā or Taḍakā (often transcribed Tārakā) appear in Sanskrit; her genealogy and previous history vary in each account. One interesting addition by Balarāma Dāsa to Vālmīki (also found in the *Vaidehīśa Vilāsa,* in Krittibāsa's Bengali, and in folk tales of the Birhors) is that Viśvamitra urged Rāma to take a road around the grove of the demoness, a suggestion the hero rejected (W. L. Smith, *Rāmāyaṇa Traditions in Eastern India,* 174). Michha Patajoshi faithfully illustrates this interesting variation, which serves to emphasize Rāma's divine mission, in his versions of the *Vaidehīśa Vilāsa.*

13. In Vālmīki twenty-one chapters intervene between these two events. In the *Adhyātma Rāmāyaṇa,* the *Vaidehīśa Vilāsa,* and the *Lāvaṇyavatī* the defeat of Subāhu and Mārīcha is briefly mentioned as a lead-in to the Ahalyā episode (*Vaidehīśa Vilāsa,* canto [*chhānda*] 7). In Vālmīki's version, Ahalyā is rendered invisible rather than turned into stone (1.47.29).

14. The episode of the boatman, absent in Vālmīki, is widely known from the *Rāmcharit-mānas,* where, however, it occurs after Rāma's exile in the next volume of the story. The emphasis upon *bhakti* appears in many late versions.

15. E.g. Deogarh, sixth century (M. S. Vats, *The Gupta Temple at Deogarh,* plate XVa—Ahalyā); Virupaksa Temple, Pattadakal (H. Cousins, *Chālukyan Architecture of the Kanarese Districts,* plate XLIV, upper left—Tāḍakī and Ahalyā); Nageshvara Temple, Kumbhakonam and other early Cola reliefs (D. T. Sanford, *Early Temples,* 79).

16. The branching lines on the limbs may derive from striped clothing commonly worn by demons (cf. Figure 184, top). The spotted face and sari vaguely resemble Persian conventions for *divs,* by this time widely adopted for *rākṣasas* in Rajput painting.

17. The *Brahma Rāmāyaṇa* itself simply says, "He released the fallen Ahalyā from the curse of Gautama" (verse 64). Arjuna Dāsa's *Rāma Vibhā,* the first Oriya *kāvya* version of the Rāmāyaṇa, probably sixteenth-century and not widely popular later, describes Ahalyā as turned into a square stone (K. C. Sahoo, "Oriya Rāma Literature," 252).

18. The text on this folio (the reverse of the leaf) comprises verses 10 to 16 of the seventh *chhānda,* which describes the charms of the forest. Presumably the text of the Ahalyā episode followed on the next leaf, not preserved in Zurich. R. Skelton, *Indian Miniatures,* 24, identifies our Figure 9 as folio 3r.

19. I am deeply indebted to Mrs. Suresvari Mishra (Reader in Sanskrit, Puri Women's College) for deciphering this verse after I and other Oriya friends had given up on it.

20. The 1902 manuscript in Koba devotes about four folios to this sequence. The 1914 version in New Delhi covers it in seven pages (including scenes of other demons killed after Tāḍakī), whereas the 1926 version in Calcutta devotes nine pages to it. The general selection of scenes is similar; for instance a full page of unillustrated text precedes the episode of the boatman in all. The disguise of Indra as a cat, found in the *Padma Purāṇa* and in Punjabi folktales as well as in Upendra Bhañja's work, may derive from the Sanskritic term for cat, *mārjāra,* which may also imply "paramour" (K. C. Sahoo, "Oriya Rāma Literature," 255).

21. Some versions of Krittibāsa include Bharata and Śatrughna in Viśvamitra's expedition,

but they are eliminated in the incident of alternative routes mentioned above in note 12 (W. L. Smith, *Rāmāyaṇa Traditions in Eastern India,* 174). The label in Figure 177 spells his name Bharatha, as does that in Figure 183, right, the standard visit of Bharata to Rāma.

22. According to A. K. Ramanujan, there is an implicit relationship between Ahalyā and Tāḍakī in Kampaṉ's Tamil version of the epic ("Three Hundred Rāmāyaṇas," 31).

23. S. I. Pollock, *The Rāmāyaṇa of Vālmīki,* 2:64–73.

24. S. I. Pollock, *The Rāmāyaṇa of Vālmīki,* 2:487–89; Vālmīki, *Rāmāyaṇa,* ed. G. H. Bhatt, 2, Appendix 1, 26. In Balarāma Dāsa, Sītā, marked with ocher, clasps Rāma, leaving a red mark, which makes them both laugh. All the crows are blinded, but Sītā persuades Rāma to restore their sight on the condition that they remain squint-eyed (K. C. Sahoo, "Oriya Rāma Literature," 322–23).

25. Cantos 18 and 19. The poet introduces the latter as "a garland of *jamakas,*" a generally untranslatable trope in which one word is repeated with different meaning. In Vālmīki and the *Adhyātma Rāmāyaṇa,* Bharata's visit is followed more or less directly by the exiles' visit to yet another illustrious sage, Atri, and his pure wife, Anasūyā.

26. The wall forms a continuous composition behind the niche, broadly similar to Prusti's design in Figure 183. Conceivably the central niche was a later addition, although this speculation is not borne out by details of painting or construction.

27. There are four in Orissa State Museum Ext. 81. In the remainder only three are preserved, but pages are missing in each, and in general Sarathi Madala Patnaik includes a picture on each page. The scenes are not always the same.

28. The *Vaidehīśa Vilāsa* reads simply, "He worshipped the king's shoes." In the Baripada manuscript I am unable to locate the sequence of Bharata's visit.

29. Victoria and Albert IS 24–1967 seems also to illustrate the shooting of the crow.

30. Michha Patajoshi's 1902 *Vaidehīśa Vilāsa* also depicts Rāma and Lakṣmaṇa's transformation, although there the brothers stand while tying their hair (Figure 106). This scene, as well as the relative elaboration of architecture in this early work, leads me to wonder whether as a youth Michha was not aware of Prusti's work.

31. He concludes that he will gain both *mokṣa* and the ease of dying earlier than Rāvaṇa: "As when heat dries up a pond, first the fish and then the crocodile die."(*Vaidehīśa Vilāsa,* 24.15).

32. Kathleen Erndl describes Śūrpaṇakhā's role in general: in the *Adhyātma Rāmāyaṇa* as the object of a prank by the brothers, elsewhere as Sītā's dark alter ego ("The Mutilation of Śūrpaṇakhā").

33. Jaṭāyu swallowing Rāvaṇa's chariot is a regular scene in Bengali paintings (J. Williams, "Jatayu the Valiant Vulture").

34. K. C. Sahoo, "Oriya Rāma Literature," 383–87, suggesting an origin in folklore.

35. K. C. Sahoo, "Oriya Rāma Literature," 377–79, suggesting parallels in the folklore of the Kols. Cf. L. Hess, "The Poet, the People," 247.

36. In this section, I must confess particular uncertainty about my identification of the scenes labeled (in Figure 200) Śūrpaṇakhā denosed by Lakṣmaṇa, Śūrpaṇakhā before Rāvaṇa, Lakṣmaṇa and Sītā, and the blue figure and woman at the bottom of wall B.

37. E.g. J. P. Das, *Puri Paintings,* color plate 23 (on the mid-right edge). For recent independent versions of the scene, see J. Williams, "Criticizing and Evaluating," figures 14–22 (plates 15 and 16 there are reversed, although the captions are in the correct order).

38. See Appendix 1. The creation of Māyā Sītā might well occur on missing leaves in

Sarathi Madala's Bharany and Utkal University manuscripts. It is definitely absent, however, in the two *Adhyātma Rāmāyaṇa* manuscripts *not* by him—National Museum 75.536 and the second copy in the Bharany collection.

39. The figures in Figure 59 are labeled from the left, Sītā, Rāmachandra, Rāmachandra (with no explanation for his change of costume), and Māyā Sītā.

40. See Appendix 1. Fruit appears in Orissa State Museum Ext. 81 and National Museum 75.536, although it is impossible to tell if it has tooth marks (not mentioned in the *Adhyātma Rāmāyaṇa* itself). The less frequent images of Kabandha always show him with extremely long arms that stretch horizontally across the scene, suggesting some shared pictorial tradition not found at Buguda or known to the illustrators of other texts.

41. J. P. Das, *Puri Paintings,* 135. This is the only written explanation for Navaguñjara I know, although similar images occur outside Orissa.

42. Śatrughna depicted the Rāslīlā similarly in his illustrated *Braja Bihāra.*

43. In even the version of Prusti, often indebted to Buguda, we see a four-wheeled *ratha* (Figure 187). The form of Puṣpaka Vimāna in the reliefs of Loro Djonggrang in Java a millennium earlier shows a similar head below, not necessarily indicating any visual continuity (W. Stutterheim, *Rāma-Legenden,* vol. 2, plate 35).

44. The form standard on *pats,* with a large-headed Jaṭāyu holding the chariot in his open beak, also occurs in the 1775 *Rāmcharitmānas* made in Midnapore District (N. Goswami, *Catalogue of Paintings of the Asutosh Museum Ms. of the Rāmacaritamānasa,* plate XIVb; J. Williams, "Jatayu the Valiant Vulture").

45. The Śabarī's costume, blouseless, with the sari over her right shoulder, is reserved in this manuscript for servants and may indicate humble, if not necessarily tribal, status.

46. Cf. his empty rooms in illustrating the *Sangīta Dāmodara* (K. Patnaik, *Rāga-citra,* 38, 42).

47. Rāvaṇa observes both these scenes in the form of an ascetic, as he does in Prusti's version (Figure 186, far left). While this is a conceivable twist, I know of no text that mentions his presence.

48. J. Williams, "From the Fifth to the Twentieth Century and Back," figure 7. It is also interesting that the "centaur" pattern, with the torso of Mārīcha emerging from the shoulders of the deer, does not, as far as I know, occur in later Orissan images, although it is common in Bengal in terra-cottas on temples, in the 1775 *Rāmcharitmānas* made in Midnapore (N. Goswami, *Catalogue,* plate XIVa), and in the *pats* of itinerant entertainers (S. Kramrisch, *Unknown India,* plate XXXIII).

49. N. C. Mehta and Moti Chandra, *The Golden Flute,* plate 1 (a page from a *Bālagopālastuti,* fifteenth century); J. M. Nanavati, M. P. Vora, and M. A. Dhaky, *The Embroideries and Beadwork of Kutch and Saurashtra,* 93, plates 36, 104, middle (traditional embroidery and beadwork); E. Fischer, J. Jain, H. Shah, *Tempeltücher für die Muttergottinnen in Indien,* figure 250, no. 29. In Rajasthan the motif occurs in late, rough wall paintings (Orchha, Shekhavati) and in the *paḍhs* used in village performances, but I have not discovered it in courtly miniatures. The two-headed deer is also (more rarely) associated with a goddess, in Gujarat (E. Fischer, J. Jain, and H. Shah, *Tempeltücher,* 233) and in the terra-cottas made at Molela in western Rajasthan.

50. I would interpret the motif here as a form of doodling, for this artist gratuitously inserted other small animals in the same way. Several three-headed deer appear as decoration (along with one- and two-headed forms) in the wall paintings of Shekhavati. The discovery of this unexpected detail in the C. L. Bharany manuscript and my reaction to it call to mind

Ogden Nash's immortal poem "The Lama" (*I Wouldn't Have Missed It: Selected Poems of Ogden Nash* [Boston: Little, Brown, 1975], 16).

51. Vana Parva, verses 336–42 in the edition of the Orissa Government Department of Culture (Bhubaneswar, 1974).

52. *Śrī Rāmalīlā,* 63, in which the deer is simply described as covered with gold and two-headed.

53. In the example from Dasapalla, one head is removed when Rāma returns with the corpse, "making it easier to carry." This unique case in Orissa could be reconciled with the Gujarati explanation discussed below, that the second head suggests the action of the live deer only. Bisipada and Amarapura in Ganjam also retain a two-headed wooden deer with both heads fixed in place (J. Williams, "From the Fifth to the Twentieth Century and Back," figure 9). In Gania and Belpada today the deer is played by a human actor without mask. In the Jeypore area actors wear a mask in the form of a hat with two tiny deer heads on top, like antennae. One of these on display in the Indian Museum, Calcutta, is illustrated in *Indian Archaeology 1978–79—a Review,* plate LIV, c (mistakenly labeled "Chhau mask").

54. J. M. Nanavati, M. P. Vora, and M. A. Dhaky, *Embroideries and Beadwork,* 93. Gujarati block-print textile makers of the kind discussed in E. Fischer, J. Jain, and H. Shah (*Tempeltücher*) have given me a similar explanation, conflating the scene of Rāma with another story that involves seven sisters and a deer that looks back. The *paḍh* painters of Bhilwara and Shahapura in Rajasthan, however, explain the two heads as showing the deer's extraordinary *māyā* nature.

55. *Tāḷa* (palm) trees are mentioned in the Bengali and northwest recensions of the Vālmīki and are depicted in sculpture in preference to the deciduous *śāḷa* (Vālmīki, *Rāmāyaṇa,* ed. G. H. Bhatt, vol. 4, chap. 11, verse 47). Only one Oriya version, the eighteenth-century *Rāma Kṛiṣṇa Kelikallol* of Tripurari Das, refers to *tāḷas* (K. C. Sahoo, "Oriya Rāma Literature," 406). Because *śāḷas* appear in all the texts and in most images considered here, I use sal.

56. Baḷarāma Dāsa, *Jagamohana Rāmāyaṇa,* Kiṣkindhā Kāṇḍa, 70.

57. K. Bulke, *Rāmkathā,* 3rd ed., 471. In the *Ānanda Rāmāyaṇa* the snake has an adversarial relationship to Vālin and is uncoiled by Lakṣmaṇa.

58. D. Desai, "Narration of the Ramayana Episode," 84, figures 47–49. The image of a serpent appears as early as Loro Djonggrang (tenth century) in Java, and the serpent is mentioned in some Southeast Asian texts such as the *Seri Ramayana.*

59. Upendra composed a collection of such verses, *Chitra-kāvya Bandhodaya.* (J. P. Das, *Chitra-pothi,* 81–84). These remain popular today, and I have heard stories that the last generation of Oriyas used *bandhas* in writing affectionate private letters. It is to be underscored that the *bandha* appears even in unillustrated manuscripts of the *Vaidehīśa Vilāsa* as well as in modern printed texts. *Chitra-kāvya* did, admittedly, exist in other vernaculars, from Tamil to Gujarati, as well as in Sanskrit: K. Jha, *Figurative Poetry in Sanskrit Literature.*

60. The Bengali and northwestern recensions of Vālmīki provide sources for Tārā's curse (K. C. Sahoo, "Oriya Rāma Literature," 414). Oriya Rāmalīlās maximize Tārā's role as advisor and underscore her curse with emphatic music.

61. That the composition resembles Hoysala reliefs rather than earlier Orissan ones need not be used to infer specific connection with thirteenth-century Karnataka.

62. Sarathi Madala Patnaik's 1875 manuscript (Orissa State Museum Ext. 81) does not illustrate this event at all. The 1892 version (Utkal University Library) is missing a folio here.

63. Rāma specifically says, "Monkeys are usually considered ugly, but this one surpasses

the nymph Rambhā in beauty" (*Vaidehīśa Vilāsa* 28.149–50). The jumbled condition of the Baripada manuscript makes it impossible to be sure whether Śatrughna illustrated her curse or not.

64. The cock on the left is mentioned in the *Lāvaṇyavatī* after the rainy season and before Rāma gets news of his wife (see Appendix 3, no. 27). Two monkeys in Figure 189 are identified by labels as minor followers of Sugrīva.

65. The initial meeting with Sugrīva, which occupies a full folio (Figure 150) includes the unexplained figure of Jāmbavan (labeled Rṣimukha) to the right of Lakṣmaṇa. Could this also be a reinterpretation of the scene at Buguda of Lakṣmaṇa straightening the arrow (Plate 11), as I have suggested in the text for Prusti's version of Mount Mālyavan in Figure 189?

66. For another scene of rain in Pathy's work, see J. Williams, "Jewels from Jalantara," plate 7.

67. In this leap, Hanumāna encounters the mountain Mainaka and the demonesses Surasā and Singhikā (Vālmīki 5.1).

68. *Vaidehīśa Vilāsa,* canto 36.

69. One might expect to find this portion among the badly damaged paintings, but I see no likely candidates. On the front wall (L in Figure 200), local tradition identifies one scene of figures beside a hut as the visit to Bharadvaja's hermitage, which occurs soon after the exile in book 2 of the epic. The occurrence of this portion in the final position is puzzling, but virtually all possible identifications pose that difficulty. I find no images of Rāvaṇa, a sine qua non if this wall depicted book 5.

70. The Orissa State Museum copy, Ext. 81, included fifteen pictures in the Sundara Kāṇḍa. Both the New York Public Library and the Utkal University copies included six pictures, and missing folios may account for more in each case. An untraceable copy, some illustrations from which were reproduced in Bansidhar Mohanty's *History of Oriya Literature* (1977), included at least five pictures in this section. The *Adhyātma Rāmāyaṇa* illustrated by another artist (National Museum 75.536) as well as the illustrated *Rāmalīlā* of Krishna Chandra Rajendra (National Museum 75.556) both lack their later portions and hence cannot be discussed from this point on.

71. I have been unable to locate this sequence in the *Vaidehīśa Vilāsa* by Śatrughna from Baripada.

72. One would, however, expect that Pathy copied the entire text leaving blank spaces for pictures before he went back to execute the illustrations, a procedure documented by the colophon of his *Gīta Govinda* now in the L.D. Institute in Ahmedabad (J. Williams, "Jewels from Jalantara").

73. K. K. Handiqui, *Pravarasena's Setubandha;* R. Basak, *Pravarasena's Rāvaṇavaha-mahākāvyam.* This event does not figure vividly in Oriya Rāmalīlās, where today it is more likely to be chanted alone than to be enacted.

74. B. L. Baij Nath, *Adhyatma Ramayana,* Yuddha Kāṇḍa, chap. 4, line 1.

75. *Adhyātma Rāmāyaṇa,* trans. Gopala, 173.

76. K. Bulke, *Rāmkathā,* 546–47. The existence of this story in Tamil and Bengali suggests its ubiquity. Islam preserves a similar tale that cats with stripes on their heads have been blessed by Muhammad.

77. *Vaidehīśa Vilāsa* 40.34–38. Nala's curse is also present in Balarāma Dāsa.

78. This couplet is a pun and can also be translated, "Lovely herds of horses came and went; shady women lost their fear [i.e. were protected by the noise?]."

79. This is not true of the Dispersed *Lāvaṇyavatī* (Figure 153), where, however, one other folio might read from right to left (Figure 149). In both of Sarathi Madala Patnaik's 1891 manuscripts, two monkeys are moving to the left, although the placement of Rāma and Lakṣmaṇa as well as the Śiva shrine would suggest movement to the right (Figures 64, 71).

80. He creates an illusionary head of the hero in at least some versions of the text (K. Bulke, *Rāmkathā*, 552), a case in which the theme of *māyā* (perhaps *moha*) goes back to the Sanskrit.

81. *Adhyātma Rāmāyaṇa* 6.5.44. In the southern recension of Vālmīki, Rāma assists Sugrīva by shooting Rāvaṇa's single umbrella (K. Bulke, *Rāmkatha*, 554).

82. K. C. Sahoo, "Oriya Rāma Literature," 487–88 (*Jagamohana Rāmāyaṇa* 6.57–60).

83. K. C. Sahoo, "Oriya Rāma Literature," 490. This variant appears to be peculiar to Orissa, although the same term is used for mushroom and umbrella in other languages also (*chhattra* or a close variant).

84. *Vaidehīśa Vilāsa* 41.23.

85. J. P. Losty, *Krishna*, plate 83. For the Kanchi-Kaveri story, see J. P. Das, *Puri Paintings*, 120.

86. The label says "Indrajita bound Hanu with the *nāga-pāśa* [hence the snake above] and brought him to Rāvaṇa." One might read the coils beneath as part of the snake. I am not aware of such a textual variant at this point in the story. In the non-Orissan examples mentioned here, snakes are not involved. Possibly the Parlakhemundi card shows a conflation of the two incidents.

87. J. Mittal, *Andhra Paintings of the Ramayana,* plate 33; H. Cousins, *Chālukyan Architecture of the Kanarese Districts,* plate XLVI, upper left.

88. The use of the monkey's tail as a seat figures in the Rāmalīlā of Dasapalla but is apparently not enacted with much dramatic effect.

89. This may be an interpolation, according to K. Bulke (*Rāmkathā*, 558).

90. *Adhyātma Rāmāyaṇa* 6.5.65–74 and 6.6.1–6.7.37. It is clear that the initial directive to pick up the entire mountain is borrowed from the subsequent episode, in which this action is explained by Hanumāna's inability to locate the herbs. Kumbhakarṇa's death follows both episodes in this version.

91. W. L. Smith, *Rāmāyaṇa Traditions in Eastern India,* 182–83. The Kālanemi episode also occurs in the Bengali recension of Vālmīki (G. Gorresio, *Ramayana,* 6.82, 91–98).

92. W. L. Smith, *Rāmāyaṇa Traditions in Eastern India,* 145–51.

93. This form in which the Garuḍa is largely human, with wings, feathered arms, and a snake raising its hood above a crown, occurs often in *paṭas*.

94. Vālmīki 6.74.

95. Conceivably the hero is Bharata shooting at Hanumāna, but the demons do shoot at him, in which case this scene would seem to represent the death of Kumbhakarṇa.

96. One exception is the early Chola temple at Pullamangai; see D. Sanford, "Miniature Relief Sculptures at the Pullamangai Siva Temple."

97. In Vaisya Sadāśiva's *Rāmalīlā*, the text does include an Uttara Kāṇḍa.

98. See Chapter 2, note 87, for the evidence about their date. This is the only Rāmāyaṇa subject there. The small figures in the upper left are presumably the seven sages, whose presence would be generally appropriate at such an auspicious event.

99. J. Williams, "Marriage Paintings in South and Central Orissa." The coronation is more

likely to be replaced by the wedding of Rāma in southern Ganjam District. In the Puri area, subjects such as the Navaguñjara and guardians visible in Figure 262 indicate that not all themes are precisely linked to marriage.

100. Jagannath Mahapatra's version of Sītā's ordeal does not actually depict flames but rather piled wood and a rain of flowers (Figure 243). Possibly even in the 1950s in Orissa, where *satī* was not in practice, there was reluctance to encourage widow-burning, evoked by an image of a woman within a fire. In the recent television version of the Rāmāyaṇa, this was an explicit concern.

101. In the published set, executed by Bibhuti Kanungo, Hanumāna is the only monkey, and he has five hillocks wrapped in his long tail (K. C. Kar, S. K. Das, and K. S. Sahu, *Ramayana in Ordisi Pata Painting,* no. 71). In the verse accompanying the publication, Hanumāna and Jāmbavan are mentioned (in Oriya and Hindi as well as English), which is not the case for the version Jagannath Mahapatra has supplied as his "text." In all versions, this verse centers on Lava's hitting Rāma with an arrow, causing him to swoon.

102. In the Bibhuti Kanungo publication, this figure is more clearly in a dancing pose (K. C. Kar, S. K. Das, and K. S. Sahu, *Ramayana in Ordisi Pata Painting,* no. 75). In his version of the verses *apsarās* are not mentioned, although they are in Jagannath Mahapatra's.

103. In Figures 54 (1875), 68 (December 1891), and 86 (1899) the extra sets radiate from the main arms, whereas in Figures 58 and 65 (January 1891) and 74 (1902) they are attached to the torso. The reader is reminded of the evidence in Chapter 2 that these are indeed one artist's work.

104. Since what survives is folios 189 through 200, we may presume that the earlier sections were as amply illustrated as in Sarathi Madala's copies. In both Figures 80 and 81 details of the text, such as Lakṣmaṇa's transformation into the serpent Seṣa, are omitted. It would be interesting to know how this book has been separated from the rest of the manuscript and whether the selection reflects some questioning of its contents.

105. The 1902 manuscript in Koba devotes one leaf to the coronation per se and a separate one to festivities that are shown below the throne in Figure 123, including music, swordplay, and the *pūrṇa ghaṭa* with fish.

106. It is possible that a previous page is missing, which might have included the death of Rāvaṇa. It is equally possible that the artist of the Dispersed *Lāvaṇyavatī,* often unconventional in his narrative choices, omitted that seemingly central event.

Chapter 5

1. *Vivaraṇa* and *varṇnana* are the entries under "narration" in standard English-to-Oriya dictionaries. Both come from *varṇa,* meaning fundamentally "covering" or "color." The same set of meanings exists in Sanskrit and other Indo-European north Indian languages. The term *kathana,* "telling," also exists (see the subsequent discussion of *kathā,* "tale," in the text) but is less commonly used to name an abstract process.

2. G. Lukacs, "Narrate or Describe." I must confess my reluctance to see "description" and "narration" as mutually exclusive binary opposites, even in English. As Tzvetan Todorov put it, "Description alone is not enough to constitute a narrative; narrative for its part does not exclude description, however" (*Genres in Discourse,* 28).

3. *Kathā* also means "speech," which includes other forms in addition to narration of a story. Nor can story and narrative be exactly equated in English. As Gerald Prince puts it, "Although any story is a narrative, not any narrative is a story" (*Narratology,* 170 n. 8).

4. "Able to be carried by articulated language, spoken or written, fixed or moving images, gestures, and the ordered mixture of all these substances; narrative is present in myth, legend, fable, tale, novella, epic, history, tragedy, drama, comedy, mime, painting (think of Carpaccio's *Saint Ursula*), stained-glass windows, cinema, comics, news item, conversation" (R. Barthes, "Introduction to the Structural Analysis of Narratives," 251). There is some slippage between "narrative" and the French term "*récit*," more easily equated with a genre.

5. P. Lutgendorf, "The View from the Ghats," and *Life of a Text,* 18–29.

6. Aristotle in the *Poetics* (chap. 6) defines six parts of tragedy (plot, characters, language, thought, spectacle, and melody) and devotes five chapters to plot, with only one chapter to the characters and even less than a chapter to the remaining parts. Thought would usually be considered a non-narrative element, and spectacle and melody may characterize the theater more than other narrative forms of literature.

7. A. B. Keith, *The Sanskrit Drama,* 277.

8. See Chapter 1, note 9.

9. Thus Upendra Bhañja is depicted at the beginning of Michha Patajoshi's *Vaidehīśa Vilāsa,* along with other poets who had created their versions of the same story. In the north Indian illustrations of the *Āraṇyaka Parvan* of the Mahābhārata, King Janamejaya's sage, Vaiśampāyana appears frequently at the top of a larger picture (K. Khandalavala and Moti Chandra, *Illustrated "Āraṇyaka Parvan"*). Cf. G. Prince, *Narratology,* 15–16 (on multiple narrators); and M. Bal, *Narratology,* 143 (on the related form of embedded texts, common in the Near East as well as South Asia).

10. *The Vishṇudharmottara (Part III),* trans. S. Kramrisch, 59–60; A. K. Coomaraswamy, "Reactions to Art in India."

11. M. Bal's terminology for verbal narrative may be one way of formulating this distinction: "fabula," the actual series of events; "story," the fabula presented in a certain manner; and "text," a story told by a narrator (*Narratology,* 5). Even for an entirely verbal situation, I find this model unnecessarily complex. We know the fabula and story only from the text, and they remain our own artifact. Why not stop there?

12. One notable exception is the image of Bharata worshiping Rāma's footprints within a circle, and even here Bharata appears alone in the second work of 1891.

13. It is likely that he worked from an unillustrated manuscript, but I have frankly not checked the consistency of his texts to be certain of this.

14. Simple statistics of the number of pictures do not make this point, for pages are missing in some cases (almost the whole second half of the last two works). Moreover, the physical dimensions of the leaves may affect the ratio of text to image. Hence the need to refer to Appendix 1 to verify my assertions.

15. Cf. J. P. Das, *Chitra-pothi,* 37; J. P. Das and J. Williams, *Palm-Leaf Miniatures,* 79.

16. The cartouches above Rāma and Lakṣmaṇa do not contain their words or thoughts, nor does there seem to be a specific rationale in the placement of other verses in the scene.

17. J. P. Das, *Chitra-pothi,* 41, 42, 56.

18. The argument that the character of this manuscript corresponds to that of the *Vaidehīśa Vilāsa* itself is borne out by my general impression that Śatrughna's illustrations of a rather different text, the *Braja Bihāra* belonging to the History Department of Utkal University, create a greater sense of order. That work awaits careful study, however.

19. Because there is remarkable consistency in Michha Patajoshi's choices, although subordinate parts of the principal scenes are added, I have omitted a chart comparing his major manuscripts like the one in Appendix 1 for Sarathi Madala Patnaik.

20. I believe that this proportion of pictures to text holds even in the case of his 1902 copy, which had 218 folios originally, versus Śatrughna's Baripada work of 281 folios, for Michha Patajoshi's was 41.6 cm long whereas Śatrughna's was only 28.5. Some of Śatrughna's multifolio pictures obviously devoted more space to a single image than did any of Michha's. The two artists' handwriting was similar in scale, a factor in the physical bulk of text. Of the 151 surviving folios in the 1911 *pothi,* only five sides comprise text alone, which is an unusually low proportion.

21. Some manuscripts, such as Śatrughna's, lack such captions, and in others the captions are fewer and shorter. Most scribes, such as Sarathi Madala Patnaik and Raghunath Prusti, began each caption "This is . . . [e.g. Rāmachandra]"; Michha Patajoshi, however, launched directly into a descriptive sentence.

22. Perhaps a battle may have occurred on a missing subsequent leaf, which might have included the death of Rāvaṇa and Vibhīṣaṇa's coronation. It remains equally possible that these too were omitted, for without pagination this manuscript is hard to reconstruct. Likewise my assumption that the encounters with Śūrpaṇakhā and the golden deer were present on a missing folio is based on my own causal preconceptions.

23. Another possible explanation is that the more auspicious episode occurs to the right. This is contradicted in Figure 153 by the placement of Rāvaṇa to the right of the building of the bridge.

24. I have toyed with the possibility that we should regard these figures as what Gérard Genette has termed "focalizers," the source of the vision presented, distinguished from the narrator (*Narrative Discourse,* 189). In general Indian literature and art seem to me to show what Genette terms "zero focalization," largely as a result of the conscious impersonality of the arts. In the present situation, I see no reason to regard Lāvaṇyavatī as more focal or critical than the various male narrators to the interpretive, subjective nature of the entire account. The artist of this manuscript was daring and sophisticated in his narrative choices, but he worked within a classical Indian tradition.

25. Hence a relatively small number of episodes is depicted in this work. This is not the case with the depiction of the *Lāvaṇyavatī* proper in this same manuscript.

26. The one exception is Riśyaśṛiṅga's marriage to Śāntā.

27. The first page is numbered 72 and the last preserved is 81. Surely one and probably two more pages followed the Gandhamādana incident. Here as in the Dispersed *Lāvaṇyavatī,* no text is interwoven with the pictures. Possibly it was concentrated at the beginning or the end, a suggestion I cannot verify. Whether the text was present or omitted, in both manuscripts the pictures seem to have a kind of independence, with no immediately accompanying verses.

28. In the New Delhi copy of Michha Patajoshi this portion of folios is missing; Śatrughna's Baripada manuscript seems to lack this scene, but its jumbled condition makes it difficult to be certain. Other scenes paired in Prusti's *Lāvaṇyavatī* that immediately resemble Buguda are the battles with Kumbhakarṇa and Indrajita (Figures 191, bottom; 192, top), which resemble the badly preserved murals at the top of wall H (Figure 212). Such dense barrages of arrows do, however, occur in other manuscripts and cannot be used as prima facie evidence for the direct impact of Buguda (cf. S. Pani, *Illustrated Palmleaf Manuscripts of Orissa,* 47).

29. Conceivably the Buguda artist, who was not entirely consistent in chronological sequence, intended this scene to follow the cutting of the umbrellas, in which case Buguda is equally hard to explain textually. It is worth noting that Prusti adds more monkeys to the extreme right, but with no suggestion of Sugrīva's palace.

One additional scene probably borrowed from Buguda but problematic in meaning is Rāma's meeting with Viśvāmitra and a pupil in Figure 184. I know of no direct textual reference for this, although there are many general allusions to ascetics on Mount Chitrakūṭa that would make it possible. The comparable scene at Buguda includes only a tall blue ascetic and a youth, their hands raised in respect (Figure 209). Here the identification is made possible only by Prusti's neatly labeled version of the same pair.

30. *Vaidehīśa Vilāsa* 17.35–36. Guha is of course absent from the brief version of the *Lāvaṇyavatī*. Balabhadra Pathy shows Guha as a boatman by a river. Śaralā Dāsa generically identifies many forest dwellers as Śabaras, as does the Rāmalīlā of Dasapalla.

31. New York Public Library, Spencer Collection ms. 11, folio 15. Michha Patajoshi also worked the motif into the final coronation of Rāma (Figure 123).

32. The text reads: "The person who hears the Rāsotsava of Rāghav-Sītā becomes a devotee of Hari and gets a place near him. The seventeenth chapter of the Brahma Rāmāyaṇa is complete here. This chapter concerns the desires of mature (*pūrṇa*) girls in the Rāmakṛīḍā. . . ." Conceivably the orb is in fact a full (*pūrṇa*) moon. The Oriyas I have consulted are equally puzzled by this image.

33. Anantaśayaṇa appears in a related form in the nineteenth-century wall paintings of Dharakot. E. Fischer, S. Mahapatra, and D. Pathy, *Orissa: Kunst und Kultur,* figure 556. For the coronation, see Chapter 4, "The Conclusion."

34. Admittedly, I cannot be certain that either Mrs. Zealey or the professor did not dictate the inclusion or omission of some particular event just because the artist does not recall that. At least we can be sure much was left up to him and that he has internalized the choices that were made.

35. J. P. Das, *Puri Paintings,* figure 3.

36. All were in the process of being painted, and my understanding of subjects and order is indebted to my conversations with the painters as they worked. The very large *paṭa* at Danda Sahi represented in Figure 289D was sold unexpectedly; hence the absence of a photo here.

37. The omission of Hanumāna with Mount Gandhamādana (except possibly in the large Danda Sahi work, only partially painted) is puzzling. Perhaps this image is hardly thought of as narrative at all, having become the most common form of image of the monkey alone in small *paṭas.*

38. The four corner events in Figure 289B seem to read counterclockwise, although it is hard to be sure about them. In any case, they are not clearly in any sequence, serving to lead from the tight order of the central circle to the final battles at top and bottom.

39. As I suggest in Chapter 3, one small hill occurs at the top of wall A, in a position where the most likely subject is Rāma and Sītā on Mount Chitrakūṭa. Conceivably the artists at this particular point saw the suitability of larger scenes set on mountains, in which the setting could be developed.

Chapter 6

1. U. K. Le Guin, "It Was a Dark and Stormy Night," p. 188.

2. After writing this chapter, I discover that these three questions correspond to C. S. Pierce's division of the field of semiotic inquiry into three parts: semantic (symbolic), syntactic (concerned with the production of meaning), and pragmatic (concerned with efficacy). M. Bal and N. Bryson, "Semiotics and Art History," 189.

3. A. Eschmann, K. Hermann, and G. C. Tripathi, *The Cult of Jagannath*; H. Kulke, "'Kṣatri-yaization' and Social Change in Post-Medieval Orissa."

4. K. C. Sahoo, "Oriya Rāma Literature," 20.

5. Philip Lutgendorf makes clear that the *rasik sādhanā* centered on Rāma should not be viewed as derivative from that of Kṛiṣṇa ("The Secret Life of Rāmcandra," 228–30).

6. Studies of this potent theme in Indian thought in general include P. D. Devanandan, *The Concept of Māyā*; R. P. Goldman, "The Serpent and the Rope on Stage"; and W. O'Flaherty, *Dreams, Illusion, and Other Realities*.

7. E. Dowling, "*Apate, Agon,* and Literary Self-Reflexivity in Euripides' *Helen*."

8. A. K. Coomaraswamy, "Reactions to Art in India," 108; J. Williams, "Śiva and the Cult of Jagannātha: Iconography and Ambiguity," deals with ambiguity largely in terms of multiple interpretations by the audience. For Indian images it is more difficult than for texts (with commentaries) to fix the response of the "actual" audience. I must reaffirm my conviction that some interpretations may be wrong, although many may be right.

9. Robert Goldman provocatively explores the extension of the philosophical cliché to the theater and to ordinary social discourse in "The Serpent and the Rope on Stage."

10. E. C. Dimock, "A Theology of the Repulsive," 195.

11. Philip Lutgendorf likewise questions claims that the television series has "put paid to Ramlilas" or homogenized the diverse Rāmāyaṇa traditions of India as a whole ("Ramayan: The Video," 166–70).

12. R. Barthes, "Introduction to the Structural Analysis of Narratives," 253, 293–95.

13. The writings of Ernst Gombrich, such as *Art and Illusion* (New York: Bollingen Foundation, 1960), deal with the psychology of representation with a sophisticated awareness of the complexity of the constructed systems of illusionism and ways in which the beholder resolves ambiguities.

14. The passage from Edward Dimock quoted in the text (see note 10) moves from the image of a two-headed deer to a Picasso painting of a woman with two eyes on one side of her head as something not in our experience. I am not convinced that Picasso was asserting multiple realities.

15. M. C. Beach, *Early Mughal Painting*, 134.

16. Wendy O'Flaherty does not really consider the pictures seriously, but she suggests this interpretation in general (*Dreams, Illusion, and Other Realities*, 280–82).

17. A better candidate than Jahangir's *Yogavāsiṣṭha* might be a well-known painting in the Freer Gallery, which includes a note that it represents a dream experienced by the emperor in a well of light. (R. Ettinghausen, *Paintings of the Sultans and Emperors of India*, plate 12.) Jahangir embraces a diminutive Shah Abbas of Persia, with whom he was at war when this work was painted and whom he never met. Combined with the meticulous representation of surface detail that characterizes painting of this period, there are various features that resist direct reading as visual phenomena. The rulers stand upon a lion and a lamb nestled against a globe that reveals the Safavid and Mughal empires. A large emblematic gold disc shines in the background. Here, as with Salvador Dali's limp watches or allegorical Elizabethan paintings, one is encouraged to read the image as potent or super-real, which is not to say that other Mughal painting consistently follows European illusionistic conventions. In this case, "dream" must be equated with vision, not with illusion, however.

18. E. Isacco, A. L. Dallapiccola, et al., *Krishna the Divine Lover*, plate 175; E. Moor, *The Hindu Pantheon*, plate 93; J. P. Das, *Puri Paintings*, 135–36. The motif resembles what has

been called a chimera in western India, both figures challenging the beholder's ability to identify them.

19. J. P. Das and J. Williams, *Palm-Leaf Miniatures*, 4.

20. K. K. Patnaik, *Kumbhāra Chaka*, 258–59. The passage is quoted in full in J. P. Das and J. Williams, *Palm-Leaf Miniatures*, 6.

21. See p. 52. One might wish that Das and Patnaik had recorded actual prices of manuscripts, but the interpersonal and negotiated nature of such transactions in a village would make the use of such information problematic.

FIGURES

Figure 49. A brahman reading from a palm-leaf manuscript (Parlakhemundi, 1981). Photograph by author.

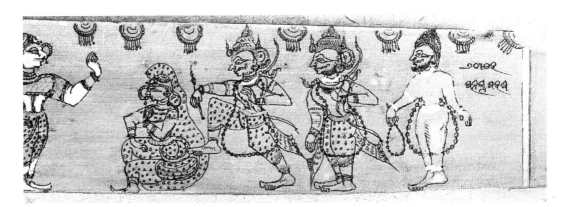

Figure 50. Sarathi Madala Patnaik, *Adhyātma Rāmāyaṇa* (courtesy Orissa State Museum, dated 1875). Ahalyā liberated, f. 8r.

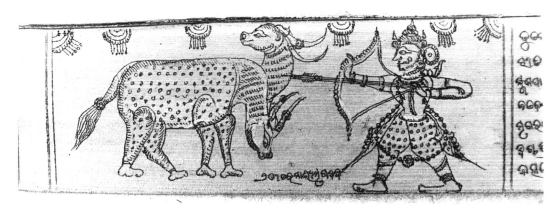

Figure 51. Sarathi Madala Patnaik, *Adhyātma Rāmāyaṇa* (OSM, 1875). Magic deer, f. 42v.

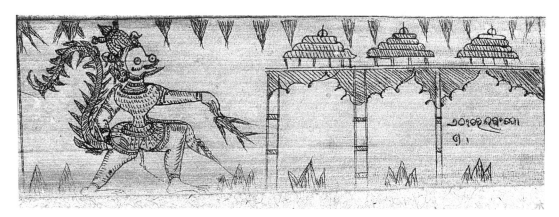

Figure 52. Sarathi Madala Patnaik, *Adhyātma Rāmāyaṇa* (OSM, 1875). Hanumāna in Laṅkā, f. 75v.

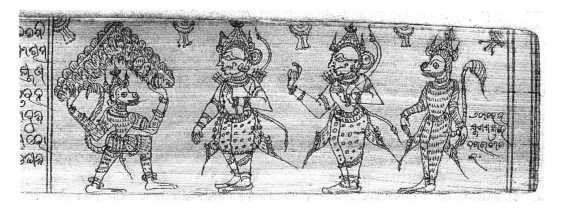

Figure 53. Sarathi Madala Patnaik, *Adhyātma Rāmāyaṇa* (OSM, 1875). Hanumāna bringing mountain, f. 91v.

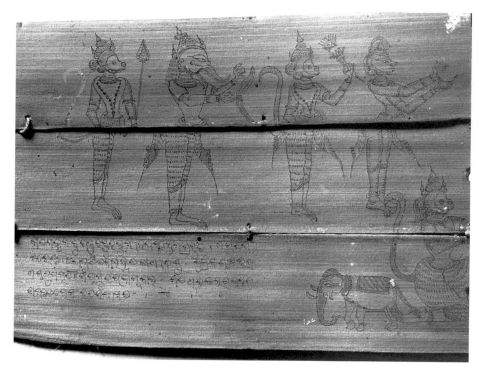

Figure 55. Sarathi Madala Patnaik, *Adhyātma Rāmāyaṇa* (OSM, 1875): (*above and opposite*) Coronation of Rāma, last three folios.

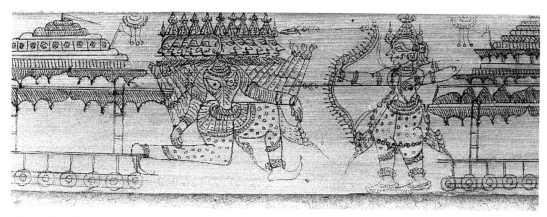

Figure 54. Sarathi Madala Patnaik, *Adhyātma Rāmāyaṇa* (OSM, 1875). Rāvaṇa and Rāma, f. 96v.

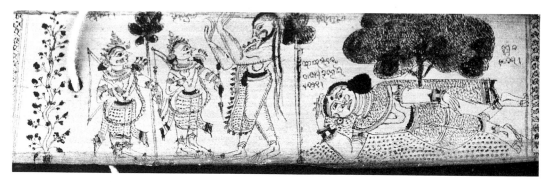

Figure 56. Sarathi Madala Patnaik, *Adhyātma Rāmāyaṇa* (courtesy New York Public Library, Spencer Collection, Astor, Lenox and Tilden Foundations, dated 1891). Ahalyā, f. 9r.

Figure 57. Sarathi Madala Patnaik, *Adhyātma Rāmāyaṇa* (NYPL, 1891). Bharata with Rāma's footprints, f. 33r.

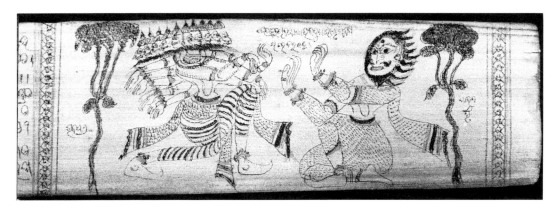

Figure 58. Sarathi Madala Patnaik, *Adhyātma Rāmāyaṇa* (NYPL, 1891). Śūrpaṇakhā before Rāvaṇa, f. 41r.

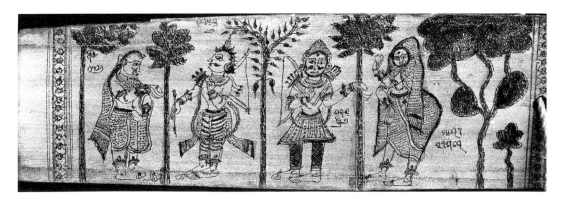

Figure 59. Sarathi Madala Patnaik, *Adhyātma Rāmāyaṇa* (NYPL, 1891). Creation of Māyā Sītā, f. 42r.

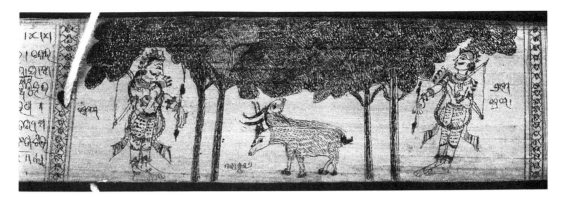

Figure 60. Sarathi Madala Patnaik, *Adhyātma Rāmāyaṇa* (NYPL, 1891). Magic deer, f. 45r.

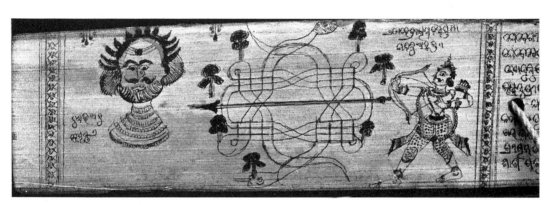

Figure 61. Sarathi Madala Patnaik, *Adhyātma Rāmāyaṇa* (NYPL, 1891). Seven trees, f. 52v.

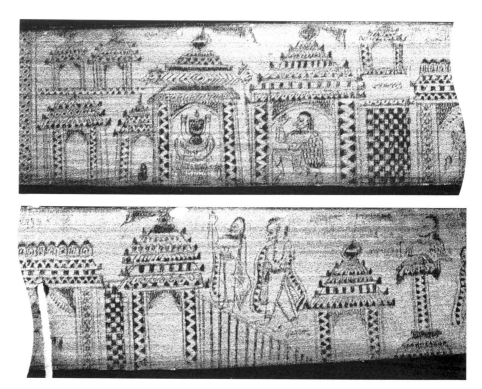

Figure 62. Sarathi Madala Patnaik, *Adhyātma Rāmāyaṇa* (NYPL, 1891).
Jagannātha Temple, f. 80v.

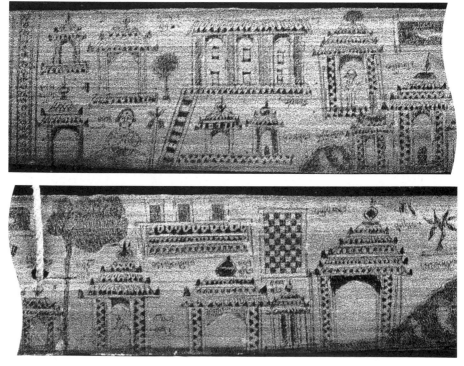

Figure 63. Sarathi Madala Patnaik, *Adhyātma Rāmāyaṇa* (NYPL, 1891). Śiva
shrine at Ramesvaram, f. 81r.

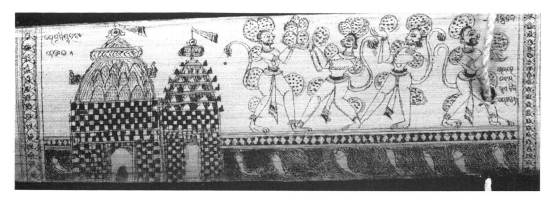

Figure 64. Sarathi Madala Patnaik, *Adhyātma Rāmāyaṇa* (NYPL, 1891). Building the bridge, f. 88v.

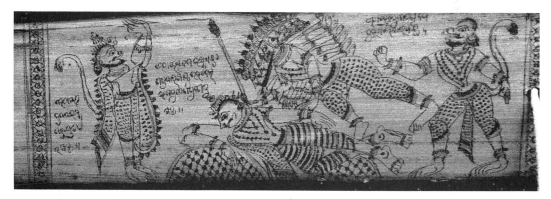

Figure 65. Sarathi Madala Patnaik, *Adhyātma Rāmāyaṇa* (NYPL, 1891). Rāvaṇa and Lakṣmaṇa, f. 92v.

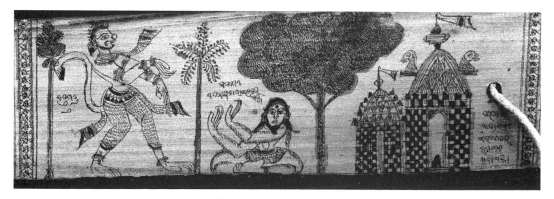

Figure 66. Sarathi Madala Patnaik, *Adhyātma Rāmāyaṇa* (NYPL, 1891). Hanumāna and Kālanemi, f. 93v.

Figure 67. Sarathi Madala Patnaik, *Adhyātma Rāmāyaṇa* (NYPL, 1891). Sītā's test, f. 107v.

Figure 68. Sarathi Madala Patnaik, *Adhyātma Rāmāyaṇa* (C. L. Bharany Collection, New Delhi, dated 1891). Magic deer, f. 64v.

Figure 69. Sarathi Madala Patnaik, *Adhyātma Rāmāyaṇa* (Bharany Col., 1891). Seven trees, f. 77r.

Figure 70. Sarathi Madala Patnaik, *Adhyātma Rāmāyaṇa* (Bharany Col., 1891).
Indrajita, serpent-arrow, and Hanumāna, f. 104v.

Figure 71. Sarathi Madala Patnaik, *Adhyātma Rāmāyaṇa* (Bharany Col., 1891).
Building the bridge, f. 118v.

Figure 72. Sarathi Madala Patnaik, *Adhyātma Rāmāyaṇa* (courtesy Utkal University Library, dated 1902). Jagannātha, f. 101v.

Figure 73. Sarathi Madala Patnaik, *Adhyātma Rāmāyaṇa* (UUL, 1902). Building the bridge, f. 111v.

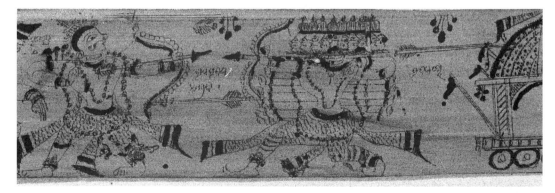

Figure 74. Sarathi Madala Patnaik, *Adhyātma Rāmāyaṇa* (UUL, 1902). Rāma and Rāvaṇa, f. 130v.

Figure 75. *Adhyātma Rāmāyana*, anon. (courtesy National Museum, New Delhi, no. 75.536). Bharata with Rāma's footprints, f. 45r.

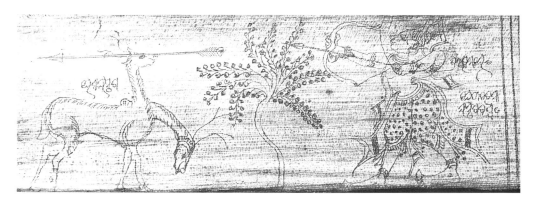

Figure 76. *Adhyātma Rāmāyana* (NM 75.536). Magic deer, f. 50r.

Figure 77. *Adhyātma Rāmāyana* (NM 75.536). Seven trees, f. 61r.

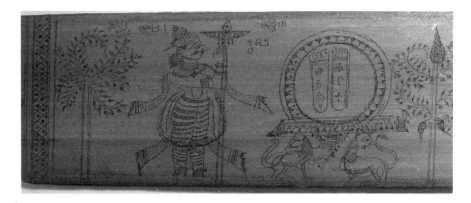

Figure 78. *Adhyātma Rāmāyaṇa,* anon. (C. L. Bharany Collection, New Delhi).
Bharata with Rāma's footprints, f. 52r.

Figure 79. *Adhyātma Rāmāyaṇa* (Bharany Col.). Three-
headed deer as marginalia, f. 95r.

Figure 80. *Adhyātma Rāmāyaṇa,* Uttara Kāṇḍa, anon. (private collection, New
Delhi). Rāma and Kāladeva, f. 195r.

Figure 81. *Adhyātma Rāmāyaṇa*, Uttara Kāṇḍa (pc, ND). Viṣṇu and Lakṣmī in Vaikuṇṭha, f. 200r.

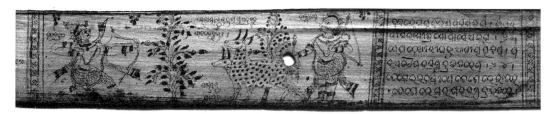

Figure 82. Sarathi Madala Patnaik, *Durgā Stuti* (courtesy of L.D. Institute of Indology, Ahmedabad, dated 1899). Magic deer, f. 13r.

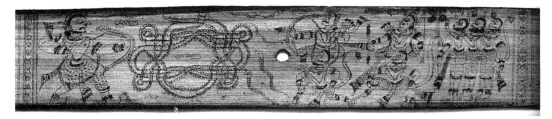

Figure 83. Sarathi Madala Patnaik, *Durgā Stuti* (LDI, 1899). Indrajita, serpent-arrow, Rāma and Lakṣmaṇa, f. 16r.

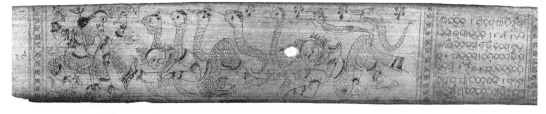

Figure 84. Sarathi Madala Patnaik, *Durgā Stuti* (LDI, 1899). Durgā rescues Rāma and Lakṣmaṇa, f. 19r.

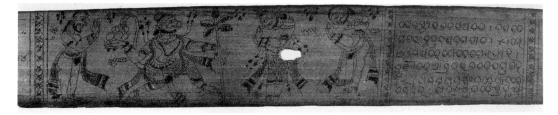

Figure 85. Sarathi Madala Patnaik, *Hanumāna Stuti* (LDI, 1899). Hanumāna carrying mountain, f. 24r.

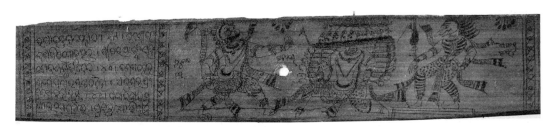

Figure 86. Sarathi Madala Patnaik, *Hanumāna Stuti* (LDI, 1899). Hanumāna before Rāvaṇa, f. 30v.

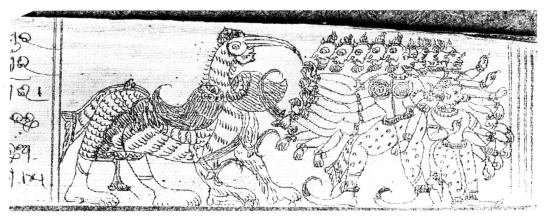

Figure 87. *Rāmalīlā,* anon. (courtesy National Museum, New Delhi, no. 75.556). Rāvaṇa fighting Navaguñjara, f. 58r.

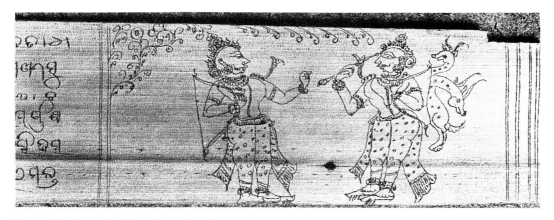

Figure 88. *Rāmalīlā* (NM 75.556). Lakṣmaṇa meets Rāma with body of magic deer, f. 59v.

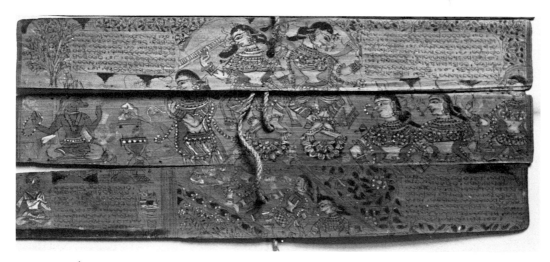

Figure 89. Śatrughna, *Vaidehīśa Vilāsa* (Jubel Library, Baripada, dated 1833). Riśyaśṛṅga and courtesans.

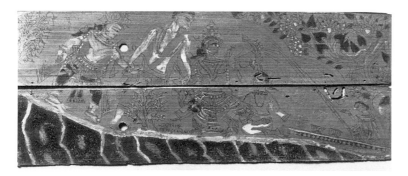

Figure 90. Śatrughna, *Vaidehīśa Vilāsa* (Baripada, 1833). Boatman washes Rāma's feet.

Figure 91. Śatrughna, *Vaidehīśa Viḷāsa* (Baripada, 1833). Rāma shoots the crow.

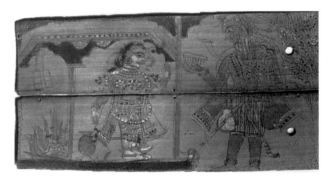

Figure 92. Śatrughna, *Vaidehīśa Viḷāsa* (Baripada, 1833). Sītā in fire, Māyā Sītā, Rāvaṇa as beggar (detail of Plate 5).

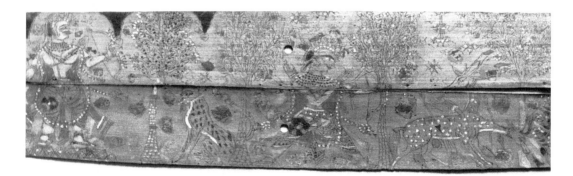

Figure 93. Śatrughna, *Vaidehīśa Viḷāsa* (Baripada, 1833). Rāma and the magic deer.

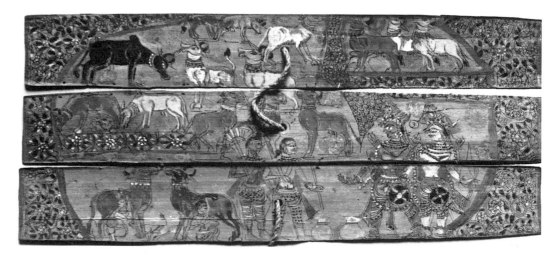

Figure 94. Śatrughna, *Vaidehīśa Vilāsa* (Baripada, 1833). Rāma, Lakṣmaṇa, and the cowherds.

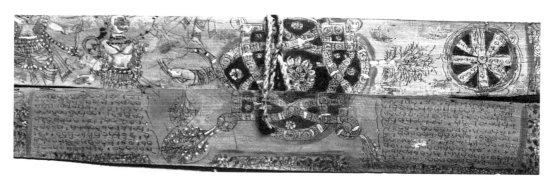

Figure 95. Śatrughna, *Vaidehīśa Vilāsa* (Baripada, 1833). Seven trees.

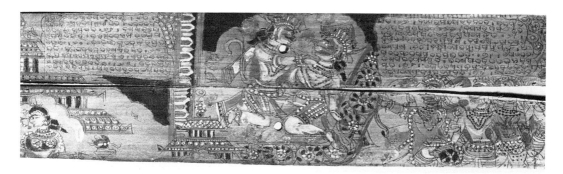

Figure 96. Śatrughna, *Vaidehīśa Vilāsa* (Baripada, 1833). Vālin and Sugrīva fight.

Figure 97. Śatrughna, *Vaidehīśa Vilāsa* (Baripada, 1833). Building the bridge.

Figure 99. Śatrughna, *Vaidehīśa Vilāsa* no. 2 (Museum Rietberg, Zurich RVI 1194). Ahalyā liberated.

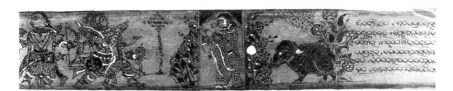

Figure 100. Śatrughna, *Vaidehīśa Vilāsa* no. 2 (private collection, New Delhi). Seven trees.

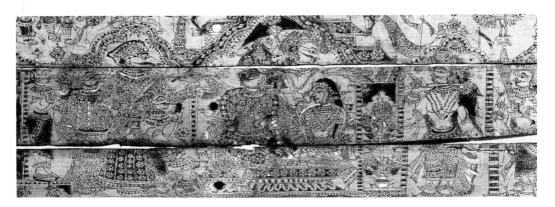

Figure 101. Śatrughna, *Vaidehīśa Vilāsa* no. 2 (Museum Rietberg, Zurich RVI 1194). Coronation of Rāma, ff. 154–156r.

Figure 98. Śatrughna, *Vaidehīśa Viḷāsa* (Baripada, 1833).
Battle.

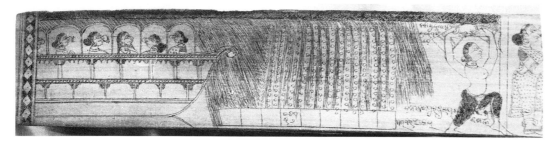

Figure 102. Michha Patajoshi, *Vaidehīśa Viḷāsa* (courtesy Shri Mahavir Jain Aradhana Kendra, Koba, dated 1902). Riśyaśṛṅga brings rains, f. 18r.

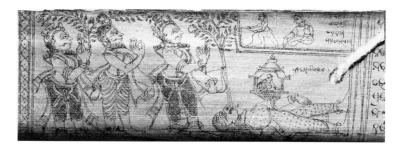

Figure 103. Michha Patajoshi, *Vaidehīśa Viḷāsa* (MJAK, 1902). Tāḍakī's apotheosis, f. 29r.

Figure 104. Michha Patajoshi, *Vaidehīśa Viḷāsa* (MJAK, 1902). Ahalyā liberated, f. 32r.

Figure 105. Michha Patajoshi, *Vaidehīśa Viḷāsa* (MJAK, 1902). Ahalyā with Indra, Gautama's return, f. 33r.

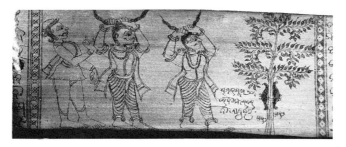

Figure 106. Michha Patajoshi, *Vaidehīśa Vilāsa* (MJAK, 1902).
Rāma and Lakṣmaṇa bind up their hair in exile, f. 69r.

Figure 107. Michha Patajoshi, *Vaidehīśa Vilāsa* (MJAK,
1902). The ocher mark.

Figure 108. Michha Patajoshi, *Vaidehīśa Vilāsa* (MJAK, 1902).
Rāvaṇa and Mārīcha, Rāvaṇa's bath.

Figure 109. Michha Patajoshi, *Vaidehīśa Vilāsa* (MJAK,
1902). Sītā in fire, Māyā Sītā, Rāvaṇa.

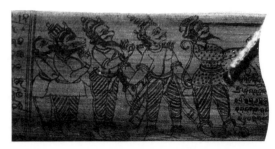

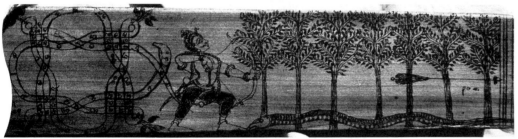

Figure 110. Michha Patajoshi, *Vaidehīsa Vilāsa* (MJAK, 1902).
Seven trees.

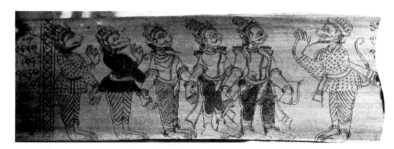

Figure 111. Michha Patajoshi, *Vaidehīsa Vilāsa*
(MJAK, 1902). Chakra bandha.

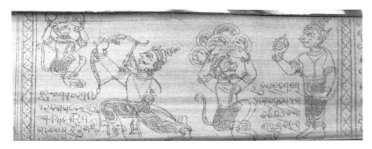

Figure 112. Michha Patajoshi, *Vaidehīśa Vilāsa* (MJAK, 1902). Hanumāna with mountain encounters Bharata, f. 186r.

Figure 113. Michha Patajoshi, *Vaidehīśa Vilāsa* (private collection, New Delhi, dated 1914). Riśyaśṛiṅga brings rains, f. 18r.

Figure 114. Michha Patajoshi, *Vaidehīśa Vilāsa* (pc, ND, 1914). Ahalyā liberated, f. 29v.

Figure 115. Michha Patajoshi, *Vaidehīśa Vilāsa* (pc, ND, 1914). Bharata's visit, f. 69r.

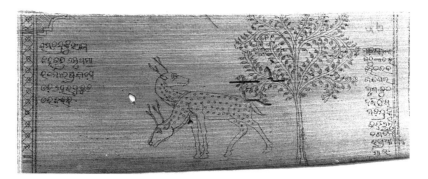

Figure 116. Michha Patajoshi, *Vaidehīśa Vilāsa* (pc, ND, 1914). Magic deer, f. 83v.

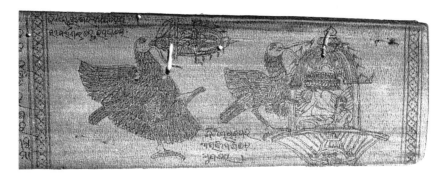

Figure 117. Michha Patajoshi, *Vaidehīśa Vilāsa* (pc, ND, 1914). Jaṭāyu attempts to stop Rāvaṇa, f. 84r.

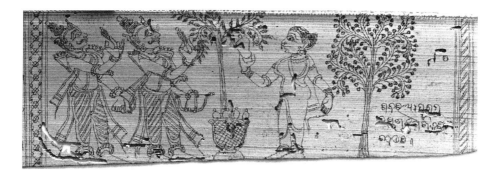

Figure 118. Michha Patajoshi, *Vaidehīśa Vilāsa* (pc, ND, 1914). Meeting with Śabarī, f. 90r.

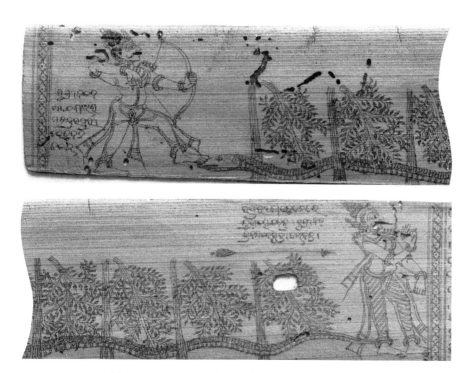

Figure 119. Michha Patajoshi, *Vaidehīśa Vilāsa* (pc, ND, 1914). Seven trees, f. 127r.

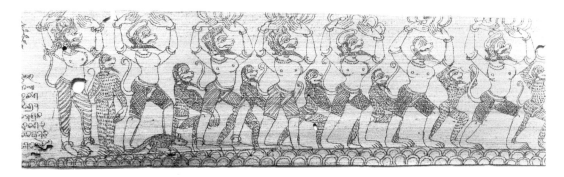

Figure 120. Michha Patajoshi, *Vaidehīśa Vilāsa* (pc, ND, 1914). Building the bridge, f. 146r.

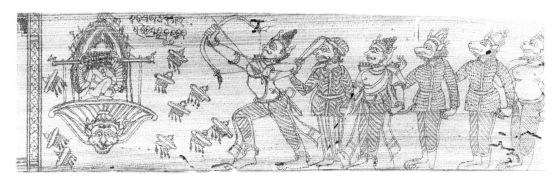

Figure 121. Michha Patajoshi, *Vaidehīśa Vilāsa* (pc, ND, 1914). Shooting Rāvaṇa's umbrellas, f. 151r.

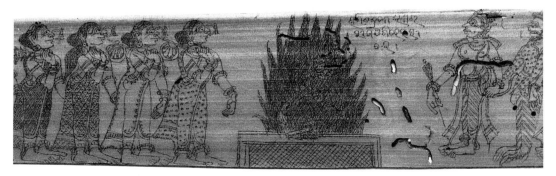

Figure 122. Michha Patajoshi, *Vaidehīśa Vilāsa* (pc, ND, 1914). Sītā's test.

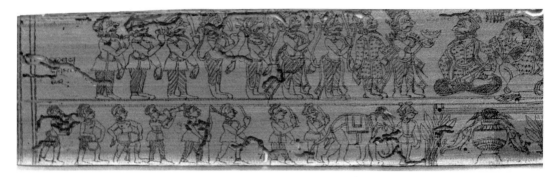

Figure 123. Michha Patajoshi, *Vaidehīśa Viḷāsa* (pc, ND, 1914). Coronation of Rāma, left half, f. 229r.

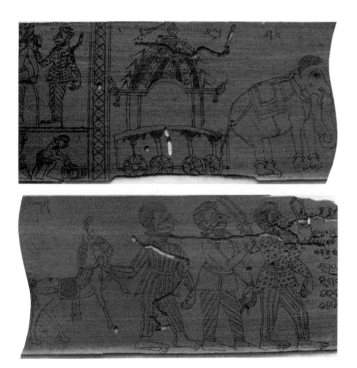

Figure 124. Michha Patajoshi, *Vaidehīśa Viḷāsa* (pc, ND, 1914). Coronation of Rāma, right half, f. 229r.

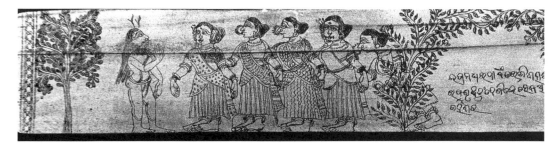

Figure 125. Michha Patajoshi, *Vaidehīśa Viḷāsa* (courtesy Asutosh Museum, Calcutta, dated 1926). Riśyaśṛṅga and the courtesans, f. 26v.

Figure 126. Michha Patajoshi, *Vaidehīśa Viḷāsa* (Asutosh, 1926). Rains are brought, f. 28r.

Figure 127. Michha Patajoshi, *Vaidehīśa Viḷāsa* (Asutosh, 1926). Ahalyā liberated, f. 47v.

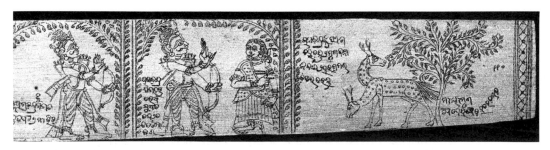

Figure 128. Michha Patajoshi, *Vaidehīśa Viḷāsa* (Asutosh, 1926). Magic deer appears, f. 110r.

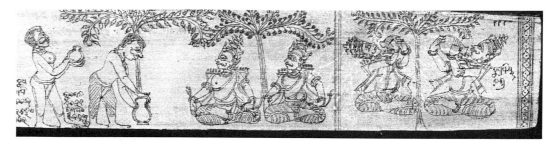

Figure 129. Michha Patajoshi, *Vaidehīśa Vilāsa* (Asutosh, 1926). Rāma, Lakṣmaṇa, and the cowherds, f. 118r.

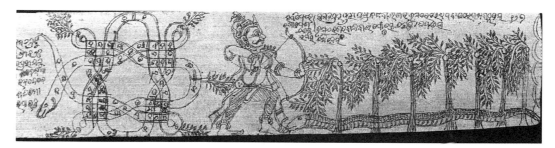

Figure 130. Michha Patajoshi, *Vaidehīśa Vilāsa* (Asutosh, 1926). Seven trees, f. 127r.

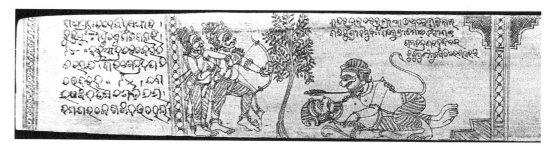

Figure 131. Michha Patajoshi, *Vaidehīśa Vilāsa* (Asutosh, 1926). Vālin and Sugrīva fight, f. 130v.

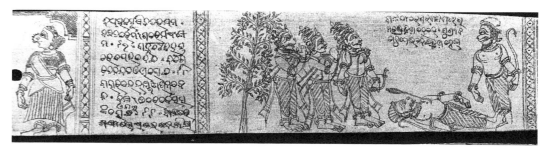

Figure 132. Michha Patajoshi, *Vaidehīśa Vilāsa* (Asutosh, 1926). Death of Vālin, f. 130v.

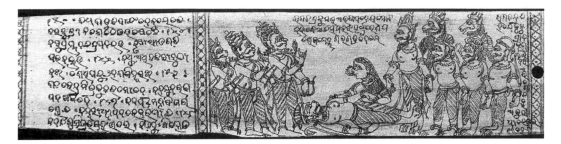

Figure 133. Michha Patajoshi, *Vaidehīśa Vilāsa* (Asutosh, 1926). Tārā's curse, f. 131v.

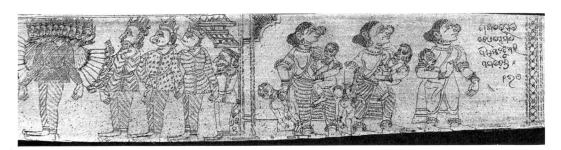

Figure 134. Michha Patajoshi, *Vaidehīśa Vilāsa* (Asutosh, 1926). Hanumāna in Laṅkā, f. 170v.

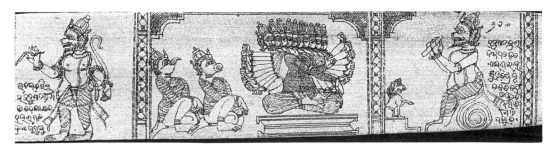

Figure 135. Michha Patajoshi, *Vaidehīśa Vilāsa* (Asutosh, 1926). Consternation in Laṅkā, f. 170v.

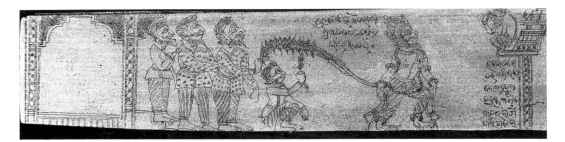

Figure 136. Michha Patajoshi, *Vaidehīśa Vilāsa* (Asutosh, 1926). Aṅgada's embassy, f. 203r.

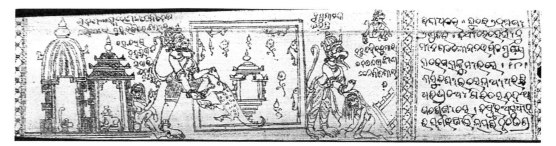

Figure 137. Michha Patajoshi, *Vaidehīśa Vilāsa* (Asutosh, 1926). Hanumāna at Kālanemi's ashram, f. 221v.

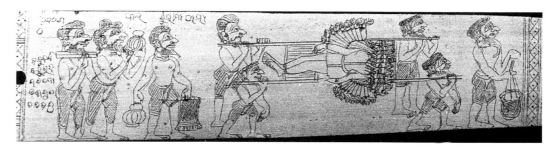

Figure 138. Michha Patajoshi, *Vaidehīśa Vilāsa* (Asutosh, 1926). Rāvaṇa's corpse, f. 241v.

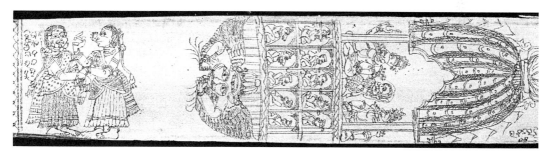

Figure 139. Michha Patajoshi, *Vaidehīśa Vilāsa* (Asutosh, 1926). Rāma and Sītā return to Ayodhyā, f. 250r.

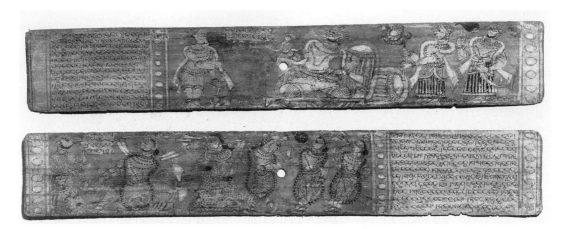

Figure 140. *Lāvaṇyavatī* (courtesy National Museum, New Delhi, no. 72.109), f. 36v: (*top*) King of Sinhala; f. 37v: (*above*) Coronation of Rāma.

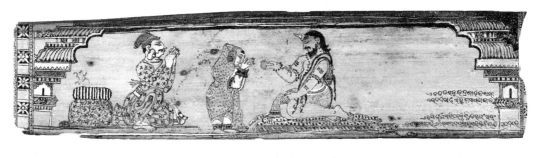

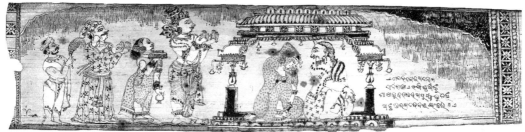

Figure 141. Dispersed *Lāvaṇyavatī* (private collection, United States). Riśyaśṛṅga meets and marries Śāntā.

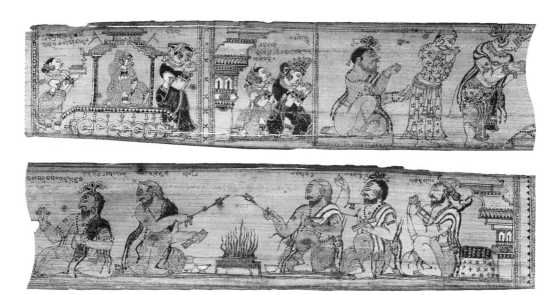

Figure 142. Dispersed *Lāvaṇyavatī* (private collection, US). Daśaratha's sacrifice.

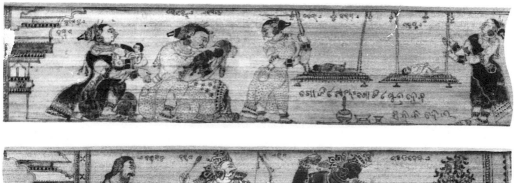

Figure 143. Dispersed *Lāvaṇyavatī* (courtesy National Museum, New Delhi, no. 62.616F r). Birth of sons to Daśaratha; Tāḍakī. Photo National Museum.

Figure 144. Dispersed *Lāvaṇyavatī* (NM 62.616F v): (*top*) Rāma shoots Subāhu;
(*above*) Mārīcha.

Figure 145. Dispersed *Lāvaṇyavatī* (NM 62.616C r): (*top*) Ahalyā; (*above*) Boatman.

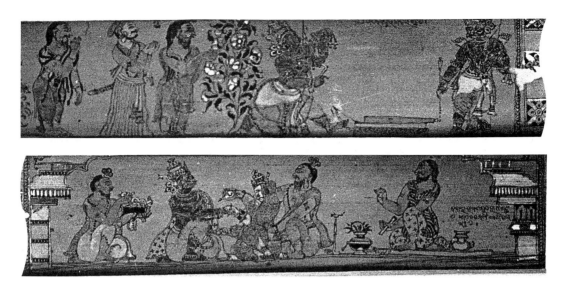

Figure 146. Dispersed *Lāvaṇyavatī* (NM 62.616C v): (*top*) Rāma bends Śiva's bow; (*above*) marries Sītā.

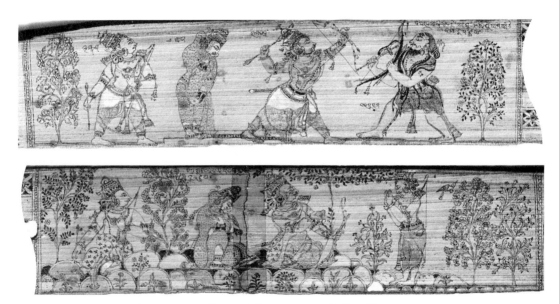

Figure 147. Dispersed *Lāvaṇyavatī* (Jean and Francis Marshall Collection, San Francisco r): (*top*) Paraśurāma; (*above*) Bharata's visit.

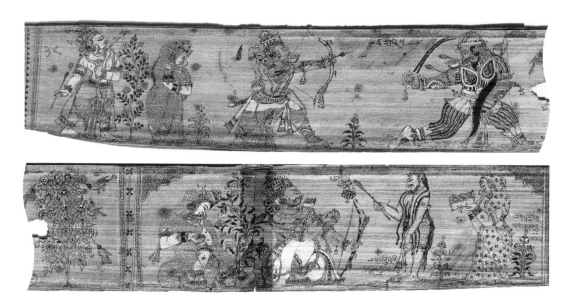

Figure 148. Dispersed *Lāvaṇyavatī* (Marshall Col. v). Rāma meets Virādha, Atri and Anasūyā.

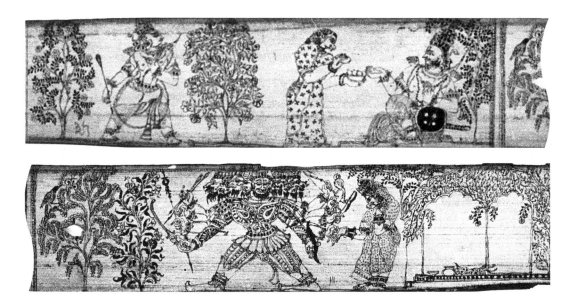

Figure 149. Dispersed *Lāvaṇyavatī* (courtesy National Museum, New Delhi, no. 63.126/14 r): (*top*) Śabarī; (*above*) Kidnap.

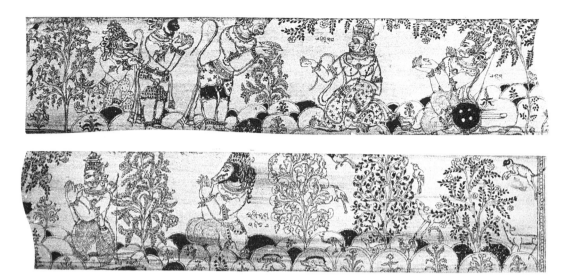

Figure 150. Dispersed *Lāvaṇyavatī* (NM 63.126/14 v): (*top*) Rāma, Lakṣmaṇa, and (*above*) monkeys.

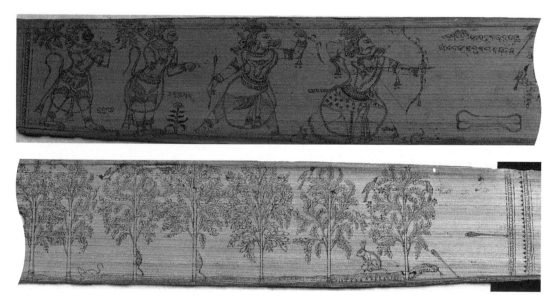

Figure 151. Dispersed *Lāvaṇyavatī* (NM 63.126/2 r): (*top*) Dundubhi's bone; (*above*) Seven trees.

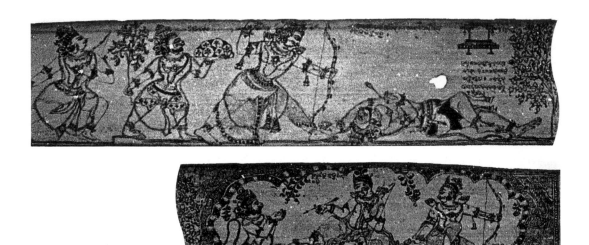

Figure 152. Dispersed *Lāvaṇyavatī* (NM 63.126/2 v): (*top*) Death of
Vālin; (*above*) Mount Mālyavan.

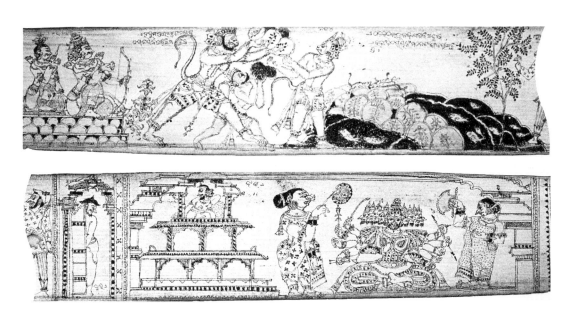

Figure 153. Dispersed *Lāvaṇyavatī* (NM 63.126/16 r): (*top*) Building the bridge;
(*above*) Rāvaṇa in Laṅkā.

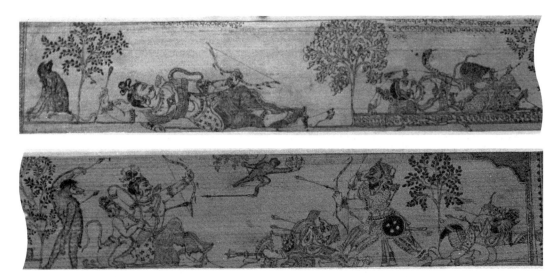

Figure 154. Dispersed *Lāvaṇyavatī* (NM 63.126/16 v): (*top*) Rāma and
Lakṣmaṇa shot by Indrajita; (*above*) Hanumāna bringing mountain.

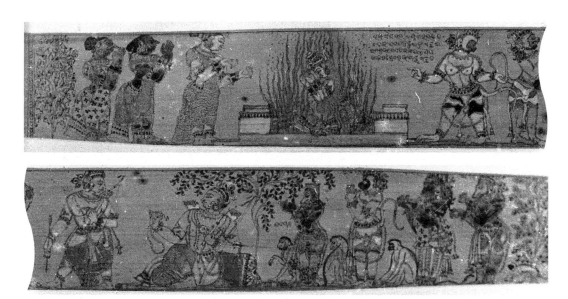

Figure 155. Dispersed *Lāvaṇyavatī* (courtesy Birla Academy of Art and Culture,
no. A246 r): (*top and above*) Sītā's test. Photo Birla Academy.

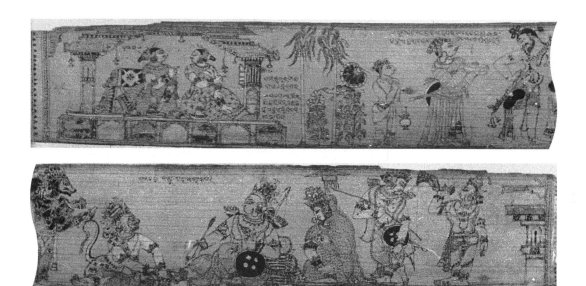

Figure 156. Dispersed *Lāvaṇyavatī* (Birla Academy A246 v): (*top and above*)
Lāvaṇyavatī watches coronation of Rāma. Photo Birla Academy.

Figure 157. Balabhadra Pathy, *Lāvaṇyavatī* (courtesy National Museum of India,
New Delhi, no. 80.1276). Riśyaśṛiṅga and courtesans, f. 138r.

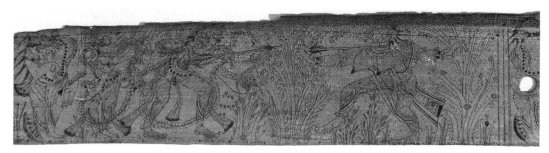

Figure 158. Balabhadra Pathy, *Lāvaṇyavatī* (NM 80.1276). Tāḍakī, f. 143v.

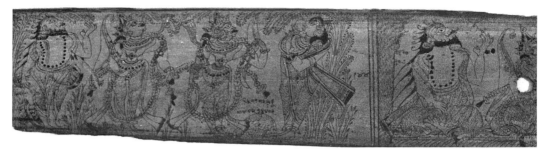

Figure 159. Balabhadra Pathy, *Lāvaṇyavatī* (NM 80.1276). Ahalyā liberated, f. 144r.

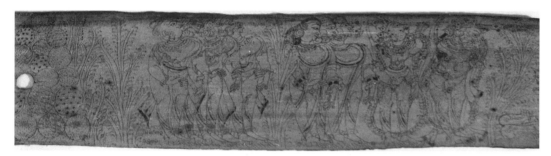

Figure 160. Balabhadra Pathy, *Lāvaṇyavatī* (NM 80.1276). Bharata's party approaches Chitrakūṭa, f. 151v.

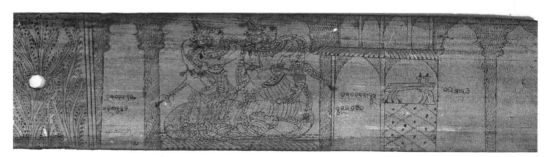

Figure 161. Balabhadra Pathy, *Lāvaṇyavatī* (NM 80.1276). Bharata worships Rāma's sandals, f. 159v.

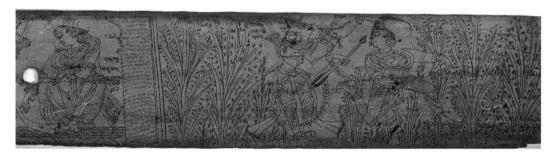

Figure 162. Balabhadra Pathy, *Lāvaṇyavatī* (NM 80.1276). Lakṣmaṇa denoses Śūrpaṇakhā, f. 162r.

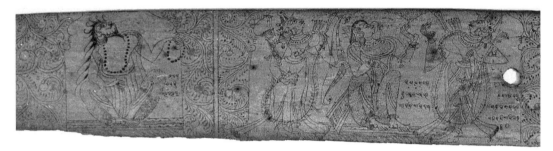

Figure 163. Balabhadra Pathy, *Lāvaṇyavatī* (NM 80.1276). Rāvaṇa watches Lakṣmaṇa, Sītā, and Rāma, f. 165r.

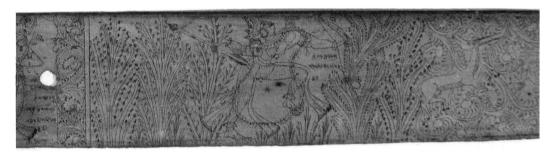

Figure 164. Balabhadra Pathy, *Lāvaṇyavatī* (NM 80.1276). Rāma chases magic deer, f. 165v.

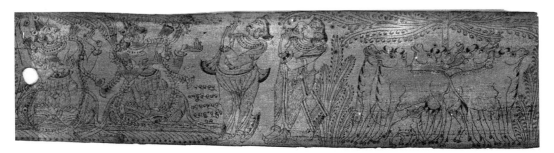

Figure 165. Balabhadra Pathy, *Lāvaṇyavatī* (NM 80.1276). Rāma shoots magic deer, f. 166r.

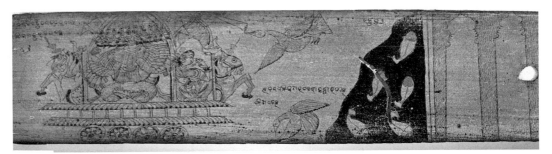

Figure 166. Balabhadra Pathy, *Lāvaṇyavatī* (NM 80.1276). Jaṭāyu attempts to stop Rāvaṇa, f. 166v.

Figure 167. Balabhadra Pathy, *Lāvaṇyavatī* (NM 80.1276). Rāma, Lakṣmaṇa, and the cowherds, f. 168r.

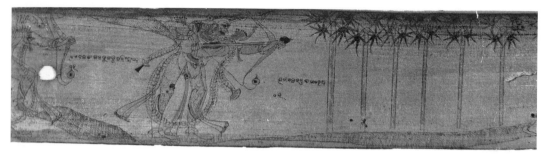

Figure 168. Balabhadra Pathy, *Lāvaṇyavatī* (NM 80.1276). Dundubhi's bones, Seven trees, f. 169v.

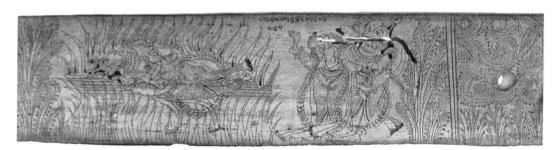

Figure 169. Balabhadra Pathy, *Lāvaṇyavatī* (NM 80.1276). Vālin's cremation, f. 171r.

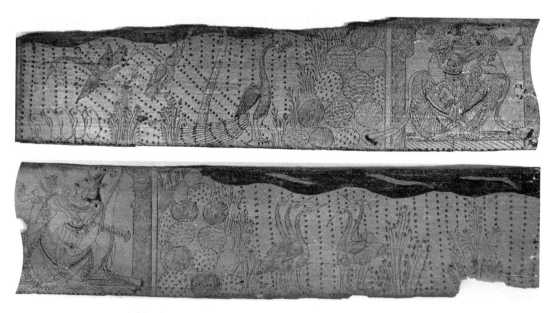

Figures 170, 171. Balabhadra Pathy, *Lāvaṇyavatī* (NM 80.1276), f. 173v: (*top and above*) Rains on Mount Mālyavan.

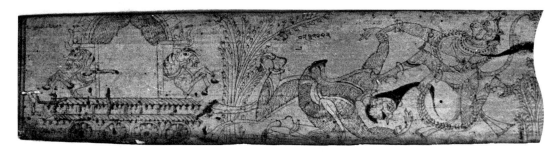

Figure 172. Balabhadra Pathy, *Lāvaṇyavatī* (NM 80.1276). Hanumāna in Laṅkā, f. 185r.

Figure 173. Balabhadra Pathy, *Lāvaṇyavatī* (NM 80.1276). Hanumāna in Laṅkā, f. 180v.

Figure 174. Balabhadra Pathy, *Lāvaṇyavatī* (NM 80.1276). Hanumāna sets fire to Laṅkā, f. 200v.

Figure 175. Raghunath Prusti, *Lāvaṇyavatī* (private collection, Mundamarai). Riśyaśṛṅga brought to Lomapāda, f. 72r.

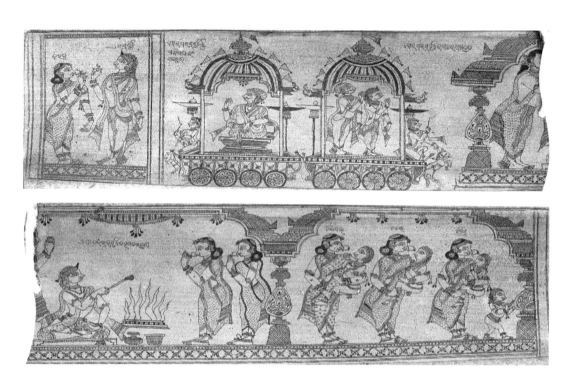

Figure 176. Raghunath Prusti, *Lāvaṇyavatī* (pc, M). Riśyaśṛiṅga and Jāratā,
brought to Ayodhyā, sacrifice, birth of Daśaratha's sons, f. 72v.

Figure 177. Raghunath Prusti, *Lāvaṇyavatī* (pc, M). Tāḍakī; Viśvāmitra's
sacrifice, Rāma shoots Mārīcha, f. 73r.

Figure 178. Raghunath Prusti, *Lāvaṇyavatī* (pc, M). Ahalyā's liberation, Boatman, Rāma bends Śiva's bow, f. 73v.

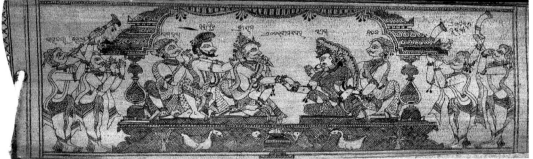

Figure 179. Raghunath Prusti, *Lāvaṇyavatī* (pc, M). Rāma's marriage, f. 74r.

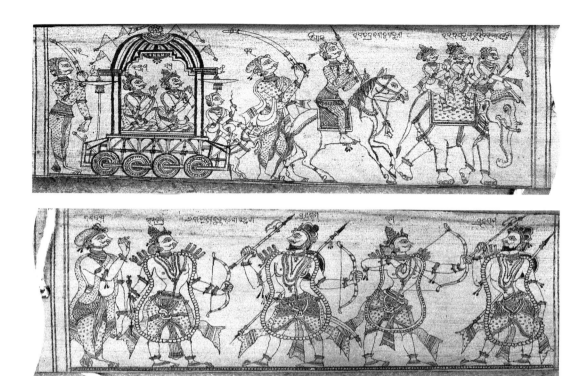

Figure 180. Raghunath Prusti, *Lāvaṇyavatī* (pc, M). Meeting with Paraśurāma, f. 74v.

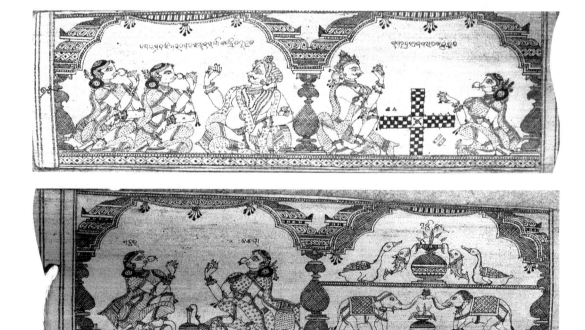

Figure 181. Raghunath Prusti, *Lāvaṇyavatī* (pc, M). Preparations for Rāma's coronation, Mantharā and Kaikeyī, f. 75r.

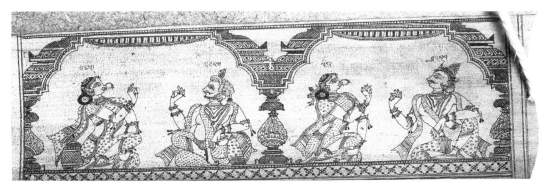

Figure 182. Raghunath Prusti, *Lāvaṇyavatī* (pc, M). Kaikeyī and Daśaratha, Sītā and Rāma; Rāma meets Śabaras, f. 75v.

Figure 183. Raghunath Prusti, *Lāvaṇyavatī* (pc, M). Rāma binds up hair, the ocher mark, Bharata's visit, f. 76r.

Figure 184. Raghunath Prusti, *Lāvaṇyavatī* (pc, M). Virādha, Atri, and Anasūyā, Viśvāmitra and disciple meet Rāma, f. 76v.

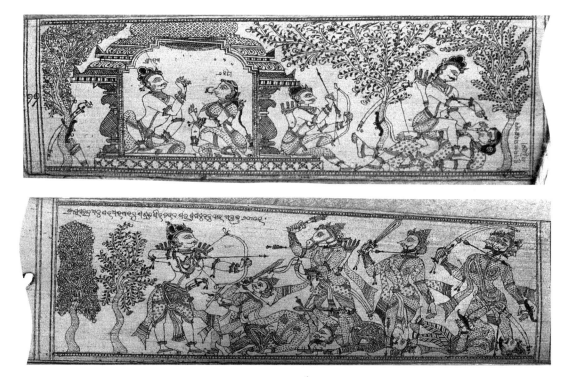

Figure 185. Raghunath Prusti, *Lāvaṇyavatī* (pc, M). Śūrpaṇakhā denosed, fight with Khara and Dūṣaṇa, f. 77r.

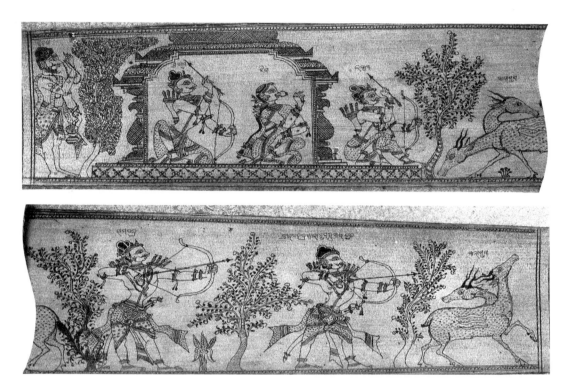

Figure 186. Raghunath Prusti, *Lāvaṇyavatī* (pc, M). The magic deer, f. 77v.

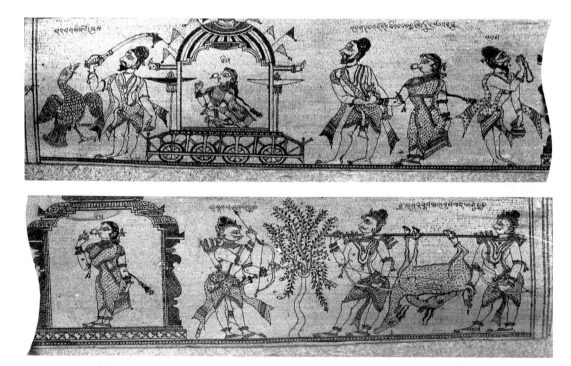

Figure 187. Raghunath Prusti, *Lāvaṇyavatī* (pc, M). Jaṭāyu attempts to stop
Rāvaṇa, Kidnap, Rāma and Lakṣmaṇa return with dead deer, f. 78r.

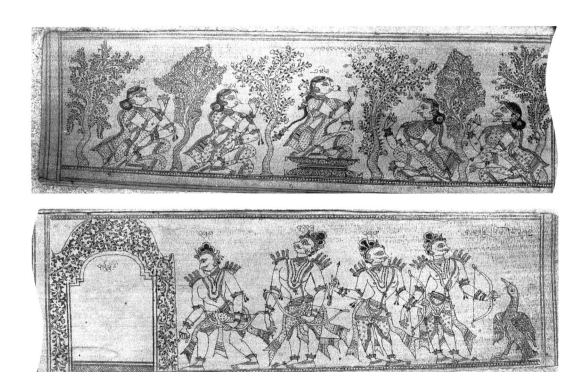

Figure 188. Raghunath Prusti, *Lāvaṇyavatī* (pc, M). Sītā in Laṅkā, Rāma finds
empty hut, meets Jaṭāyu, f. 78v.

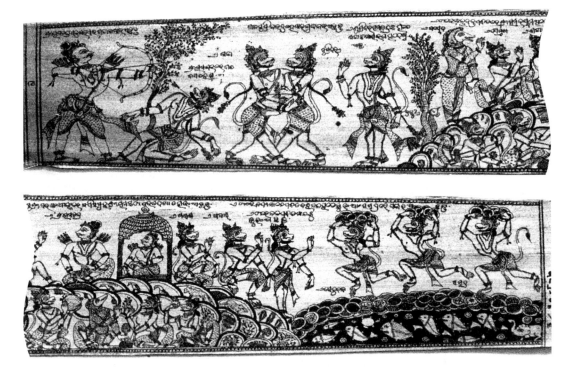

Figure 189. Raghunath Prusti, *Lāvaṇyavatī* (courtesy Bharat Kala Bhavan,
Banaras, no. 10927). Vālin's death, Rāma and *vānaras,* building the bridge, f. 80r.

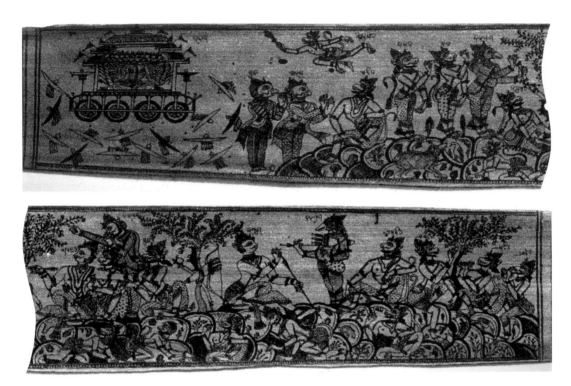

Figure 190. Raghunath Prusti, *Lāvaṇyavatī* (BKB 10927). Rāvaṇa's umbrellas cut, Lakṣmaṇa and Jāmbavan, f. 80v.

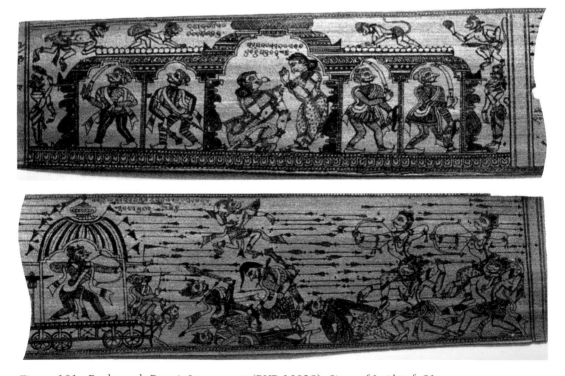

Figure 191. Raghunath Prusti, *Lāvaṇyavatī* (BKB 10928). Siege of Laṅkā, f. 81r.

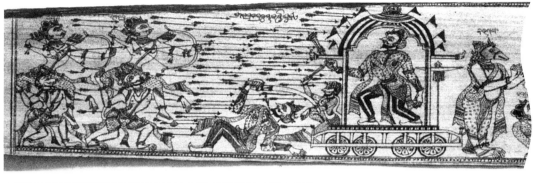

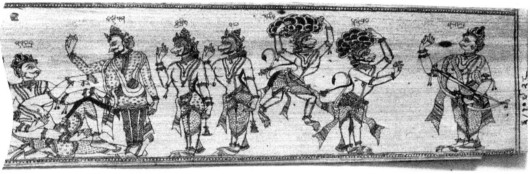

Figure 192. Raghunath Prusti, *Lāvaṇyavatī* (BKB 10928). Indrajita in battle, Hanumāna brings mountain to Rāma, f. 81v.

Figure 193. Raghunath Prusti, *Lāvaṇyavatī* (private collection, Mundamarai). Performers rewarded, f. 83r.

Figure 194. *Brahma Rāmāyaṇa* (Maṭha collection). Brahma's garden, f. 6v.

Figure 195. *Brahma Rāmāyaṇa*. Tāḍakī, f. 13r.

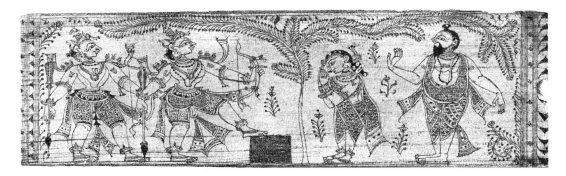

Figure 196. *Brahma Rāmāyaṇa.* Ahalyā (detail), f. 13v.

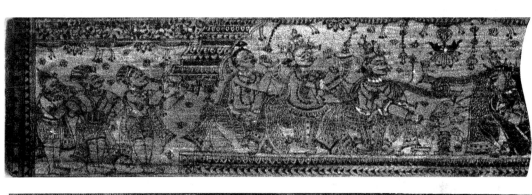

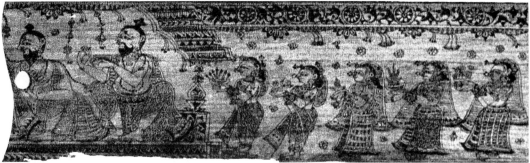

Figure 197. *Brahma Rāmāyaṇa.* Rāma's marriage, f. 21r.

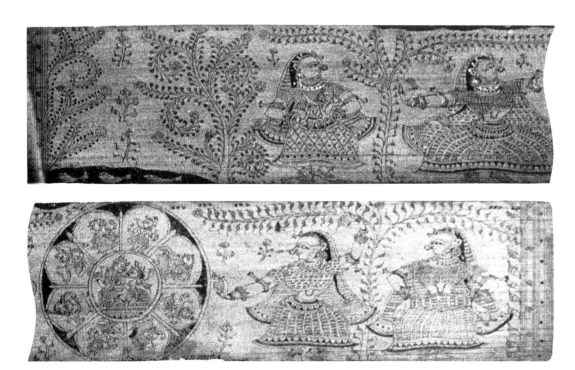

Figure 198. *Brahma Rāmāyaṇa. Rāmakrīḍa* (sport of Rāma), f. 46r.

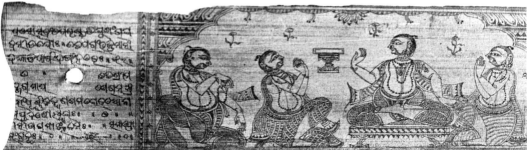

Figure 199. *Brahma Rāmāyaṇa.* Final sacrifice, f. 65v.

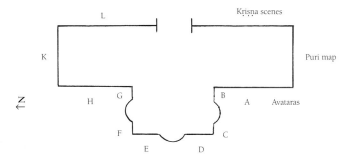

Wall A (from bottom to top)

tier 1 (right to left)
Riśyaśṛṅga's sacrifice
Riśyaśṛṅga & Daśaratha
Daśaratha & 3 queens
4 births

tier 2 (left to right)
4 sons in swings
Daśaratha & Viśvāmitra
Viśvāmitra takes Rāma & Lakṣmaṇa
Viśvāmitra's sacrifice
Rāma & Tāḍakī
Rāma & Ahalyā

tier 3 (left to right)
Boatman washes feet
Rāma & Lakṣmaṇa disembark
Sītā garlands Rāma
Marriage 1—*vivāha*
Marriage 2—*majju sajya* (hands joined)
Paraśurāma & Daśaratha?
Paraśurāma & Rāma

tier 4 (right to left)
Mantharā & Kaikeyī
Rāma & Sītā in shrine?
Rāma, Sītā, Lakṣmaṇa, 3 mothers
Chariot—Rāma's exile
Sītā, Rāma & Lakṣmaṇa wind hair as ascetics
Rāma, Lakṣmaṇa, & sage?

tier 5 (right to left)
Rāma & Sītā, Lakṣmaṇa with bow
Rāma, Sītā, Lakṣmaṇa on Chitrakūṭa
Śūrpaṇakhā denosed by Lakṣmaṇa; Rāma & Sītā?
Śūrpaṇakhā before Rāvaṇa?

Wall B (from top to bottom)

tier 1 (left to right)
Deer
Rāma shoots Mārīcha in human form
Lakṣmaṇa & Sītā?

tier 2 (right to left)
Sītā in hut, Rāvaṇa as beggar
Rāma, Lakṣmaṇa, & dead deer
Rāvaṇa, Sītā (kidnapped), & Jaṭāyu

tier 3 (left to right)
Rāma & 2 blue figures (Kumbhāsura & Kabanda?)
Rāma, Lakṣmaṇa, & cowherd

tier 4
Blue figure & woman (Śabarī?), room

Wall C (from top to bottom)
Hanumāna meets Rāma
Dundubhi's bones
7 sal trees
Death of Vālin

Wall D
top: Bharata's visit
bottom: Rāma, Lakṣmaṇa, & monkeys

Wall E
top: Chitrakūṭa; Rāma marks Sītā with ocher
bottom: Building the bridge to Laṅkā

Wall F
top: Jāmbhavan; Lakṣmaṇa straightens arrow on way to
Kiṣkindhā
bottom: Blue ascetic & youth (Viśvāmitra and disciple)

Wall G: Rāma, Lakṣmaṇa, Vibhīṣaṇa, monkeys, cutting um-
brellas of Rāvaṇa

Wall H
top, right: Battle with Indrajita? charioteer vs. archer
bottom, right: Hanumāna with Gandhamādana;
Garuḍa with snake
top, left: Death of Kumbhakarṇa? big white figure
bottom, left: Viṣṇu, twice

Wall K (top): Battle between Rāma (right) & Rāvaṇa (left)

Wall L: Visit to Bharadvāja's ashram? Atri's ashram out of
sequence?

Figure 200. Buguda, Virañchi Nārāyaṇa Temple, plan showing location (A–L)
of Rāmāyaṇa paintings.

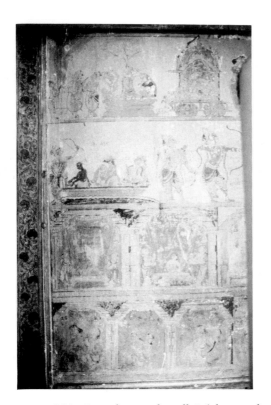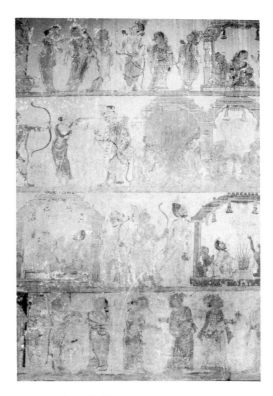

Figure 201. Buguda mural, wall A (*above and opposite, top of page*). From Sacrifice by Riśyaśṛṅga to Rāma's exile (*read bottom to top*).

Figure 202. Buguda mural, wall B (*opposite; read top to bottom*). Magic deer; Kidnap, Jaṭāyu, Rāma, Lakṣmaṇa, and dead deer; Rāma encountering Kabandha, cowherds; Śabarī.

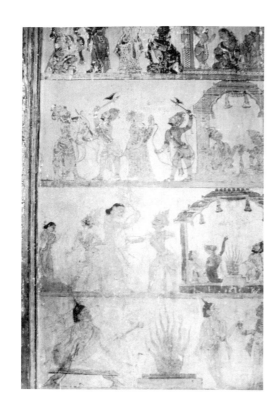

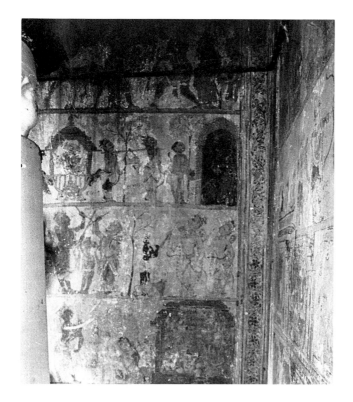

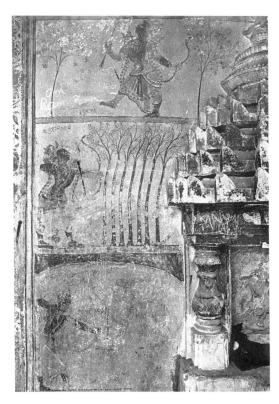

Figure 203. Buguda mural, wall C. Dundubhi's bones, Seven trees, Death of Vālin.

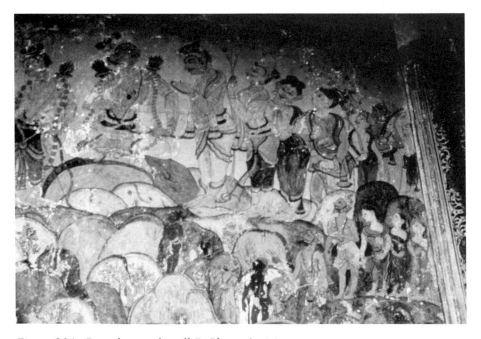

Figure 204. Buguda mural, wall D. Bharata's visit.

Figure 205. Buguda mural, walls D–E, general view. Bharata's visit, Rāma and monkeys, Ocher mark, Building the bridge.

Figure 206. Buguda mural, wall E. Ocher mark, Building the bridge.

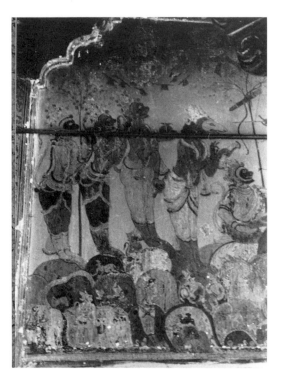

Figure 207. Buguda mural, wall G, top.
Cutting Rāvaṇa's umbrellas (left).

Figure 208. Buguda mural, wall G, top right.
Vibhiṣaṇa points to Rāvaṇa.

Figure 209. Buguda mural, wall F, top.
Viśvāmitna and disciple.

Figure 210. Buguda mural, wall H,
bottom. Garuḍa.

Figure 211. Buguda mural, wall H, bottom.
Hanumāna.

Figure 212. Buguda mural, wall H, left, top. Battle with Kumbhakarṇa.

Figure 213. Buguda mural, wall K. Battle between Rāvaṇa and Rāma.

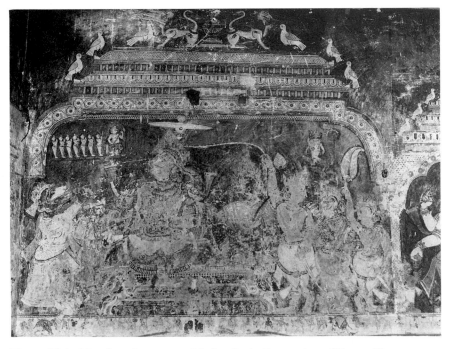

Figure 214. Mural in Gangāmātā Maṭha, Puri. Coronation of Rāma. Photo: Archaeological Survey of India.

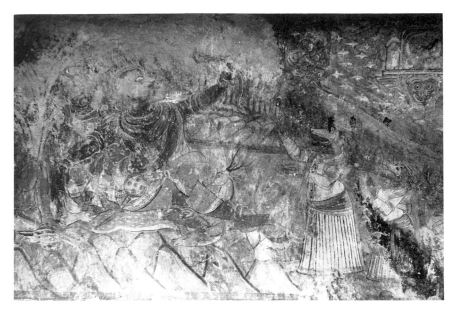

Figure 215. Mural in Jagannātha Temple, Manikarnika Sahi, Puri. Cutting Rāvaṇa's umbrellas.

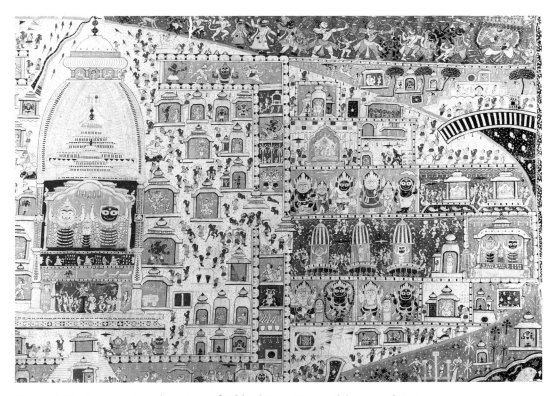

Figure 216. *Paṭa* painting (courtesy of Bibliothèque Nationale). Map of Puri, confrontation between Rāma and Rāvaṇa in upper right. Photo Bibliothèque Nationale.

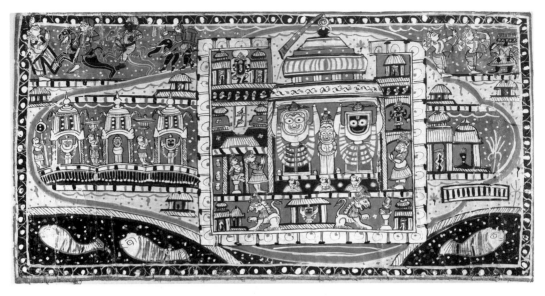

Figure 217. *Paṭa* painting (courtesy of British Museum). Map of Puri, confrontation between Rāma and Rāvaṇa in upper right. Photo British Museum.

Figure 218. Jagannath Mahapatra, 1954, unfinished set (artist's collection). Crossing to Laṅkā.

Figure 219. Jagannath Mahapatra, 1954, unfinished set (artist's col.). Lava and Kuśa fight Bharata and Lakṣmaṇa.

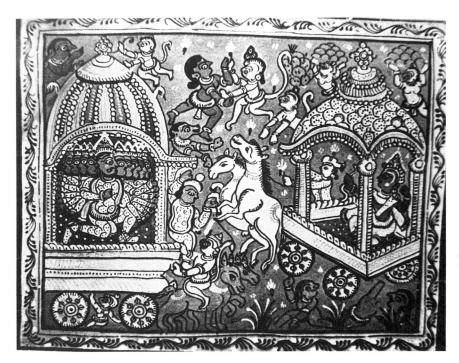

Figure 220. Jagannath Mahapatra, 1965. Battle between Rāvaṇa and Rāma.

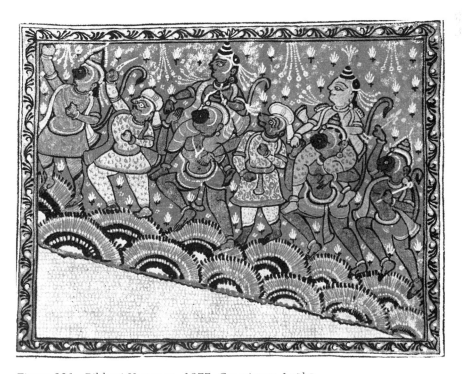

Figure 221. Bibhuti Kanungo, 1977. Crossing to Laṅkā.

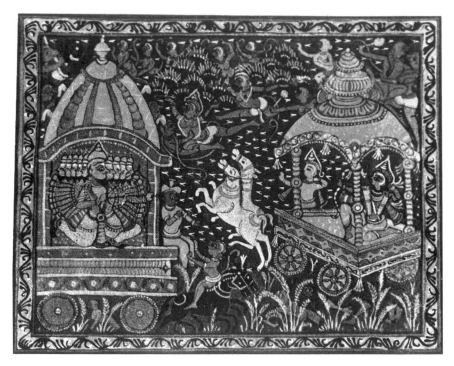

Figure 222. Bibhuti Kanungo, 1977. Battle between Rāvaṇa and Rāma.

Figure 223. Jagannath Mahapatra, 1982–83 (author's collection), no. 1,
Riśyaśṛiṅga and the courtesans.

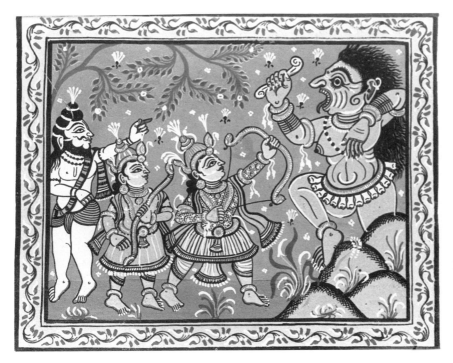

Figure 224. Jagannath Mahapatra, 1982–83, no. 11. Tāḍakī.

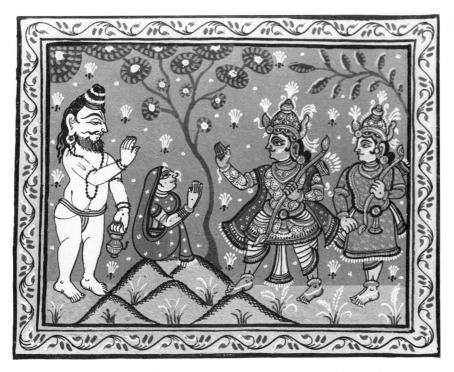

Figure 225. Jagannath Mahapatra, 1982–83, no. 12. Ahalyā liberated.

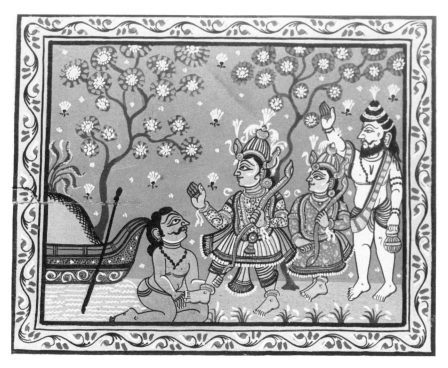

Figure 226. Jagannath Mahapatra, 1982–83, no. 13. The boatman.

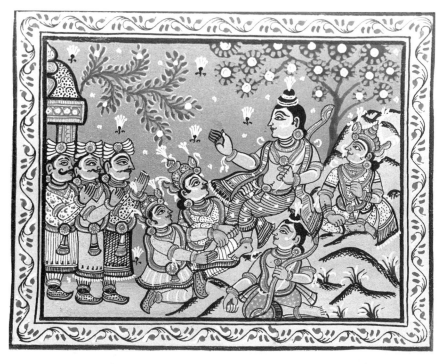

Figure 227. Jagannath Mahapatra, 1982–83, no. 22. Bharata's visit.

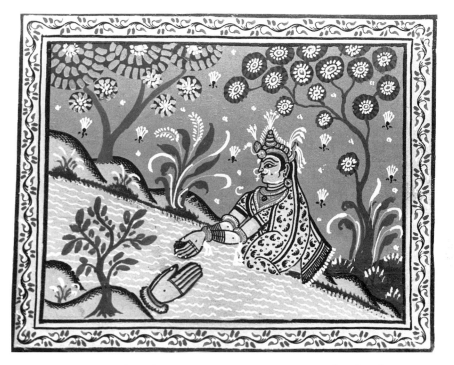

Figure 228. Jagannath Mahapatra, 1982–83, no. 23. Daśaratha's hands receive *piṇḍa* at Gaya.

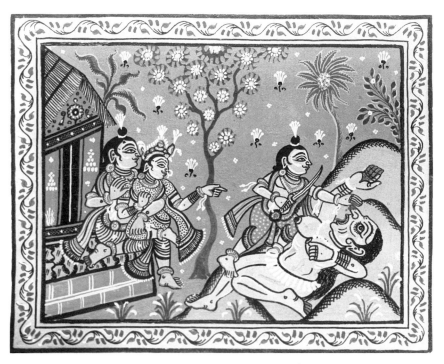

Figure 229. Jagannath Mahapatra, 1982–83, no. 24. Śūrpaṇakhā denosed.

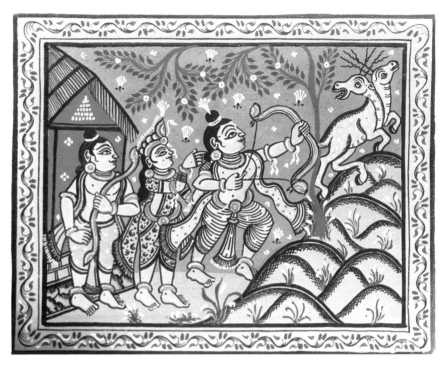

Figure 230. Jagannath Mahapatra, 1982–83, no. 26. The magic deer.

Figure 231. Jagannath Mahapatra, 1982–83, no. 27. The kidnap.

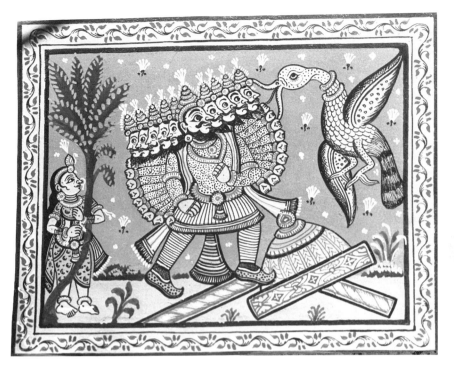

Figure 232. Jagannath Mahapatra, 1982–83, no. 28. Jaṭāyu attempts to stop Rāvaṇa.

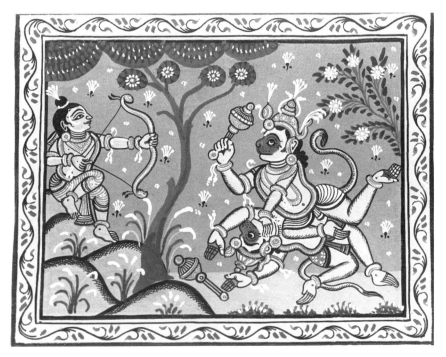

Figure 233. Jagannath Mahapatra, 1982–83, no. 31. Death of Vālin.

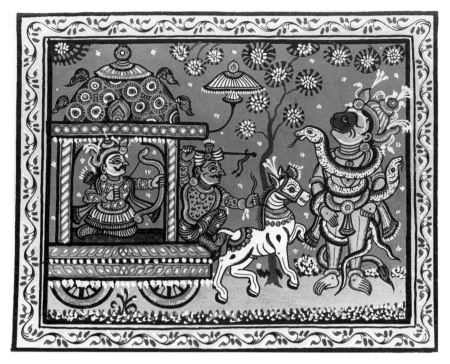

Figure 234. Jagannath Mahapatra, 1982–83, no. 41. Hanumāna shot by serpent-arrow.

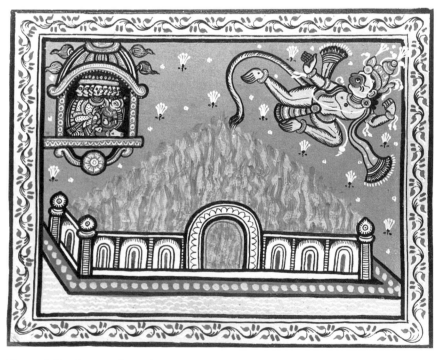

Figure 235. Jagannath Mahapatra, 1982–83, no. 43. Hanumāna sets fire to Laṅkā.

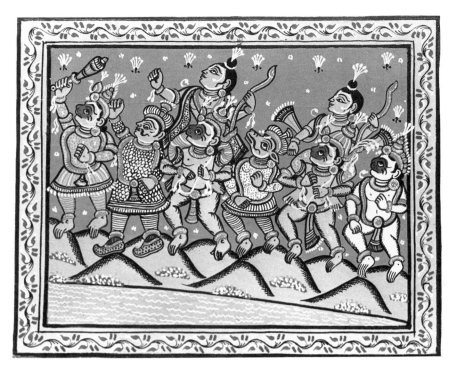

Figure 236. Jagannath Mahapatra, 1982–83, no. 45. Crossing to Laṅkā.

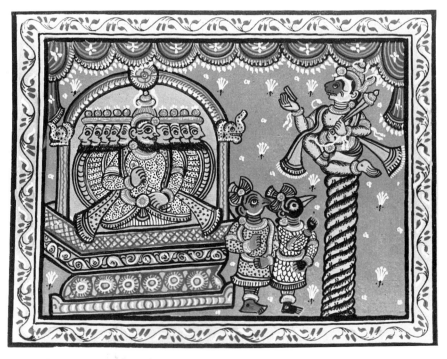

Figure 237. Jagannath Mahapatra, 1982–83, no. 47. Aṅgada's embassy.

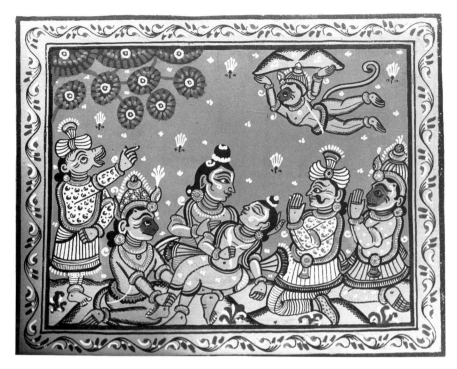

Figure 238. Jagannath Mahapatra, 1982–83, no. 56. Hanumāna with mountain.

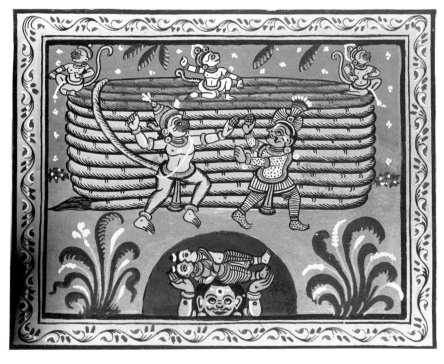

Figure 239. Jagannath Mahapatra, 1982–83, no. 57. Mahīrāvaṇa kidnaps Rāma and Lakṣmaṇa.

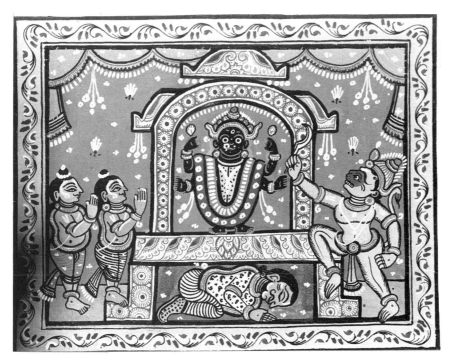

Figure 240. Jagannath Mahapatra, 1982–83, no. 58. Mahīrāvaṇa bows to Durgā.

Figure 241. Jagannath Mahapatra, 1982–83, no. 59. Rāma worships Durgā.

Figure 242. Jagannath Mahapatra, 1982–83, no. 60. Rāvaṇa fights Rāma.

Figure 243. Jagannath Mahapatra, 1982–83, no. 61. Sītā's test.

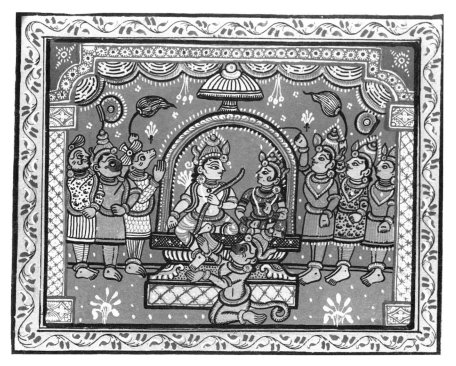

Figure 244. Jagannath Mahapatra, 1982–83, no. 62. Coronation of Rāma.

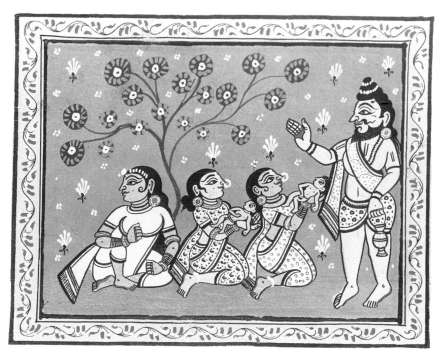

Figure 245. Jagannath Mahapatra, 1982–83, no. 66. Sītā's sons shown to Vālmīki.

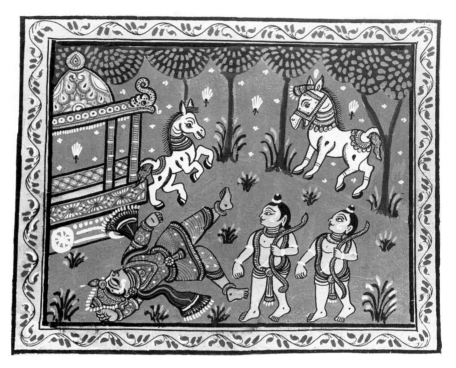

Figure 246. Jagannath Mahapatra, 1982–83, no. 69. Lava and Kuśa fight
Śatrughna.

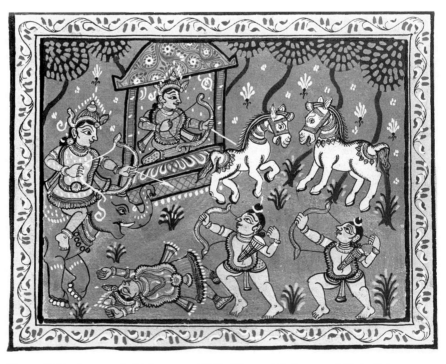

Figure 247. Jagannath Mahapatra, 1982–83, no. 70. Lava and Kuśa fight
Bharata and Lakṣmaṇa.

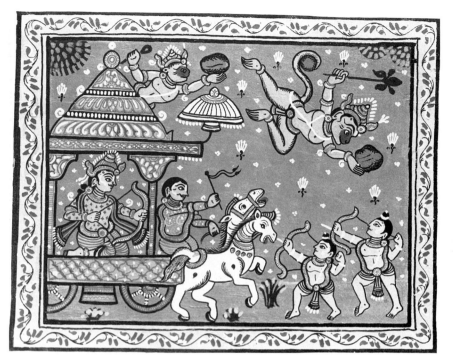

Figure 248. Jagannath Mahapatra, 1982–83, no. 71. Lava and Kuśa fight Rāma.

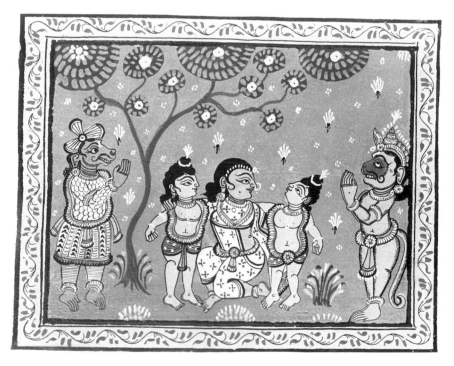

Figure 249. Jagannath Mahapatra, 1982–83, no. 72. Lava and Kuśa comfort Sītā.

Figure 250. Jagannath Mahapatra, 1982–83, no. 73. Rāma holds his sons.

Figure 251. Jagannath Mahapatra, 1982–83, no. 74. Sītā rejoins mother earth.

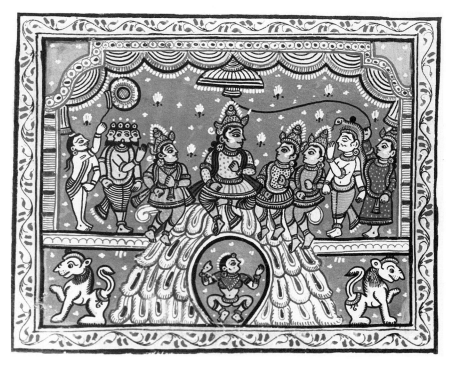

Figure 252. Jagannath Mahapatra, 1982–83, no. 75. Rāma crowns his sons.

Figure 253. Unfinished Rāmāyaṇa *paṭa*,
Danda Sahi, 1983.

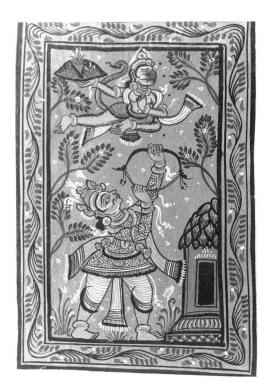

Figure 255. Banamali Maharana, 1982. *Paṭa* of Bharata shooting Hanumāna.

Figures 254 a–d (*top of page, opposite and above*). Bhikari Maharana, 1983.
Paṭa of Rāma's story in seventy-five scenes.

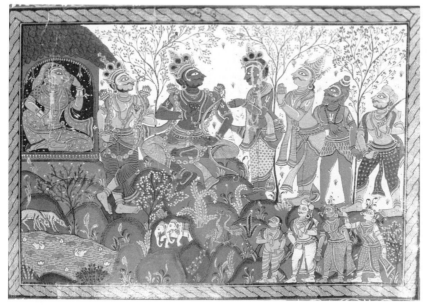

Figure 256. Bhagavata Maharana, 1983. *Paṭa* of Bharata's visit.

Figure 257. Book cover (courtesy of Orissa State Museum). Coronation of Rāma.

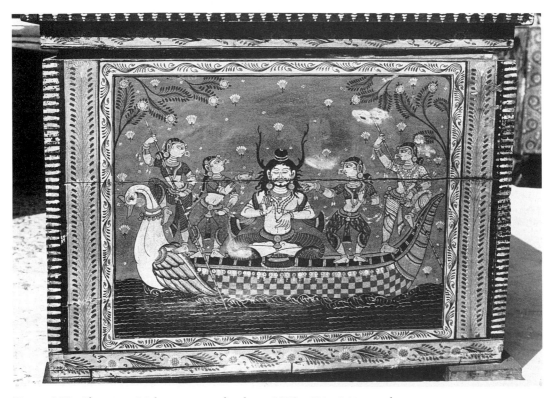

Figure 258. Bhagavata Maharana, wooden box, 1970s. Riśyaśṛiṅga and courtesans.

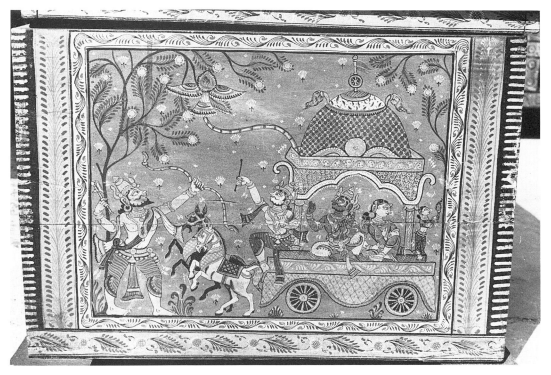

Figure 259. Bhagavata Maharana, wooden box. Meeting with Paraśurāma.

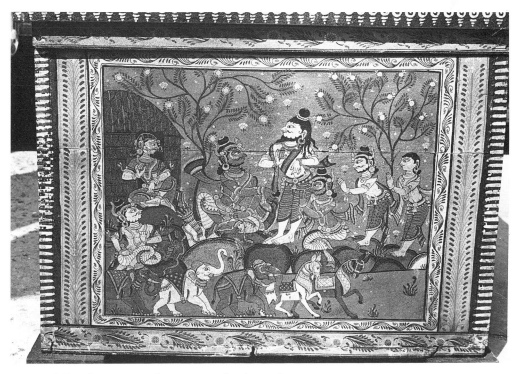

Figure 260. Bhagavata Maharana, wooden box. Bharata's visit.

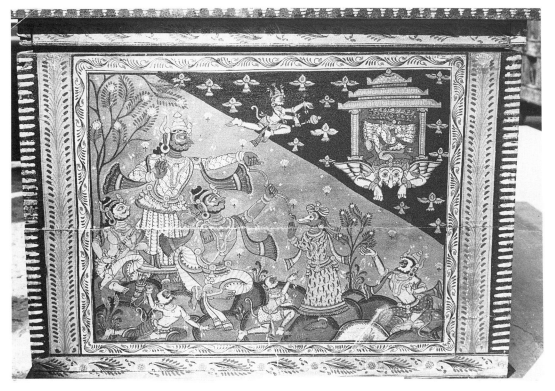

Figure 261. Bhagavata Maharana, wooden box. Cutting Rāvaṇa's umbrellas.

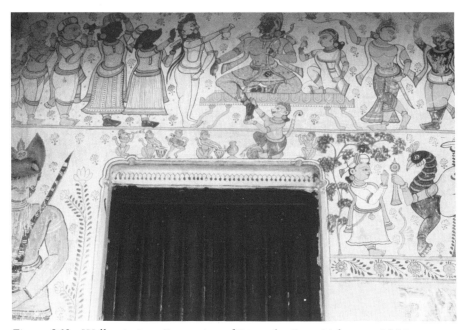

Figure 262. Wall painting, Coronation of Rāma, by Panu Maharana, 1950s, Danda Sahi.

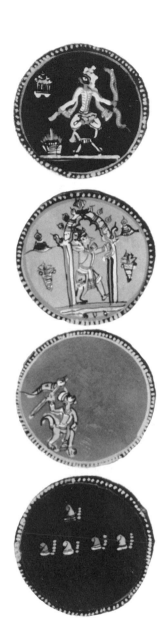

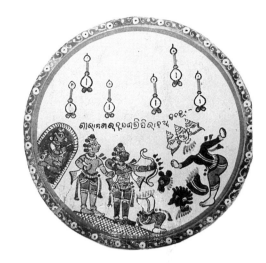

Figure 264. Parlakhemundi, playing card (courtesy of Victoria and Albert Museum, London). Rāma shoots Khara, Dūṣaṇa, and Triśiras.

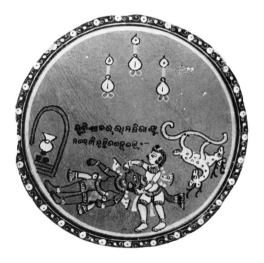

Figure 265. Parlakhemundi, playing card (V&A). Rāma faints at not seeing Sītā.

Figure 263. Sonepur Rāmāyaṇa playing cards: Indrajita suit, king; Lakṣmaṇa suit, minister; Sugrīva suit, one; Hanumāna suit, five.

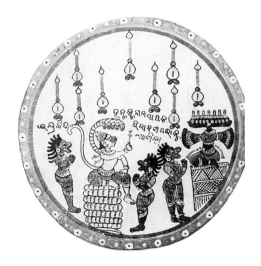

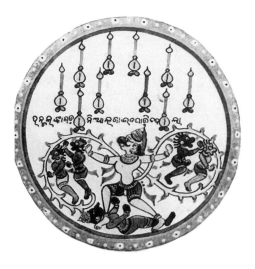

Figure 266. Parlakhemundi, playing card
(V&A). After tying up Hanumāna, Indrajita
brings him to Rāvaṇa.

Figure 267. Parlakhemundi, playing card
(V&A). Hanumāna sets fire to Laṅkā.

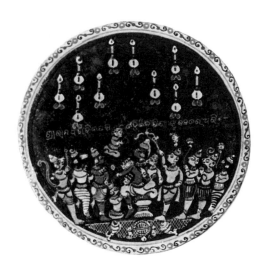

Figure 268. Parlakhemundi, playing card
(V&A). Coronation of Rāma.

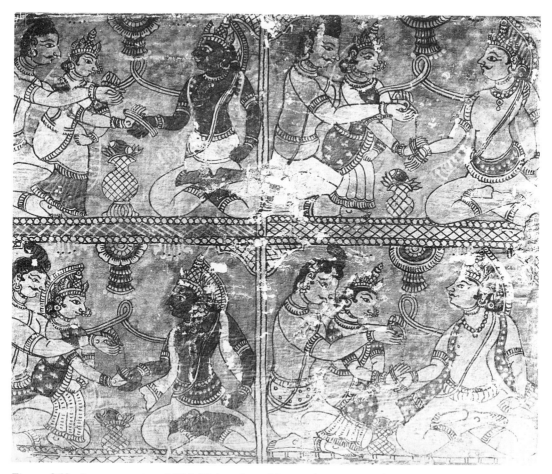

Figure 269. Jeypore, *paṭa* c. 1900 (Orissa State Museum). Marriage of Rāma and his brothers.

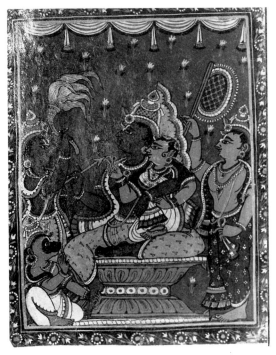

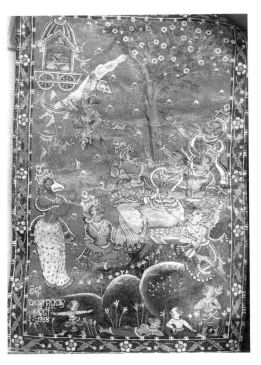

Figure 270. Apanna Mahapatra, Chikiti, 1982, *paṭa*. Coronation of Rāma.

Figure 271. Apanna Mahapatra, Chikiti, 1988, *paṭa*. Cutting of Rāvaṇa's umbrellas.

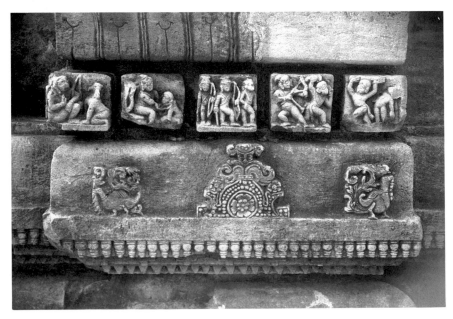

Figure 272. Śatrughneśvara Temple, Bhubaneswar, dentils. Death of Vālin.

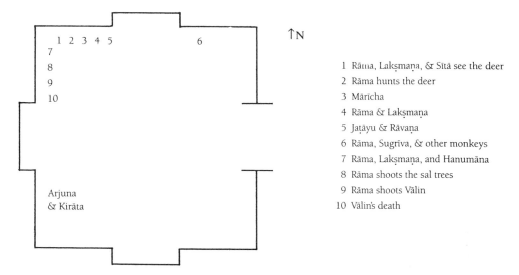

↑N

1 Rāma, Lakṣmaṇa, & Sītā see the deer
2 Rāma hunts the deer
3 Mārīcha
4 Rāma & Lakṣmaṇa
5 Jaṭāyu & Rāvaṇa
6 Rāma, Sugrīva, & other monkeys
7 Rāma, Lakṣmaṇa, and Hanumāna
8 Rāma shoots the sal trees
9 Rāma shoots Vālin
10 Vālin's death

Figure 273. Svarṇajāleśvara Temple, Bhubaneswar. Plan showing original placement of Rāmāyaṇa reliefs.

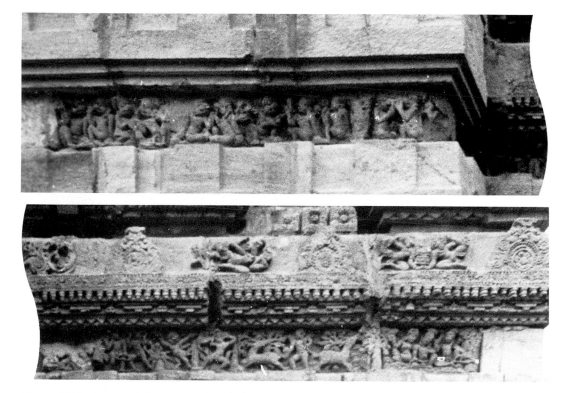

Figure 274. Svarṇajāleśvara Temple, Bhubaneswar. View of north frieze, 1987 (*top* shows 6 on Figure 273, now moved; *bottom* shows 5 to 1).

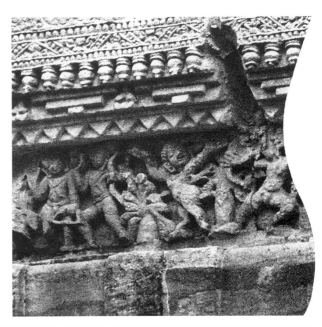

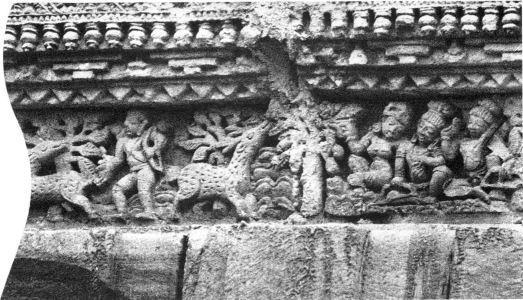

Figure 275. Svarṇajāleśvara Temple, Bhubaneswar, north wall. Detail of magic deer episode (*top*: Maricha emerging from deer).

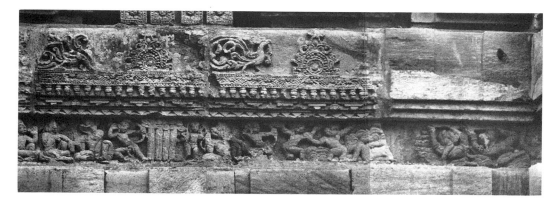

Figure 276. Svarṇajāleśvara Temple, Bhubaneswar, west wall. Rāma shoots trees, Death of Vālin.

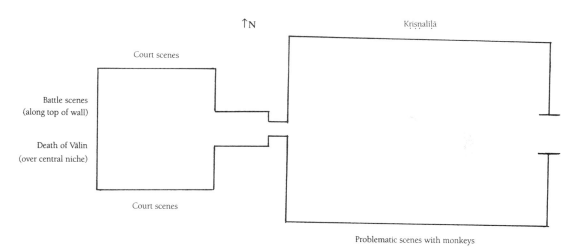

Figure 277. Simhanātha Temple. Plan showing placement of Rāmāyaṇa reliefs.

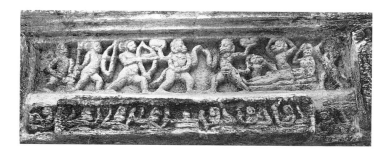

Figure 278. Simhanātha Temple, frieze over west central niche. Death of Vālin.

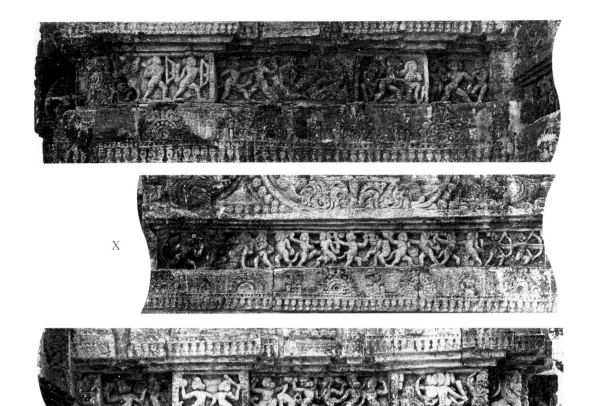

X

Figure 279. Simhanātha Temple, frieze at top of west wall. Battle for Laṅkā (see p. 73).

```
            13                12  11  10  9  8  7  6
    ↑N                                                  5
                                                        4
                                                        3
                                                        2
                                                        1

    to the shrine

                                          lower tier: Monkey business?
                                          upper tier: Building the bridge?
```

1 Rāma, Lakṣmaṇa, & Śūrpaṇakhā?	8 Rāma, Lakṣmaṇa, & Jaṭāyu
2 Śūrpaṇakhā flees Lakṣmaṇa	9 Vālin & Dundubhi
3 Rāvaṇa & Mārīcha	10 Rāma, Lakṣmaṇa, & Sugrīva
4 Rāma & the magic deer	11 Seven sal trees
5 Lakṣmaṇa & Sītā?	12 Death of Vālin
6 Mārīcha, Rāma, & Lakṣmaṇa	13 Scenes of Laṅkā?
7 Rāvaṇa & Jaṭāyu	

Figure 280. Varāhi Temple, Chaurasi. Plan showing placement of Rāmāyaṇa reliefs.

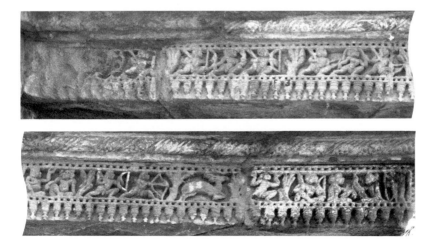

Figure 281. Varāhī Temple, Chaurasi, frieze on east wall of porch. Śūrpanakhā, Magic deer.

Figure 282. Varāhī Temple, Chaurasi, frieze on north wall of porch. Mārīcha's death, Jaṭāyu confronts Rāvaṇa and meets Rāma, Vālin kills Dundubhi, Rāma shoots trees, Death of Vālin.

Figure 283. Varāhī Temple, Chaurasi, friezes on south wall of porch. *Below,* unidentified scenes with monkeys; *above,* building of bridge to Laṅkā(?).

Figure 284. Compound of Gaurī Temple,
Bhubaneswar. Hanumāna.

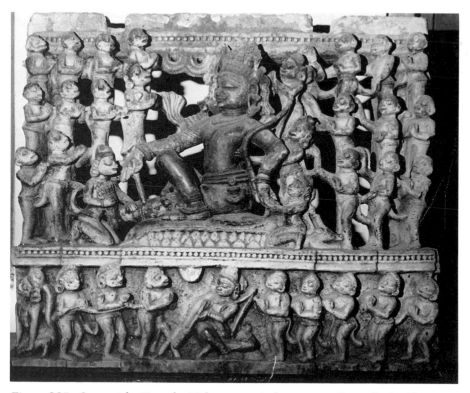

Figure 285. Somanātha Temple, Vishnupur, window screen. Rāma flanked by
monkeys; *below*, Lakṣmaṇa straightening his arrow.

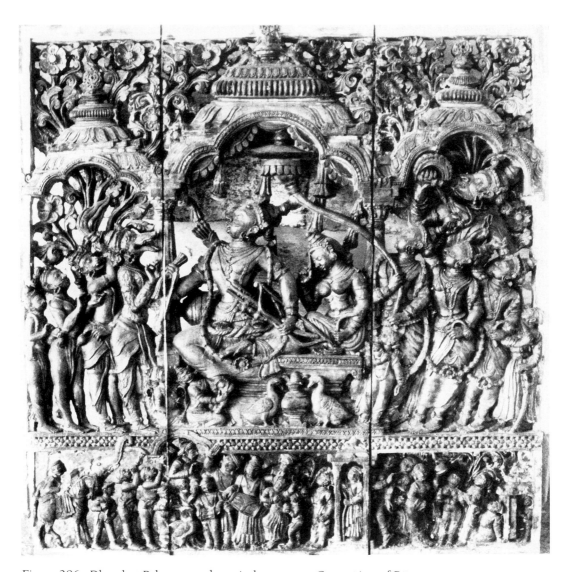

Figure 286. Dharakot Palace, wooden window screen. Coronation of Rāma.

Figure 287. Mukteśvara Temple, Bhubaneswar.
Foliate carving on south wall.

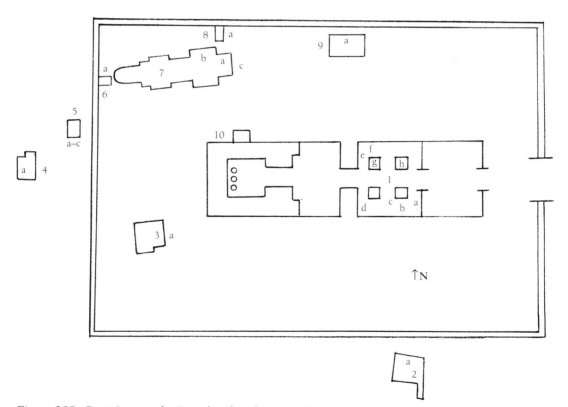

Figure 288. Purī, Jagannātha Temple. Plan showing placement of Rāmāyaṇa paintings (see Appendix 4).

A. Raghurajpur, 21 scenes B. Danda Sahi, 22 scenes

C. Bhikari Maharana's *paṭa*, 75 scenes

D. Danda Sahi, 108 scenes

Figure 289. Narrative *paṭas* of Rāmāyaṇa themes, diagrams (see Appendix 5); numbers on diagrams indicate sequence in which scenes are to be read.

BIBLIOGRAPHY

Primary Texts

(The Oriya authors are listed in alphabetical order by first name, the name by which they are commonly known.)

Adhyātma Rāmāyaṇa. Translated (from Sanskrit) into Oriya by Gopala Telenga. Behrampur: Sharada Press, 1975.

Ananga Narendra. *Śrī Rāmalīlā*. Cuttack: Orissa Jagannath Company, 1978.

Balarāma Dāsa. *Jagamohana Rāmāyaṇa (Daṇḍi Rāmāyaṇa)*. Edited by Tareshvar Chaudhury and Banamali Bishvala. 4 vols. Cuttack: Dharmagrantha Store, n.d.

Upendra Bhañja. *Lāvaṇyavatī*. Edited by Ranjit Singh. Cuttack: Durga Press, 1977.

————. *Vaidehīśa Vilāsa*. Edited by Gaurikumar Brahma. Cuttack: Orissa Government Press, 1974 (vol. 1, chapters 1–27 only).

————. *Vaidehīśa Vilāsa*. Edited by Ranjit Singh. 4 vols. Cuttack: Orissa Jagannath Company, 1975–83.

Vaiśya Sadāśiva. *Śrī Rāmalīlā*. Cuttack: Dharmagrantha Store, n.d.

Vālmīki. *Rāmāyaṇa*. Chief editor G. H. Bhatt. 7 vols. Baroda: Oriental Institute, 1960–75.

Viśvanātha Khuṇṭiā. *Vichitra Rāmāyaṇa (Biśi Rāmāyaṇa)*. Cuttack: Dharmagrantha Store, n.d.

Secondary sources (including translations into Western languages)

Archer, Mildred. *Indian Popular Painting in the India Office Library*. London: Her Majesty's Stationery Office, 1977.

Aristotle. *Poetics*. Translated with commentary by Stephen Halliwell. London: Duckworth, 1987.

Aryan, K. C., and Subhashini Aryan. *Hanumān in Art and Mythology*. New Delhi: Rekha Prakashan, n.d.

Bagchi, P. C. Introduction to *Adhyātmarāmāyaṇam*. Edited by N. Siddhantaratna. Calcutta: Calcutta Sanskrit Series 11, 1935.

Bahura, G. N. *Literary Heritage of the Rulers of Amber and Jaipur, with an Index to the Register of Manuscripts in the Pothikhana of Jaipur*. Jaipur: United Printers, 1976.

195

Bahura, G. N., and Chandramani Singh. *Maps and Plans from Kapardwara.* Jaipur, forth-coming.

Baij Nath, B. L. *The Adhyatma Ramayana.* New Delhi: Oriental Books Reprint, 1979.

Bal, Mieke. *Narratology: Introduction to the Theory of Narrative.* Translated by C. van Bohee-men. Toronto: University of Toronto Press, 1985.

Bal, Mieke, and Norman Bryson. "Semiotics and Art History." *The Art Bulletin* 73, no. 2 (June 1991), 174–208.

Barthes, Roland. "Introduction to the Structural Analysis of Narratives." In *A Barthes Reader,* edited by S. Sontag. New York: Hill and Wang, 1982.

Basak, Raghugovinda. *Pravarasena's Rāvaṇavaha-mahākāvyam.* Calcutta: Calcutta Sanskrit College, 1959.

Bautze, Joachim. "The Problem of the Khaḍga (*Rhinoceros unicornis*) in the Light of Archaeo-logical Finds and Art." In *South Asian Archaeology 1983,* edited by Janine Schotsmans and Maurizio Taddei. Naples: Istituto Universitario Orientale, Dipartimento de Studi Asiatici, Series Minor 23, 1985, 405–33.

Beach, Milo C. *Early Mughal Painting.* Cambridge: Harvard University Press, 1987.

Beams, John. *Comparative Grammar of the Modern Aryan Languages of India,* vol. 1. Lon-don, 1872.

Behara, Dandapani. *Freedom Movement in the State of Ghumsar in Orissa, 1836–1866.* Cal-cutta: Punthi Pustak, 1984.

Bisoi, Nilamani. *Dasapalla Itihasa* (in Oriya). Cuttack: Saraswati Press, 1940.

Boner, Alice, and Sadashiv Rath Śarmā. *Śilpa Prakāśa.* Leiden: Brill, 1966.

Bonnemaison, Sarah, and Christine Macy. "The RamLila in Ramnagar." *Design Quarterly* 147 (1990), 2–22.

Brockington, J. L. *Righteous Rāma: The Evolution of an Epic.* New Delhi: Oxford University Press, 1984.

Bulke, Kamil. *Rāmkathā (Utpati aur Vikās).* 3rd ed. Allahabad: Hindi Parishad Prakashan, 1971.

Chakravarti, Uma. "The Development of the Sita Myth: A Case Study of Women in Myth and Literature." *Samya Shakti* I, no. 1 (1983), 68–75.

Chandra, Pramod. *Indian Miniature Painting in the Collection of Earnest C. and Jane Werner Watson.* Madison: Elvehjem Art Center, 1971.

Collins, Charles Dillard. *The Iconography and Ritual of Śiva at Elephanta.* Albany: State Uni-versity of New York, 1988.

Coomaraswamy, Ananda Kentish. "Reactions to Art in India." In *Transformation of Nature in Art,* 99–109. Reprint. New York: Dover, 1956.

Cousins, Henry. *Chālukyan Architecture of the Kanarese Districts.* Archaeological Survey of India, New Imperial Series, vol. 42. Calcutta: Government of India, 1926.

Czuma, Stanislaw. *Indian Art from the George P. Bickford Collection.* Cleveland: Cleveland Museum of Art, 1975.

Das, Chittaranjan. *A Glimpse into Oriya Literature.* Bhubaneswar: Orissa Sahitya Akademi, 1982.

Das, Jagannath Prasad. *Chitra-pothi: Illustrated Palm-Leaf Manuscripts from Orissa.* New Delhi: Arnold-Heinemann, 1985.

———. *Puri Paintings: The Chitrakāra and His Work.* New Delhi: Arnold-Heinemann, 1982.

Das, Jagannath Prasad, and Joanna Williams. *Palm-Leaf Miniatures: The Art of Raghunath Prusti of Orissa.* New Delhi: Abhinav Publications, 1991.

Das, Kulamani. *Kavisūrja Granthāvaḷī.* 10th ed. Cuttack: Cuttack Publishing House, 1977

Dash, Dhiren. *Jatra: People's Theatre of Orissa.* Bhubaneswar: Iota Publications, 1981.

———. *Pālā Itihāsa Pālā.* Bhubaneswar: Iota Publications, 1984.

De, S. C. "Svarna Jāleswar, One of the Early Temples of Bhubaneswar." *Orissa Historical Research Journal* 10 (1962), 17–22.

Dehejia, Vidya. *Early Stone Temples of Orissa.* New Delhi: Vikas, 1979.

———. "On Modes of Visual Narration in Early Buddhist Art." *Art Bulletin* 62, no. 3 (September 1990), 374–92.

Derrida, Jacques. "The Law of Genre." In *On Narrative,* edited by W. J. T. Mitchell, 51–78. Chicago: University of Chicago Press, 1981.

Desai, Devangana. "Narration of the Ramayana Episode—Vali-Vadha—in Indian Sculpture." In *Indian Studies: Essays Presented in Memory of Prof. Niharranjan Ray,* edited by Anita Ray, H. Sanyal, and S. C. Ray, 79–89. New Delhi, 1984.

———. "Placement and Significance of Erotic Sculptures at Khajuraho." In *Discourses on Śiva,* edited by M. Meister. Philadelphia: University of Pennsylvania Press, 1984.

Devanandan, Paul David. *The Concept of Māyā: An Essay in Historical Survey of the Hindu Theory of the World, with Special Reference to the Vedanta.* London: Lutterworth, 1950.

Dimock, Edward C. "A Theology of the Repulsive: The Myth of the Goddess Śītalā." In *The Divine Consort: Rādhā and the Goddesses of India,* edited by John Stratton Hawley and Donna Marie Wulff, 184–203. Delhi: Motilal Banarsidass, 1984.

Donaldson, Thomas E. *Hindu Temple Art of Orissa.* 3 vols. Leiden: Brill, 1985–87.

Dowling, Eric. "*Apate, Agon,* and Literary Self-Reflexivity in Euripides' *Helen.*" In *Cabinet of the Muses: Essays on Classical and Comparative Literature in Honor of Thomas G. Rosenmeyer,* edited by M. Griffith and D. Mastronarde. Berkeley: Scholars Press, 1990.

Eisner, Will. *Comics and Sequential Art.* Tamarac, Fla.: Poorhouse Press, 1985.

Erndl, Kathleen M. "The Mutilation of Śūrpaṇakhā." In *Many Rāmāyaṇas,* edited by Paula Richman, 67–88. Berkeley: University of California Press, 1991.

Eschmann, Anncharlott, Hermann Kulke, and Gaya Charan Tripathi. *The Cult of Jagannath and the Regional Tradition of Orissa.* New Delhi: Manohar, 1978.

Ettinghausen, Richard. *Paintings of the Sultans and Emperors of India in American Collections.* Bombay: Lalit Kala Akademi, 1961.

Fakirmohan Senapati. *My Times and I.* Translated by John Boulton. Bhubaneswar: Orissa Sahitya Akademi, 1985.

Feer, Léon. "Introduction du Nouveau Catalogue des Monuments Malais-Javanais de la Bibliothèque National," *Revue des Bibliothèques* 8 (1898), 371–80.

Fischer, Eberhard, and Dinanath Pathy. *Die Perlenkette dem Geliebten.* Rietberg Serie no. 5. Zurich: Museum Rietberg, 1990.

Fischer, Eberhard, Jyotindra Jain, Haku Shah. *Tempeltücher für die Muttergottinnen in Indien.* Zurich: Museum Rietberg, 1982.

Fischer, Eberhard, Sitakant Mahapatra, and Dinanath Pathy. *Orissa: Kunst und Kultur in Nordost-Indien.* Zurich: Museum Rietberg, 1980.

Fischer, Klaus. "Orissan Art in the Evolution of Postmediaeval Indian Culture." *Orissa Historical Research Journal* 3, no. 1 (1954), 27.

Genette, Gérard. *Narrative Discourse: An Essay in Method.* Translated by Jane E. Lewin. Ithaca, New York: Cornell University Press, 1980.

———. *Narrative Discourse Revisited.* Translated by Jane E. Lewin. Ithaca, New York: Cornell University Press, 1988.

Ghosh, D. P. "Eastern School of Mediaeval Indian Painting (Thirteenth–Eighteenth Century A.D.)." In *Chhavi Golden Jubilee Volume,* edited by Anand Krishna, 91–103. Banaras: Bharat Kala Bhavan, 1971.

Ghurye, G. S. *Indian Sadhus.* 2nd ed. Bombay: Popular Prakashan, 1964.

Goldman, Robert P. "The Serpent and the Rope on Stage: Popular, Literary, and Philosophical Representations of Reality in Traditional India." *Journal of Indian Philosophy* 14, no. 4 (December 1986), 349–69.

Goldman, Robert P., ed. *The Rāmāyaṇa of Vālmīki: An Epic of Ancient India.* Vol. 1, *Bālakāṇḍa,* annotation by R. P. Goldman and S. J. Sutherland. Princeton, New Jersey: Princeton University Press, 1984.

Gole, Susan. *Indian Maps and Plans, from Earliest Times to the Advent of European Surveys.* New Delhi: Manohar, 1989.

Goodman, Nelson. "Twisted Tales; or, Story, Study, and Symphony." In *On Narrative,* edited by W. J. T. Mitchell, 99–115. Chicago: University of Chicago Press, 1981.

Gorresio, Gaspare. *Ramayana, poema sanscrito di Valmici.* 7 vols. Paris: Stamperia Imperiale, 1843–48.

Goswami, Niranjan. *Catalogue of Paintings of the Asutosh Museum Ms. of the Rāmacaritamānasa.* Calcutta: Asutosh Museum, 1981.

Handiqui, K. K. *Pravarasena's Setubandha.* Ahmedabad: Prakrit Text Society, 1976.

Hein, Norvin. *The Miracle Plays of Mathurā.* New Haven, Connecticut: Yale University Press, 1972.

Hess, Linda. "The Poet, the People, and the Western Scholar: Influence of a Sacred Drama and Text on Social Values in North India." *Theatre Journal* 40, no. 2 (1988), 236–53.

———. "Rām Līlā: The Audience Experience." In *Bhakti in Current Research, 1979–1982,* edited by Monika Thiel-Horstmann, 171–94. Berlin: Dietrich Reimer, 1983.

Ingalls, Daniel H. H. *An Anthology of Sanskrit Court Poetry: Vidhākara's "Subhāṣitaratnakoṣa."* Cambridge: Harvard University Press, 1965.

Isacco, Enrico, A. L. Dallapiccola, et al. *Krishna the Divine Lover.* London: Serindia Publications, and Boston: David R. Godine, 1982.

Jha, Kalanath. *Figurative Poetry in Sanskrit Literature.* Delhi: Motilal Banarsidass, 1975.

Kane, Pandurang Vaman. *History of Dharmaśāstra.* 5 vols. 2nd ed. Poona: Bhandarkar Oriental Research Institute, 1968–77.

Kar, Krushna Chandra, Surendra Kumar Das, and Kumari Shantilata Sahu. *Ramayana in Ordisi Pata Painting.* Cuttack: Panchali Publications, 1977.

Keith, A. Berriedale. *The Sanskrit Drama.* Reprint. London: Oxford University Press, 1964.

Khandalavala, Karl, and Moti Chandra. *An Illustrated "Āraṇyaka Parvan" of the Asiatic Society of Bombay.* Bombay: Asiatic Society of Bombay, 1974.

————. *New Documents of Indian Painting—a Reappraisal.* Bombay: Prince of Wales Museum, 1969.

Kramrisch, Stella. "The Hundred Verses of Amaru Illustrated." *Journal of the Indian Society of Oriental Art* 8 (1940), 226–40.

————. *Unknown India: Ritual Art in Tribe and Village.* Philadelphia: Philadelphia Museum of Art, 1968.

Kulke, Hermann. "'Ksatriyaization' and Social Change in Post-Medieval Orissa." In *German Scholars on India,* 2:146–59. New Delhi: Nachiketa Publications, 1976.

Le Guin, Ursula K. "It Was a Dark and Stormy Night; or, Why Are We Huddling about the Campfire?" In *On Narrative,* edited by W. J. T. Mitchell, 187–95. Chicago: University of Chicago Press, 1981.

Leyden, Rudolf von. *Ganjifa: The Playing Cards of India.* London: Victoria and Albert Museum, 1980.

Losty, Jeremiah P. *The Art of the Book in India.* London: British Library, 1982.

————. *Krishna: A Hindu Vision of God.* London: British Library, 1980.

Lukacs, Georg. "Narrate or Describe." In *Writer and Critic and Other Essays,* edited and translated by Arthur D. Kahn. New York: Grosset and Dunlap, 1970.

Lutgendorf, Philip. *The Life of a Text: Performing the Rāmcaritmanās of Tulsidas.* Berkeley: University of California Press, 1991.

————. "Ramayan: The Video." *Drama Review* 34, no. 2 (Summer 1990), 127–76.

————. "The Secret Life of Rāmcandra of Ayodhya." In *Many Rāmāyanas,* edited by Paula Richman, 217–34. Berkeley: University of California Press, 1991.

————. "The View from the Ghats: Traditional Exegesis of a Hindu Epic." *Journal of Asian Studies* 48 (1989), 272–88.

Lutzker, Mary-Ann. "The Celebration of Arjuna—the Kirātārjuniya and the Arjunawiwāha in South and Southeast Asian Art." Ph.D. dissertation, University of California, Berkeley, 1983.

Mahapatra, Kedarnath, compiler. *Descriptive Catalogue of Sanskrit Manuscripts of Orissa in the Collection of the Orissa State Museum, Bhubaneswar.* vol. 3, *Purāna Manuscripts.* Bhubaneswar: Superintendant, Research and Museum, Orissa, 1962.

————. *Khurudha Itihasa.* 2nd ed. Cuttack: Granthamandir, 1984.

Mahapatra, Sitakant, and Dukhishyam Pattanayak. *Amarusatakam.* Bhubaneswar: Orissa Lalit Kala Akademi, 1984.

Mansinha, Mayadhar. *History of Oriya Literature.* New Delhi: Sahitya Akademi, 1962.

Marglin, Frédérique Apffel. *Wives of the God-King.* New Delhi: Oxford University Press, 1985.

Mazumdar, B. C. *Typical Selections from Oriya Literature.* 8 vols. Calcutta: Calcutta University Press, 1921–25.

Mehta, N. C., and Moti Chandra. *The Golden Flute: Indian Painting and Poetry.* New Delhi: Lalit Kala Akademi, 1962.

Mishra, P. K. *The Bhāgavata Purāna: An Illustrated Oriya Palmleaf Manuscript, Parts VIII–IX.* New Delhi: Abhinav Publications, 1987.

Mitra, Debala. "Four Little-Known Khākara Temples of Orissa." *Journal of the Asiatic Society of Bengal* 2 (1960), 1–23.

————. *Konarak.* New Delhi: Archaeological Survey of India, 1968.

Mittal, Jagdish. *Andhra Paintings of the Ramayana.* Hyderabad: Andhra Pradesh Lalit Kala Akademi, 1969.

Mohanty, Bijoy Chandra. *Appliqué Craft of Orissa.* Ahmedabad: Calico Museum of Textiles, 1980.

————. *Patachitras of Orissa.* Ahmedabad: Calico Museum of Textiles, 1980.

Moor, Edward. *The Hindu Pantheon.* London, 1810.

Mukhopadhyay, Durghadas. "Sahi Yatra." In *Lesser Known Forms of Performing Arts in India, Minimax: Special Number '76,* 119–23. New Delhi, 1976.

Nanavati, J. M., M. P. Vora, and M. A. Dhaky. *The Embroideries and Beadwork of Kutch and Saurashtra.* Baroda: Department of Archaeology, Gujarat State, 1966.

O'Flaherty, Wendy. *Dreams, Illusion, and Other Realities.* Chicago: University of Chicago Press, 1984.

Pani, Jiwan. *Ravana Chhaya.* New Delhi: Sangeet Natak Akademi, n.d.

Pani, Subas. *Illustrated Palmleaf Manuscripts of Orissa.* Bhubaneswar: Orissa State Museum, 1984.

Panigrahi, Krishna Chandra. *Archaeological Remains at Bhubaneswar.* Bombay: Orient Longman, 1961.

Patnaik, Kabichandra Kalicharan. *Kumbhāra Chaka.* Cuttack, 1975.

————. *Rāga-citra.* Cuttack: Odisi Kala Prakash, 1966.

Pattanayak, Sudhakar. *Brajanātha Granthāvalī.* Bhubaneswar: Orissa Sahitya Akademi, 1975.

Pathy, Dinanath. *Mural Paintings in Orissa.* Bhubaneswar: Orissa Lalit Kala Akademi, 1981.

Pillai, L. D. Swamikannu. *An Indian Ephemeris,* vol. 6. Reprint. New Delhi: Agam Kala Prakashan, 1982.

Pollock, Sheldon I., trans. and intro. *The Rāmāyaṇa of Vālmīki: An Epic of Ancient India.* Vol. 2, *Ayodhyākāṇḍa.* Princeton, New Jersey: Princeton University Press, 1986.

————. *The Rāmāyaṇa of Vālmīki: An Epic of Ancient India.* Vol. 3, *Araṇyakāṇḍa.* Princeton, New Jersey: Princeton University Press, 1991.

Prince, Gerald. *Narratology, The Form and Functioning of Narrative.* Berlin: Mouton, 1982.

Ramachandran, T. N. "The *Kirātārjunīyam* or 'Arjuna's Penance' in Indian Art," *Journal of the Indian Society of Oriental Art* 18 (1950–51), 1–111.

Ramanujan, A. K. "Three Hundred *Rāmāyaṇas.*" In *Many Rāmāyaṇas,* edited by Paula Richman, 3–49. Berkeley: University of California Press, 1991.

Rath, Tarini Charan. *Ghumsar Itihāsa.* Cuttack: Utkal Sahitya Press, 1913.

Ray, Eva. "Documentation for Paiṭhān Paintings." *Artibus Asiae* 40 (1978), 239–82.

Richman, Paula. "E. V. Ramasami's Reading of the *Rāmāyaṇa.*" In *Many Rāmāyaṇas,* edited by Paula Richman, 175–201. Berkeley: University of California Press, 1991.

Richman, Paula, ed. *Many Rāmāyaṇas: The Diversity of a Narrative Tradition in South Asia.* Berkeley: University of California Press, 1991.

Sahoo, K. C. "Indian Rama Literature and Jagamohan Ramayana." In *Ramayana Traditions and National Cultures in Asia,* edited by D. R. Sinha and S. Sahai, 175–78. Lucknow: Directorate of Cultural Affairs, Government of Uttar Pradesh, 1989.

————. "Oriya Rāma Literature." Ph.D. dissertation, Ranchi University, 1965.

Sahu, N. K., state editor. *Balangir District Gazetteer.* Cuttack: Orissa Government Press, 1968.

Sanford, David Theron. "Early Temples Bearing Rāmāyaṇa Relief Cycles in the Chola Area: A Comparative Study." Ph.D. dissertation, UCLA, 1974.

————. "Miniature Relief Sculptures at the Pullamangai Siva Temple, with Special Reference to the Ramayana Sequence." In *Kusumāñjali: New Interpretation of Indian Art and Culture,* edited by M. S. Nagaraja Rao, 277–87. Delhi: Agam Kala Prakashan, 1987.

Schechner, Richard. *Between Theatre and Anthropology.* Philadelphia: University of Pennsylvania Press, 1985.

Skelton, Robert. *Indian Miniatures from the Fifteenth to Nineteenth Centuries.* Venice: Meri Pozzi, 1961.

Smith, W. L. *Rāmāyaṇa Traditions in Eastern India.* Stockholm: Dept. of Indology, University of Stockholm, 1988.

Stache-Rosen, Valentia. "On the Shadow Theatre in India." In *German Scholars on India,* edited by the Cultural Department of the Embassy of the Federal Republic of Germany, 2:276–85. Bombay: Nachiketa Publications, 1973.

Stutterheim, Willem. *Rāma-Legenden und Rāma-Reliefs in Indonesien.* 2 vols. Munich. Georg Müller, 1925.

Thapar, Romila. "The Ramayana Syndrome." *Seminar* 353 (January 1989), 71–75.

Todorov, Tzvetan. *Genres in Discourse.* Translated by Catherine Porter. Cambridge: Cambridge University Press, 1990.

Vats, Madho Sarup. *The Gupta Temple at Deogarh: Memoirs of the Archaeological Survey of India,* vol. 70. New Delhi: ASI, 1954.

Vatsyayan, Kapila. "The Illustrated Manuscripts of the Gita-Govinda from Orissa." In *Madhu: Recent Researches in Indian Archaeology and Art History, Shri M. N. Deshpande Festschrift,* edited by M. S. Nagaraja Rao. New Delhi: Agam Kala Prakashan, 1981.

The Vishṇudharmottara (Part III). Translated by Stella Kramrisch. Calcutta: Calcutta University Press, 1928.

The Viṣṇudharmottara-Purāṇa, Translation of the Third Khaṇḍa. Translated by Priyabala Shah. Baroda: Gaekwad Oriental Series no. 137, 1961.

Waldman, Marilyn Robinson. "The Otherwise Unnoteworthy Year 711: A Reply to Hayden White." In *On Narrative,* edited by W. J. T. Mitchell, 240–48. Chicago: University of Chicago Press, 1981.

Waldschmidt, Ernst, and Rose Lenore Waldschmidt. *Indische Malerei.* In *Indien und Südostasien, Propylaen Kunstgeschichte,* vol. 16, edited by H. Hartel and J. Auboyer. Berlin: Propyläen Verlag, 1971.

Welch, Stuart Cary. *India: Art and Culture, 1300–1900.* New York: Metropolitan Museum of Art, 1985.

————. *Indian Drawings and Painted Sketches.* New York: Asia Society, 1976.

Whaling, Frank. *The Rise of the Religious Significance of Rāma.* New Delhi: Motilal Banarsidass, 1980.

Williams, Joanna. "Criticizing and Evaluating the Visual Arts in India: A Preliminary Example." *Journal of Asian Studies* 47 (1988), 3–28.

————. "The Embassy—an Orissan Painting in the Asutosh Museum." In *Indian Art and*

Connoisseurship: Essays in Honour of Douglas Barrett, edited by John Guy, 240–48. Ahmedabad: Mapin, 1995.

———. "From the Fifth to the Twentieth Century and Back." *College Art Journal* 49, no. 4 (Winter 1990), 363–69.

———. "Jatayu the Valiant Vulture in the Vernacular Art of Eastern India." In *The Story of Rama in Art and Culture,* edited by V. Dehejia, 117–26. Bombay: Marg, 1994.

———. "Jewels from Jalantara: Orissan Illustrated Manuscripts by Balabhadra Pathy." In *Indian Painting: Essays in Honour of Karl Khandalavala,* edited by B. N. Goswamy, 464–74. New Delhi: Lalit Kala Akademi, 1995.

———. "Marriage Paintings in South and Central Orissa." *Journal of the Orissa Research Society* 3 (1985), 4–9.

———. "A Painted Rāgamālā from Orissa." *Lalit Kala* 23 (1988), 14–19.

———. "Śiva and the Cult of Jagannātha: Iconography and Ambiguity." In *Discourses on Śiva,* edited by Michael W. Meister, 298–311. Philadelphia: University of Pennsylvania Press, 1984.

Williams, Joanna, and Jagannath Prasad Das, "Raghunātha Pruṣṭi: An Oriya Artist." *Artibus Asiae* 48 (1987), 131–59.

INDEX

(Most Oriya authors and artists are listed in alphabetical order by first name, the name by which they are commonly known.)

Designer: Rick Chafian
Compositor: Graphic Composition, Inc.
Text: 10/12 Berkeley
Display: Baker Signet
Printer: Malloy Lithographing, Inc.
Binder: John H. Dekker & Sons